ROGUES'
GALLERY

Also by the author

The Ultimate Trophy:
How the Impressionist Painting Conquered the World

Breakfast at Sotheby's: An A–Z of the Art World

Novels

Optical Illusions

The Stonebreakers

The Island of the Dead

The Soldier in the Wheatfield

An Innocent Eye

ROGUES' GALLERY

A HISTORY OF ART AND ITS DEALERS

PHILIP HOOK

P

PROFILE BOOKS

First published in Great Britain in 2017 by
PROFILE BOOKS LTD
3 Holford Yard
Bevin Way
London
WC1X 9HD
www.profilebooks.com

1 3 5 7 9 10 8 6 4 2

Typeset in Garamond by MacGuru Ltd

Printed and bound in Great Britain by
Clays, St Ives plc

A CIP catalogue record for this book is available from the British Library.

ISBN 978 1 78125 570 4
eISBN 978 1 78283 215 7

CONTENTS

INTRODUCTION

In the 1920s the legendary dealer Joseph Duveen, alert to all the nuances of selling art, deployed a strategy known as 'Below-stairs Intelligence'. He paid bribes to the servants of his richer clients to elicit useful information about their masters. By this means he discovered that the Baron Maurice de Rothschild, a notoriously autocratic and ill-tempered collector, suffered from chronic constipation. Buying art is a matter not of science but of stomach, so before contemplating any business with him it was advisable to telephone his *valet de chambre* to see if his bowels had moved that morning. Such attention to detail distinguishes the great art dealers. There is a heroism to their persistence and ingenuity. They can be pioneers, too: 'A man of action like the conqueror, a man of judgment like the critic, a man of passion like the apostle' was the rhapsodical verdict of Arsène Alexandre on the art dealing champion of the Impressionists, Paul Durand-Ruel. Marcel Duchamp's view of art dealers, on the other hand, was more succinct: 'Lice on the backs of the artists'. Whether they are conquerors or parasites, or somewhere in-between, the history of art would be very different and much less rich (both literally and metaphorically) without art dealers. Both the pleasure and the hazard of their profession can be traced to the unique nature of the commodity in which they are trading.

Art has very little functional value. I suppose that in the direst emergency a canvas by Roy Lichtenstein could be strung up horizontally on four poles to provide shelter from sun or rain, or a Henry Moore maquette could be used as a doorstop. I have a friend who, with no string to bind the asparagus he was cooking upright in a pan of boiling water, undid the picture wire from the back of a nearby framed work by Bernard Buffet and used that. This was a rare instance of a work of art providing (indirectly)

1

physical as well as spiritual sustenance. But that is not the purpose for which art is sold to a buyer, even a Buffet. No, the value of art lies in less quantifiable realms, governed by concepts like beauty, quality and rarity. That makes it a commodity with a value of disconcerting elasticity, because the criteria that determine it are spiritual, intellectual and aesthetic, often mixed with the social and aspirational. Thus those charged with the sale of works of art dwell in a glorious, free-ranging territory where fantasy is king, and something worth $100,000 in one context can the next day be worth $200,000 in another (or sometimes, more dispiritingly, only $50,000). It depends who is selling it, and how compelling their sales pitch is.

Art dealers are purveyors of fantasy. I don't mean fantasy in the sense of an untruth, but rather the sort of fantasy that stimulates soarings of the imagination, elevations of the spirit, and tantalising glimpses of highly remunerative investment. This is the territory of the art dealer, that Elysian Field bounded at the one end by the price of the work bought and at the other by the price of the work sold (or, to use the modern euphemism, the work 'sourced' and the work 'placed'). The larger the distance between the two, the happier the dealer. Delacroix recognised the element of fantasy that attends every successful sale of a work of art when he described art dealers as '*financiers du mystère*'. We all create myths about ourselves. Art dealers are particularly good at it, purveying as they do a compelling brand of fantasy in a market that is passionate rather than rational. Fantasy is infectious, too: sometimes it seeps through from the object sold to the seller himself, who starts to believe his own myth. Indeed some of the most successful art dealers have been those most firmly convinced of their own wonderfulness.

Art dealing is about persuading people to buy things they want but don't need. That, of course, is the challenge confronting the entire luxury goods industry. But what sets art apart is that you are marketing something beyond mere skill; you are marketing something intangible, unmeasurable, but infinitely desirable: genius. It is the mystery ingredient, inherent in the perception of art from the Renaissance onwards, but first identified and deployed in a big way by the Romantic movement. And it is no coincidence that the period when art starts being most boldly perceived as a matter of genius, in the nineteenth century, is the moment when art dealers start to flourish most significantly. Because genius is that gloriously unquantifiable value-adder.

'The price of a work of art is an index of pure, irrational desire,' wrote Robert Hughes, 'and nothing is more manipulable than desire.'

The buyer of the superb Cézanne *Garçon au gilet rouge*, which made a record-breaking price in the Goldschmidt sale at Sotheby's in 1958, was revealed to be the great American collector Paul Mellon. To the question of whether he had paid too much his answer was emphatic: 'You stand in front of a picture like that, and what is money?' What indeed? Great art was being acknowledged as, literally, beyond price. It is an extension of the devotional metaphor. Art, for twenty-first-century society, is the new religion. Buying art is like religious belief: it involves an act of faith. Trying to rationalise that process by a clinical analysis of the sum paid for a great work of art is as futile as the application of scientific reason to transcendent religious experience. It is, as Paul Mellon declares, irrelevant. That irrelevance, vouched for by a major and respected player in the top league of world wealth, was a glorious justification for art dealers to set their own prices for the best works. As the art-market historian Gerald Reitlinger observed, 'the value placed on pure genius is limited only by the fluid capital available'. 'You stand in front of a picture like that, and what is money?': it is a quotation that Sotheby's and Christie's might print next to any masterpiece they offer in their catalogues, in lieu of a pre-sale estimate.

The history of art dealing is different from the history of the art market. The key to art dealing, and to the history of its most significant exponents, is the personality of the art dealer. That is the theme of this book, a study of the fascinating band of men (and women) who devoted their imagination, ingenuity and powers of persuasion to selling works of art. The history of art dealing is also distinct from the history of collecting, but you cannot study the former without some awareness of the latter. Collectors are the clients of art dealers. You cannot understand the challenges that confront art dealers, and the methods they have devised to meet them, without understanding something of the motivations of the people to whom they purvey art. There are collectors primarily driven by investment, and collectors whose priority is intellectual and aesthetic. There is a similar scale that defines art dealers: at one end you have the merchant, in it for the money, and at the other end the scholar who wouldn't soil his hands with commerce at all if he didn't need to finance his own collection. All art dealers take their place somewhere along that line. Then there is the distinction between the dealer who handles old art (by dead artists) and the one who handles and promotes living artists. It is the distinction between a Duveen and a Kahnweiler or a Castelli.

How far does an art dealer influence the works that a collector buys,

and therefore contemporary taste? How far does an art dealer ever influence what an artist actually paints? In their promotion of one artist or movement over another, how far has the history of art – and particularly modern art – been determined by art dealers? This book attempts answers to these questions. While I have tried to anchor it on the dealers who made the most significant contributions to the development of their profession, I apologise in advance for the omissions and errors of emphasis that are inevitable in a study of this scope. Those featured are predominantly dealers in pictures, and, because I value good relations with my colleagues in the art world, I have avoided where possible writing about those still living. But notwithstanding all that, I hope that the assessment of the evolution of art dealing that follows will shed light from a new angle on the history of art.

PART I

RENAISSANCE AND ENLIGHTENMENT

I

AGENTS AND
MERCHANTS:
DEALING BEFORE 1700

Where should a history of art dealing begin? The original template
for the acquisition of a work of art was for an artist to paint a
picture which he then sold to a person who liked it enough to want to
hang it on his wall, or for the owner of a work that had already changed
hands to find a buyer for it in exchange for an acceptable price. It was a
one-to-one transaction. Sometimes rich men – patrons – would commis-
sion paintings from artists, but again they would go direct to them. The
process changes when the seller of a work of art – be he its creator or its
current owner – concludes that the price he is going to achieve will be
higher in the hands of an expert third party mediating between seller and
buyer than by relying on his own efforts. This is the moment when the
vague form of the art dealer – wielding his timeless attributes of charm,
cunning and expertise – emerges from the primeval gloom.

The poet Horace attests that a trade in Ancient Greek statuary was
conducted by collectors turned dealers in Imperial Rome. According to
the historian Pliny, paintings by the artists of antiquity were similarly
bought and sold. Pliny, who had a scientifically inquiring mind, grapples
with the question of how prices for works of art are established. He rec-
ognises that the identity and the reputation of the artist is one factor, and

subject matter is another: he gives an interesting account of how demand for scenes of everyday life increased in Imperial Rome, in preference to more traditional scenes of a grander nature involving gods and military triumphs. Here is a precedent for the bourgeois taste for genre painting that emerged in seventeenth-century Holland. But uncertainty over correct pricing persists, and Pliny also tells us that, when all other criteria for mutual agreement between buyer and seller failed, paintings were sometimes priced by weight. A similar system in the present day would presumably make Frank Auerbach, with his thickly trowelled-on impasto, the most expensive painter in the world. But the fact that such a measurement was sometimes resorted to in Rome indicates that the power of the dealer was still limited. If the only specialist knowledge required to trade in art is a pair of weighing scales, then the operation is no different from dealing in potatoes. But to the extent that successful dealing also involves expertise in artists' identities and understanding of what makes desirable subject matter, then the role of the art dealer takes on greater significance.

The Dark Ages intervene, but the art trade regathers momentum in the fifteenth century. In pre-Renaissance times the main function of Western Art was as the visual arm of the Christian religion. Most paintings were directly commissioned from artists by Church authorities or by rich donors anxious to please the Church. But with the early Renaissance, new lines of more commercial subject matter emerge alongside depictions of saints, crucifixions and holy families: mythological scenes, portraits, even some landscapes. The early art market was exactly that: a physical marketplace, where stallholders gathered on pre-arranged days through the year to offer works of art for sale. The first examples of these markets sprang up in Flanders, the great centre of European trade.

There were guilds and corporations regulating the production of and commerce in many things by this time. Paintings were no exception. The regulations of the Bruges Corporation of Image Makers of 1466 laid down that a merchant could only sell art 'in his inn at opening hours except on the three exhibition days during the Bruges year market, and the panels have to be of good quality, and this will be approved and expressed by the dean and the inspectors on their oath'. The dean and the inspectors on their oath sound ominously familiar: they are the direct ancestors of the vetting committees at international art fairs five-and-a-half centuries later. No doubt they met with similarly aggrieved reaction from exhibitors falling foul of quality control.

In 1460, a covered market, or 'Pand', began operation in the grounds of the church of Our Lady in Antwerp expressly for the sale of works of art. Stalls were rented to individuals for use during the biannual trade fairs. These stallholders were generally artists selling their own paintings, but gradually some took on the selling of the work of other (possibly less persuasive) artists. In so doing they were carving out for themselves the role of art dealers. The buyers were generally merchants, often buying paintings for export and resale in other countries – here were the first international art dealers. Or they were agents; the Medici, for instance, sent their representatives to Antwerp to buy paintings and tapestries, which they then shipped to Florence packed between bales of wool. By the 1540s the Pand had been subsumed into the Antwerp Exchange, an enterprise in which bankers, merchants and art dealers were brought together under the same roof to facilitate all sorts of transactions. Business boomed. It was a reflection of Antwerp's position as one of the great European trade centres, a place where people from all over Europe came to buy and sell. Daniel Rogers, an English envoy, recorded in wonder that the Antwerp Exchange was 'a small world wherein all parts of the great world are united', an early instance of globalisation. Art was a commodity like the others being traded in the same premises. In 1553 more than four tons of paintings and 70,000 yards of tapestries were shipped from Antwerp to Spain and Portugal. Art, when aesthetic criteria became commercially confusing, was still in the last resort being priced by weight.

But it was in the seventeenth century that the art market moved up a further gear, given impetus by dealers becoming increasingly international, and thus leveraging the price differential for individual works of art from country to country. In Amsterdam Hendrick van Uylenburgh, who effectively became Rembrandt's dealer by employing him in the Uylenburgh workshop in the 1630s, over time established a web of international agents with whom he did business: Peter Lely in London, Everhard Jabach in Paris and Jürgen Ovens in Schleswig-Holstein. Jean-Michel Picart (1600–1682) was an art dealer in Paris who entered into a commercial arrangement with Matthijs Musson (1598–c.1679) in Antwerp. Musson provided Picart with works painted in Antwerp to sell on the Paris market. Picart conveyed to Musson the ins and outs of Parisian taste, and Musson organised artists in Antwerp to paint pictures that met it. Correspondence between them survives. What did Picart (and therefore Paris) want? Church interiors; allegorical pieces such as *The Five Senses*; scenes of peasants and animals.

Musson supplied him with a pair of hunting scenes by Frans Snyders for which he had high hopes, but ended up only making a profit of 9 per cent on them, or so he told Musson. As ever, the challenge was speed of communication. Letters took seven days to reach Paris from Antwerp, and vice versa. A lot can happen in seven days, and each side suspected the other of deceiving them. Another Parisian dealer supplied by Musson was Nicolas Perruchot, who wrote him letters further deepening his understanding of Parisian taste. 'As for the paintings of Francesco Albani, they are esteemed in Paris, as long as they are not his latest ones,' Perruchot advised him. Such art market intelligence is always crucial. Its exchange helps keep dealers ahead of the game.

The pattern of Antwerp as a major source of supply of art to other European centres of consumption was reinforced by Melchior Forchondt, together with his son Guillam and various grandsons. As a family they fanned out across Europe, the Duveens of the seventeenth century, selling both mass-produced Flemish works and also older, more rarefied pictures. Three Forchondt offspring set up a branch in Vienna in the 1660s, which did well and enabled them to meet the growing demand in Germany as collectors recovered economically from the Thirty Years' War. They also had branches in Paris, Lisbon and Cádiz, where – a couple of centuries too early – they staked an early claim to the inchoate transatlantic market for European art.

Almost all the names mentioned above as active in the European art trade in the seventeenth century were artists; many of them turned to dealing because they couldn't make a living painting. There was a blurring of the distinction between the two activities, and artists were at an advantage as dealers because there was a wide presumption that only artists knew enough about art to be successful or reliable in purveying it. In 1619 the Guild of Painters and Sculptors in Paris tried to enshrine this presumption in law by adding articles to their statutes obliging bailiffs to obtain authorisation of a master in order to sell paintings or sculptures.

At the top end of the art market, the advance of art dealing in the seventeenth century was also driven by dealers exploiting the growing perception that artists were more than the manufacturers of a product. The great masters of the Italian Renaissance set a standard of heroic excellence, which had a trickle-down effect and raised the status of all artists and the desirability of their creations. Paintings were increasingly marketed not just as luxury objects but as examples of one of the Liberal Arts. In their

own time, the success of Leonardo, Raphael, Michelangelo and Titian had not been mediated by the efforts of dealers, because their work was commissioned directly by princes (royal, ecclesiastical or commercial). But in the generations that followed a myth about these artistic giants was established, encouraged by writers such as Giorgio Vasari, the first great art historian. This in turn led to rich collectors hunting their work like the rarest of big game. Here was the first trophy art, and embryonic dealers were on hand to purvey it, in the first instance as agents prepared to travel to source it, most productively to Italy itself.

That dealers were successful in Italy is attested by the outrage they provoked. There was seventeenth-century resistance to the trafficking of works by already-established and highly revered masters. The Accademia di San Luca thundered, 'It is serious, lamentable and indeed intolerable to everybody to see works intended for the decoration of Sacred Temples or the splendour of noble palaces exhibited in shops or in streets like cheap goods for sale.' Clearly dealers were going to have to adapt, to present themselves as something more than mere traders in goods. At the root of the invention of art dealing in its modern form lies the Renaissance-era transmutation of the painting, the object to be sold, from manual craft to Liberal Art. This made new demands on dealers and opened up new opportunities for them. What emerged – alongside the more traditional dealer who might ply his trade from a shop or an artist's workshop – was a new sort of dealer, operating in that no man's land where the amateur shades into the territory of the merchant – the collector who assembles beautiful works in his house or gallery, and occasionally allows himself to be separated from them, generally at a substantial profit. What he is offering is a combination of social acceptability and expertise. He presents what he is dealing in not as merchandise but as something more rarefied. As a way forward it has its merits. You can ask a higher price for an example of the Liberal Arts into which you have a superior understanding than for a mere product of manual craft. The prototype was a man such as Jacopo Strada in Venice in the sixteenth century. One of Titian's most compelling portraits is of Strada, who, if not an art dealer by name, was a connoisseur and collector who managed to accumulate great wealth through the amassing of his collection and the advice he gave to others regarding their collections (see plate 1). Why does this portrait depict him looking away from the piece he is handling? There is a message here. He knows its value, both aesthetically and commercially. But he is not necessarily totally committed to its ownership. It could be traded – at a price.

The importance of critics and art historians to the efforts of art dealers, an enduring alliance, dates from these times. The writings of Vasari, as we have seen, gave a framework to buyers' understanding of the relative merits of the artists of the past. A practical instance of the sort of support that a dealer could derive from a critic is provided by our old friend Jean-Michel Picart, who sold a large number of works by Rubens to the Duc de Richelieu in the 1660s and 1670s. The fact that simultaneously the art historian Roger de Piles was plugging Rubens in a series of writings asserting the Flemish painter's superiority over Poussin may not be entirely coincidental. Such a cooperation – between art dealer or collector and critic or art historian – to boost a particular artist is a commercial tactic not unknown in the years since.

The demand for supreme examples of art was still driven by princes and the aristocracy. In Germany, France and Spain the royal houses were acquiring major pictures as a statement of their power. In the seventeenth century they were joined for the first time by the British monarchy, as Charles I asserted himself as one of the great royal collectors. Sadly his progress went into reverse with the political difficulties that he encountered in the 1640s, ending in his execution. But for a time he was one of the biggest trophy hunters in Europe. His acquisitions were facilitated by Italy's economic decline, which meant that many owners there were willing sellers of their treasures. The process by which royal houses and other aristocrats acquired art abroad opened up opportunities for skilful art dealers. Generally there were two options available to collectors who had the cash available but were unable to travel to make purchases. Either they made use of diplomats already posted to foreign cities where good art could be bought at reasonable prices, or they used personal agents and advisers – often underemployed artists – who acted for them with varying degrees of transparency, discrimination and scrupulousness.

To be British Ambassador in Venice was an open invitation to become a de facto art dealer. At the beginning of the seventeenth century Sir Dudley Carleton, who held the post from 1610 to 1615, was one of the agents who facilitated purchases by the Earl of Arundel, the leading British collector who was instrumental in assembling the collection of Charles I. Carleton acted for others, too: in 1615 he bought fifteen Venetian pictures and a sculpture collection on behalf of the Earl of Somerset, from Daniel Nys. Nys was a wily Flemish art dealer who cropped up regularly wherever big art deals were being done in the first half of the seventeenth century, which

meant that he spent a lot of time in Italy. Unfortunately for Carleton, his transaction hit the rocks when Lord Somerset fell out of royal favour and was unable to pay for the collection. This is the art agent's nightmare: Carleton had already advanced the money to Nys out of his own pocket. There was no going back. An old hand like Nys was not going to unravel the deal. You can just imagine his regretful refusal: he was sorry, but he wasn't a charity. Carleton, landed with the merchandise, threshed around for another buyer. In time he offloaded the pictures on to Arundel, but the sculptures were harder to shift. It was only when his diplomatic career took him to The Hague that he finally found a buyer for them in the shape of Sir Peter Paul Rubens, who was a shrewd operator in the art market. Carleton took payment in the form of works by Rubens himself, and in turn managed to place one of them, *Daniel in the Lions' Den*, in the collection of Charles I. So the wheel of commerce turned.

Arundel, in search of a reliable man to operate for him in Italy, moved on from the diplomatic corps to the clergy, and recruited the Rev. William Petty. Petty, formerly tutor to the Arundel family, was despatched to Italy at regular intervals in the ensuing years and rather took to art dealing. He acquired a number of major works for Arundel and for Charles I. By the 1630s Petty's buying technique had taken on a distinctly experienced and cunning character. One of his strategies with pictures belonging to an Italian owner was bitterly outlined by a rival collector, the Duke of Hamilton:

> He [Arundel] gives directions to Petty to make great and large offers to raise their price, by which means the buyers are forced to leave them and the pictures remain with their owners, he well knowing that no Englishman stayeth long in Italy. So consequents the pictures must fall into his hands at his own price; Petty being always upon the place and provided with monies for that end.

Eliminating your rivals by making higher offers, then waiting till they have left Italy before doing the deal at a rather reduced price is not a very becoming trick for a clergyman; but Petty was a clergyman with a head for business. And he did have a royal patron.

In assembling his collection Charles I also made use of George Villiers, Duke of Buckingham, an ardent collector who in turn employed as adviser and agent an operator possibly even wilier than Petty: Balthazar Gerbier.

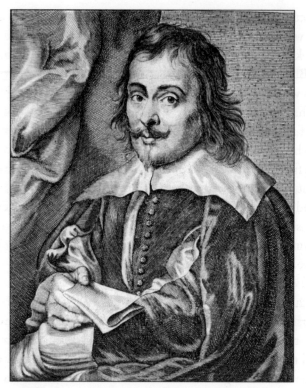

Balthazar Gerbier, prototype of the sweet-talking dealer.

Gerbier was a Dutchman who trained as an artist but found more gainful employment in the art trade. In 1621 he went on an art-buying trip to Italy for Villiers and did particularly well in Venice. Once again it was with the help of the British Ambassador, now Sir Henry Wotton, and the ubiquitous Daniel Nys. Gerbier managed to acquire the magnificent Titian *Ecce Homo*, for instance, for £275. In succeeding years he travelled to Spain and France on art-buying trips. He was ahead of his time as a dealer in the way he talked up the trophies he had laid hands on to his eager clients back in England. If it was sensuality you wanted, he could provide it: he spoke of 'the most beautiful piece of Tintoretto, of a Danae, a naked figure the most beautiful, that flint as cold as ice might fall in love with it.' Or there was work of a more devotional nature, if that was your taste: 'a picture by Michael Angelo Buonarotti [sic], but that should be seen kneeling, for it is a Crucifixion with the Virgin and St John – the most divine thing in the world. I have been such an idolater as to kiss it three times...' But just to get across that he was discriminating on behalf of his clients, he also advised

against 'a picture of our Lady by Raphael, which is repainted by some devil who I trust was hanged'.

Gerbier knew how to ingratiate himself with those he worked for, writing to Buckingham in 1625 in an ecstasy of oleaginous sycophancy: 'Sometimes when I am contemplating the treasure of rarities which Your Excellency has in so short a time amassed, I cannot but feel astonished in the midst of my joy. Out of all the amateurs and princes and kings, there is not one who has collected in forty years as many pictures as Your Excellency has in five.' And it was as well to remind his employer of the financial achievement, too: 'Our pictures, if they were to be sold a century after our death, would sell for good cash, and for three times more than they cost.' It is an early instance of a dealer extolling art as investment. I particularly like that 'three times'. Based on no informed economic calculation beyond his own instinct and interest, it nonetheless carries the sort of casual authority in which art dealers excel.

The death of a major collector is an exciting event for art dealers, though it is of course only decent to shroud your elation at the prospect of the release onto the market of a quantity of great works of art in a proper show of grief and respect. On 31 May 1640 Rubens died, and almost immediately Gerbier was writing to Charles I to alert him to an impending sale. Two days later he was also reporting the artist's demise to Arundel. At the very least he scented high prices, market excitement and the possibility of remunerative commissions. But what he hadn't properly registered was that the political wind was changing for these great royalist collectors. By the end of the decade the King would be beheaded, and under the Commonwealth no one in Britain would be buying pictures any more.

Daniel Nys could have told Gerbier about this change in the British political wind and its dampening effects on the King's collecting ardour. One of Charles I's greatest coups as a collector had been his purchase of the magnificent Gonzaga collection, the property of the Duke of Mantua. It was an audacious project, initiated and conducted by Nys, and negotiations continued throughout 1627. Deploying all his talents of charm and cunning, Nys now and then even affected a certain coyness, writing to the Duke of Mantua's chief negotiator: 'I did not respond earlier because of a grave disagreement that sprang up between me and my purse. I wanted to offer more than I already had but it did not want to and said it was enough...' In the end a deal was struck at a price of 68,000 scudi, and Nys reported to Endymion Porter back in London, 'I used every tactic possible

to have them at a reasonable price, at which I succeeded, for if they had known they were for His Majesty they would have wanted much more.' 'In treating for them,' he added, 'I sensed divine help, without which it would have been impossible to have effected the purchase.' God taking an interest in art transactions is a novel theological idea. We will come across it again with Paul Durand-Ruel and the Impressionists. In view of such divine intervention, it is consistent that Nys claimed not to have made a penny on the deal. 'I undertook all of this only to please His Majesty without any personal interest in the contract,' he wrote to Carleton in 1629.

Is this credible? One of the greatest art deals of the seventeenth century being brokered by a dealer who refuses to take a penny for his efforts? It is just possible, in an age when royal favour was an asset beyond financial value. I don't know for sure, but if an art dealer today were in position to sell something big to President Putin, they might do so for no commission because of the privileged introductions to the Russian oligarchy that might follow. Presumably Nys also calculated that his noble gesture in waiving any remuneration from the King would bring all sorts of remunerative future business. If so, he was for once mistaken. He took a risk too far in acquiring further statues and paintings from the Gonzaga collection without the definite royal go-ahead. Charles, now in political and financial difficulty, never actually came up with the payment. It precipitated Nys's ultimate bankruptcy. The moral of this story for all art dealers is that you do business with royal houses (and Russian presidents) at your peril.

Cromwell's accession to power in Britain meant that Cavalier grandees had to sell up their art collections fairly smartly in the middle of the century. Private art holdings were not likely to endear you to the new regime. In London and Amsterdam large numbers of good pictures thus came onto the market at very reasonable prices. Charles I's collection was offered for sale in London, displayed in Somerset House, and a number of continental collectors emerged to snap up the bargains. One was the Parisian banker Everhard Jabach, who cultivated a reputation as a leading connoisseur. Jabach's opportunism drew him over the boundary separating the collector from the dealer; bit by bit his private collection became his stock and his considerable financial resource enabled him to bide his time and only sell at the most advantageous moment. A contemporary of Jabach was unequivocal in his opinion of him as tainted with the dealer's brush. The Count de Brienne, a passionate collector, referred with scorn to 'the Jabachs and the Perruchots... those great horse-traders of paintings

who, in their time, have often sold copies for originals'. To be called a horse-trader was bad enough, but the imputation that Jabach sold copies as authentic works is evidence that the sort of personal enmities that have lit up the art market in more recent times were already in play early on.

Foreign diplomats in London were also opportunistic buyers. Alonso de Cárdenas, the Spanish ambassador who bought for the Spanish royal family, competed with Antoine de Bordeaux, the French ambassador buying for Cardinal Mazarin in France. Again the activities of these collectors and agents were close to those of the dealer; certainly many purchasers at these sales were doing so as speculators. Some were more successful than others: two nephews of Jabach, Franz and Bernhard von Imstenraedt, bought two Holbeins, four Titians and an Antonello da Messina, which they then spent the next twenty years unsuccessfully trying to sell off to different buyers, including Emperor Leopold I in Vienna. Finally, in 1670, they managed to offload them to the Bishop of Olmütz. The egregious Balthazar Gerbier, on the other hand, had learned the capacity speciously to reinvent himself, which is the hallmark of all agile traders adapting to new sociopolitical conditions: we now find him ingratiating himself with Cromwell's Council of State, denigrating Charles I and his court for the 'great sums squandered away on braveries and vanities; on old, rotten pictures, on broken-nosed marbles'.

While indigenous picture buying in London almost ground to a halt in the middle of the seventeenth century, it proceeded apace on the continent. In the extraordinarily mercantile atmosphere of the Netherlands, where everyone was dealing in something, from grain to silk to tulips, trade in works of art took significant strides forward. During this period there was a marked increase in the number of artists and of pictures painted, to meet the demand that was growing amongst the burgeoning middle class. 'Pictures are very common here,' reported John Evelyn on a visit to Rotterdam in 1641, 'there being scarce an ordinary tradesman whose house is not decorated with them.' Art dealers flourished (see plate 2). It was now generally recognised that the market for art was subject to rather different rules from, say, the market for grain, that the commodity being sold had a value established according to less tangible criteria. But the debate continued as to what those criteria were. The ancient precedent of weight was abandoned, but the metric of the size of the painting obviously played a part. An ancient Dutch proverb has it that the object sold 'is worth what a fool is willing to pay for it', but others more thoughtfully proposed that

since a painting was primarily a rendering of nature, the criterion of merit and therefore of value should be the accuracy of its depiction.

The seventeenth-century Dutch art dealer was the medium whereby artists were fed information about what picture-buyers wanted. Artists increasingly became specialists in particular subjects: flowers or still lives; animal pictures; history pictures; amusing scenes of peasant life; military subjects. Thus they established brands that were more easily marketed by dealers. A successful dealer such as Leendert Volmarijn was not above exploiting his artists, either. He paid Isaac van Ostade the miserly sum of 27 guilders for thirteen paintings of peasant life. The artist's brother brought a legal action against him, as a result of which he rather begrudgingly put the rate up to 6 guilders a painting. Other artists were put to work in workshops by dealers who paid them an annual stipend for all their production. Paul Durand-Ruel, when he offered the same deal to the Impressionists in the early days of the movement, was thus following a long-established precedent. Not that artists were easy to deal with. In 1663 a Dutch dealer, Cornelius de Stael, reported to his client: 'It's very troublesome to do business with these gentlemen [painters]. I find it much better to buy pictures already painted than to commission new ones.' It's the cry echoed by Nathan Wildenstein more than two centuries later, when he warns his young grandson Daniel only to work with dead artists, 'because living ones are impossible to deal with'.

The case of the family firm of van Uylenburgh is a good illustration of how art dealing at a relatively high level worked in seventeenth-century Holland. The previous generation of his family – members of the Mennonite sect – had fled to Poland because of religious persecution, but in 1625 Hendrick van Uylenburgh returned and set up as an artist in Amsterdam. He was obviously entrepreneurial: he opened a studio where he employed other artists, and started selling their work as well as his own. His workshop became known as a place you could go to if you wanted to buy a good picture. In 1631 van Uylenburgh took Rembrandt into his workshop. Being handled, in effect, by a dealer, had an interesting effect on Rembrandt's production. It meant he painted many more portraits, because van Uylenburgh procured for him a rapidly growing number of commissions. In fact of the 100 or so portraits Rembrandt painted in his career, half were crammed into the four years he worked for van Uylenburgh. The wily van Uylenburgh used Rembrandt as a poster boy for his business, arranging the increasingly popular portraitist's sittings in the workshop itself so that the

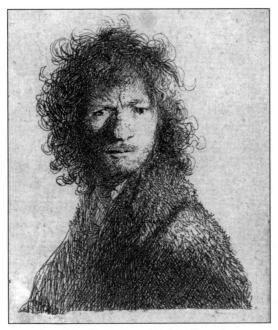

Rembrandt's self-portrait, an etching from the 1630s.

sitters got to see all the other stock available at the same time. And under van Uylenburgh's influence, Rembrandt's work changed in other areas too, particularly his etchings. There was an increase in biblical subjects, for which there was demand from the wide circle of fellow-Mennonite clientele that van Uylenburgh had gathered, and Rembrandt's actual etching technique became more tonal and carefully worked.

That the van Uylenburgh workshop encouraged its artists in the production of prints as well as paintings is an early instance of a dealership striving to meet the public demand for art at different price levels. Not everyone, then as now, could afford an oil painting by an artist, but an etching, produced in multiples, gave access to that artist's work to an increased number of less well-off art collectors and helped with the cash flow. Three hundred years on, Marlborough Fine Art did the same thing: in the post-war era they had under contract a majority of the most important names in British art, including Henry Moore, Francis Bacon, Graham Sutherland, Lynn Chadwick and Ben Nicholson. In order to maximise sales at lower price points, all the Marlborough stable of artists were encouraged to take up printmaking, generally lithographs that could be marketed in signed editions, not too small, not too large, to people

who couldn't afford major oils or sculptures by the artists concerned. It was a successful venture for Marlborough, even if for some of the artists involved it represented a detour off their natural track.

What also deepened the relationship between Rembrandt and his dealer in the early 1630s was the fact that Saskia, the woman he married, was Hendrick van Uylenburgh's niece. As a dealer, to marry off your star artist to a member of your family is generally a sound exercise in asset retention, but in this instance Rembrandt was too talented, popular and independent to remain totally shackled to the van Uylenburgh workshop, and he moved on. In Italy, too, art dealers were still seen as people you got involved with as a serious artist only at the beginning of your career. Once you were established you would do better without them, because patrons would come straight to you. The early works of Caravaggio were handled by a French dealer called Valentin, and Ribera and Salvator Rosa also began their careers in Rome working for dealers. But they all moved on to better things without being directly in thrall to any individual art trader.

Later in his career, at those moments of financial stress that afflict even the most successful artists, Rembrandt turned in other directions for help – to Harmen Becker, for instance, in the 1660s. Becker, a successful financier, became in effect a banker to painters, lending them money against their future production. Thus Becker pioneered a different route to art dealing: the money man who supports an artist by buying his work and then sells on what he acquires at a profit.

Hendrick's son Gerrit became the prominent figure in the Uylenburgh business from the 1650s onwards. Gerrit was also trained as a painter, but seems to have spent most of his time procuring paintings by other artists. The works he supplied were now not just Dutch but also, via his web of international contacts, from further afield. As an acknowledged authority on art, art history and the market, he was involved in the assembly of works put together as a gift from the Dutch state to Charles II on his restoration to the British monarchy in 1660, a gift that included works by Italian artists. In 1671 Gerrit was approached by an agent of the Elector of Brandenburg to put together another group of distinguished works to form the Elector's collection. Sadly the venture ended in acrimony when there was a dispute as to the quality – and in some cases the authenticity – of the paintings supplied.

In February 1673, after protracted negotiations, Gerrit was forced to take the consignment back at considerable financial loss. He held a sale of

the collection, for the catalogue of which he commissioned a poem that declares bravely:

The fog of libel is dispelled by the clarity of the Cognoscenti
Lies vanish before the searing light of truth

At a time when poets are generally worse off than artists, this poetic form of sale promotion and authenticity guarantee is one that dealers and auction houses should perhaps look at again today. Or perhaps not, because it didn't do Gerrit van Uylenburgh much good. The failure of the sale, in what was now an economic downturn in Holland, left his finances in a mess. Even great dealers have moments – under dire stress – when their moral compass temporarily loses its sense of direction. There is some suspicion that Gerrit took consignments from Jabach in Paris, had them copied in his workshop, sent the originals back as unsold, but sold the copies as originals on the Amsterdam market. It would have been a risk, but perhaps it was a risk worth taking, given his extreme need and the distance that separated Paris from Amsterdam. The situation is a trifle ironic bearing in mind that Jabach himself was being accused at home by the Count de Brienne of peddling copies as originals. Perhaps the 'originals' that Gerrit had copied in Amsterdam were themselves copies that Jabach had had made in Paris.

Finally Gerrit had to run for it. He left Holland for England, where he found employment in the studio of his erstwhile agent, Peter Lely, painting in the costumes and landscapes in Lely's portraits. This sounds an ignominious end to a glorious career, but there was time for one more twist in the story, when he gained a position in the court of the restored Charles II as 'Keeper of the King's Pictures', a suitably royal rehabilitation. Gerrit was neither the first nor the last dealer to find his career an alarming roller coaster of peaks and troughs.

The seventeenth century saw various different templates for art dealing established: the head of the artists' workshop, marketing his employees' products; the merchant who buys them and then sells them at a profit in a different location; the agent abroad who sources art for his clients, often the great art of the past; the collector gradually drawn into commerce by the excitement of selling from his own collection at a profit. And dealers' allies emerge in the form of the critic and the historian, whose role is to boost particular artists and provide a framework for the attribution of merit and therefore of value to the artists of the past.

2

CROOKS AND CONNOISSEURS: THE EIGHTEENTH CENTURY

How do you arrive at a fair price for a painting? With the expansion of the market across Europe in the eighteenth century, this was a question that continued to preoccupy collectors and dealers. In answer to the problem, the mechanism of the auction became increasingly important as the means of transferring ownership of works of art from one pair of hands to another. Private treaty was perceived as a dangerously unregulated operation, open to abuse by the unscrupulous. The public nature of the auction seemed to offer protection, a means of establishing a price for the unpriceable. Dealers are nothing if not adaptable, and were quick to exploit the popularity of the auction, doing so as both buyers and sellers. Some even went to the extent of holding their own auctions, often comprising works of art they had bought cheaply themselves in other markets in Europe.

As art expertise and appreciation became desirable attributes in smart circles on either side of the English Channel, there was an increasing demand for what art dealers purveyed. To form a collection had moral, intellectual and social benefits. It was one of the things you did to announce yourself as a gentleman. This was the age of the connoisseur,

the virtuoso and the dilettante. There was a difference of nuance between these three roles. The connoisseur was the discerning judge of a work of art, able to identify quality with a natural discrimination. At the ideal end of the scale, the connoisseur was capable, according to Lord Chesterfield, of appreciating the arts on a philosophical level, but did not necessarily stoop to the practical work of differentiating between the hand of one Italian master and another. The virtuoso was also extremely knowledgeable, but erred on the side of accumulation of knowledge and collecting for its own sake; the degenerate example was as interested in a collection of seashells as of old master drawings. He was connoisseur as nerd. The dilettante, in its eighteenth-century force, was simply an amateur with a love for art, untouched by the earnestness of the professional; it did not acquire its slightly pejorative meaning as a dabbler till later.

The question of connoisseurship was of absorbing interest. Taste and beauty became increasingly desirable commodities by which to define your life. Lord Shaftesbury wrote that the appreciation of aesthetic beauty was the first step towards understanding nature and communing with the deity. In 1719 Jonathan Richardson published *An Argument in Behalf of the Science of a Connoisseur*, in which he takes a pragmatically British attitude to the question. Connoisseurship is a good thing because it contributes to England's wealth, status and power by encouraging traffic in the art market and the efforts of local painters. Richardson adds that if you spend money on pictures and antiques rather than lavishing it on luxury you will make successful capital investment. Here was a social and economic justification for art dealers. And the result, by the second half of the century, was that connoisseurship became socially a very desirable thing to practice. It was how to get on in the world. Goldsmith commented: 'The title of connoisseur in that art [painting] is at present the safest passport into every fashionable society; a well-timed shrug, an admiring attitude and one or two exotic tones of exclamation are sufficient qualifications for men of low circumstances to curry favour.' The pretension was too much for the acerbic Sydney Smith:

I hate coxcombry in the fine arts as well as in anything else. I got into terrible disgrace with Sir George Beaumont once, who, standing before a picture at Bowood, exclaimed, turning to me: 'Immense breadth of light and shade!' I innocently said, 'Yes, about an inch and a half.' He gave me a look that ought to have killed me.

Dealers catered to the needs of the new connoisseurs, and indeed presented themselves as connoisseurs, but connoisseurs with a practical bent, connoisseurs who *were* prepared to get their hands dirty with the reading of artists' handwritings. For obvious commercial reasons it became advantageous to advertise themselves as experts with superior abilities in the field of attribution. But there was an ambivalence about commerce: the purist view of the eighteenth-century French Academician maintained that 'No *honnête homme* can embrace the profession of commerce. The honour and sentiments he possesses are incompatible with the science of petty details, the dirt of merchandise and the dust of bales.' Such reservations were expressed even more proscriptively in relation to art by the philosopher Diderot in 1776: 'At the moment when the artist thinks of money,' he says, 'he loses his feeling for beauty.' Dealers who sold the work of living artists were felt to be a necessary evil, which at least had the merit of removing from artists the obligation of soiling their hands with filthy lucre. But the purists reserved their most virulent scorn for those painters who themselves became dealers in older art: 'Those wretches bear the same antipathy to a real Artist as a Eunuch does to a Man.'

And how many dealers were actually prepared to promote and sell the work of local living artists? Not many in Britain, it seemed. 'The Arts in England have hitherto been depressed by picture dealers, who in the most unfair manner never fail to oppose to rising merit the works of some dead master,' wrote John Gwyn in the mid-eighteenth century. It was easier to make money by dealing in the already established masters of the past: hence the feebleness of English art up to the middle of the eighteenth century. Living English artists had few commercial champions, until the foundation of the Royal Academy in 1769 provided a trade union for them, and an arena in which to sell their work in the shape of the annual exhibition. A flowering of English art resulted: this was the age of Reynolds and Gainsborough, of the great portraitists and animal and landscape painters, of Stubbs and Richard Wilson. But what some in the art trade felt about living artists is illustrated by the dealer who employed the English marine painter Charles Brooking (1723–1759): he had Brooking's signature on his paintings erased before he offered them for sale. This suppression of the identity of the painter could be read in different ways. It could be an attempt by the gallery owner to promote the brand of his gallery as the supplier of beautiful paintings at the expense of the brand of the artist who produced them (in the same way that the jewellery produced by Cartier

or Bulgari is known by the jeweller's brand rather than by the name of the designer within their workshop who created it). Or it could be a very eighteenth-century connoisseurial attitude that what counts is the spiritual beauty of the painting rather than the more mundane question of who actually painted it. Antoine Coypel wrote in 1721:

> It is not a painting's reputation that determines its merit; rather its merit must determine its reputation, and I wish the *curieux* would address the question of what is good and bad instead of preoccupying themselves with authors, style, and originality. For the majority of them would not dare offer praise or blame until they had satisfied themselves in these matters.

The question of the innate quality of a painting as the determining factor of its value without reference to the artist who created it has exercised succeeding generations of art dealers. As we will see with Kahnweiler later, dealing in modern art becomes increasingly a question of getting the identity of the artist right rather than marketing the aesthetic pleasure of unattributed paintings. That's not what dealing in modern art is all about. No one is going to pay a lot of money for, say, a Cubist painting without hard knowledge of who it's by. But in the eighteenth century it was still possible, if all else failed and you really couldn't say who had painted a picture, to connect your sales pitch to the argument put forward by Coypel and thereby sell even unattributed works by playing on the buyer's connoisseurial purity. I leave till last a third, rather less heroic but possibly most likely explanation for Brooking's dealer's obliteration of the artist's signature from his seascapes: he hoped to sell them as works by Willem van de Velde, as which they would be worth considerably more.

There was a marked increase in the number of paintings imported from abroad into England at the end of the seventeenth century, reflecting a burgeoning demand, as the country emerged from the puritan restrictiveness of Cromwell's regime, as well as the fact that more money was being made. That they had to be imported also reflected the lack, apart from a few indigenous portraitists, of a home-grown art production at this time. The works imported from France, Italy and the Netherlands were mostly old masters, and generally the people responsible for importing them were dealers or agents who then offered them for resale in auctions in London. When William Petty foraged for paintings in Italy for Charles I's royal

collection in the 1620s and 1630s, he was the Earl of Arundel's exclusive agent. When Thomas Manby went there in the 1680s to buy art, however, he had moved on from being the exclusive agent of one client to being the agent of several. His final step was to become the principal himself, buying paintings outright and returning in 1686 to London, where he held a successful auction of what had in effect become his stock.

In the first half of the eighteenth century more specialist dealers emerged in London. Andrew Hay for instance, a Scottish artist who found dealing more profitable than painting, made his living travelling regularly on the continent and sending home old masters. France and Italy were his main sources of supply. He bought extensively with his own capital, then sold at the auctions he himself arranged in England. Between 1725 and 1745, Hay travelled to France fourteen times and to Italy six times. Two of his Italian journeys were made on foot, a commitment to his trade probably beyond most twenty-first-century art dealers, despite their regular protestations of 'going the extra mile' to do this or that for their clients.

In the lower reaches of the eighteenth-century art trade, however, the image persisted of the art dealer as crook. Instances abound of dishonest behaviour, at the centre of which was the whole issue of authenticity. Dealers who held auctions were widely guilty if not of deliberate misrepresentation then at least of excessive optimism in their catalogues. An insight into their practice is provided by the egregious Mr Puff, the auctioneer in Samuel Foote's theatrical farce *Taste*, first staged at the Haymarket in 1752, which satirises unscrupulous art dealers and their pretentious clients.

The artist Carmine, who is deeply embroiled in the nefarious end of the art trade, rues his involvement in the commercial side of the business: 'Was the whole of our profession confined to the mere business of it, the employment would be pleasing as well as profitable; but as matters are now managed, the art is the last thing to be regarded.' More important than the art is the means of selling it: 'Family connections, private recommendations, and an easy, genteel method of flattering'.

A 'Guido Reni' of Susannah and the Elders actually painted by Carmine has just been sold by the dealer/auctioneer, suitably named Mr Puff, for 130 guineas. Carmine calculates the costs and the net profit: 'four guineas the frame, three the painting; then we divide just one hundred and twenty-three'. Puff corrects him: 'Hold – not altogether so fast – Varnish has two pieces for bidding against Squander; and Brush five for bringing Sir Tawdry Trifle.' And Puff points out that the Susannah as a Carmine

would have made twenty, whereas 'by the addition of your lumber-room dirt, and the salutary application of the spaltham pot, it became a Guido, worth 130 pounds... praise be to folly and fashion, there are in this town dupes enough to gratify the avarice of us all.'

Puff decides to impersonate a rich foreign buyer, the Baron de Groningen, in order to excite competition for Carmine's daubs amongst the 'home crowd' of virtuosi and connoisseurs. Carmine approves the idea: 'You have no conception how dear the foreign accent is to your true virtuoso; it announces taste, knowledge, veracity, and in short, every thing.' Puff's world-weary conclusion is: 'We all are rogues, if the taking advantage of the absurdities and follies of mankind can be called roguery.'

But the fraudulence could not go on forever at fine art auctions. It gradually became clear that buyers needed help, in the form of protection from the unscrupulous Mr Puff, and in the form of more reliable information about what they were bidding on and buying. And thereby the evolution of respectable art dealing in the eighteenth century is informed by the gradual growth of expertise. A business model developed of the art dealer who is not just buying cheap in one place and selling expensive in another, but who enhances the value of what he has bought by exercising his scholarly connoisseurship on it and redefining it as something more important than what he bought it as. Soon after, a number of more scholarly dealers emerge, an early example being the Englishman Arthur Pond (1701–1758), artist, entrepreneur and connoisseur. By 1725 Pond had taken the well-travelled route to Rome, to study and learn. No doubt he had in mind a career as a painter, but was already intrigued by connoisseurship. On the way back to England he stopped in Paris and met the famous Pierre-Jean Mariette (1694–1774), along with other French connoisseurs who drew him into their trade in Netherlandish, Italian and French drawings and prints. As Lippincott remarks, 'Pond and Mariette would correspond for the rest of their lives, bickering respectfully over the quality and attributions of their wares.'

Out of the circle of Mariette evolved the concept of the 'hand', the identification of an artist simply by reference to the technique of his drawing or painting, literally his artistic handwriting. There were obviously important commercial implications to this development. It meant that paintings and drawings did not have to be signed, or boast cast-iron provenances, in order to be sold as the work of a particular master. They were genuine, and therefore valuable, if they came with the attested attribution of an

acknowledged connoisseur. How far were advances in connoisseurship and a growing understanding of art history propelled by art dealing and the development of the art market? There comes a point at which transparency is recognised by participants in a market – by buyers and sellers and by the middlemen in between – to be a good thing. Transparency is achieved by being able to describe the object you are selling as accurately as possible and to set it in its historical context. Here the art historian Roger de Piles came in useful again. The book he published in Paris in 1708 entitled *Cours de peinture par principes avec une balance de peintres* contained a numerical ranking of the fifty-six most prominent artists of the past. Even if de Piles's book was not directly driven by the requirements of the budding art market, publications such as his met needs that the more intelligent amongst art dealers were now realising they had.

It was a further contention of Mariette that artists were too jealous of rival artists to make informed judgements about the work of others. Attribution was more reliable when made by unbiased connoisseurs. While Pond, as an artist himself, might not necessarily have agreed with that view, he acquired from Mariette the belief that drawings were the most revealing indices of an artist's 'hand'. Indeed the internationalism of his early experience was important to Pond's development as a dealer. In the early 1730s the Society of Dilettanti was founded in Rome, entering into an alliance with the Roman club in London to promote appreciation of Italian art and culture in England. Pond was instrumental in these arrangements. He acted as mentor and adviser to a group of wealthy merchants and government office holders in the City of London. Clubs were dear to the heart of the eighteenth-century gentleman, and Pond would corral them into meetings at his own house, or at Christopher Cock's auction room, where works would be discussed and purchases would be made. Thus important personal collections of paintings, drawings and prints would be assembled and the circle of people interested in art – future dealer clientele – was expanded.

Pond's house in Covent Garden was the place where he conducted much of his business. Dealing has taken place over the centuries in a number of different settings: the studio, the gallery, the fair, the shop. But Pond's is an early example of a dealer using his own reasonably grand house as a selling venue. He saw it as a natural showroom, at once less threatening and more stylish than a shop, a place that emphasised in situ how works of art might enhance a pleasing domestic setting. The public rooms chez

Pond were well hung with examples of his own work – portraits, copies after Raphael made in Rome – and of old masters by others. There is a subtle nuance here. To his clients Pond presented himself primarily as a painter who happened to have one or two other works by old masters hanging on his wall, works which might conceivably be for sale. This was because a painter was definitely perceived as higher up the social scale than an art dealer or a common printseller. Pond deliberately minimised the commercial aspect of his trade in old masters, elevating the process into a 'polite exchange' and a 'quest for beauty' suitable for gentlemen. Although the relative ignorance of most English connoisseurs forced them to rely on the judgement and honesty of their dealer, Pond was subtle enough to downplay that aspect of his relationship with his clients. He preferred to win their confidence by living like a gentleman, thus insinuating himself into the patterns of their daily life.

In his prime Pond was firing on many cylinders. He was constantly inventive in finding ways to sell art. In 1737 he started making tours round England visiting noblemen's houses, doing portraits, copying paintings and offering drawing lessons, particularly for women. In London he performed the duties of a receiving agent for the works that rich aristocratic travellers to the continent sent home, easing through customs not just paintings but sculptures, marble tables and even harpsichords. He developed a practice as a portrait engraver and – nothing if not an energetic self-publiciser – used the products like printed advertisements for his portrait painting. Pond's relationship with Sir Peter Delmé, Governor of the Bank of England and Lord Mayor of London, is an example of what he would do for a client. Delmé went on the Grand Tour in the 1730s, and Pond received and unpacked at London docks the crates of pictures that Delmé acquired, then cleaned and framed them. Pond painted portraits of Delmé's sisters, and made pastel copies after Rosalba Carriera for Delmé's London house. He bid for him at auction. He provided him with old masters. It was an impressively comprehensive service.

Unlike that of the leading auctioneer of the time, Christopher Cock, Pond's expertise was generally regarded as reliable and discriminating. His authority increased with time. The word 'true' with his signature on the back of a work of art was a widely accepted imprimatur of its genuineness and quality. Many outstanding works on paper today in major museums bear Pond's mark. English grand tourists, having had their fingers burned in Rome by unscrupulous dealers, came to rely on Pond. And Pond came

to see himself as retailing professional expertise in art in the same way as a lawyer did with law or a doctor with medicine. Perhaps he was the first professional art adviser.

In his time he acquired a number of indisputable masterpieces, such as his purchase in 1739 of the marvellous Rembrandt *Woman Bathing* now in the National Gallery, London. And there were more mundane moments of dealing triumph. A vignette is provided by his purchase of a sketch by Castiglione from his friend the artist George Knapton for £1.11.6 in March 1740. He sold it only a month later to Lord James Cavendish for 5 guineas. Ah, the sweet spot of the 350 per cent profit margin!

By the end of his life, Pond was more of a collector than a dealer, and indeed something of an art historian. He set out to make a comprehensive survey of the works of Poussin and Claude to be seen in England. This links him into the tradition of dealer scholarship that produced in the twentieth century definitive *catalogues raisonnés* of major artists by three generations of Wildensteins. Pond also became a printseller: he employed the best engravers to make reproductions of significant works by old masters, which he sold as scholarly aids to collectors. Prints in general were growing in mass appeal. Marketing his own prints was an important source of income for William Hogarth, for instance, a great self-publicist who had no truck with dealers. There were plenty of dealers lower down the scale who made livings from being popular printsellers. Lippincott records an Irish adventuress called Laetitia Pilkington who decided to deal in prints in London, an indication of the demand for the product and the way all sorts of people were now becoming dealers, a bit like the flurry of enthusiastic if underqualified ladies of a certain background and age who opened antique shops in the home counties in the mid-twentieth century.

What drew enterprising dealers to Italy in the eighteenth century was that, whereas the original patrons of the great artists of the past had been rich, their descendants were now struggling financially. Aristocratic Italian families were eminently persuadable into parting with their treasures. As the Grand Tour became fashionable for rich Northern Europeans, glorious opportunities opened up for skilled middlemen 'sourcing' works from Italian owners and 'placing' them with moneyed buyers. Besides acquiring art in Italy and sending it back to London for sale by auction, dealers from Britain established themselves in Rome and Florence as 'on the spot' advisers and salesmen to the grand English gentlemen on tour there. Some grand English gentlemen even set up house in Rome and stayed. The Duke

of Shrewsbury was one, causing his friend Lord Halifax to write to him from England: 'I am glad you are grown so great a virtuoso. I shall have much more pleasure in that sort of conversation than in the field sports you admired when you went from hence.' A clientele that had previously found its pleasure and amusement in the hunting field or on the grouse moor was now doing so in collecting art. The conditions were ripe for the foundation of Christie's (in 1766), a very English institution traditionally susceptible to the appeal of both grouse moor and art collecting, in which order sometimes not being entirely clear.

Rome in the eighteenth century was a fascinating melting pot of political intrigue, social ambition and trade in art. A surprising variety of people were involved in the mix: diplomats, merchants, spies, aristocrats and cardinals. A typical intriguer was Philipp von Stosch (1691–1757), a secret agent of the King of England spying on the Old Pretender (then resident in Rome). Stosch found the sourcing of art treasures to sell to the international clientele congregated in Rome both profitable and a useful cover for his more clandestine activity; he was described as 'by profession a spy, and by reputation a homosexual, an atheist, a blasphemer, a liar and a thief'. What must have made him an even more convincing art dealer was his belief in wine – 'la clef universelle des mystères humains' – as a loosener of the tongue and a means of information gathering.

In the Vatican itself a particularly significant figure for the art trade was Cardinal Albani (1692–1779), a politician sympathetic to British interests, a close friend and correspondent of the diplomat Sir Horace Mann, and an art connoisseur. He was one of those grandees who gravitated towards art dealing in a discreet but highly effective way, although he would have been horrified to be called a dealer. He was very adept at putting together on the one hand his cash-strapped fellow-countrymen who owned art and antiques, and on the other those English gentlemen who had the money with which to buy them. He operated like some sort of benign Lord Duveen in episcopal purple. But, less like Duveen, he was a genuine connoisseur with a sincere pleasure in beautiful objects: it was said of him that 'when he grew blind in old age the sense of sight seemed to have migrated into his finger tips'. Albani took a benign interest in the Rome art trade, on occasion operating as a kind of discreet court of appeal to its inevitable disputes. A typical case presented to him for judgement involved the English dealer Thomas Jenkins. Jenkins was accused of having reneged on an agreement to buy a bust on an English gentleman's behalf; instead, it

was alleged, he had bought it for himself, and then made rather a large profit on it. Albani sorted the matter out in favour of Jenkins.

Mann and Albani made use of their official connection to promote increasing acquisitions of art for the great houses of England. There were tiresome export restrictions in place on antiques and works of art, put in place by Pope Clement XI in 1701, and Albani helped with the evasion of these. Thus Matthew Brettingham – Lord Leicester's agent and art adviser – tells Mann to make clear to Lord Leicester that the statues he is buying have only been described as 'ordinary' to facilitate their export from Italy. In June 1753 Albani recommends statues from Villa d'Este to Bubb Dodington, the British diplomat and connoisseur. And on the British side it was not unusual for the Royal Navy to help get works of art home from Italy for collectors of influence. It is an indication of how important the art trade had become to the national interest: here was the acquisition of wealth, status and power that Richardson had foreseen accruing from traffic in art.

Albani built his own villa on the Via Salaria and filled it with beautiful things, continuing to occupy that ambivalent territory between collector and dealer. Were his treasures his collection or his stock? In 1762, for instance, they were stock, when James Adam (brother of the architect Robert Adam) and Richard Gaven (an Irish merchant and agent) succeeded in buying works of art from Albani 'on behalf of George III'. It seems that Albani's mistress influenced the deal, in order to raise a dowry for her daughter out of the profit. Allowing your love life to complicate your transactions is dangerous territory for any dealer, particularly if you are also a cardinal; thus, when Gaven came back for more, Albani's treasures were a private collection once again and their owner was reasserting regretfully that he did not buy in order to sell.

Joseph Smith (1682–1770) also occupied that profitable no man's land between the gentleman-collector and the middleman-trader, where the former state is both cloak to and facilitator of the latter. He was yet another to make use of his position as British Consul in Venice to facilitate the sale of works of art to English gentlemen, in this case large numbers of 'view' paintings by Canaletto, thereby fostering the English taste for the Venetian artist. That there was a commercial component to Smith's role is clear from the fact that he became known as the 'Merchant of Venice'. Besides supplying English collectors, he managed to assemble a very fine collection himself, including many Canalettos, which he sold to George

III in 1762. So effective an operator had he become that one of the motives behind Canaletto's relocating to London between 1746 and 1753 was to evade the middleman commissions of Smith, and sell direct to his English clientele.

Later in the eighteenth century, a British artist-dealer who made a name for himself in Rome was Gavin Hamilton. He was an archaeologist as well as an art dealer, and if you were an English gentleman visiting Italy – or indeed mail-ordering from home – he would find you antique statuary besides paintings. It is extraordinary how much art dealing at this time was carried out by letter, occasionally supported by visual aids such as sketches or engravings of the work for sale. In the end there had to be a leap of faith – yes, buy it for me – followed by the sobering moment of truth when the picture or sculpture was unpacked after its shipping to Britain. Occasionally a buyer reneged when he didn't like what he saw, which must have been tiresome for all concerned. But the number of deals that went through on this basis is surprisingly high, and attests to the reliability of the better dealers' eyes and in some cases, perhaps, to the lack of discrimination of the unfortunate British buyer holed up in some remote Scottish castle and without the critical wherewithal to distinguish between copy and masterpiece.

But by and large Hamilton was honest and discriminating. He collected oil studies and bozzetti for his own pleasure, knowing that there were few buyers for them. He wrote well-informed letters to his fellow dealer Giovanni Maria Sasso in Venice, from whom he bought many Venetian school works that ended up in Britain. He explains to Sasso that large pictures are difficult to sell, and that dark ones are likewise a problem with British buyers, in whom, because of the lack of sun in their country, there is a preference for bright colours. There is also a resistance to the rapid, impressionistic style of Tintoretto. In another letter to Sasso he deplores the fact that a less fastidious Venetian dealer, Pietro Concolo, has cut up Veronese's Petrobelli altarpiece, 'like meat in a butcher's shop'. Still, that does not deter him from putting in an offer for the most appealing fragment. Dealers have to eat, after all.

Sasso was the predominant art dealer in Venice in the last quarter of the eighteenth century, and had profitable relations with a succession of visiting English dealers, agents and collectors. As ever the British Consul or Resident was a crucial middleman in providing English collectors or mail order collectors with the pictures they wanted, be they by Venetian

Renaissance masters or more recent painters such as Tiepolo or Guardi. Sasso made sure he was on good terms with a succession of British Consuls, notably John Strange and Sir Richard Worsley. Another dealer of the time was Giacomo della Lena, who in his position as Spanish vice-Consul did much profitable picture dealing, supplying largely German collectors. Della Lena is the author of an interesting letter written in 1786 to the economist Giuseppe Maria Ortes. The arts, he maintains, are unlike the sciences. In the arts fantasy predominates over the intellect, and what is of value and pleasurable in the arts is indirect and unformulated. Fantasy again, that commodity so difficult to pin down, but of such joyously elastic financial value. Della Lena is getting to the essence of how successful art dealing functions.

To return to Hamilton: he would travel about Italy on buying trips accompanied by a good copyist having worked out that it was easier to persuade owners to sell if you offered them a copy of the work concerned as part of the deal. Similarly, in the case of the monks in Bologna whose altarpiece he wanted to buy, it is interesting to observe his techniques of persuasion. He warned them that the altarpiece was not in a good state of preservation, and if it was left hanging in its present location the excessive humidity would bring about its decay and destruction. There was only one answer: sell now, before your asset becomes valueless, a message compelling in its mixture of concern and menace that has stood many dealers in good stead since.

When it came to selling, Hamilton's technique often depended on flattery. He assured Charles Townley, the great collector of antique art, that he was 'the only true dilettante I have ever met'. He was fond of ratcheting up the pressure on the client to buy by telling him that the object in question had been kept back specially for him. It's the oldest trick in the book; he assured Lord Shelburne that he was 'happy that your lordship should receive the choice fruits'. The implication was that Shelburne must be bold enough to pluck them. There were moments when Hamilton's imagination and optimism got the better of him, as when he tried to sell to Lord Breadalbane a couple of Veroneses that he confessed had apparently been clandestinely removed from the Public Library of Venice. 'I only beg that what I have mentioned may be kept a secret for the sake of peace and quiet,' he added a trifle disingenuously, attesting to the absence of a legal compliance department in his business set-up.

Hamilton's greatest triumph was his discovery of Leonardo's *Madonna*

of the Rocks, which he bought from the Hospital of Santa Caterina alla Ruota in Milan (see plate 4). This was too good a trophy to consign to a mail order purchaser. Hamilton accompanied the work back to London, where he arrived in 1785 and offered it to Lord Lansdowne. The price was £800. 'I should be glad of an answer before two o'clock tomorrow,' he told Lansdowne, 'when I must go to Mr Desenfans.' Desenfans was a rival collector. There was no mistaking the threat. But Hamilton added, 'All my ambition is that your Lordship should have the preference of this.' Lansdowne had been given first bite. He should take it. He did.

The London art market grew increasingly important in the eighteenth century as Britain developed into the richest nation in the world and London supplanted Amsterdam as the leading financial centre in Europe. But on the continent, too, art dealing was developing along international lines. For instance in 1750 the Danish art dealer Gerhard Morell settled in Hamburg in order to sell to the German nobility paintings that he bought at auction in Holland. Similarly by 1765 Christian Benjamin Rauschner was importing works of art he had bought in Holland, to be auctioned in his native Frankfurt. Alongside these German developments, Paris remained not just an important art trading centre but also a centre of the continuing traditions of connoisseurship initiated by Mariette and his circle.

Two art dealers in eighteenth-century Paris who set new standards of expertise (which they purveyed to their buyers as enhancements of the works of art they were selling them) were Edme-François Gersaint (1696–1750) and, in the second half of the century, Jean-Baptiste Pierre Le Brun (1748–1813), husband of the painter Élisabeth Vigée Le Brun. These connoisseur dealers were responsible for the first modern auction catalogues, in that they provided not just basic information as to size and authorship but justified their attributions and gave art-historical details about the artists concerned, sometimes even of previous prices paid for their work. This was education of their clientele rather than deception of it. They travelled widely in their search for paintings to offer on the Paris market, to Holland and the Low Countries, to Germany, to Italy and, even in the case of Le Brun, to Spain; he was responsible for the rediscovery and rehabilitation of artists as varied as Holbein, Ribera and Louis Le Nain. These are early instances of enlightened and knowledgeable dealers forming taste not so much by the promotion of contemporary artists but by judicious rediscovery and marketing of dead ones.

Gersaint's sales pitch is as an honest broker on whom both buyer

and seller can rely. In the preface to his sale of the collection of Gode-froy (1748), he emphasises the importance of staying 'within the strict bounds of the truth so as not to prejudice the interests of either party'. Noble words indeed, particularly when contrasted with those of Mr Puff on the London stage about the same time. And indeed Gersaint went to considerable lengths to feed the market with reliable information, about artist's lives, about the collecting histories of those whose property he was selling, and occasionally even with reflections on varying national tastes and prejudices. The Dutch, for instance, are notoriously difficult to per-suade to part with anything valuable, he tells his clients; and the English have a marked fondness for the works of Willem van de Velde.

One of the earliest depictions of an art dealer at work is the picture painted by Antoine Watteau in 1720, of the premises in which Gersaint traded. *L'Enseigne de Gersaint* is a fascinating image of how art dealing was carried on in early-eighteenth-century Paris (see plate 3). The shop itself, elegantly done up, is nonetheless open to the street and designed to break down the same threshold resistance that twentieth-century American shopping malls came into being in order to counter. The smooth-talking dealer is doing his best to make a sale. Elsewhere a grand couple are viewing. We are left in no doubt that buying pictures was a gentlemanly thing to do. Indeed elsewhere Gersaint makes clear the social advantage of collecting art – its power to enhance your status: 'it gives him [the amateur] entrée into the most celebrated cabinets where he may also pursue his recreation. As an amateur he becomes by virtue of a common passion the equal of those superior in rank and condition.' But once a dealer, always a dealer. Despite the fact that Watteau had painted *L'Enseigne* as a very personal tribute to Gersaint, and it was indeed his shop sign, Gersaint had no qualms about selling it when the right offer came along.

Half a century later, Le Brun's analysis of what sold and what didn't provided a revealing insight into contemporary popular taste. He acknowl-edged that one factor that created high prices for artists' work was rarity on the market, but he said that buyers were most moved by 'workmanship'. Thus the minutely and realistically executed paintings of Gerard Dou and van Mieris were especially desirable; it was much more difficult to sell those painters whose style was more painterly and impressionistic, such as van Goyen. Most eighteenth-century art lovers still wanted value for money, and therefore prized evidence of intense labour.

Although Jean-Baptiste and Élisabeth Le Brun were possibly the first

instance of a power couple in the art world – he the renowned dealer and connoisseur, she the sought-after portraitist – all was not well between them. The personal vignettes we get of Le Brun from his wife's memoirs show him to have been extravagant, unfaithful and unreliable. She accompanied him on a buying trip to the Low Countries in 1782, but she was constantly made aware that she took second place to his art dealing. 'After my marriage,' she recounted, 'I continued to live in Rue Clery where M. le Brun possessed a large and richly furnished apartment; paintings by great masters hung on every wall. As for me, I was relegated to a small antechamber and a bedroom which had also to serve as a salon.' Their problems came to a head with the Revolution. She was too closely identified with the *ancien régime*, having painted most of its brightest lights, and had to flee France. Le Brun stayed put, struggling to prevent her name from being listed as émigrée; this was prompted less by marital loyalty than by fear of the consequent forfeiture of their property, which might have included his stock. Finally he divorced her in 1794, and by dint of some deft footwork succeeded in reaching a rapprochement with the Republic. Art dealers not infrequently have to reach an accommodation with controversial political regimes in order to function. Some do it rather well.

In the eighteenth century the big money was in selling the art of the past. The question of how to promote the work of living artists only engaged a minority of art dealers. But some of those who did grapple with the challenge found a novel way of doing so, as impresarios, as purveyors of spectacle. In 1736 Jonathan Tyers first started showing art at the Vauxhall Pleasure Gardens in London. He exploited a leisured and pleasure-seeking audience by exhibiting essentially light-hearted paintings showing pretty women and rustic amusements by artists such as Joseph Highmore, Francis Hayman and William Hogarth. How far his initiative led to sales is not clear, but there was commercial intent in the operation. Later in the century came the sensation picture, a single work generally on an impressively large scale that could be marketed as attractive or controversial enough to bring people in to see it at a shilling a time. A particularly sensational early example was the painting Nathaniel Hone exhibited in 1775, which included a representation of his fellow artist, the glamorous Angelica Kauffman, holding a torch in a state of nudity. Attendance was high. The public, its appetite for naked lady artists not yet dulled by Tracey Emin, turned up in numbers. In this instance Hone was his own impresario; but often it was a cooperation between artist and dealer, the

former executing the attention-grabbing work and the latter promoting and exhibiting it in suitable premises. In the later eighteenth century even landscapes became bigger and more dramatic in order to qualify as sensation pieces, promoters realising that the public could be moved by the majesty of nature on a grand scale. The final step in the process, after the punters had paid their shillings to see the original of the sensation picture, was to sell them specially produced engravings of the subject. This business model set a profitable template for dealers in the nineteenth century, as we shall see in Chapter Four.

PART II

THE NINETEENTH CENTURY

3

THE ART OF
SPECULATION:
WILLIAM BUCHANAN

From the later eighteenth century onwards the barrier deterring a gen-
tleman from involvement in trade became increasingly rickety, and
one of the places where it was first breached was in art. In fact by 1800
an extraordinary variety of people were buying art with an eye to profit:
the British aristocracy, the diplomatic service, even prelates of the Church
of Rome. And a turf war was being fought between participants in the
market. Purists denigrated artists who became dealers. Artists still main-
tained their own supremacy as connoisseurs of old masters. High-minded
connoisseurs criticised collectors who became speculators, as did dealers
outraged by such flagrant trespassing on their own territory. F.-C. Joulain,
a French dealer, excoriated 'the most reprehensible class of amateurs...
which, possessing no precise taste for anything in particular, pursue every-
thing with an eye to speculation, [and] buy in order to sell.' To complete
the circle of recrimination, the young William Buchanan, the subject of
this chapter, was happy to describe himself as a speculator but would have
been horrified to be considered a dealer.

William Buchanan was a glorious, larger-than-life product of the
Regency era, an entrepreneur operating in a period that offered oppor-
tunity and disappointment in tantalising succession. His differentiation

of himself as a speculator rather than a dealer is an interesting one. In Buchanan's eyes, to be a speculator in paintings was a respectable, even gentlemanly way to approach art, akin to a commercial venture like buying a boatload of bananas from the West Indies, importing them and selling them at a profit in Britain. But a dealer, no. That was a lower form of commercial life. 'Mr Champernowne in his letter suggests my joining him in a scheme of purchasing pictures in London to send out to Rome which he says may turn out to good account,' Buchanan reported sniffily to his English agent David Stewart in February 1803. 'This is dealing, not speculating, and I have entirely declined it.' In the same year George III deprecated the fact that most of his noblemen had become picture dealers, and doubted whether the English had any true love for art; a little later Sir Walter Scott declared, 'I fear picture-buying, like horse-jockeyship, is a profession a gentleman cannot make much of without laying aside some of his attributes.' So the distinction between dealing and speculating was important to Buchanan. It preserved his apparent status as a gentleman.

And yet if he didn't call himself a dealer, Buchanan's life as a speculator was subject to many of the trials and tribulations familiar to those engaged in the art trade in the two centuries since. Indeed in the daily struggle to persuade sellers (generally Italian) to part with their treasures, and British collectors (the end users) to buy them at prices significantly more than he himself had paid for them, he confronted and found answers to a number of very modern-sounding challenges.

'In troubled waters we catch the most fish,' wrote Buchanan in 1824. What made the opening years of the nineteenth century such an exciting juncture in the British art market was the fact that the upheavals of the French Revolution and of the Napoleonic invasions into Italy and Spain loosened the grasp of many continental aristocratic families on their art collections. 'Scarcely was a country overrun by the French than English-men skilled in the arts were at hand with their guineas,' wrote John Pye in 1845, looking back on this golden era. For in Britain no such depri-vations were felt, and collectors – mostly aristocratic, but also including members of the new plutocracy – began looking to the continent to make acquisitions of works by the great names of the past. The importation to Britain and sale of the Orléans Collection in 1798 was a huge stimulus to the market. The disposal of what had been the French royal collection was brokered by a syndicate of British noblemen, led by the Duke of Bridge-water, but masterminded by the dealer Michael Bryan. Bryan came from

an industrialist family. He appeared in London in the 1790s from Ghent, where he had been working for his brother's textile mill. His familiarity with the importation of goods from continental Europe, which was the business model of most British art dealers of the time, encouraged him into art dealing. The Orléans Collection was his great coup. The syndicate of British noblemen divided up the choicest trophies amongst themselves, then put the rest up for sale in London under Bryan's direction in December 1798.

The sale went so well that the great works held back by the syndicate in effect cost them nothing. The result was a number of very fine pictures finding appreciative homes in Britain and equally excitingly a large amount of money being made by those lucky enough to have a hand in their sale. Michael Bryan was established. He married 'up', into the family of an earl, never a bad move for an art dealer. But in the end he pushed his luck too far. He boasted of having duped Lord Lonsdale into selling him cheap an unattributed painting that Bryan felt confident was a Titian. It led to court proceedings, and ultimately to his bankruptcy. He retired quietly to the country to write his monumental *Biographical and Critical Dictionary of Painters and Engravers*. It is a pleasing art-dealing morality tale of hubris, nemesis and a productive contrition.

In the giddy aftermath of the success of the sale of the Orléans Collection, the young William Buchanan set about creating a regular supply line of distinguished old masters from France and Italy that could be offered to British buyers on their own doorsteps. He recruited an agent in Italy (James Irvine, a Scottish artist) to make the purchases and an agent in London (David Stewart) to arrange the importation formalities and exhibit the merchandise to prospective purchasers in commodious rooms in the capital. For funding they used money raised by Buchanan and a number of other speculators whom Buchanan had persuaded into his syndicate. But there was never any doubt that the driving force was Buchanan himself. He kept his man in Italy informed as to what sort of pictures would and wouldn't sell in Britain, told him how much to pay, and sometimes directed him to likely sellers whose money troubles he had heard about on the international grapevine. To his man in London he issued increasingly detailed instructions as to how sales were to be achieved. As both a buyer and a seller, he developed methods of an ingenuity and occasional duplicity that have remained serviceable in the international art trade ever since.

The years 1802–06 are particularly well documented in Buchanan's career of art speculation. A series of letters between him and his agents survive, and have been entertainingly edited by Hugh Brigstocke. This correspondence is worth following in more detail in order to understand Buchanan's manner of business. His efforts are described by Brigstocke as being 'assisted by two particular personal qualities: an almost total ignorance about works of art, which enabled him to turn a deaf ear and blind eye to any criticism of his wares, and an utter contempt for his clients and indeed for picture lovers of every kind, institutional, aristocratic, or nouveau-riche'. I am not sure that this is entirely fair. Buchanan was only twenty-four at the beginning of this correspondence, a recently qualified lawyer in Edinburgh feeling his way in the art market. Under the circumstances it is remarkable how quickly he succeeded in acquiring a modicum of serviceable knowledge about the works of art that he was handling; admittedly it was knowledge deployed in the interests of making sales, and sometimes he was guilty of an excess of that optimism that afflicts art dealers in assessing the quality of their own stock, but he was perceptive about what sort of art and artists found favour in British taste of the time. The accusation of contempt for his clients is harder to argue with. But that has been a feature of the careers of a number of highly successful and well-regarded art dealers in the two centuries since, notably Ambroise Vollard and Félix Fénéon in the early years of Modernism.

The Buchanan letters reveal a man who was cunning and surprisingly modern in the methods he employed both to find works that were desirable to the market and to achieve their sales. Because he was in regular correspondence with both his buying agent and his selling agent, and favoured them often with his thoughts, hopes and strategies, a remarkable insight into the functioning of an art dealer emerges. He was a great enthusiast for lists: an early example was the list of pictures in Angerstein's collection that he sent to Irvine as a means of identifying 'gaps' that the collector may wish to fill. 'All these hints I give you for future regulation,' Buchanan told Irvine, and went on to recommend Flemish cabinet pictures, particularly works by Ostade, Wouwerman and Teniers; but he counselled caution with portraits, unless they were by Rembrandt, Rubens, van Dyck or Titian. 'A fine Titian is probably the greatest object at present of any master for people appear Titian mad,' he observed. He read widely to research artists and collections, and to identify opportunities. He drew attention to a Danae by Titian that was recorded in Florence in

1771, mentioned as being 'most beautiful' in a travel book written by a Mrs Miller. 'Would it not be worthwhile making enquiry after this picture?' he suggested. Elsewhere he told Irvine to be careful of big pictures. For one thing they covered too much wall, leaving less space for future purchases.

'I am the longer the more convinced of the propriety of endeavouring to know the private views and wants of each collector,' Buchanan went on, this time to his man Stewart in London. Information is power: 'It is of great consequence to know the taste of purchasers for the different Masters, and the individual Master each Collector is most fond of, for all have a favourite Master. And it could be a great point gained to know from their own mouths by asking "What master are you looking for at present?" And note down the answer.' In March 1804 he instructed Stewart: 'I wish you would engage the <u>Abbott</u> who is a clerk in Christie's to furnish you with marked catalogues of all the principal sales of pictures there – with jottings of what is purchased in, and what sold with the purchasers' names – you may allow 10/6 for each.' Buchanan was fond of making extensive lists of prospective purchasers of his stock. There was a certain amount of wishful thinking in these lists, and you sense Buchanan stretching plausibility to its limits. But there are times when every dealer needs the consolation of fantasy.

Buchanan also emphasised the importance of preserving a picture's freshness to the market. 'We must be very nice about <u>who</u> sees them <u>first</u>,' he explained to Stewart. 'This is considered you know if sold privately, as a matter of great favour, and importance, in the sale of them.' 'You're the first person I've offered this to,' has since been the sales pitch of many a dealer, in his eagerness to please, occasionally to several different buyers in succession in relation to the same picture. Indeed the renewability of the virginity of paintings is one of the miracles of the art market.

Buchanan maintained a strict control over the quality of the works he acquired. Secretly he dreamed of the holy grail of the establishment of a National Gallery, and of his putting together a group of pictures of sufficient quality to offer them to the government. It is a moot point whether this would have been more exciting to Buchanan as a cultural deed or a financial transaction. 'I am determined no indifferent picture shall disgrace it,' he declared of his stock. 'Should such appear they must troop off to the sound of Monsr Christie's hammer.' By February 1803 a group of twelve choice items had been assembled, comprising a portrait of Charles I by van Dyck, four pictures by Rubens from the Balbi and Doria Palaces, Genoa,

two works by Raphael from Florence, the celebrated Colonna Poussin (*The Plague*), the celebrated Colonna Parmigiano, a Claude from a Palace in Rome, a Venus and Satyr by van Dyck and a Magdalene by Guido Reni.

By June there had been success with the works by Rubens: three of them were sold at a profit. But the Raphaels had turned out to be too 'hard, brown, early and Gothick' for English taste. 'The vanity of the English now is to possess a few rare and highly celebrated works, and for these any money is given,' reported Buchanan to Irvine. This was an early instance of the pursuit of 'trophy art', so familiar to the twenty-first century, and a recognition that the dealer was generally better off with one superlative work than several good ones. Gradually Buchanan also formulated theories about what subject matter sold. Youth and beauty was preferable to old age, he noted: 'St Jerome, St Francis and the like do not take. Young St Johns – Virgins and Child, Venus and Cupids... on the other hand are the rage.' In England landscape pleased more than historical compositions – hence the popularity of Claude and Poussin. He wisely emphasised the importance of provenance. 'Everyone asks "what collection was it in?" It is a fine picture [the Claude] but without its history the picture loses much of its value'. Knowing the provenance insured the sale, because it appeared to the buyer as 'a check against any pictures being a Copy.' Buchanan regularly reminded his agents that successful speculation depended on selection. It may be a truism, but it's an enduring one. In the twenty-first century, one of the great euphemisms of the art world after a disappointing auction or art fair is to describe the market as 'selective'.

Buchanan grappled gamely with other obstacles to commercial success that were distinctive to his time. How were images of paintings communicated to prospective buyers in a pre-Internet age? Prints of famous works in Italian collections were important aids. Where such prints did not exist, sketch-copies might be commissioned from local artists in Italy to be sent back to England to whet buying appetites. As part of his research Buchanan sometimes asked Irvine to send him books from Italy that listed paintings in old collections and the buildings in which they hung. In October 1805 he asked for 'Manzales description of Rome in 2 vols and Ratti's account of the pictures of Genoa'. But generally the most reliable way to conclude a sale was by putting the original in front of the buyer. This created hideous logistical problems. Shipping and insurance were time-consuming and expensive challenges, particularly in an era of European war. British vessels, the most reliable carriers of works of art

from Italy to Britain, were excluded from Italian ports. Insurance premiums were high, although less so if the vessel carrying the art was part of a convoy. Given the difficulties, it is a miracle that any sales at a profit were achieved at all. No wonder that, while Buchanan sometimes made use of restorers to remove layers of old varnish and grime, at other times he economised by doing it himself: 'The Venus I have gone over with my pen knife and taken off the fly blows which had formed distinct tints, and given in some places an appearance of incorrect drawing which is now very much removed,' he reported optimistically after one such foray.

By October 1803 Buchanan was revising somewhat his high-minded reservations about sending works to Rome for sale by 'dealers'. It might be the best plan for the troublesome Raphaels, the sort of pictures which in their unsaleability Duveen would describe a century later as 'ungrateful'. He directed the consignment of Raphaels to Caraciollo, a Roman dealer, 'to make it appear Roman property'. And by the beginning of 1804 Buchanan was sufficiently worried about sales to consider consigning some of his stock to Christie's, but only if they could be offered alone, 'unmixed with other Collections – for if Trash were added it might throw a stigma on the collection as being secondary, while if very valuable pictures were added it might avert the Current of Cash into other pockets'. But he resolved to keep back the Parmigiano because it was in his view superlative, and Buchanan felt that 'people in general do not give <u>very</u> large sums for pictures in this way [by public sale]'.

Buchanan took rooms in Oxendon Street in which to exhibit his stock for sale. Extensive instructions as to how to hang the pictures to best advantage while on view were directed to David Stewart. 'The Claude I think does best with the shadow side to the light... The [van Dyck] Charles [should be] always placed angleways to the light... The Venus of van Dyck looks in better drawing than when the feet are placed to the light side.' The Parmigiano was of particular concern, and Buchanan urged Stewart to show it to Thomas Lawrence, the Royal Academician, whose positive opinion would be valuable. 'I am inclined to think Lawrence would be struck dumb by this picture, as it is in so soft and beautiful a style of painting. I think you should show it in all its glory to him, and appoint an hour betwixt 1 and 3 o'clock as at this season of the year [January] favourable light must be hit upon.' Framing and lighting were of crucial importance: 'I would rather have you in future lose the showing of a picture altogether, than show it till properly dressed up.' The Buchanan manual

of salesmanship received further refinement: 'We must in future keep all our pictures arranged in another room to whom nobody can have access but yourself, and pull them out one by one into the front room, as you find they are likely to suit your callers.' They should be displayed singly because 'one picture often destroys the effect of another, though both may be extremely fine in their different ways'. Buchanan was tireless in his planning. He sent Stewart lists of potential purchasers who were likely to be in London at any given time and should be persuaded in to view. You can imagine him waking up in the night in Edinburgh feverish with ideas, convincing himself that so and so, if he could just be placed in front of a particular work, would unquestionably buy it. So his lists got longer and ever more optimistic.

Buchanan had been aware for some time that 'The old Earl of Wemyss has a particular rage for naked beauties, and plenty of the ready to purchase them with'. Now he decided amongst other works to offer him the van Dyck Venus because 'the lecherous old Dog is not likely to send a Venus and Cupid a begging'. Later in the same letter the idea had taken such root that Buchanan urged Stewart to get the pictures to him as soon as possible: 'We must lose no time as Old men sometimes die.'

In the meantime Buchanan had to struggle with malicious rumours put about by jealous rivals in the art world as to the authenticity of works in his stock. There was a nasty moment when someone suggested that his Claude was not recorded in the *Liber Veritatis* of the artist's work. Buchanan thought on his feet: 'There are other four volumes of that book which were never published and the originals of which are, I believe, upon the continent,' he riposted. But this sort of unhelpful talk had to be stamped out. 'We know very well whence the remark comes,' he told Stewart. 'I really fear we must bribe West with a promise of 5 per cent on all pictures sold by his means, or his tongue will wag to our prejudice.' Buchanan was speaking of Sir Benjamin West, the President of the Royal Academy. In March Buchanan declared himself in favour of extending the promise of commission to other Royal Academicians, too. He identified a number to whom prospective buyers often turned for advice about old masters – Sir Thomas Lawrence, Richard Cosway, Henry Tresham, John Hoppner and William Beechey. Yes, particularly Beechey, Buchanan decided: 'I have reason to suspect that... Beechy [sic] if he recommends would not make a very prim mouth at receiving a due recompense.'

Then came the bombshell: doubt was cast on Buchanan's precious

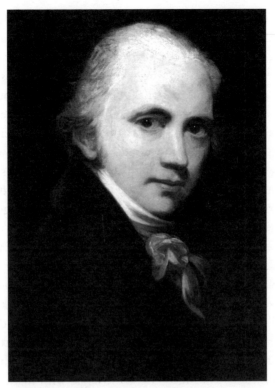

William Beechey, avoiding making a prim mouth.

Parmigiano. The infamous suggestion was made that the Colonna version (which Buchanan owned) was only a copy of the original version (which was in Bologna). 'I am afraid West is at the bottom of this criticism, and made it before he received my letter offering him a commission,' he reported to Stewart. A number of strategies occurred to his ever-inventive imagination. In Italy Parmigiano was sometimes known as Parmigianino. Why not present them as two different painters? Why shouldn't the Bologna version be by Parmigianino and the Colonna version by Parmigiano? Or the other way round? But for the time being he retreated to a loftier position about the Parmigiano. 'I do not much care whether it sells or not, as I think it one of the most elegant and enchanting pictures I ever beheld, and in possessing it should consider I had a collection in that one picture itself.'

Wemyss was now very much in Buchanan's sights as a buyer of the Poussin. And the Parmigiano. And the van Dyck. And the Claude. But Buchanan found out that a fellow called Vernon 'has more sway over

him than I was aware of'. The remedy was clear: 'It may therefore not be improper to give that Gent a clear idea of the next sum he may pocket, provided he, by his advice to the old Earl, should induce him to be purchaser at £3000 or even 2500 guineas.' The outcome of the approach to Wemyss was positive in that he bought the Claude for 1,500 guineas, but there remained the vexed question of how far to accommodate the regrettable Vernon. Buchanan tried to guess at what was passing through Vernon's mind: 'I shall recommend, or at least not oppose the Claude because it puts a large sum of percentage in my pocket.' But it could be that he would not support future purchases from Buchanan as they intruded on his 'sole province' of selling pictures to Lord Wemyss. In fact the dreaded Vernon became a bit of an obsession to Buchanan, who went to extraordinary lengths to prevent him from seeing the Parmigiano in London before it was despatched up north to offer to Wemyss. Buchanan had now convinced himself that Wemyss would definitely take the painting if Vernon could be kept out of it.

At this point Buchanan reverted to his idea of selling the Parmigiano to Wemyss as the Colonna Parmigianino. His pitch was to be that it might be a copy of a Parmigiano, but it was a perfectly genuine work by Parmigianino. At all events he would get the Parmigiano (or Parmigianino) sent up immediately to Wemyss, but tell Wemyss that there was someone else looking at it in Scotland too. 'This will create a competition, which will bring the old fellow to a decision before it is possible to have Vernon's reports,' he confidently predicted. A few days later Buchanan was having second thoughts about the reattribution, however, having received definite confirmation that Parmigiano and Parmigianino were one and the same artist. It was probably better not to confuse Wemyss, anyway. It was a perfectly genuine Parmigiano after all. And, unable to resist gilding the lily a little, he told Wemyss that, according to the Custodi of the Colonna, the head of the angel was the work of Correggio.

On 15 April, however, Buchanan discovered that he had been comprehensively outmanoeuvred by the snake Vernon. Vernon had taken the 40 guineas that Buchanan paid him to facilitate the sale of the Claude and returned it to Wemyss himself, saying, 'My Lord, I have brought you back 40 guineas of your own money, as my bribe from Mr Buchanan, which I decline to pocket on such a footing, but as the picture can bear this reduction it is better to be returned to the proper quarters, only I put your Lordship upon your guard with whom you may have to deal.' Buchanan was incandescent with rage. He ranted that he would write to Vernon

demanding that he return the 40 guineas to him, not Wemyss, as he now had it on good authority that Vernon's advice played no part in the sale to Wemyss. In the months following Buchanan wasted a lot of time scheming ways to do down Vernon, to diminish him as a professional adviser in the eyes of Wemyss. 'Oh we shall cook Mr Vernon a pretty Dish for his late base conduct.'

When Wemyss came back to him saying that he was not going to buy the Parmigiano because 'at present I am short of money and cannot think of laying out so large a sum', Buchanan's optimism took over and he just about convinced himself that this was a yes, and that probably Wemyss would buy it next year and that 'he hopes to have it cheap, some months hence'. Ah, the self-delusional capacity of even the best art dealers! There was an awful moment of realisation later the same year that this deal wasn't going to work. Buchanan actually went to Wemyss's house and had to admit the Parmigiano did not fit in with the rest of the earl's collection. 'He has a whole Seraglio of Venuses,' he reported regretfully to Stewart, 'the saddest trash many of them you ever saw.'

Now Buchanan's attention shifted to the sale at Christie's scheduled for 12 May. He talked boldly about bidding his property up 'through the medium of a friend'. He issued extensive instructions as to the wording of the catalogue descriptions and the hanging of his pictures in the saleroom, a regrettable propensity in sellers that auction houses have got used to in the two centuries since. All in all there were nine lots, which Buchanan instructed Christie's to describe as 'Very capital and Celebrated pictures from the Colonna and Bernini Palaces of Rome and Buoncorsi Perini Palace of Florence lately imported from Italy'. He fussed about revarnishing, but decided against it because 'the Conoscenti do not like pictures with a glare upon them, which new Varnish always gives'.

In the days leading up to the sale Buchanan went into overdrive, producing more and more of his lists of likely purchasers, commanding catalogues to be sent far and wide, even bribing a clerk at Bryans' for a list of the successful buyers in the rival auctioneer's recent sale so as to 'dazzle them immediately with a Card and a Catalogue, as many as may escape us from not knowing of them'. He even sent suggestions to his agent, Stewart, for compelling exclamations to utter in the hearing of the cognoscenti should any Buchanan merchandise come under discussion. His favoured recommendation was to 'cast up your eyes with an "aye that is a picture"'.

The sale, when it happened, was a bit of a disappointment. The three major lots in Buchanan's consignment – the two van Dycks and the Poussin, which he had cunningly choreographed as the climactic last three lots in the sequence – failed to meet their reserves. He put a brave face on it: 'I do not feel myself so much disappointed as you may imagine I ought to be,' he reported to Stewart. And the next day he was reflecting philosophically, 'There is a tide in all things, and I think we shall soon have a turn... by and bye we will get quit of our pictures by giving time and taking opportunities as they cast up.'

There is something splendid about Buchanan's refusal to be daunted. He resolved to move to London to take a more personal role in the sale of his syndicate's stock, and to rent more commodious space in which to display and sell his wares. In August the same year, ever alert for a selling opportunity, he noted that Napoleon himself had been making purchases of art in Rome. He encouraged his man Irvine in Italy to take advantage of the situation and offer the Emperor the Poussin of *The Plague*, which had just failed to sell at Christie's. The small matter of Britain being effectively at war with the potential buyer was no obstacle to the doing of a deal.

By the autumn the new premises, a gallery just behind Oxendon Street, were nearly ready. 'The Principal Room is 30 ft square,' he reported proudly to Irvine, noting it was 'of the same proportions as Christie's rooms upon a smaller scale. The antechamber is also a skylight and may do for Cabinet pictures.' But there was a glut of pictures on the market. By December Buchanan was urging Irvine that 'our care in only taking select articles must not be departed from'. He added, 'the English are more caught by the fascination of colouring than by any other means, provided drawing and composition are in themselves correct, and the subject good. This renders the works of Rubens, Titian, van Dyck, Ad. Ostade and the other great colourists so much sought for.' But how to get hold of such works at reasonable prices?

By January 1805 there were cash flow problems in the Buchanan art investment scheme. These were exacerbated by the wars on the continent. 'Never was there a worse time for a Speculation of this kind in this Country. The old spirited collectors have either died out, or are blind; and the more modern and recent collectors have either filled their Collections, or from pressure of times have given over purchasing till peace returns.' Further acquisitions were suspended until more sales could be achieved. To that end the gallery opened displaying the existing stock,

which to some eyes must have been looking a little tired by now, although Buchanan remained positive: 'these make a tolerable good selection and will feel the public pulse pretty well'. However, he referred to the market as 'selective', a further early instance of that term being euphemistically employed to indicate commercial inertia.

Meanwhile Buchanan began to look at other areas of operation. He put himself on a crash course in trading in jewellery and even considered venturing into the silk market. 'If the money cannot be got I will gladly take 3000 lb. weight of Silk for the price of the picture provided it is good, and delivered immediately,' he wrote to Irvine in July 1805. You cannot fault his energy and inventiveness. The same month he adopted desperate measures in order to dispose of the wretched Parmigiano. He sent it back to Italy. 'I have no doubt [it] will prove of more consequence in Rome than it was at all likely to have done here. I understand the Prince Colonna is again purchasing back his larger Gallery pictures, and this you may either sell him or Exchange for small pictures better suited to this Country.' The work had gone full circle.

But there were better times ahead. Joseph Farington's diary entry for 7 April 1807 reads:

> Lawrence called in the even'g in raptures on having seen a picture by Titian at Buchanan's in Oxendon St. – the subject Bacchus & Ariadne. He described it to be the finest piece of colouring that He had ever beheld for splendour, force, & freshness. He said the Titians at the Marquiss [sic] of Staffords could not be mentioned with it. The colours of it Blue, Green, red and yellow. The landscape part being pushed to the extremity of colour in depth & feelings. In one corner Titian seems after He had otherways finished the picture, to have dashed a piece of bright yellow drapery, on which is a golden Vase, & this part alone by its effect proves it from the hand of Titian. The yellow colour used is such as we have not, Naples yellow wd. be weak to it. – There are in parts of the trees evident marks of the touch of the Pallet Knife. – Lord Kinnaird has bought the picture for 3000 guineas.

It is not hard to imagine the triumph that Buchanan must have felt at this coup, which simultaneously confirmed all his theories: the taste of English buyers for bright colours; their mania for Titian; their willingness to pay exceptional prices for exceptional quality; and the importance of selection

to successful speculation. The thought also crosses one's mind that Lawrence – even though his words of praise for this masterpiece might have been elicited without financial incentive – may nonetheless have emerged from the transaction richer by 5 per cent of the purchase price.

Buchanan now cast around for new sources of merchandise. He lighted on war-torn Spain, where the Napoleonic conflict was offering new opportunities to dislodge art from ancient collections. Here were more troubled waters in which he might profitably fish. Between 1808 and 1813 Buchanan cooperated with a productive agent in Madrid, George Augustus Wallis. Wallis is one of those fascinating characters that art dealing throws up now and then, an agent of huge resourcefulness and cunning, the ambiguity of whose status enabled him to make money behind French lines in Spain. Six enormous cartoons, apparently by Rubens, were acquired by Wallis from the monks of the Convent of Loeches. The local inhabitants were hostile to their removal, and – even though the British were fighting the French on the Portuguese border – Wallis enlisted the help of a French general who provided heavily armed infantry protection in return for two of the cartoons. Wallis was an expert at dodging from one side to the other in the European hostilities. He inveigled more pictures out of Spain by leaving the country with the French when they retreated in 1812. In order to get his pictures to England he had to transport them 1,600 miles to the nearest neutral port on the European mainland, Stralsund on the Baltic, which involved a passage through the lines into territory controlled by Blücher. He then moved smartly back to Paris, where he was in time to receive a second Spanish consignment of pictures, which he disposed of to a French dealer, M. Bonnemaison, before making his way on to London.

One of the prizes Buchanan and Wallis conjured into Britain in the Stralsund consignment was Velázquez's *Toilet of Venus*. Fully aware of the appeal of such an image of lubricious female charm to a certain sort of English collector – what a pity Lord Wemyss was no longer around to compete for it – Buchanan managed to get £500 for what became known as 'The Rokeby Venus' from John Morritt of Rokeby Hall (see plate 5). The new owner, in a distinctively English appreciation of his new acquisition, wrote to Sir Walter Scott: 'I have been all morning pulling about my pictures and hanging them in new positions to make room for my fine picture of Venus's backside which I have at length exalted over my chimney piece in the library.' But Venus's backside is the exception, and although

a number of outstanding pictures were brought back by Buchanan and Wallis, there was limited enthusiasm from British buyers for Spanish art.

Buchanan's high opinion of himself as an art dealer did not waver in the remainder of his long career. He liked to claim the establishment of the National Gallery in 1824 as largely his achievement, although it was a source of personal regret that his contribution had never been fully acknowledged or recompensed by an ungrateful nation. In 1839 he made what was probably his first trip to Italy, and although resulting trading was thin, he felt moved to declare that the visit had given him 'I may almost say the command of that market.' He dexterously exploited trends that emerged in British taste during these decades, such as the swing back to Dutch cabinet pictures. You could not fault his opportunism.

But the British dealers most closely identified with the market for Dutch and Flemish old masters in the first half of the nineteenth century were John Smith and his sons. We know much of the minutiae of their day-to-day existence from their correspondence, published by Charles Sebag-Montefiore in 2013. Smith was a genuine authority who sought to memorialise and monumentalise his expertise in a nine-volume catalogue of artists of the past, mostly Dutch and Flemish, to the compilation of which he devoted many years of his life. In the pursuit of good pictures to offer his British clientele, which included Sir Robert Peel and many of the serious collectors of the time, Smith travelled regularly and extensively on the continent. There has always been a direct correlation between the amount of travelling a dealer is prepared to undertake and the success of his business. The need for fresh and interesting stock is a constant one, as is unearthing it in places and at prices that will be unknown to his buying clients.

Smith's two sons, as they became increasingly involved in the business, also found themselves travelling more and more. In the quest for new buyers they took to the road in Britain, flogging long distances to Liverpool, Glasgow, Birmingham, Manchester and Leeds, and trailing their stock behind them. They bemoaned the provincialism of their clients (the appetite for pictures in Manchester and Birmingham was reported to be 100 years behind that of London, and Leeds 150 years behind Manchester and Birmingham), but they kept at it. Railways were invented just in time to ease their plight. The trade they conducted was largely in works of the artists of the past, especially Dutch and Flemish. There was no great attempt to alter taste or promote living artists. The great Victorian contemporary art boom was still some way in the future.

The Smiths conducted a lifelong rivalry with another dynastic dealership, the Dutchman L.J. Nieuwenhuys and his son C.J. Nieuwenhuys. Smith and the former fell out over the joint purchase of Rubens' marvellous *Le Chapeau de Paille*, acquired at auction in Antwerp in 1822. The hammer price was apparently 32,700 florins, the equivalent of about 3,000 guineas. The price Smith sold it for two years later, to Sir Robert Peel, was £2,725. The loss would have been born equally by both partners. But Nieuwenhuys was convinced that Smith had actually bought it considerably cheaper before the 1822 sale, and allowed it to go to auction and run it up so as to extract a higher price out of Nieuwenhuys for his half share. This dispute engendered an enmity between them that lasted a lifetime. It was sad, too, that the highly productive relationship with Peel ended in tears: another dispute over a relatively minor fee charged by Smith for cleaning a picture in Peel's collection caused a rupture between them that was never fully repaired. Perhaps all business activity is prone to personal disputes, but art dealing – where what is being sold contains an element of fantasy, and therefore of subjective interpretation – seems particularly susceptible to umbrage being taken on personal grounds.

It is not surprising that William Buchanan should attempt to step into the vacancy as art adviser to Robert Peel created by Peel's argument with the Smiths. His persistence was remarkable. Even as late as 1850 Buchanan was trying to sell to Sir Robert a Rembrandt self-portrait, and offering as part of the deal restoration services that would 'bring the picture by a farther removal of the varnish to whatever key of tone Sir Robert might choose to direct'. For a parallel to William Buchanan one has to wait for Joseph Duveen in the twentieth century. The two men match each other in their sublime confidence in their own judgement, their relentless salesmanship, and their thick-skinned refusal to take no for an answer. But, as Brigstocke emphasises, Buchanan was essentially a Regency character, and although he lived until 1864 (the same decade Duveen was born), he was not a man made for the pieties of the Victorian era. A different sort of entrepreneurialism was called for to meet the taste of the mid-century, and the man who provided it most successfully was Ernest Gambart. He did so dealing not with the art of the past, but with paintings produced by his contemporaries.

4

ERNEST GAMBART AND THE VICTORIAN ART BOOM

'The influence of the dealer is one of the chief characteristics of contemporary art,' declared *The Art Journal* in London in 1871. 'He has taken the place of the patron, and to him has been owing, to a great extent, the immense increase in the prices of modern pictures.' Sir John Everett Millais, probably the most successful of all Victorian painters, confirmed the assessment: 'I am inclined to think that we are chiefly indebted to the much-abused dealer for the great advance in the prices paid for modern art,' he wrote in 1875. 'It is he who has awakened the Spirit of Competition. Where the Artist knows of only one purchaser, the dealer knows many, and has no scruples of delicacy in accommodating what is choice and admirable.'

The dealer who had been most responsible for these developments in the British art market of the previous thirty years was Ernest Gambart. If he had ever been subject to 'scruples of delicacy' he successfully suppressed them. His influence didn't just increase prices; it affected the sheer volume of artistic production in the mid-nineteenth century. Thanks to his efforts, taste and production were very satisfactorily aligned. To be a Victorian artist at this time was to be conscious of a very rewarding demand for your work. At the top of the tree, artists lived like princes. And in the middle

branches, many were comfortably off. Contemporary art had never been so valuable.

Ernest Gambart was the product of the Industrial Revolution, in that he catered for the pictorial needs of the burgeoning mercantile class that nineteenth-century wealth created. He wasn't there to *épater la bourgeoisie*; he was there to comfort and pleasure them, to identify the sort of paintings they liked and to give them more and more of them at higher and higher prices. In the following century Modernist art dealers found themselves marketing a pleasingly ill-defined commodity called genius; the word was rarely used in Gambart's vocabulary of salesmanship (except once in jocular reference to an art dealer who had succeeded in getting a very high price for a fake old master). No, Gambart was marketing something else, something dear to the hearts of the Victorians: exceptional workmanship, paintings that did a representational job in a way that would appeal to the values of the new rich by convincingly telling a story, or particularly real-istically evoking a thing or a place. He was a dealer in the works of living artists, so he needed to defend them in order to increase their popularity and therefore their prices. But he didn't have to confront the challenge with which Paul Durand-Ruel struggled in promoting the Impressionists, to win acceptance for living artists who were producing a new and difficult art. He didn't have to explain what he was selling, merely to praise it. He didn't have to persuade his clientele into difficult artistic terrain, merely encourage them to give in to their instincts.

He was Belgian but gravitated to London, where he arrived as a young man in 1840. London was the centre of an empire, the commercial hub of the world, and a place where by the middle of the nineteenth century more and more people were making more and more money. Gambart's achievement was to bring art into more and more people's consciousness and range of aspiration. You did not have to be rich enough to buy an orig-inal work by a major name in order to partake in art. Gambart offered you two simpler and less expensive entry points into active art appreciation: by paying to attend one-off exhibitions of a single great painting, and by buying a print of it. As moneymaking enterprises, these were eighteenth-century inventions; but Gambart developed them to their ultimate pitch. You went to the movie, and then you bought the DVD.

He had arrived in London as a printseller. This was a booming area of the art business from the eighteenth century onwards. The stock of engraving plates of the leading print publishers in Britain, Boydell, had

been valued in 1804 at the prodigious sum of £300,000, and the flourishing copyright market in engravings was paralleled in literary publishing: in 1813 John Murray offered 1,000 guineas to Byron for the copyrights of his new poems 'The Giaour' and 'The Bride of Abydos'. But as the century progressed the market for original paintings was expanding, too. In London in 1820 barely ten art dealers were listed in the trade directory; by 1840, the year of Gambart's arrival, there were 160.

Why? The burgeoning wealth of the country was one factor. But what Gambart quickly understood was how much the new rich liked and were reassured by the work of contemporary artists. They were reassured for two reasons. First because works by living artists were purveyed by dealers who got them direct from the artists' studios, which largely eliminated authenticity problems. And second because contemporary artists, under the guidance of dealers, were happy to give the public what they wanted, rather as they had done to a similar emerging bourgeois audience in seventeenth-century Holland: scenes of peasant life, historical genre scenes, animal scenes – familiar, accessible subjects that pleased and excited rather than daunting them with too much learning.

Gambart realised that the existing opportunities for selling works of contemporary art – in arenas operated by painters themselves, like the annual exhibition of the Royal Academy – were inefficient. The system could be considerably energised by an impresario of flair and imagination, to the benefit of the prices that artists commanded. Gambart was that impresario. Not only did he market paintings by the leading British stars of the era – men such as William Powell Frith, Edwin Landseer, Frederic Leighton and the Pre-Raphaelites – but he was the first to introduce to London regular exhibitions of work by living continental artists. In his prime in the 1870s, official figures show that up to 29,000 works a year were being imported from France, an increase from 2,000 twenty years earlier; not all of them were being brought over by Gambart, but he was the driving force. He mounted many exhibitions, often simultaneously, in a variety of rented premises in central London and the provinces. These shows were sometimes devoted to a single work, whose momentousness would be accentuated by its splendid isolation. This was the new incarnation of the sensation picture.

How he handled *The Horse Fair* by Rosa Bonheur is a textbook example of his success as a promoter. It was a vast painting measuring 8ft by 17ft, and had created a sensation when first exhibited at the Salon in Paris in

1853, although it had not yet found a buyer. Gambart identified it as ideal for an English audience: the subject matter would appeal to the national love of horses, while the substantial acreage of pigment would reassure the punters that they were getting value for money; so he arranged for the painting and the artist to make a triumphal entry into London in July 1855. It only just fitted into Gambart's gallery in Pall Mall, but once installed huge numbers came to see it, paying a shilling a head. Meanwhile the artist herself was the object of considerable media attention, not least for the impression of masculinity she exuded, with her male clothing and short hair. She could have brandished the special permit she obtained from the Prefect of Police in Paris to wear men's clothes – necessary, she maintained, for her to operate safely when painting *The Horse Fair* on location in very male surroundings. Presumably Grayson Perry has a similar permit issued by the Metropolitan Police. Even Queen Victoria was enamoured of Rosa Bonheur's masterpiece, and asked for it to be sent on approval to Buckingham Palace for a day. She didn't buy it in the end, but the royal interest it elicited did Gambart's reputation no harm. After London, the painting was sent on for exhibition in Glasgow, Birmingham, Sheffield and other provincial cities, where the turnstiles clicked merrily.

The next year Gambart produced the print of *The Horse Fair*, engraved by Thomas Landseer (see plate 6). It was heavily subscribed, and finally the painting itself was sold in London in early 1857 to William P. Wright, for 30,000 francs. Significantly, the buyer was from New York. 'It takes two horse dealers to make one picture dealer,' observed the Victorian painter J.C. Horsley, a trifle bitterly. This was the business model perfected by Gambart, which gave the dealer three bites at the cherry of the newly painted work consigned to you for sale. First you squeezed out a healthy revenue by showing it on exhibition to the entry-paying public. At a shilling a ticket, it was not unusual for £20–30 to be taken in a day. Then you issued a print of it that the art-buying public would pay more good money for. By now you had probably covered the costs of the original investment in the painting several times over, and the sale of the work itself was something of an afterthought. Sometimes Gambart didn't actually bother with the final stage in the process, and donated the original to a museum amid a goodly flurry of positive publicity. Having sold so many golden eggs in the form of engravings after the original, it was no great financial sacrifice for a dealer to present the exhausted goose to a public institution rather than sell it.

As a business model, it served Gambart well in his heyday. But it

couldn't last beyond his generation. The willingness of the public to pay money to attend exhibitions of a single oil painting, no matter how sensational, diminished with the advent of other more lurid attractions, like the cinema. And the whole print business was undermined by new photographic techniques that made it easy to pirate editions of popular prints. But that was in the future. In the 1850s and 1860s the Gambart machine was turning over very nicely. One of the most successful paintings of the mid-nineteenth century in Britain was William Powell Frith's *Derby Day*, a spectacular panoramic rendering of the crowds gathered for the most important event in the racing calendar. It was costive with separate anecdotal incident, and as an image of popular appeal it came as near to perfection as a Victorian painting ever attained. The spectator could lose himself in the separate dramas unfolding. You knew you were getting value because of the sheer volume of people and episodes depicted. It was like a novel with a gratifyingly large number of chapters, or perhaps a particularly rich compendium of short stories. As the picture of the year in the Royal Academy in 1857, it proved so popular that the crowds in front of it had to be held back by the police.

Gambart had made a point of seeking Frith out earlier in his career. He had rightly identified him as one of the artists with potential for future commercial development, and – a bit like Castelli with Rauschenberg a century later – had gone to his studio to propose cooperation. Gambart had come away with a painting to sell, on which Frith had named a very aggressive price. When Gambart achieved it for him, Frith became his 'friend for life'. But Gambart didn't buy *Derby Day*, perhaps judging that its huge impact when on show at the Royal Academy might not be so easily replicated in his own galleries at a shilling a time. But what he did do was buy the copyright, for £1,500, the same sum as its purchaser the collector Jacob Bell paid to acquire the original. It was the correct decision. He made huge profits on the ensuing dissemination of prints.

Gambart was not afraid to deal with artists who were outsiders to the establishment. He took on and marketed the work of the Pre-Raphaelites, giving them the platform that more conservative elements in the Royal Academy were inclined to deny them. He sold well for Millais and Rossetti, but his most glittering success was probably with Holman Hunt. Gambart knew that Hunt had been working for some considerable time on a New Testament scene, *The Finding of the Saviour in the Temple*, and he homed in on it with his instinct for images that would generate blockbuster sales.

William Powell Frith, Derby Day: *a Victorian engraving with the appeal of a movie.*

Perhaps there weren't horses in this one, but there was religion, drama and intricately researched detail to insure total historical accuracy, all of which made a potent combination. Gambart's honeyed words and very deep pockets did the trick for Hunt. He was persuaded under Gambart's guidance not to give the work its debut at the Royal Academy summer show, but in a single-picture exhibition with admission charged, the whole thing orchestrated by Gambart. This time Gambart needed both the picture and its copyright, and for the privilege he had to break the bank. He paid the extraordinary sum of £5,500 (the fact that he could justify a price at this level shows how much money he must have made on Hunt's *The Light of the World*, whose copyright he had bought for just 200 guineas two years earlier). The exhibition of *Saviour in the Temple* opened in February 1860, in the German Gallery at 168 New Bond Street.

Preparations had been laid well in advance. Gambart was an early master of public relations, and part of his strategy included getting influential critics onside to boost the works he was selling. In 1858, for instance, he had succeeded in promoting and managing for John Ruskin a lecture tour to Manchester. It is testament either to Gambart's persuasiveness, or to Ruskin's eccentric flights of inconsistency, that the notoriously prickly and high-minded critic agreed to do such a thing for a dealer. As for Gambart, even if Ruskin was not in this instance puffing his specific pictures, the spread of knowledge about art among the rich but hitherto-untutored populace that such an event achieved could only benefit his future trade in the area. Education brings aspiration.

So for Hunt's *Finding of the Saviour in the Temple* Gambart recruited F.G. Stephens, the art critic of *The Athenaeum*, to write a piece about the picture.

Stephens' review was an extensive one, and went into minute and generally approving detail on the work. He dwelt on the well-rendered character of the rabbis, examined the archaeological accuracy of the interior, and complimented the artist on the beauty of his models. The movie had received its good notices. The dealer as film producer and distributor now moved into gear. Huge numbers of people filed through the door paying their shilling a head, and at the same time visitors put their names down for the print, at a cost of £3, £5 or £8 each depending on the size. The wily Gambart had succeeded in presenting to the public an image that offered both the appeal of a compelling visual anecdote and the seriousness of a religious experience.

One of the characteristics common to the most successful art dealers of modern times has been their willingness to exploit advances in technology, and particularly to take advantage of the development of rapid communications. It has been a progression, from the telegraph, to telephones, to air flight, and culminating in the myriad opportunities of the Internet. But the first and arguably most crucial innovation was the railway. Gambart embraced it and travelled constantly: to Paris, Brussels, Ghent and Antwerp; to Birmingham, Manchester and Glasgow; seeing clients, visiting artists, mounting exhibitions. He believed in the potential globalisation of the market and even sent pictures to the USA in 1857, although in this he was slightly premature, and not much sold.

Gambart did not, of course, operate alone in the remunerative contemporary art market of the mid-nineteenth century. Other dealers of varying degrees of rectitude, knowledge and sophistication emerged as his competitors. There was Thomas Agnew and Company, who expanded in 1860 from their original Manchester base to London, where they were leading players in the old master market for more than a century, but also handled the work of living artists. Another rival was Louis Victor Flatow, whose career followed an unconventional pattern after his arrival in England from Germany in 1835. At first he too dealt in old masters, but he was so unsuccessful that he gave up and temporarily reinvented himself as a chiropodist. A chance surgical encounter introduced him to an indigent artist with corns to tend and pictures to sell. Flatow managed to shift the paintings and was launched on a much more profitable career dealing in modern art. Flatow was coarse and illiterate, but he had charm and daring and flexibility. In 1848, for instance, he sold six pictures to the collector and industrialist Joseph Gillott for 14,020 gross of steel pins.

The sort of paintings that had most box office appeal in the middle

William Holman Hunt, The Finding of the Saviour in the Temple: *a popular engraving combining visual anecdote with religious experience.*

of the nineteenth century were the large-scale ones Frith was producing. The cinematic parallel is clear: the latest Frith was awaited with the same anticipation as the latest James Bond film is today. Frith's prescription for a successful pictorial blockbuster was that 'there must be a main incident of dramatic force, and secondary ones of interest'. Having established the formula, the artist stuck to it, and in 1862 produced a painting set in Paddington Station as replete with drama, character and incident as *Derby Day* had been. But this time it was Flatow who bought the picture, and not just the picture, but also the exhibition rights (which prevented the work being shown at the Royal Academy) and the copyright, for a total rumoured to be in excess of the £5,500 Gambart had given for Hunt's *Finding of the Saviour in the Temple.* In seven weeks during the months of April and May 1862, 21,000 people paid to see it. Even at a shilling a time this represents a revenue of 1,000 guineas; more, in fact, because Flatow apparently upped the entrance fee to two and sixpence on Saturdays. And Flatow's persistence in selling the print impressed even Frith. 'Flatow was triumphant,' he recorded, 'coaxing, wheedling, and almost bullying his unhappy visitors. Many of them, I verily believe, subscribed for the engraving to get rid of his importunity.' 'Lord Bless you!' Flatow is recorded as saying. 'There ain't a dealer in London that knows how to manipulate a customer; you must walk round 'em as a cooper walks round a tub.'

As with Gambart and *Finding of the Saviour in the Temple*, so with Flatow and *The Railway Station*: the key to the successful commercial exploitation of a new and highly anticipated work was excluding it from exhibition at the Royal Academy, giving it its 'premiere' in a place and at a time under your control as a dealer. It has sometimes been argued that dealers in the nineteenth century only gained their power through taking on the work of revolutionaries like the Impressionists who had been excluded from the official exhibitions because of their controversial innovation and had nowhere else to find buyers. But Gambart and Flatow show that dealers had already set themselves up as effective alternatives to the Royal Academy or the Salon, not by giving wall space to its rejects but by presenting their premises as more remunerative arenas for its favourites.

How close art had come to commerce in the middle of the nineteenth century is illustrated by the way that Frith, for instance, was pursued by commercial enterprise keen not so much to 'product place' in his pictures but actually to take over the whole canvas. That was the proposal of the owner of Whiteleys department store: if you're looking for a new subject teeming with incident and human interest, set it in Whiteleys. The financial rewards to Frith would have been considerable. But Frith, though tempted, never went ahead with the idea. Later in the century Millais's famous painting *Bubbles* was bought by Pears to advertise their soap, and a hugely successful campaign ensued. That these things worked in the nineteenth century illustrates that art was attuned to popular taste in a way that it has never been before or since. For this the successful art dealers of the time were partly responsible.

The fact that Flatow handled Frith's *Railway Station* was not just a commercial opportunity missed by Gambart; it was also a blow to his professional dignity. He wanted to be known as the man who had paid the highest price ever for a modern painting, and wrote to *The Athenaeum* in 1863 setting the record straight. He wished to make it clear that Flatow had only paid Frith £4,500 for *The Railway Station*, plus £750 to keep it out of the Royal Academy. The £5,500 he had paid for the Hunt was therefore still the record. It doesn't seem to have occurred to him that diminishing the price paid by Flatow for such a remunerative piece of business actually enhanced his rival's apparent prowess as a dealmaker, given that Frith himself estimated that Flatow made £30,000 on *The Railway Station*. But such is the vanity of dealers. Just to emphasise the point, Gambart approached Frith to offer him the outrageous sum of £10,000 for his next

production, a set of three street scenes entitled 'Morning', 'Noon' and 'Night'. The commission was never executed, but Gambart had underlined to the world that he was still the most financially muscled dealer around.

His supremacy dated from the economic crisis that had rocked London in 1858, sending many dealers out of business. Only the fittest survived. When the dust settled, Millais noted that the landscape had changed and the remaining dealers, led by Gambart, were more powerful than ever. 'There is no chance of my selling pictures *to gentlemen* – the dealers are too strong,' he laments. 'Picture-buyers can barter with them when they cannot with the artists.' Millais's relationship with dealers, and with Gambart in particular, is an ambivalent one. Gradually he came to an acceptance of their power, and a realisation that they brought artists like him financial benefit. Even the lordly Frederic Leighton, who early on professed himself aloof from the activities of dealers, finally succumbed to the commercial blandishments of Gambart. But Leighton managed to keep a distance. 'With regard to the money paid me by Gambart,' he informed his mother in a letter, 'I invested as soon as I got it £1,000 in Eastern Counties Railway debentures, at par, 4 ½ per cent.' Somehow the fact that Leighton put the proceeds of his transaction with Gambart into Railway Debentures made it all right. It removed it from the realm of art at all. Diderot would have been proud of him.

One senses, however, that Gambart exerted more power over Millais than the artist might in certain moods have wished. Did Gambart's commercial influence turn Millais into a more crowd-pleasing painter than he had been in his earlier, more purist phase of rigorous Pre-Raphaelitism? There is an agonising passage of interplay between artist and dealer in the creation of Millais's *Sir Isumbras at the Ford*. Millais painted the picture and showed it to Gambart. Gambart said the horse's head was too big. Millais repainted it. Now it was too small. Millais never quite got it right. Once you countenance a dealer's input into the creation of a painting, you are on dangerous ground as an artist. But it was difficult to disregard Gambart now. He was at the peak of his career. In the words of his biographer, Jeremy Maas, this was 'the golden age of the living painter', and Gambart 'seemed to stand like a human turnstile between the artist and his public'. He continued to hold highly successful exhibitions at his premises in Pall Mall, the French Gallery. The money poured in. He moved his wife and family into 'Rosenstead', a very large house in Avenue Road, St John's Wood, where he lived and entertained in palatial style.

In 1865, on one of his regular trips to northern Europe in search of promising new artists to unleash on the British market, Gambart chanced in Antwerp upon the studio of Lawrence Alma-Tadema. He recognised immediately the young Dutch artist's immense potential for a British audience, with his photographic realism and his fondness for subjects of meticulously researched historical realism. It is not too much of an exaggeration to describe Alma-Tadema as Gambart's creation. He brought him to London and commissioned twenty-four works from him, which were executed to a reliably high level of quality (and punctuality) over the next four years. Under the dealer's influence the era in which his pictures were set was suitably recalibrated. The dour medievalism of his early works gave way to colourful evocations of classical times. And the subject matter itself lightened, too, into a gentle historical genre, an anecdotalism rather than the depiction of grand historical events. The vividness of his technique opened up a vision of the past that drew thrilling parallels between the everyday life of antiquity and that of Victorian England. Spectators in Britain and the United States loved the implicit message that Alma-Tadema communicated: Look, the ancient Romans were just like you. They fell in love, enjoyed a joke, even collected art. And Gambart was able to orchestrate a rewarding upward curve in the artist's prices as each year's production came in. In 1870 he commissioned a new series of forty-eight works. One of those was a depiction of a Roman art gallery in which some nervous contemporary connoisseurs are shown inspecting a work that is being offered to them for sale. The dealer, in the centre of the composition, is clearly Gambart himself (see plate 7). It is Alma-Tadema's tribute to the man who marketed him so successfully, as piquant in its way as Picasso's masterly Cubist portrait of his own dealer, Daniel-Henry Kahnweiler.

Not all artists were easy to deal with. The mercurial and often devious Rossetti would have presented a challenge to any dealer. But, like Millais, Rossetti gradually came to understand the benefits of selling to Gambart: it meant his prices went up. If he sold a drawing to Gambart for 50 guineas, which Gambart then managed to sell for 100 guineas, it meant that Rossetti could ask 100 guineas next time he sold a similar drawing to a private buyer, pointing this out as the going rate charged by Gambart. But there was trouble when Gambart bought from Rossetti his *Blue Bower* for 200 guineas, and then sold it for £1,500 to a collector in Manchester called Sam Mendel. Rossetti, half horrified at the mark-up, and half delighted by the price at which a sale of a work of his had been effected, talked of it

indiscreetly to his friends. The story percolated through to Gambart, who thundered back to Rossetti: 'There is an end to the possibility of business if the producer of any article sold by a middleman publishes the price he obtained.' Oh dear. That difference, again, between the work sourced and the work placed. It is a wonderful thing, but it should not be allowed into the public domain. And if it is, the dealer has to come out fighting: the artist must understand that asking such a high price is a means of raising in the longer term the prices received for his future works. Thirty years later Durand-Ruel had a very similar conversation with Pissarro. I know you sold this painting to me for 1,000 francs, he told him. But if you sell it to anyone else you must ask 3,000 francs, because that is the price I ask for your paintings. The system won't work otherwise.

Rossetti called Gambart 'Gamble-Art', which was perceptive of him. It underlines the way that Gambart brought money and art so close together; and the way he took punts on art, too, although his instincts as to what would and wouldn't sell were so acute that there wasn't much risk to his speculations. In a letter to James Smetham – a painter on the periphery of fashion looking in on the process masterminded by Gambart a trifle wistfully – Rossetti explains the dealer's methods and the sureness of his commercial judgement: 'Gambart understands pictures to some extent & their marketable qualities perfectly, & is quite able to know if a thing can be made something of, even without a name to back it, only it would be in very rare cases that he would go in for such, having so much of the exclusive section of the trade in his hands & wishing to keep up his character in this respect.'

A further result of Gambart's 'having so much of the exclusive section of the trade in his hands' was that artists' work became increasingly branded. Because he knew he could sell it, he encouraged his artists to produce more of the same. Thus artists became fixed in the public's minds as producers of a certain sort of subject matter: you wanted antiquity by Alma-Tadema, battle pictures by Lady Butler, cows by Thomas Sidney Cooper. And as an artist you erred outside the parameters of what you were well known (and marketable) for at your peril. It was a foolhardy painter who risked brand disintegration. The extreme form of this sort of art dealing is Arnoux in Flaubert's *Sentimental Education*, who 'with his passion for pandering to the public, led able artists astray, corrupted the strong, exhausted the weak, and bestowed fame on the second-rate'. Gambart was not as cynical as Arnoux, but as P.G. Hamerton wrote in 1867: 'Assuming the dealer

wishes to sell, and recommends his goods in the manner which experience proves to be the most effective, we cannot be far wrong in concluding that a kind of art which, however degraded, is popular, will be encouraged by him, and rendered, if possible, more popular still.'

But if Gambart made himself rich by playing to popular taste, he made his artists rich too. He was a sophisticated manipulator of the market who understood the power of auctions as validators of rising prices for contemporary art. When several thousand pounds was paid at Christie's for a Frith or an Alma-Tadema (often by Gambart himself) it reinforced confidence. The extraordinary sum of 6,300 guineas achieved by Edwin Long's *Slave Market* at Christie's in 1882 was the equivalent of the multi-millions bid in the twenty-first century for living artists such as Jeff Koons. It's OK, such prices say to the new rich collector: public auctions cannot lie. This is the way the market's going. This is what these things are worth. The traditional role of the dealer as connoisseur was expanding into a new kind of commercial expertise based on detailed knowledge of fluctuating prices: here is the art dealer as market-making stockbroker.

Not everyone was happy with the rise of the dealer in Victorian Britain. P.G. Hamerton puts the phenomenon down to the laziness of art collectors, writing in 1868: 'So long as buyers would rather give 500 pounds to a dealer for a picture than 300 for the same picture to the artist, the dealer was necessary to the artist himself.' Ruskin, never a model of consistency, forgot that he had himself lectured for Gambart in 1858, and blamed venal critics for the power of the art trade: 'We are overwhelmed with a tribe of critics who are fully imbued with every kind of knowledge which is useful to the picture dealer, but with none that is important to the artist.' He may not have liked it, but Ruskin identified one of the most effective supports to the art dealer in his marketing of contemporary art: the tame critic or academic. We will see more of this holy trinity of artist-dealer-critic with the advent of Modernism.

Gambart's was an attractive personality: he was enthusiastic, energetic and humorous, and something of a ladies' man. He was determined, too. In 1866 a personal disaster occurred that would have finished lesser beings: his house in St John's Wood blew up. It was an accidental gas explosion, on the day he had been planning a magnificent fancy dress ball at Rosenstead. Several people were injured and a servant was killed. The back part of the house fell down, and major pictures were destroyed. Coming a few days after a spectacular bank collapse in the City of London, which involved

losses of £19 million, such an event could have been interpreted as a portent of the imminent collapse of the art market, too. But Gambart was not daunted. He postponed his fancy dress party and rebuilt his house. Later in life he retired to an even grander residence outside Nice, where he continued to entertain lavishly.

People who did business with him regarded him as a hard negotiator, and fond of a profit, but honest. Like most art dealers, he could be imaginative about figures, and sometimes a little vain. In the census of 1851 he gave his age as twenty-eight when he was actually thirty-six. But optimism is an essential weapon in the art dealer's armoury, and some operate on a considerably more substantial margin of exaggeration. Not every artist responded to him positively. The jaundiced verdict of Sir Edwin Landseer was that 'he only thinks of himself, not the least feeling for art or the reputation of the author or authors, a heartless flattering humbug'. But most artists who dealt with him liked him, even when he was laying down the law to them about what they should be painting. The landscape painter John Linnell writes in 1851: 'EG wants subjects comprising good & well-defined foreground with figures & animals & other accessories, as well & as completely finished as the subject & effect will allow – What is called Sketchy to be avoided.'

Here is a classic instance of the dealer as two-way radio, receiving clear signals from his clientele as to their preferences and relaying them to the artist. The pursuit of the popular encapsulates the essential difference between a dealer like Gambart and one like Durand-Ruel or Vollard: Gambart relayed to the artist what the public was on about and told him they should do something about it; the day was shortly coming when Durand-Ruel and Vollard would be relaying to the public what the artist was on about, and telling them that they should do something about it.

PART III

MODERN TIMES

5

JOSEPH DUVEEN: THE SALESMAN AS ARTIST

The years leading up to the First World War are remarkable as a period of uniquely intense innovation and revolution in modern art. Pioneering dealers played an extraordinary part in fomenting this revolution. Without men such as Vollard, Kahnweiler, Cassirer and Herwarth Walden the course of Modernism would have run very differently. Their crucial contribution is examined in later chapters. But their commercial activities represent a tiny proportion of the value of the art traded at this time. The removal of the import tax on works of art into the US in 1909 led to prodigious old master traffic in the years that followed. The dealer-princes with outlets in the USA, the Duveens, the Knoedlers, the Wildensteins and the Seligmanns, were turning over huge sums: Duveen's sales in Paris totalled $13.5 million in 1913 alone. And the good times continued to roll after the war, too. Such was the wealth that the Duveens and the Wildensteins had accumulated that even the Wall Street Crash in 1929, so disastrous to many of their clients, only briefly disturbed the momentum of their success.

In 1936 Kenneth Clark, director of the National Gallery in London, visited the palatial New York galleries of Joseph Duveen in the pomp of the great dealer. Clark takes up the story as the proprietor himself, recently created Lord Duveen of Millbank, showed him round:

We were accompanied in our peregrination by a heavily-built man

called Bert Boggis, who had worked in the packing department and had all the qualifications of a chucker out. Since he had long accompanied Lord Duveen as a personal guard he had come to know the names of painters, which is more than Lord Duveen ever did. 'There you are,' Duveen would say as we entered the room, 'it's a Blado – what is it Bert?'

'Baldovinetti.'

'That's right, Bladonetti. What do you think of it?'

'Well, I'm afraid it's a bit restored.' (It was in fact a completely repainted work of a painter called the pseudo-Pier Francesco Fiorentino.)

'Restored? Ridiculous. Bert, has it been restored?' Silence. 'Ah! he knows. Next, next.' A profile head appeared. 'It's a Polly, Polly – what is it, Bert?'

'Pollajuolo.' Silence all round.

If the picture exhibited was one of his favourites, Lord Duveen would blow kisses at it. Occasionally his enthusiasm would make him giddy with excitement. Then Bert would say 'Sit down, Joe, keep calm,' and the great man would passively comply.

Duveen was an epic character, whose biography by S.N. Behrman is one of the funniest books ever written about art. A salesman of genius overburdened neither with scruples nor with knowledge of academic art history, Duveen was born in London in 1869, which meant that he was approaching his prime at the turn of the century. This was happy timing: around 1900 there was a perfect confluence of socio-economic developments in America and Europe ideal for an international art dealer of energy and initiative to exploit. On the one side of the Atlantic there existed a bevy of increasingly rich Americans who had everything except class and history, and on the other a slew of European aristocrats, torpid with class and history but in increasing need of money. How to remedy the situation? What could be satisfactorily transferred between them that would endow class and history to the former? Art, in which 'old' Europe was rich, was the perfect commodity. It was this transference that Duveen perfected, taking up comfortable residence in that sweet territory positioned between the lower price of the thing sourced and the higher price of the thing placed. It was a territory that he generously shared with a number of others: experts, like Bernard Berenson and the German museum director

*Joseph Duveen: 'when he was present everyone behaved
as if they had had a couple of drinks'.*

Wilhelm von Bode, whom he paid generously; venal middlemen, often shameless aristocrats claiming secret commissions; and restorers, to whom Duveen gave every encouragement to express themselves creatively.

The statistics are extraordinary: almost 50 per cent of the legendary Andrew Mellon collection, which provided the basis for the National Gallery in Washington, was supplied by Duveen. Indeed Duveen is calculated to have been responsible for the import into American collections of 75 per cent of their best Italian pictures. In this respect he invented a kind of cultural money laundering: by taking the rich Americans' new money in return for classic European art, he was transmuting that new money into old. And the old money, in the hands of the European aristocrats, was running short. From the 1880s onwards even the British aristocracy, hitherto largely buyers of art rather than sellers, found themselves under financial pressure, as a result of the collapse of agricultural prices under the glut created by the expansion of farming in the new world. Land rich and cash poor, they looked around for what they could sell, and their ancestral art collections were the easy options.

Joseph Duveen – Joe – was born into an established art-dealing

business. The Duveen firm created by Joe's father and uncle was already by the beginning of the twentieth century an important and well-connected one, with branches on both sides of the Atlantic. For his coronation in Westminster Abbey Edward VII called in Duveen Brothers as decorators to improve the look of Buckingham Palace and brighten up the ceremony at the Abbey. But the young Joe was very keen to enter the picture market, and in June 1901 he persuaded his father to pay 14,050 guineas for a late-eighteenth-century portrait by Hoppner, an auction record for any English picture. As a statement of intent it was impressive. And it reflected a simple equation that Joe formulated early on: that a high price was a mark of quality, and a low price a mark of the lack of it.

In the five years either side of 1900, business at Duveens tripled. The Duveens had initially operated out of shops. Now they moved up a level of grandeur, and their premises in London, Paris and New York began looking like opulent private houses. Joe's picture business flourished. Besides English portraiture, he purveyed French eighteenth-century masters, Dutch works as long as they were by Rembrandt or Hals, and of course classic Italian works of the Renaissance. This, as defined by Joe, was rich American taste. And for the first four decades of the twentieth century rich Americans were very happy to buy into it. Later-nineteenth-century and modern art he disapproved of because there was too much of it. He also disapproved of auctions, where prices were too fortuitous and constantly needed help. In the words of his long-time business colleague Edward Fowles, Joe was dynamic, enthusiastic, excitable, aggressive and impatient. He had a good working knowledge of the British school, a superficial knowledge of French and Dutch painting, but very little of Italian. The shortcomings of his connoisseurship were usually disguised by his consummate salesmanship, but with Italian paintings he was intelligent enough to realise that he needed expert help. It came in the greedy, high-minded, unscrupulous and thoroughly conflicted shape of Bernard Berenson. The partnership that they formed of salesman and scholar was one of the most productive in art-dealing history, but also – on Berenson's side at least – one of the most fraught.

Berenson's emergence as the expert with whom the art trade must reckon in their dealings in Italian Renaissance art was underlined in 1895, at the Italian Art Exhibition of that year. The young scholar from Boston produced an 'alternative' catalogue to the show, pointing out all the misattributions and worse. In fact he was already working with Otto Gutekunst

of Colnaghi in supplying Isabella Stewart Gardner with major Renaissance art. This eccentric but highly driven collector, also from Boston, was buying heavily, and provided Berenson with an early lesson in the pitfalls of trading in art. He sold her three Rembrandts at rather larger mark-ups than he admitted. He only just avoided being found out by her suspicious husband. It was a nasty moment, a glimpse of the moral chasm opened up by the dangerous elasticity that art offers between the price of the work sourced and the price of the art placed. This is indeed the sweet spot for dealers, but it can very rapidly become the bitter spot if your client gets wind of the extent of the gap. Not for the last time in his life, Berenson seemed to want to have it both ways, which elicited a justified rebuke from Gutekunst. 'Business is not always nice,' he wrote to Berenson, continuing:

> I am the last man to blame you, a literary man, for disliking it. But you want to make money like ourselves so you must do like wise as we do... if the pictures you put up to us do not suit Mrs G it does not matter. We will buy them all the same with you or by giving you an interest in them... It is important for both of us to make hay while Mrs G shines.

Berenson and his wife Mary became expert at smuggling pictures out of Italy to sell to Americans. 'I don't consider this wrong,' wrote Mary in 1899, 'because here in Italy the pictures are apt to go to ruin from carelessness.' The Berenson method was to approach the overseer of the local gallery in Italy to get permission to export. They presented the work in a box, but substituted a worthless daub. The box was then given a seal by the overseer, but could be reopened elsewhere and the real picture replaced for the actual act of export. Other times, other standards.

The existence of Berenson made Duveen nervous and excited at the same time. Duveen recognised that, whereas English eighteenth-century paintings generally had clear provenances, and Dutch and Flemish art presented fewer problems of expertise, Italian Renaissance art was the most speculative market of all. There were huge profits to be made in it. And Berenson, as the acknowledged expert in the field, was an asset almost beyond price. He could provide the expertise that would turn the speculative picture into the moneymaking certainty. His was the eye that could authoritatively attribute the works to individual artists, some of whom he had discovered, and others of whom he had invented.

But Berenson also needed Duveen, because he needed money. He

Bernard Berenson, reaffirming his belief in tactile values.

had been born with none, and his precocious brilliance with works of art had propelled him into circles where there was a lot of it, often a danger-ous sequence of events for art experts. In particular his dream for I Tatti, the villa he had set his heart on in the Tuscan hills, which needed very expensive financing. So they signed a contract in 1906. If Joe had been a self-analytical man he might have recognised in Berenson the attrib-utes they shared: egotism, ambition, pleasure in a rich lifestyle, greed and charm. But it was left to Joe's uncle Henry, usually a force of reason in the Duveen business, to note perceptively of Berenson: 'It appears that he could be most useful to us, but I advise caution as all are agreed that he will never play the second fiddle but must lead the band, if not conduct it. It could be dangerous to be out of step with him.'

Thanks to Duveen, Berenson started making large amounts of money. It has been calculated that he earned more than $8m in the twenty-six years between 1911 and 1937; enough to buy and improve I Tatti, institute a 16-acre formal garden, acquire a car commensurate with his new status and engage a butler, an employee that Roger Fry wryly described as 'that essential adjunct to academic life'. Within Duveen's organisation high levels of secrecy were maintained to protect Berenson. The transactions on which he was due commission were entered into 'the X book', a confi-dential ledger to which only Duveen and his right-hand man Fowles were

privy. Tellingly, Berenson's codename within Duveen was 'Doris'. Those familiar with Ancient Greek will recognise that the name shares a root with the word meaning 'bribe'.

Did Berenson act fraudulently in the expertises that he made for Duveen? It is certainly true that his attributions became more generous in his years of cooperation with the art trade. And there is also no doubt that Berenson came to hate himself for the Faustian pact he had entered into, for the compromise of his scholarship that it represented. Posing as an impartial judge – an art historian and a connoisseur – when in reality you are a paid advocate is on the edge of dishonesty; hiding and covertly expanding your commission is straying further towards the territory of fraud. 'I soon observed that I ranked with fortune-tellers, chiromancists, astrologers, and not even with the self-deluded of these, but rather with the deliberate charlatans,' reflected Berenson bitterly, and a trifle disingenuously, on his role in the art market. Elsewhere he spoke of Duveen's seductive powers: 'that noble peer's power of persuading without convincing'. But Berenson himself was also guilty of overenthusiasm, and the floridity of his language in his praising of pictures turned into a useful sales pitch for Duveen.

There are specific instances when, if Berenson does not transgress a moral line, he strays very close to it. In 1922 Duveen had to get retrospective certificates from Berenson for a collection of pictures which he had sold to the financier William Salomon. Nicky Mariano, the companion and confidante of Berenson in his latter years, says Berenson refused categorically to do this; but nonetheless they appear in the X book. And of course everything that went in the X book entitled Berenson to a financial reward. In the back of Berenson's mind turned the constant mathematics: a more positive attribution = a higher price from the buyer = a higher commission (anything from 10 to 25 per cent of the selling price) payable to Bernard Berenson. Another ambiguity was the Venetian portrait of Ariosto: in 1913, when Duveen was selling it to Benjamin Altman, the department store tycoon, Berenson was prepared to 'stake his reputation on the painting's being a Giorgione', undaunted by the fact that in 1896 he had declared it as 'a work by the young Titian, or a copy of such a work'. It was a convenient change of mind.

Perhaps it is kinder to say that, as the supply of Italian Renaissance masterpieces dwindled, Berenson – under pressure from Duveen – succumbed to bursts of attributional optimism that tended to give the benefit

of the doubt to a number of pictures that did not always deserve it. As Meryle Secrest suggests, one of the reasons for his inaccuracies is that from the 1920s onwards he was invariably judging from photos. Perhaps this was deliberate. 'Given Berenson's prickly conscience and his perfectionist expectations for himself, traits so evident in his later diaries, perhaps the only way he could live with himself, in the thick of a very murky and conniving world, was to judge from evidence that, after all, told him so little. He could always blame the evidence.'

Berenson was a demanding financial partner. He wanted maximum benefit from the deals he facilitated, but no responsibility for the actual making of sales. This meant that he participated in profits, but not in losses. He was very firm on this point. It was as if the Catholic Church secretly owned a condom factory, the profits of which they were happy to bank, but when a faulty batch of merchandise was returned to the maker, they were not willing to accept the loss. A moral balancing act had to be achieved by those experts who provided authentication services to the art trade (Berenson, if the best known and the most brilliant, was not the only one). Some, like Wilhelm von Bode, salved their consciences by using ambiguous language. 'I have never seen a Petrus Christus like it,' he wrote once, seized on by the dealer as the ultimate accolade of praise for his picture, but actually signifying the expert's doubt as to its authenticity. Bode, in his old age notoriously susceptible to the charms of young women, found Berlin dealers sending their most attractive secretaries round to him in order to get positive verdicts on works from their stock. He obliged regularly. René Gimpel, as ever, is an amused witness of the process: he records how the eminent art historian and museum director Max Friedländer was passionately attracted to a dealer's wife, who squeezed authentications out of him by hints of the surrender of her virtue. 'If she slept with him,' notes Gimpel, 'it would be swiftly finished, so she keeps her garters fastened. On the basis of such certificates, American collections are formed!'

Duveen's ability to make people do what he wanted was legendary. He fought battles on many fronts simultaneously, deploying an extraordinary armoury of allies in order to win his victories. Clients, staff, tamed experts, restorers, fellow dealers, lawyers, aristocratic middlemen, even royalty were all persuaded by a variety of means into doing his will. His success was based on huge energy, a relentless optimism, and a kind of blustering charm that the British found rather marvellous because they thought it was American and the Americans found rather marvellous because they

thought it was British. 'Joseph Duveen does business as he would wage war, tyrannically,' recorded Gimpel in his diary in September 1920. 'He is an audacious buyer and an irresistible salesman. But he is childish too, and indeed asks me like a child what people think of him and his firm. "That you are a great seller and that you have the most beautiful pieces." "They're right, don't you think?"' Even Duveen needed reassurance occasionally.

At the beginning of his career, Joe learned the trade from his father Joel and his wise uncle Henry in New York. And in his prime he was blessed with a supportive and intelligent team of staff. Much of the detail of the buying was actually seen through by his brothers Edward and Ernest in the London gallery and Edward Fowles and Armand Lowengard in Paris. There were times when they saved Joe from himself, because in the art market enthusiasm can occasionally be a dangerous thing. Then there was the redoubtable Bertram Boggis, a character with a name straight out of P.G. Wodehouse, who assumed increasing power in the Duveen entourage. Boggis was recruited from the New York waterfront (where he was working, as legend went, after deserting from an English cargo ship in 1915) in answer to an advertisement for a job as a porter at Duveen's. There was a queue of applicants. Each time Boggis was rejected, he rejoined the end of the line and presented himself as a different candidate. At the third attempt he was taken on, and became the commissionaire, a role in which he felt it necessary to carry a pistol. He had a face like a bullfrog and the sort of street wisdom that made him infinitely resourceful. Prohibition he treated as an opportunity rather than a limitation. He used a fashionable delicatessen on Madison Avenue as his base, from which he conjured illegal liquor for the Duveen clientele.

One of Boggis's roles was as gatherer of 'below stairs intelligence': with generous bribes he routinely recruited servants of Duveen clients to pass on any private information that might be of use to Duveen in his business negotiations with their masters. It was Boggis's proudest boast that when Andrew Mellon was Secretary of the Treasury 'the contents of his wastepaper basket were on the train from Washington to New York within an hour of his leaving his office in the evening'. In Paris in the 1920s information obtained by similar means established Maurice de Rothschild's problems with constipation. As already mentioned, the telephone call to his *valet de chambre* to see if his bowels had moved that morning determined whether the day was propitious for offering him a masterpiece. The strategy of winning over a client's household staff still goes on. Not so long

ago a leading dealer, discovering that a major collector's butler was a keen amateur artist, offered the butler a West End exhibition in order to curry favour with his master. Indeed the butler of another Duveen client, Jules Bache, was so well looked after by Boggis that he managed to send his son to Harrow.

The art market was stupendous in the period leading up to the First World War. The confidence of the leading players verged on the hubristic. In 1909 the Duveens' rival Jacques Seligmann bought the sumptuous Palais de Sagan in Paris as his centre of European operation. Here he entertained and sold to his American millionaire clients on their visits to France. It was not just pictures, of course: Seligmann was offering the full works, including furniture, silver, tapestries, faience, gold boxes. The descriptions given by Germain Seligman (he dropped the second 'n' after obtaining US citizenship) of his father's sessions with the visiting J. Pierpont Morgan in the Palais de Sagan are vivid accounts of the relationship that existed between these rich collectors and their dealers. In the course of an afternoon's exchange of commercial negotiation and aesthetic exposition half a million dollars' worth of business might well have been done. 'Great transactions must be accomplished with lightning and thunder,' comments Germain Seligman. 'Otherwise where is the fun?' In 1914 Jacques Seligmann bought the Wallace-Bagatelle collection 'sight unseen' for an initial investment of $500,000. It was a huge gamble, but Seligmann knew it had been assembled by the great Lord Hertford, and once Seligmann got to see it in the house at 2 rue Laffitte, it turned out to be on a par with what is now the Wallace Collection. In the summer that remained before war broke out, Seligmann moved everything to the Palais de Sagan and managed to sell many treasures from it to Frick and other international collectors.

The early twentieth century was also a golden age for American plutocracy. Of what sort were the men who had made prodigious amounts of money, and thereby qualified as the natural clients of Duveen and the other art merchant-princes? In their behaviour and aspirations the very rich are largely unchanging over the years. But one thing distinguishes these early tycoons: they were often not very prepossessing to look at. Perhaps the biggest difference between the rich of today and those of a hundred years ago is the lengths to which twenty-first-century plutocrats are prepared to go to preserve and beautify themselves (even the males). Botox, plastic surgery, hair tinting and transplants are all copiously employed to

J. Pierpont Morgan: a stranger to the cosmetic surgeon.

correct the malformations of an unkind Nature, to hold back the years, and reinforce the idea that if you are rich enough today you can buy anything, even eternal youth. There was none of that nonsense in America in 1900. Men such as Benjamin Altman, Henry Clay Frick, Pierpont Morgan, P.A.B. Widener and the Huntingtons, Collis and Henry, were rough-hewn moguls, brutish, seeking salvation only in the soft emollient of art. All were self-made men: Altman in department stores, Frick in steel, Morgan in banking, Widener in meat and the Huntingtons in railways. All were conscious of the need to refine themselves, and seduced by the vision of art that Duveen sold them. Art offered atonement, an idea that the artist-turned-adviser Mary Cassatt was eager to play on in the interests of a sale. She bullied her client James Stillman mercilessly. In front of a Velázquez she urged him, 'Buy this canvas, it's shameful to be rich like you. Such a purchase will redeem you.'

The other notable thing about the very rich of the early twentieth century, according to Behrman, was their taciturnity. 'Perhaps there is some mysterious relation between the possession of great wealth and parsimony of speech,' he speculates. Elsewhere he suggests that millionaires talk slowly and sparely 'in order to keep themselves from sliding over into

the abyss of commitment'. This trait survives into the twenty-first century, but I have a different theory to explain it. I have met very rich people who don't speak much because it is too much effort. Such emotional and intellectual fulfilment as the hyper-rich male requires often appears to be met by the playing of golf. In fact most of his energy, social and physical, seems absorbed by it. He has grown so rich that he can't be bothered to finish his sentences. It is as if the very effort of talking at all seems an unwarrantably intrusive demand on his now priceless time and energy. He proceeds on the assumption that those set upon this world to serve him and accommodate his whims (most of the rest of the human population, including his wife) should be obliged to operate with antennae constantly tuned to his own wavelength, so that the barest minimum of words on his part should be enough to head them in the right direction in the meeting of his requirements. Indeed the act of communicating at all is irksome to him, an irksomeness that he expresses by the regular insertion of expletives into his half-formed sentences. 'Fucking Matisse, fucking outasight', is as far as one very, very rich client was prepared to go in his aesthetic assessment of one of the gems of his collection when showing me round his drawing room.

While it was fairly clear that as far as Duveen was concerned money was more important than art, his message to his buying clients was that art was more important than money. By buying great art, they were buying immortality, allying their names with Leonardo, Botticelli and Raphael, etc. Reproached for putting a high polish on his old masters, Duveen said his rich clients wanted to see themselves reflected when they looked at works of art. Such was Duveen's mastery of the market that he rarely bought without in effect pre-selling. He knew what he could afford to pay for a painting or a collection because he knew how much a specific well-heeled client, already seduced by the fantasy of buying into the dream of immortality through art that Duveen purveyed, could be persuaded to pay for it. This was true of the first of Duveen's big purchases: the Kann collection, for which Joe and uncle Henry paid $4.2m in 1907. It was a purchase that also marked the beginning of business relations with Nathan Wildenstein, a combination of two big beasts that was frequently acrimonious but nearly always profitable to both parties. Almost simultaneously Duveen bought the great Hainauer collection from Berlin. Buyers were already lined up. Altman, Widener and J.P. Morgan all jumped in, as did Arabella Huntington, widow of Collis P. Huntington, who bought Rembrandt's *Aristotle with a Bust of Homer*. Very soon Duveen was in profit,

and still had lots of desirable stock left over. Arabella Huntington was the sort of woman dealers dream about, a rich and fanatical collector herself and a practiced loosener of the purse strings of the even richer men that she married. Between 1908 and 1917 she and her new husband, Henry Edwards Huntington (nephew of Collis P.), spent $21m with Duveen. Henry Clay Frick was also won over to the Duveen cause when Joe sold him J.P. Morgan's Fragonard Room, conveniently on view at the Metropolitan Museum (neither the first nor the last instance of a dealer taking advantage of the exhibition of privately owned art in a major museum to make a sale, bolstered by the authority of the museum exhibition). Over time collectors such as Altman were rewarded on a new variation of the 'Ars longa, vita brevis' principle. The department store that bore his name went out of business, but it lives on as a wing in the Metropolitan Museum. No one in Britain wants to see Sainsbury's go out of business, but should the worst happen the name will live on in the wing at the National Gallery. And Duveen himself, ever keen to emulate his clients, is immortalised in his galleries at the Tate.

Duveen's strategy of paying – and asking for – very high prices for his stock was an intelligent one. At the stratospheric level of the market you are by and large protected from fakes. Duveen knew enough to be buying the very best, with immaculate provenance and unimpeachable authenticity (often provided in-house by Berenson). Shelling out a lot of money is in itself attractive to a certain sort of buyer, who takes comfort, pleasure and cachet from paying the highest price of the year. And history shows that generally the very best goes up quicker than the merely good (always allowing for shifts in taste, which is the unknown factor in all this).

A further element in the Duveen business model was the 'grand' intermediary who was happy to take discreet payment from the dealer for delivering to his premises fellow aristocrats or rich Americans as sellers or buyers, but needed at all costs for the commission he received to be kept secret in order to preserve his unsullied reputation in society. Joe cultivated distinguished British middlemen, peers like Lord Esher and Lord Farquhar, who were responsible for introducing royal patronage to Duveen. Farquhar, for instance, besides conducting a profitable trade in honours, pointed Duveen in the direction of fellow aristocrats in money trouble. In return Duveen furnished Farquhar's houses and never sent him a bill. The bitter Berenson wrote that Duveen 'stood at the centre of a vast web of corruption that reached from the lowliest employee of the British

Museum to Buckingham Palace itself'. Berenson's worst fears were confirmed as Duveen himself was created first a knight, in 1919, and then a peer of the realm in 1933.

Duveen was constantly inventive about works of art. He was quite prepared to reshape them in a form that was more pleasing to his clientele. Even in the 1970s, the old master department at Christie's could be cast into gloom by a Gainsborough portrait in oval format. That was certainly not the Duveen spirit. Under Duveen's instruction less commercial oval portraits were cut down into more commercial rectangular shapes, and everyone was happy. The client was always right after all. Sometimes even more esoteric requests were made: one client, the American Carl Hamilton, wanted young boys: 'young fellows – about 12–13 years', that he'd like to take home to America and adopt. Amazingly, Duveen obliged. A French one and a Spanish one were provided. It was perhaps this that Berenson had in mind when he confided bitterly to René Gimpel:

> in Florence the Yankee becomes an art lover between a visit to a little girl and one to a little boy, a flourishing trade here. The middleman who deals in works of art follows close on the heels of the procuress; often they are one and the same. They invariably know how to find somewhere in the same town the twin brother of the picture admired in the museum, and the American flings himself into this new kind of debauchery at fantastic cost. But there at least he isn't risking the dread disease; only the picture is contaminated!

Berenson, despite his increasingly critical attitude towards Duveen, had to admit that he was an artist as a salesman. 'He would make you pay outrageously, he would exact the last possible penny in a deal, and then would spend thousands of dollars on you with the most open-handed generosity.' Duveen's mantra was a simple but beguiling one to American millionaires: 'When you pay high for the priceless, you're getting it cheap.' Frick found practical ways of reassuring himself that Duveen's high prices were actually rather reasonable. Frick's research revealed that Philip IV had paid Velázquez the equivalent of $600 for a work for which Duveen was now asking $400,000. Frick compounded $600 at 6 per cent per annum from 1645 to 1910, and to his joy came up with a sum that made the $400,000 look like a bargain.

Even the greatest art dealers are a bit like plumbers when it comes to

discussing their rivals' wares with clients. The sigh and shake of the head that plumbers are so good at when inspecting another plumber's handiwork looked amateur by comparison with Duveen's reaction to a fellow professional's goods. It was beautifully judged: a sharply raised eyebrow, an exhalation of disbelief and a world-weary shake of his head that spoke not so much of anger but rather of sorrow at the cupidity of humankind; and of relief that, at least in this instance, he was on hand to protect an innocent consumer – who was also a friend, because Duveen's clients were his friends – from making a costly mistake. 'On one occasion,' records Behrman, 'an extremely respectable high church duke was considering a religious painting by an old master that Agnew's, the distinguished English art firm had offered him. He asked Duveen to look at it. "Very nice, my dear fellow, very nice," said Duveen. "But I suppose you are aware that those cherubs are homosexual."' On another occasion a prospective buyer of a sixteenth-century Italian painting offered him by another dealer 'watched Duveen's face closely and saw his nostrils quiver. "I smell fresh paint," said Duveen sorrowfully'.

The reassuringly vast sums that Duveen charged his clients only became a problem in the event that the buyer decided to resell the work in question. On the rare occasions when Duveen's best clients did return pieces to the market, Duveen would move heaven and earth to keep up their prices in a kind of successful Ponzi scheme, by providing other favoured clients to buy them at even higher levels. The so-called Baldovinetti that caught Kenneth Clark's eye on his visit to Duveen's premises in 1936 is an instructive case in point. Joe originally bought it on Berenson's recommendation in Florence in 1910 for $5,000; even then it was acknowledged to be much repainted, quite possibly by the vendor, a notoriously creative restorer. Nonetheless, it was sold by Joe to William Salomon for $62,500. When Salomon wanted to get out of it, Joe sold it to another rich client, Clarence Mackay, for $105,000. When Mackay went bust in the Depression, Joe took it back. Hence its appearance on Duveen's walls when Kenneth Clark called. But it was only there briefly because the same year Joe sold it on to Samuel Kress, who in turn gave it to the National Gallery in Washington. This last stage in the sequence, the donation to Washington, was an even more effective way of insuring that no one lost out. Persuading his biggest clients to endow museums with their collections was a brilliant scheme on Joe's part. Besides achieving them immortality, there were tax advantages too, to which his clients responded equally positively. It was genius. In

the words of Behrman, at a stroke 'oblivion and the Collector of Internal Revenue were circumvented'. Huntington, Frick, Mellon, Bache and Kress were all persuaded into this kind of philanthropy by Duveen. In fact in 1936 Joe sold Andrew Mellon $21m-worth of paintings and sculpture from Duveen stock in order to fill in gaps in the embryonic collection of the National Gallery in Washington. Puritan guilt was assuaged, and the agony of wealth was dulled. The art of atonement was atonement through art. Sadly, however, some of the Duveen swans turned back into geese over time in Washington: the so-called Baldovinetti now languishes in storage in the National Gallery, its attribution uncertain.

In preparation for an encounter with a prospective purchaser, Duveen sometimes staged role-playing sessions, with his secretary impersonating the client. He was a master at creating desire through insecurity. A new collector coming to Duveen for the first time always got told he couldn't buy from him. Whatever caught his eye was invariably reserved for someone else. 'As a novice in collecting I expected to have to pay the highest prices for masterpieces,' admitted Albert Lasker. 'What I did not expect was that I would also have to pay a large premium for the privilege of paying the highest prices.'

That was Duveen as a seller. As a buyer, he had runners all over Europe, 'franc-tireurs routing out hard-up noblemen with good pictures'. When dealing with British sellers, in the words of Behrman, 'he didn't waste breath on art patter. He just talked money.' 'I can't pay you £18,000 for this,' he announced regretfully to one titled seller. 'I insist on £25,000.' He simply didn't understand small amounts of money. In England he played the role of the generous buffoon, the court jester to the aristocracy. In America he played the aristocratic Englishman (which he managed to do with conviction once he got himself ennobled). Osbert Sitwell wrote of Duveen's 'expert amiability, which resembled that of a clownish tumbler on the music-hall stage'. Sitwell went on: 'Being a remarkably astute man in most directions, I think that... he enjoyed having the stupid side of his character emphasised; it constituted a disguise for his cleverness, a kind of fancy dress.' And Duveen was a generous benefactor of the nation, but even this was an act of brilliant prestidigitation, a sort of cultural three-card trick: the public galleries that he paid for in Britain were actually funded, in Sitwell's words, 'by the sale to the United States of the flower of the English eighteenth and early nineteenth-century paintings. We have the galleries now, but no pictures to hang in them.'

He lived better than his millionaire clients. I used to wonder if this made clients suspicious when negotiating with an art dealer. But on balance I think the extraordinarily rich are reassured by extraordinary wealth. They prefer to pay 25 per cent more to be dealing with one of their own. Because clients such as J. Pierpont Morgan dealt in large sums and made large profits, 'he conceded to his dealer the same privilege,' in the elegant words of Germain Seligman. Indeed he expected it. Like most of his clients, Duveen was not an intellectual and seldom read anything. Again, not much has changed. I once sent a book I had written to a leading New York gallerist, who shares some of the characteristics of Lord Duveen. 'Did you enjoy it?' I asked him – in a shameless attempt to elicit praise – some months later. 'Yeah, it was good,' he told me. 'I had it read.'

Lawsuits gave Duveen's life savour. In 1897 a tiresome new US Revenue act had imposed a 20 per cent tariff on imported works of art. In 1909 this was repealed to allow duty-free exemption on works of art more than 100 years old, a cause of unconfined joy in the American art trade. In the 'difficult years' leading up to 1909, Duveen kept two account books – one real and another a work of fiction, for the eyes of US Customs. Unfortunately a whistle-blower within the Duveen organisation revealed the deception to US Customs, and Duveen was prosecuted for the evasion that had taken place up till 1909. A great art dealer needs a great lawyer and Duveen found one in Louis Levy, who represented Duveen in this and all his future American litigations. It was sorted out in the end, and a penalty fine of $10m was whittled down to $1.2m, still a substantial sum. Joe, typically, was rather proud of the magnitude of the settlement. And of course the removal of the tariff now opened up the US market still further. But you had to think on your feet as an international art dealer even in 1909. That year a law came into force in London imposing UK tax on overseas branches of UK companies. Deftly Duveen shifted his business to New York and Paris. This was the reason why sales at Duveen in Paris in 1913 amounted to more than $13m. They included Raphael's *Cowper Madonna*, for which Duveen apparently paid $500,000 that year and sold to P.A.B. Widener almost immediately for $700,000.

In 1920, the year after Duveen's knighthood, his firm's net profits were $710,032. The stage was set for a booming decade, during which he added to his already glittering client list Andrew Mellon, Randolph Hearst, Julius Bache (codename Julie) and Clarence Mackay, a new generation of huge American wealth who all began buying. It was to H.E. Huntington that he

sold Gainsborough's *Blue Boy* in 1922 for the staggering sum of $728,800, having somehow persuaded the Duke of Westminster to part with it. On top of that Duveen also contrived a three-week farewell exhibition in the National Gallery, London when it was announced that the painting was leaving British shores. Cole Porter even wrote a song about it – 'The Blue Boy Blues' – which celebrated the portrait's journey from 'the gilded galleries of Park Lane' to the primitive western frontiers of America.

Yet one more major lawsuit, which lasted off and on through most of the 1920s, was the affair of *La belle ferronnière*. (It was almost as if Duveen orchestrated it as an entertainment to brighten his otherwise monotonously successful progress through the decade.) The fact that Duveen was not a connoisseur of Italian pictures did not deter him from pontificating loudly on them. René Gimpel recorded: 'He has no knowledge of painting and sells with the support of experts' certificates, but his intelligence has enabled him to keep up a cracked facade in this country, which is still so little knowledgeable.' Andrée Hahn, a lady in Kansas, claimed to own a Leonardo, a version of *La belle ferronnière* in the Louvre. Duveen was asked his opinion of it, and roundly condemned it as not authentic. The Hahn family then sued him for fouling up a sale they were negotiating. They proved remarkably tenacious litigants. Though they had very little right on their side, they eventually accepted an out-of-court settlement of $60,000 in 1930, but not before Duveen himself had made court appearances in the course of which he claimed infallibility as to authenticity (although he admitted he didn't always know attribution). A less willing expert witness was Bernard Berenson, although he too had his moment of majesty in one hearing, as recounted by René Gimpel:

> The lawyer asked him [BB]: 'You've given a good deal of study to the picture in the Louvre?'
>
> 'All my life; I've seen it a thousand times.'
>
> 'And is it on wood or canvas?'
>
> Berenson reflected a moment and answered: 'I don't know.'
>
> 'What, you claim to have studied it so much, and you can't answer a simple question?'
>
> Berenson retorted: 'It's as if you asked me on what kind of paper Shakespeare wrote his immortal sonnets.'

It is a masterful reassertion of eighteenth-century connoisseurial values

on Berenson's part, an underlining of his superiority to the mere techni-
cian. Berenson's position is 'I don't know what it's painted on but I know
it's beautiful', as against the technician's 'I know what it's painted on but I
don't know whether it's beautiful.'

At the end of the 1920s came the slump. 'Julie' Bache had $4m of
Duveen pictures in his possession that he hadn't paid for, but he didn't
dare return them for fear of word spreading that he was broke. Duveen
suffered too: in 1929 the firm recorded a loss of $900,000 and this rose
in 1930 to $2.9m, but he still carried on with style, and it seems likely
that he was given advance warning of the stock market crash by his friend
Calouste Gulbenkian and pulled out his money in time. One Saturday
morning soon after the Wall Street disaster Alfred Erickson of McCann
Erickson, who had bought Rembrandt's magnificent *Aristotle with a Bust
of Homer* from Duveen for $750,000, called on him. Duveen immediately
made out a cheque for $500,000; generous, but not of course a refund of
the full purchase price. Still, Duveen allowed Erickson to buy it back for
$590,000 when times were better.

There are different kinds of dishonesty. Collis Huntington, one of the
grosser examples of the first generation of American mogulhood, was once
described as 'scrupulously dishonest'; he was the sort of operator who in
the twenty-first century would do dubious deals behind the cover of a
high-profile legal compliance department. But Duveen was thrillingly dis-
honest, intoxicating in his bravado. He might take your money off you
but he made you feel good in the process, and you sometimes ended up
with quite a decent picture from him, even if you'd overpaid for it. 'He
was irresistible,' wrote Kenneth Clark. 'His bravura and impudence were
infectious, and when he was present everyone behaved as if they had had
a couple of drinks.' Duveen thrived on risk, on surmounting obstacles he
had strewn in his own way by an injudicious criticism or praise of a work
of art. He couldn't help going over the top. Berenson's dishonesty, on the
other hand, crept up on him: 'You know the beginnings of evil are apt to
be very good,' he confided to Kenneth Clark in 1934.

A generation of early-twentieth-century moguls in America were
taught by dealers such as Duveen, Seligman, Knoedler, Agnew, Colnaghi
and Wildenstein to revere the Italian Renaissance beyond anything, and
to express that reverence by spending large amounts of money on its works.
This involved new levels of education and expertise to back up the high
prices, provided by Duveen through the crucial medium of Berenson.

How far was the cult of Giorgione, for instance, stimulated by the late-nineteenth- and early-twentieth-century art trade? Titian, as the leading artist of the Venetian school, was a known and highly desirable quantity. Kings, emperors and the upper echelons of the aristocracy had vied for his works for centuries. But dealers now found that Giorgione offered an extra piquancy. Besides genius, Giorgione had romance. He was responsible for the injection into early-sixteenth-century Venetian painting of an irresistible element of mysterious longing, seized upon by Walter Pater in an essay entitled 'The School of Giorgione' (1877) to conjure very nineteenth-century dreams of yearning shepherds in an idyllic Arcadia playing pipes to the sound of plashing water.

And Giorgione had something even more desirable to offer than genius and romance: he died young. 'To live for only 33 years,' wrote Reitlinger of Giorgione, 'is to give a lot of trouble to art experts' – but a lot of opportunity to clever art dealers. The fact that there was a certain flexibility to his oeuvre, that he was rarer than Titian, that no one quite knew where Giorgione ended and early Titian began, but that he was widely regarded as having had more influence over Titian at this early stage than vice versa, all were played upon by the trade to make Giorgione a more desirable commercial proposition even than Titian.

The dispute over the beautiful Nativity that Duveen managed to buy from Lord Allendale in 1937 was the final point of conflict between Duveen and Berenson, and precipitated the end of their business relationship. It all hinged on whether Berenson was prepared to attribute the work to Giorgione rather than Titian. As a Giorgione it was definitely worth more. Berenson had been prepared to do it in 1913 with the portrait of Ariosto, which had been transmuted from a Titian to a Giorgione in order to make a sale to Altman. But in a gesture born of bad conscience or bad temper he now refused to give Duveen the confirmation he wanted. Indeed it is possible to argue that the shrinkage of Giorgione's accepted oeuvre in the mid-twentieth century is a direct reflection of Berenson's remorse at his embroilment in the art trade, a retrospective reassertion of over-rigorous scholarly standards. Only three or four works were definitely accepted as by his hand. While Berenson still lived, Giorgione became forbidden and much-reduced territory. Only after Berenson's death did it become possible, in Reitlinger's words, 'to repeat Giorgione's name in something above a hoarse whisper'. Nonetheless Duveen still managed to sell the *Allendale Nativity* to Samuel Kress at a considerable profit, even though

its attribution was marooned somewhere between Titian and Giorgione. It was one of his final deals.

Joe was good company and had an impish sense of humour: Dick Kingzett of Agnew's recounted how in his youth he was at a dinner in the summer of 1938 with Duveen, who spoke to him exclusively about cricket. Did Kingzett not agree that Jack Hobbs was the finest batsman who ever lived? A fellow guest, the rather more aesthetic Eddy Sackville-West, tried to turn the conversation to opera, and mentioned *Don Giovanni*. 'Ah,' said Duveen, 'the Don. Now in my view Don Bradman is the greatest batsman playing today...' The grandeur of the circles in which Duveen moved is constantly amazing. He was popular with courtiers, peers and even prime ministers. Ramsay MacDonald was comprehensively seduced by the Duveen charm, which was indeed enough to turn a socialist into a socialite. Joe's entertaining was constant and sumptuous. Jean Fowles, wife of Edward, describes the effect of his eyes, which were 'a brilliant, hypnotic blue'. Apparently Duveen had a vast aquarium in his entrance hall, but he confessed to Jean Fowles that he was disturbed by the inactivity of the fish – they never did anything – so he was thinking of replacing them with a huge cage of monkeys. Lady Duveen objected to the idea because of the smell. That wouldn't be a problem, said Duveen. He would have them constantly sprayed with Guerlain perfume. It was a metaphor for his art dealing.

6

THE WILDENSTEIN DYNASTY

The Wildensteins have been almost selflessly opaque about their own history and functioning. They do not approve of the release of unnecessary information. They feel there are better things for the art world to focus on. What is generally known is that the business was first established after the Franco-Prussian War by Nathan Wildenstein, who came to Paris from his native Alsace and set up an art gallery. His preferred period of specialisation, in which he helped to establish a booming market, was the French eighteenth century. Or, as Daniel Wildenstein, fighting shy of any false modesty, later put it: 'Watteau, Boucher and Fragonard had to wait more than a century, for the arrival of my grandfather, before their qualities were fully recognized.'

The gallery thrived, and expanded to New York and later London (they even for a few heady years had a branch in Buenos Aires). Nathan was joined in the business by his son Georges. The range of merchandise handled expanded too, to include great Renaissance masterpieces – and, crucially, Impressionist and Modern art as well. Georges also established himself as a serious authority, an art historian compiling definitive *catalogues raisonnés* of major modern artists and putting together a legendary art library. On top of that, the Wildenstein intelligence resource came into being, a meticulously assembled archive of secret information about where all the most desirable paintings in the world were held. There was

Daniel Wildenstein, whose book broke the silence about his family firm.

a little hitch in the Second World War – a misunderstanding that led to the unfortunate allegation that Wildenstein had done business with the Nazis – but that was put behind them, and under Georges's son Daniel the business went from strength to strength in the post-war years.

The official opacity about their own history was cleared a little by a fascinating book, *Marchands d'Art*, published in 1999, in which Daniel Wildenstein indulged in some personal reminiscences of the art trade and in the process set the record straight about his family business. This highly intriguing memoir casts the Wildenstein dynasty, hitherto synonymous with rapacious success, in an unexpectedly altruistic light. It seems that the making of money has not really been the primary aim of their operation: no, it is a happy by-product of their scholarly mission in rediscovering for their fortunate clients the attractions of the French eighteenth century; in purveying great Renaissance art out of Italy, where it was wasted, to American business moguls who expressed their appreciation in the way they knew best, through their chequebooks; and in winning a monopoly in the expertise on a large number of major (and expensive) Impressionist painters. In this simultaneous stockpiling of art historical and market power they are undeterred by malicious suggestions of a conflict of interest. It is work that has to be done. It is work that Wildenstein cheerfully undertake for the greater benefit of the art world.

Nonetheless, Daniel Wildenstein's book is revealing for the light it shines on what made a top art dealer successful in the twentieth century. Daniel's memories of Nathan are of various pieces of advice handed down from grandfather to grandson, which enshrine certain principles of the Wildenstein philosophy and business model. 'There are only two things which count,' said Nathan. 'To love France. And to go to the Louvre.' It is a message uplifting in its simplicity: patriotism and expertise above everything. Nathan goes on a little later: 'You see, Daniel, you must only work with dead artists. Living ones are impossible to deal with.' And, although in the years since, Wildenstein have occasionally sinned against this principle and dabbled with contemporary art – notably in partnership with Paul Rosenberg in the 1920s, and with Pace Gallery more recently – these have not been the ventures that have brought them their most glorious successes. Nathan's third piece of wisdom was imparted as follows: 'Our metier is to find the hat that is going to be fashionable and wear it before anyone else does.' Wise words.

Nathan's definition of what constitutes a great dealer is one who has the daring and the power to buy whole collections. In the golden pre-First World War years, this was what distinguished the Duveens, the Seligmanns, the Knoedlers and the Wildensteins, the big beasts in the jungle of the market for old masters. Besides Duveen and Wildenstein and Knoedler, the other great early-twentieth-century purveyor of major European treasures to American millionaires was the Parisian firm of Seligmann. Jacques Seligmann, the founder, left Germany for France aged sixteen in 1874. His success, like that of Nathan Wildenstein, was founded on the belief that the art dealer 'could be both connoisseur and businessman'; thus dealers should own the things they sell as evidence of their faith in the object. It's an important point. Ideally a client buys from a dealer because he likes that dealer's taste and wants to buy into it. The top dealer is not just selling art, but selling his own taste. You can't sell good taste unless you have it yourself. Or at least unless someone in your business does. These dealer-princes put large amounts of their own money on the table to acquire entire properties, often deceased estates, which they then had the financial strength to take their time over selling piece by piece at considerable profit. Audacity in buying, patience in selling. This was the Wildenstein recipe for success; but there were cruel moments, as when a rich client, looking round at the palatial style in which the Wildensteins lived, observed bitterly to Madame Nathan

Wildenstein, 'Nice carpet you've got there. Bought with our money, of course.'

Jacques Seligmann belonged to an older generation, for whom the artistic quality of what he sold was more important than the minutiae of attribution. It was a survival of the eighteenth-century ideal of the connoisseur. Even with paintings, establishing the name of the artist responsible was a mere detail in comparison with the essential question of appreciating the quality of the work. This high-mindedness, of course, had a low commercial benefit for the dealer, releasing him from the strait-jacket of having to guarantee attributions. Seligmann extended his disdain to most art historians, whose knowledge and memory were better than their eye. He regretted that the new generation of American collectors had become overdependent on 'experts'. Nathan would have felt much the same.

Nathan was an inspired operator. And of course there were still opportunities to make large mark-ups in price for dealers prepared to run their businesses internationally. René Gimpel recounts how Nathan and his father (who operated in partnership for a time at the turn of the century) found Watteau's *The Poet's Dream* in a back room at Colnaghi in London. They bought it for 10,000 francs and sold it in Paris for 150,000 ten years later. Although René Gimpel split from the Wildensteins in 1919, his diaries are full of admiring references to Nathan's constant trading; he was a dealer of genius. He had considerable success buying and cleaning pictures from English collections, which often resulted in tremendous discoveries because of the horribly distorting yellow varnish common in England. He also knew how to sell. When the Wildensteins and the Duveens bought the magnificent Rudolph Kann collection in 1907 Nathan persuaded the Kann heirs to keep the house open and allow the dealers to offer works to their American clients in their original context. It was a brilliant move that led to brilliant sales.

The problem with commercial dynasties is that the domestic disputes, disagreements and jealousies endemic to all families tend to be reproduced as fault lines in the business. The Wildensteins were no strangers to internal stresses. Fathers and sons frequently fell out, not to mention brothers and sisters, husbands and wives and stepmothers and stepchildren. Generally the operation held together. Just. The young Georges Wildenstein was instructed by his mother to spy on his father, Nathan, and report back on his infidelities, which were apparently fairly numerous, because Nathan

Georges Wildenstein: businessman, scholar, and romantic.

had a *faiblesse* for pretty women. But Georges, too, had his moments as a Lothario. One of his less well-judged moves later in his career was to have an affair with the wife of his business partner, Paul Rosenberg.

In 1934 Nathan finally died, to the end an opponent of modern art who never understood his son's involvement in it. His death precipitated a bitter legal dispute about the ownership of the gallery stock between Georges and his sister Elizabeth. It took fourteen years to reach a compromise. Daniel describes his aunt as 'a stupid ugly minx', but the tone of his remarks about his father suggests that he did not nurse a great love for him either.

The attitude of the Wildensteins to dealing in contemporary art remained ambivalent. Broadly they were prepared to do it where the money to be made looked secure. Hence, as we have seen, they were only tempted into their first venture in this direction in conjunction with Paul Rosenberg, when the artist concerned was Picasso. With Picasso profitability was assured, although the fact that his production in the early 1920s was largely representational also gave them comfort. The artist had moved on from his unfortunate involvement with Cubism, which Nathan Wildenstein had described as a joke. Wildenstein chose Paul Rosenberg as their partner rather than his brother Léonce because, in Daniel's words, Léonce was an intellectual and a visionary, but had little business sense,

whereas Paul was anything but a visionary, but was amusing and a born businessman. Going into business with a visionary was to be avoided at all costs, so Paul it was.

Even so the contract that Georges Wildenstein, in partnership with Paul Rosenberg, entered into with Picasso was against all his principles. To buy everything an artist did meant you had to take and sell the eight out of ten paintings that weren't good along with the two out of ten that were. Sensing his basic predisposition against avant-garde art, Picasso teased Georges: 'What shall we have today? Cubes? Circles? Squares? Whatever you want.' But still, the Wildensteins made sure they were ahead of the game. Georges had on his desk two telephones, one that connected him to Paul Rosenberg, and the other direct to the studio of Picasso – just to make sure. No doubt he trusted his partner, but there was no point in taking risks, bearing in mind that Picasso's house was dangerously close to Rosenberg's gallery. They were neighbours, in fact, in the rue La Boétie. It all ended in tears in 1933 when Paul Rosenberg and Georges Wildenstein 'fell out over a woman', as Daniel Wildenstein puts it. The woman was Mrs Paul Rosenberg. The consequent acrimony meant that Wildenstein's grasp over the artist they jointly represented – Picasso – was weakened and prised away.

Perhaps it was for the best. None of the Wildensteins seem totally convinced about dealing in contemporary art. Yes, Daniel took the Wildenstein into a fairly profitable partnership with Pace Gallery in New York in the 1990s, but you get the feeling his heart wasn't really in it. The problem with contemporary art, he tells us, is that 'the living artist never stops yelling that everything he's done in the past is shit, and that only what he will produce tomorrow will be great and a work of genius'. Daniel's right, of course: just as you've built up an interesting and comprehensive holding of the early work of Gerhard Richter you find the artist has decided publicly to disown it. And Daniel could not get used to the idea of offering clients the opportunity to reserve works in advance, before the artist has actually painted them. He calls this 'art as stamp collecting'. But Arne Glimcher and Pace Gallery served their purpose for Wildenstein for a while. Glimcher probably had the same attraction as a partner as Paul Rosenberg, being a competent businessman rather than a dangerous visionary.

Daniel Wildenstein sees art dealing as a species of warfare. As in a military campaign, security is everything. He says he never talks about his

stock. It's his most precious and secret weapon: he describes it as *'le nerf de la guerre'*. What Wildenstein may have hidden away in their storerooms is still the stuff of fantasy for collectors and other dealers. Another of Nathan's wisdoms as recorded by Daniel was that no self-respecting dealer had the right to keep a painting for his own collection. He should put it back on the market. Fortunately for the Wildenstein dynasty, this was not a principle adhered to by Georges and his son Daniel, who put away masterpieces in their basement that have never come out again. The storerooms of the Wildensteins remain legendary. Even now no one knows what treasures are still held there, not even the Wildensteins themselves, it seems, according to evidence given in recent French court cases. Indeed for a large part of the twentieth century there was always an uneasy suspicion, whenever a collector bought a great painting from another dealer, that Wildenstein probably had a better one. An article in the French magazine *Réalités* in 1959 speculated that, apart from multiple works by artists such as Titian, Velázquez, Rembrandt, Rubens, Fragonard and Watteau, there were never fewer than twenty Renoirs, fifteen Pissarros, ten Cézannes and ten van Goghs in stock. But Georges Wildenstein had by now divested himself of the 250 Picassos that had been his settlement after the break-up with Paul Rosenberg. Perhaps the memories were too painful. Or perhaps he'd never really liked Picasso.

Daniel Wildenstein naturally extends the secrecy that attends all Wildenstein dealings not just to his stock but also to his clients. He respects their privacy – 'it should be the first priority of an art dealer,' he says severely. It is a duty of care incumbent upon the professional of integrity. True enough. But the anonymity in which Wildenstein are eager to cloak their clients also conveniently prevents other dealers getting to them. Actually, with the exception of Ambroise Vollard, an opponent worthy of his steel, Daniel Wildenstein doesn't think much of other dealers, although he's amused by their antics. There's the Parisian Raphael Gerard, who apparently repainted the disturbingly monkey-like heads of the ballet dancers by Degas that he had in stock with more pleasing dolls' heads, and as a matter of principle (because he felt they were detrimental to saleability) always painted out cows whenever he found one in a landscape he had acquired. Then there was the salesman at Knoedler – not a favourite institution of the Wildensteins, being their long-time rival in the struggle to purvey great art to rich Americans – who was a pretty useless art dealer but a decent golfer, and whose only comment of aesthetic judgement, whether

he was confronted by a Rubens, Picasso or a Monet, was 'this one's the absolute Eiffel Tower'. Not that other dealers were particularly enamoured of Wildenstein, either. Heinz Berggruen once had to conduct the sale of Picasso's *L'Italienne* to the director of the Basel museum in a room put at his disposal in the Wildenstein gallery. 'Whilst he was inspecting the painting, I noticed a large, dark eye observing us through a crack in the sliding door that was not completely shut,' remembered Berggruen. 'It was rather like being in a Hitchcock film. Then the sliding door gradually opened and Monsieur Wildenstein entered the room.' Thereupon Monsieur Wildenstein – to Berggruen's understandable annoyance – tried to interest the director in 'important old masters' that he had in stock.

The Wildenstein operation in its prime was a supremely efficient exercise in military-style espionage and deception. They were on a constant war footing in their relations with major rivals like Knoedler or Duveen. Daniel recounts how as a seventeen-year-old he was sent to London to bid on some choice Bouchers coming up at auction. Joseph Duveen found out he was in town and insisted he come to dinner. There he was grilled mercilessly on the reason for his visit. Daniel stuck to the story he'd been given that he was there to inscribe himself for a university course. Duveen ranted and raved. Then he got Georges Wildenstein on the telephone and ranted and raved again: 'You sent your boy over to buy the Bouchers behind my back!' Wildenstein ranted and raved himself: 'What do you mean? Daniel's over to register for a university course.' Finally the storm calmed. A pause. 'Better come to an arrangement, don't you think?' 'OK.' 'Fifty-fifty?' 'Fifty-fifty.' And Daniel was forthwith sent back to Paris, there being no point in his staying for the sale.

Duveen's relationship with Berenson is generally regarded as the paramount one in Berenson's dealing life, but not according to Daniel. There are apparently letters in a top-secret file in Wildenstein which show that a clandestine agreement existed between Wildenstein and Berenson: before alerting Duveen, Berenson gave Wildenstein first refusal on everything he found. The arrangement collapsed in mutual recrimination. Apparently Berenson's insistence on 50 per cent of the profit on business he introduced precipitated the break. As a commission for an expert, it was 'astounding' according to Daniel, not entirely without a note of admiration. 'He's a swindler!' declared Nathan. 'I've no respect for him. With charges like that, what's he waiting for to become a dealer!' In January 1925 Gimpel recorded in his diary: 'Berenson hates Wildenstein, inveighs against him,

and says: "That man goes about telling everyone that I'm a swindler, that I can easily be bribed; I've other things to do than sue him for slander.'" In fact, the Wildensteins were dangerous and implacable opponents, whom you took on at your peril. Georges Wildenstein once admitted in an interview: 'I know how Stalin thinks. I think in the same way he does. At the bottom line Stalin is a bit like me.'

The web of Wildenstein representatives and agents across the world was for many years intricate and far-reaching. Each one worked in their locality to identify great pictures that might come for sale, so that Wildenstein could get there first. From Tokyo to Zurich, from London to Buenos Aires, there would be a local man reporting in to Georges or Daniel. As a covert information-gathering organisation, it could probably have taught valuable lessons to many countries' intelligence services. Very occasionally it came unstuck. In 1956 Wildenstein were accused of tapping the telephone line of their New York rivals, Knoedler. Wildenstein protested their innocence but made an apology for the fact that 'a Wildenstein employee' had paid an employee of the New York Telephone Company to do the tapping. Regrettable, and nothing to do with them, of course. The employee in question would not be in receipt of a bonus that year.

The delicate question of Wildenstein's dealing activities in the Second World War has been much debated. There are indeed murky aspects. But one point should be emphasised: it is not fair to judge the behaviour of Georges Wildenstein with the benefit of hindsight. In 1940 he didn't know that the war was going to grind on so appallingly for five more years. No one did. It was widely expected that hostilities would not last more than a few months. Yes, Paris had just been occupied by the Germans, but the Boche hadn't stayed long the last time they came, in 1870. So it was desirable to make arrangements to see one through till peace was re-established, when proper business could be resumed. In the meantime the priorities were to secure one's stock and withdraw temporarily to America, and if the tides of war occasionally washed up onto your shore the odd deal to be done, then you took advantage of them. People still needed to buy and sell pictures, after all, even in times of hostility. William Buchanan would attest to that.

Already in 1937 Wildenstein had availed themselves of the opportunity to handle Gauguin's *Riders on the Beach*, newly deaccessioned from the Wallraf-Richartz Museum in Cologne as part of the Nazi purge of degenerate art from public collections (see plate 8). Their acquisition of it was the

first deal done between Wildenstein and the Nazi art dealer Karl Haberstock, and the painting was sold on to Edward G. Robinson in America. On page 87 of his book Daniel Wildenstein suffers a lapse of memory about the picture's provenance: he asserts that it was sold to Robinson having been acquired from the Oscar Schmitz Collection, which Georges had bought in Dresden in 1936. But Wildenstein were not alone in dealing with the Nazis, directly or indirectly, at this time. The international art trade had to confront a moral question in the final years of the 1930s: Did you step aside from engaging with dealers selling art from German museums? Did you boycott events like the Nazis' sale of degenerate art conducted by Fischer of Lucerne in 1939 on the grounds that the proceeds would benefit a deplorable regime? Or did you participate on the grounds that this was the best way of saving great art that might otherwise be destroyed by the same deplorable regime? Plenty of respectable dealers took the latter view.

When the invasion of France came in June 1940, Georges Wildenstein put 329 works of art in the Banque de France in Paris, and had eighty-two taken in by the Louvre, but many were left in the gallery showrooms and in his house outside Paris. Some of these were ultimately plundered by Goering. Georges Wildenstein withdrew to Aix, leaving the running of the business to Roger Dequoy, the manager who had been put in place in London some years earlier, and with admirable foresight, because in Georges Wildenstein's words he was 'the type of Frenchman who appeals to Anglo-Saxons'. Also he was an exceptional salesman. He was brought back to Paris in time to see if his appeal extended to the Teutonic variety of the Anglo-Saxon. It seemed that it did. A highly significant meeting took place in November 1940, arranged by Dequoy between Haberstock and Georges Wildenstein at Aix. Exactly what passed between them can never be definitively established. Daniel Wildenstein, who was present for at least part of the meeting, says that Haberstock offered George Wildenstein 'honorary Aryanisation' if he would return to Paris and continue to deal. Haberstock, of course, had his own agenda. Working with Wildenstein would make his own job of sourcing great art for the Nazis a lot easier. Georges rejected the proposal; but he too had an agenda. Various proposals were discussed involving swapping Wildenstein stock in Paris for degenerate art that Haberstock would ship to Wildenstein in New York for sale on the American market. Also playing on Wildenstein's mind was the anxiety that the Wildenstein archive in Paris might fall into Nazi hands. This included not just details of all the great pictures in private

collections in France, but also the names and addresses of their owners. As it turned out the archive was spirited away into a safe place by a Wildenstein employee called Madame Griveau. And Wildenstein took passage for America, having separately given instructions to Dequoy to continue to buy in France and ship to the US for sale.

Business continued under Dequoy's stewardship: in September 1941, for instance, the Swiss collector Emil Bührle visited Paris to buy two Renoirs, a Greuze and a David from Dequoy. In 1942, Dequoy sold two major Rembrandts via Haberstock to the embryonic Führermuseum in Linz from the wine broker Étienne Nicolas, an old Wildenstein client, for 60 million francs. In early 1943 Wildenstein officially became the business of Dequoy, but not before he had to perjure himself to the German authorities by denying he had had any contact with Wildenstein since 1939. Meanwhile Georges Wildenstein fumed away in New York, managing to get letters through to Dequoy that show he had no grasp of wartime conditions in France. Why is the shipment of his stock held up in Bordeaux? Why is Dequoy not buying more and shipping it to him in New York?

There was plenty of business being done in New York in the war, and plenty of opportunities to make sales. The arrival of so many Europeans who were either art dealers or collectors invigorated the market. In 1941 Parke-Bernet announced its best season for twelve years, with turnover up 54 per cent over the previous year. Amongst the new arrivals were major dealers like Wildenstein and Rosenberg, able to continue to conduct business, whilst of course doing their bit for the war effort. These were two stalwarts of what has been rather unkindly described as the Fifth Avenue Resistance. The young Daniel Wildenstein saw service in Navy Supplies, where he distinguished himself by creating a pipeline of very attractive female secretaries to the upper echelons of Naval Command.

After the war Georges Wildenstein still saw Dequoy, but did no business with him. When the dust settled, the Wildensteins may at least have reflected that they owed Dequoy a debt in that without him their business would not have been in such good shape for the post-war years. And remarkably little of the Wildenstein stock ended up in German hands by comparison with, say, that of Rosenberg. Yet a cloud of suspicion still hung over the Wildenstein business. In 1949 charges against them were rejected by the French courts on the grounds that, while sales had taken place from the gallery to the enemy, there was no proof that they had been voluntary.

In the years since the war, Wildenstein have taken an interest in restituting great pictures lost in the conflict to their original owners. They joined forces, for instance, with a Polish family, the Czartoryskis, to try to find their magnificent missing Raphael. And they entered into an agreement with a German family, the Scharfs, to help them lay claim to their Impressionist collection expropriated by Red Army soldiers in 1945, and held in the Hermitage Museum, St Petersburg. Neither venture has yet borne fruit, but they are testament to the Wildenstein desire to right the wrongs of history. They have even done business, Daniel Wildenstein recounts, with the daughter of Joachim von Ribbentrop. There was a struggle with his conscience, but at least he made a profit on the deal.

The Wildenstein archive is a huge and admirable repository of knowledge. It was begun by Nathan in the nineteenth century; according to Daniel, whenever he went to a collector he took notes on the works he saw there. It was an enterprise meticulously continued by Georges, a natural scholar. Wherever possible photographs were included. A huge library was also assembled, at a rate of ten thousand books a year. Georges began compiling *catalogues raisonnés*. They were good ones, and they met with critical acceptance. In Daniel's opinion, dealers anyway make the best experts, because they have to put their money where their mouth is. They can't afford to get it wrong. In its purest form, the scholar-dealer is an ideal of excellence.

In time the Wildenstein archive – or the Wildenstein Institute, as it latterly became known – acquired the archives of other distinguished dealers and experts, notably that of Durand-Ruel, and of the great authority on Renoir and Sisley, François Daulte. Today the Institute, which operates as a separate entity from the art-dealing enterprise of Wildenstein but under the same umbrella, is the accepted authority on a number of major artists, including Gauguin, Monet, Renoir and Manet. It does a pretty good job. Lateral seepage between the two entities has to be guarded against. Daniel Wildenstein, besides running the art-dealing business, also operated as the accepted ultimate authority on, for instance, Monet. It seemed there was a door in the Chinese wall that separated dealership and institute through which he and he alone might pass. 'I am the expert on Monet. And Gauguin, and Manet,' he explained. Was there ever any doubt in his mind about the authenticity of pictures that he passed? 'Most of the time, I'm 100 per cent sure. If I am 95 per cent sure, I say yes, but there is a possibility of error. At 90 per cent, I say no.' This calibration of doubt and

Michelangelo's Pietà: *even Daniel Wildenstein stepped back from trading it.*

certainty makes interesting reading, particularly to owners of pictures that have fallen either just inside the line of demarcation or just outside it. But art expertise, in the end, is itself an art, not a science.

Without a strong moral compass the power of Wildenstein as dealers and the power of Wildenstein as the ultimate arbiters of authenticity in the artists in whose works they were dealing might represent a conflict of interest. But Daniel explains the checks and balances he employed to mitigate this conflict: 'One thing I never do,' he says, 'is to tell an owner I'm interested in his painting without telling him I'm going to include it in my *catalogue raisonné*. Even then I don't make an offer. I tell him I'm interested, but he should get prices elsewhere and then come back to me. If I want it, I offer him a bit more than the price he's been offered.' A cynic might riposte, but what about cases where you say no to works submitted by other dealers who believe them to be genuine? These are

difficult questions; but my own experience suggests that the Wildenstein Institute gets it right most of the time, probably more often than most other authorities. Nonetheless the robustness of the Chinese wall between institute and dealership needs constant checking.

Over more than a century the Wildensteins have become used to dining at the topmost tables. They deal in the best, be it works of art or racehorses. An almost incredible, but just plausible story is told by Daniel Wildenstein about business negotiations that he entered into with Pope Paul VI. His Holiness was exercised about the rising art market, and the enormous financial value that this gave the Vatican art collection. How could such wealth be reconciled with the Church's mission to alleviate the suffering of the poor? Daniel Wildenstein was called in, apparently, to offer advice on the saleability of Michelangelo's *Pietà*. Showing admirable restraint, Wildenstein argued the Pope out of such a step. It must have hurt. But perhaps it was because, carried away by the momentousness of the situation, he had rashly already offered his services without commission. 'A Jew selling the Pietà of Michelangelo?' Daniel exclaimed. 'I'd be crucified.' The Pope smiled benignly. 'You wouldn't be the first.'

7

SELLING THE NEW: PAUL DURAND-RUEL

There are a number of paradoxes in the life and career of Paul Durand-Ruel. He was the champion of a highly avant-garde artistic movement, and yet he was a profound political reactionary. Although deeply religious, he was prepared to do almost anything for a profit. He was a high-minded purveyor of intelligent art criticism, but a shameless manipulator of the auction market. While he was undoubtedly the saviour of the starving Impressionists, he was at the same time manoeuvring to tie them in to exclusivity contracts that wouldn't necessarily play to their financial advantage. An unashamed elitist and dismissive of popular taste, he was nonetheless prepared to handle works that pandered to that popular taste in order to make a bit of cash. And, if one believes Arnold Bennett, who visited the apartment of the now-famous art dealer in 1911, he was a man with great discrimination in the fine arts but none whatsoever in the applied arts. His pictures were wonderful, but his furniture was a disaster.

No dealer was closer to an artistic movement than Durand-Ruel was to Impressionism. He was its promoter and its champion, its defender and its bankroller. He was the first dealer of whom it is possible to say that without him art history might have looked different, not so much in its ultimate progression, but in the speed of that progression. His portraits show an oddly military-looking figure, with none of the flamboyance sometimes associated with princes of the art market. Arsène Alexandre, while he

eulogised his achievements, described him as 'of average height with a round, clean-shaven face crowned by short grey hair and punctuated by a bottlebrush moustache and bushy eyebrows that are serious and questioning'. Durand-Ruel is the perfect refutation of the theory that those who promote new art must be rebels politically as well as artistically. This spearhead of innovation and change in painting was himself an ardent Catholic and die-hard conservative, whose dearest wish was the restoration of the monarchy in France. That is why Émile Zola dismissed him in 1886 as 'a small beardless man, cold in temperament and sustained by clerics'.

A study of the politics of those who deal in art today suggests that most are to the right of centre, because dealing is a commercial activity and profits tend to be better protected by right-of-centre governments. Even those who are at the cutting edge of contemporary art in the twenty-first century do not tend to be rabidly left-wing. But that is partly a reflection of the way the avant-garde has become the new orthodoxy. Art is now expected to be new and daring; in this respect there is no longer anything revolutionary about it. For Durand-Ruel, however, the climate was different. He was the first contemporary art dealer in the modern sense, and he was fighting a seemingly unwinnable battle against entrenched attitudes about what a painting should look like. He was the purveyor of something shocking. Renoir was probably right when he said: 'We needed a dyed-in-the-wool reactionary to defend our work, which the *Salonards* were calling revolutionary. At least Durand-Ruel wasn't someone they would shoot as a Communard.' Renoir pinpointed a further surprising element, his audacity: 'This neat bourgeois, good husband and father, loyal monarchist and practising Christian was also an out and out gambler.'

Durand-Ruel was an unashamed elitist. In his view it was the politics of equality that was actively holding back understanding of what was good in the new art. 'In these days of democracy it is the public who judges, who determines fashion; and since the public is ignorant of everything, especially art, it likes only what is second rate because that is all it can grasp. That is the fatal flaw of our system of parliamentary government and universal suffrage.' His political views and his commercial practice were built on the bedrock of his religious faith. 'Often, the night before I had to conduct an uncertain piece of business I would go into some church along the way to ask God for His help, and help He always did,' he recounted. It is a moot theological point what priority the Deity gives to the prayers of art dealers. Lower than those of footballers, perhaps, but higher than those

Paul Durand-Ruel: man of paradox.

of estate agents or bankers? There were plenty of dark days in the 1870s and 1880s, when Durand-Ruel must have tested his special relationship with God. Perhaps in the end God doesn't know much about art, but He knows what He likes, and He likes the Impressionists.

The phenomenon of Durand-Ruel was a product of the collision of art and commerce in an increasingly entrepreneurial age. Gambart was already showing how successful an art dealer could be in selling to the new rich. By the second half of the nineteenth century the idea of art as investment was well entrenched, and it was understood that the investments that produced the best returns were made in the works of contemporary artists. Moguls such as Monsieur Walter in Maupassant's *Bel-Ami* (1881) are buying pictures. He explains to the hero the secrets of his art-investment strategy:

> 'I have other pictures in the adjoining rooms, but they are by less known and less distinguished artists... At present I am buying the works of young men, quite young men, and I shall hold them up in the private rooms until the artists have become famous.' Then he said in a low voice: 'Now's the time to buy pictures. The artists are starving, they haven't a sou, not a sou.'

In the middle of the nineteenth century the role of the art dealer increased in importance, as the middleman between the artist and this newly expanded bourgeois clientele on the lookout for cultural and financial profit. In some ways Durand-Ruel was a Parisian Gambart, but with one big difference: he was prepared to nail his colours to the mast of the avant-garde. His achievement was to see the potential of Impressionism and, dynamic and innovative salesman that he was, to stick diligently to the challenge of promoting it.

Paul Durand-Ruel was born in 1831, which made him a little older than the Impressionists. His father had been in the art trade before him, as a dealer in paintings and a supplier of artists' materials. This was important because it meant that the young Durand-Ruel's early experience of the business brought him into direct contact with working artists. He was drawn to contemporary art, to the process of painters painting pictures. He dealt in the increasingly popular Barbizon School, and continued to do so throughout his career, those sales often subsidising his interest in and support for the Impressionists. He also even dealt in works by academic artists, 'which we found easier to sell than the works we favoured. It was beneficial to the firm because we could increase our business by satisfying different kinds of art lovers and the profits we made allowed us to broadly support our friends... [whose] works were still difficult to sell.' These 'different kinds of art lovers' were presumably those whom he disparaged elsewhere as 'liking only what is second-rate because that is all [they] can grasp'.

But academic painters and their admirers fulfilled a purpose in his business model, and he even developed a strategy of outflanking the Salon system by visiting the studios of its favourite artists in advance of the annual exhibitions, and reserving 'whatever I thought would be popular'. 'That was why, from 1860 up to 1874, a fairly large number of the paintings that created a stir in the Salons – including a few that won medals – had been purchased by me from the artists in advance.' In the same way that Gambart was undermining the selling power of the Royal Academy in London, here is another illustration of dealers supplanting the big annual exhibitions of official art as the most agile and productive agents of sale for artists.

In 1870 Durand-Ruel took refuge from the Franco-Prussian War in London, where he set up a gallery at 168 New Bond Street. Ironically, it was in London that he met Monet and Pissarro, who were fellow refugees,

and for the first time bought work directly from them. Back in Paris after the war Durand-Ruel was introduced by Monet and Pissarro to Renoir, Sisley and Degas, from whom he also bought. And in January 1872 he experienced an epiphany to underline the fact that, besides being a man of commercial acumen, he responded passionately to art and was capable of being strongly moved by it. He saw two works by Manet in the studio of another artist, Alfred Stevens. He bought them immediately, and the next day went to Manet's studio, where he bought everything he found: twenty-three canvases for 35,000 francs.

What drew Durand-Ruel to the new art, to this conviction that it was worth supporting? He himself remembers that it was the experience of seeing works by Delacroix for the first time at the Exposition Universelle of 1855. Their 'splendid colour, finesse and harmony' represented in his view 'the triumph of modern art over academic art... they permanently opened my eyes and reinforced the idea that I might, perhaps, in my own humble way, be of some service to true artists by helping to make them better understood and appreciated'. Initially his enthusiasm was for the artists of the School of 1830. But then came Impressionism.

From then on, Durand-Ruel's career was linked closely to the progress of the Impressionists. He made mass acquisitions of their work, and when times were particularly difficult helped them out with monthly stipends. Like Maupassant's Monsieur Walter, he bought the pictures of the younger men and held them in anticipation of the artists becoming famous. But unlike Monsieur Walter, he himself was the agency for their acquisition of fame and wealth. Building up their reputations (and their prices) was a slow and sometimes disheartening process, one that didn't start paying dividends till the later 1880s.

It is a mistake, however, to see Durand-Ruel as labouring exclusively in the cause of the Impressionists from the early 1870s onwards. He was already a successful art dealer in Paris and London and his day-to-day efforts continued to be centred on more conventional artists. This was where most of his income was generated. In March 1873 he paid 96,000 francs for Delacroix's *Death of Sardanapalus*. In 1872 he spent a total of 390,000 francs on works by Jean-François Millet alone. The few hundred francs he spent on individual works by the Impressionists were speculations for the future. On 11 July 1872 he even bought Courbet's *Returning from the Fair*. This was one of the most anticlerical paintings of the nineteenth century, showing drunken priests rolling along a country lane, but

in this case Durand-Ruel suppressed his Catholic scruples and sold it on for a quick 50 per cent profit.

Still, there is no arguing with the fact that in the decades of the 1870s and 1880s Durand-Ruel spent increasing amounts of money (sometimes money he didn't have) in subsidising the Impressionists. He worked hard to keep up his artists' morale: 'I am sending you the 1,500 francs you requested,' he writes to Monet in September 1882, continuing:

> I would also like to send you the strength to overcome the countless difficulties you encounter at every step... I would understand your discouragement if you still painted poor pictures when everything was going your way... On the contrary, never have you been on a surer path or of better inspiration... Return as soon as you want, and then you can mull over – we can mull over together, if you wish – what you might like to do. There are countries where the skies are balmier. I have often mentioned Venice to you... Remain confident. You are closer to success than you think. This is no time to become discouraged.

In October 1884 he tells Pissarro: 'do me handsome landscapes like the one you sold to Heymann so cheaply. It is very fine and I wish I had it. Seek out pretty subjects, which are a key element of success. Leave figures aside for the moment, or add them merely as props – I feel that landscapes are much more likely to sell.' He also makes recommendations to Monet as to what will make his landscapes more saleable, advice which disconcerts Monet. In a letter of November 1884 he says:

> you yourself advised me to finish them as completely as possible, saying that the main cause of failure lay right there. Thus I become very tormented when faced with what I've done, with choices to make... But as to polish – or rather slickness, because that's what the public wants – I'll never agree to it. I'll clean up a few canvases and bring them along to you myself...

Thus the back and forth continued between the painter, intent on his own vision, and the dealer, keen to encourage his artist but also to make sales.

As his artists became more successful in the 1880s and 1890s, the question of exclusivity was one that increasingly occupied Durand-Ruel. Periodically Monet and the others would challenge it, even start doing

business with other dealers such as Georges Petit or Theo van Gogh at Boussod-Valadon. Durand-Ruel didn't like this at all. In an exchange of letters with a clearly suspicious Pissarro in 1892, he guided the artist through the financial intricacies of art dealing. There are two things that art dealers have to protect their clients from. If the client is a buyer, he must at all costs be shielded from the knowledge of the dealer's cost price. There is no point in upsetting him unnecessarily. And if the client is a seller – indeed if, as in Pissarro's case, he is the creator of the work being sold – he must as far as possible be protected from the potentially painful discovery of the dealer's selling price. Just occasionally, of course, the system breaks down, information about prices reaches the wrong quarters, and then tremendous agility is called for from the dealer in order to save the situation. Arguments have to be deployed as to why the artist-seller should under no circumstances accept higher prices from rival dealers. This is a difficult case to make convincingly, but Durand-Ruel sets about it valiantly, with the same gusto as Gambart reproving Rossetti.

On 23 November 1892 Durand-Ruel writes to Pissarro:

> If by chance you sell directly to someone who does not want to go through a dreadful art dealer like myself, the price should be three times what you ask from me. That is the only way I can manage to sell your paintings decently, and it can make both of us rich by enabling me to pay you more and more – assuming I succeed as I hope.

Four days later, Pissarro replies: 'I have decided to set my prices as you advise and to ask a collector three times what I ask you. However, I can't promise only to sell to you: that would be awkward for both of us.'

Artists! Patiently Durand-Ruel writes back the next day:

> What I am asking is very straightforward and fair. I am entirely disposed to take all your paintings, which will not be awkward for either me or yourself, as you fear. It is the only way to avoid competition, the competition that has prevented me from boosting your prices for so long. Only with the monopoly that I am requesting from you can I successfully campaign... This was the system that five or six years ago enabled me to sell Monets in America at the prices they still fetch today. And if prices haven't increased in the past five years that's because other dealers have obtained some of them, and naturally cut each other's

throats, often settling for just 5 per cent profit. It's only because I hold all Renoir's pictures that I've finally managed to get him to the rank he deserves... I'll take responsibility for everything – but I need your promise not to sell to other dealers, even at higher prices.

Pissarro wavers under the assault, and on 19 December confides to his son Lucien, 'I believe it is best to sell to Durand for a while.'

Durand-Ruel found new ways to grapple with the challenge of marketing 'difficult' contemporary art. He realised that such paintings needed their expert interpreters in order to be understood and bought. He changed the conventional approach by shifting the attention of the public away from specific canvases and on to artists and the span of their work. Hence the one-man shows he pioneered – for Monet, Renoir, Pissarro and Sisley – in a strategy that has been described as 'the promotion of temperaments'. At the same time he published magazines and catalogues to extol and explain what he was selling. In this process the critic grew in importance. What people read about modern art in their journals and newspapers helped them to accept it. 'We can do nothing without the press,' acknowledged Monet in a letter to Durand-Ruel in 1881.

In art dealing, Durand-Ruel claimed, it was the art and not the dealing that mattered. Many times in his memoirs he berates himself for 'behaving too much like an art-loving artist' and not enough like a 'businessman'. He invented the self-serving image of the dealer as idealistic pioneer, altruistic hero, almost as artist himself in the discovery, appreciation and promotion of new talent. He wrote in 1869: 'A genuine dealer must be at once an enlightened amateur, ready to sacrifice if necessary his apparent immediate interests to his artistic conviction, as well as capable of fighting against speculators rather than involving himself in their schemes.' Even in 1896, when Impressionism was selling well, he was still maintaining, 'I am rather particular as to what I buy, and if I were less rigorous in my choice, I would certainly have a much larger clientele than is the case at present.' The truth about his priorities is more nuanced. Throughout his life Durand-Ruel remained a canny operator with an acute eye for a financial opportunity. He had seen the value of the Barbizon School escalate, and there is no doubt that one of the attractions of the Impressionists was their potential as a speculation. Because he believed they were good, he also believed they would go up in value. And the way to benefit most from them was to retain as far as possible the monopoly over their sales. There are many

examples of Durand-Ruel manipulating the market at auction. In 1872, the year he spent nearly 400,000 francs on works by Millet, he created a fever for the painter by artificially inflating prices through his secret representative bidding them up. As part of his strategy to boost the Impressionists he would now and then buy a Monet in the saleroom 'not in my name so that the public thinks it has been sold to a collector'. And in 1901 he confides to Renoir: 'It is essential that public sales reach big figures, whether or not the prices are fabricated. This is the only way we will achieve great success.' It's a bore, Durand-Ruel seems to be saying, that prices have to be manipulated upwards, but that is the only way that your work will get the appreciation it deserves. Oh, does it make me richer as well? I barely noticed.

The active branding of artists as commodities, paying stipends to them, nursing them through various price levels by a carefully judged series of commercial gallery exhibitions, maintaining their price levels by monitoring and if necessary manipulating the performance of their works at auction, all are features of the sophisticated contemporary art market of the twenty-first century. But all have their origins in the way Impressionism was marketed by Paul Durand-Ruel in the last quarter of the nineteenth century. It wasn't easy. The initial hostile response to Impressionism has been well documented. It was simply too shocking for the average Salon visitor, with its spontaneity, its lack of finish and its high colour key. The range of people prepared to buy the Impressionists was limited to a small number of eccentric enthusiasts, none of them with very deep pockets. The Impressionist exhibitions that took place in the 1870s and 1880s resulted in few sales, and those at very slim prices. The standard price paid by Durand-Ruel to the artist, even for a Monet, was 300 francs. Sometimes at auctions works changed hands for appreciably less.

On top of that, in the period 1871–85 French commerce was distorted by a series of boom and bust cycles that would bring tears to the eyes of a modern economist. First there was the desolation of the Franco-Prussian War, then for two or three years after hostilities there was a recovery, and people made money. A slump followed in 1874, the year of the first Impressionist Exhibition. By 1880 things looked better again: there was an economic upturn led by a boom in railway building. Durand-Ruel began to buy Impressionist paintings in significant numbers once more. 'He'll soon have four hundred pictures he won't be able to get rid of,' warned Gauguin. And sure enough in 1882 there was another crash, the dire after-effects

of which pushed Durand-Ruel into debt for more than a million francs, and meant he had to sell several great works too soon. It's worth comparing the fortunes of Durand-Ruel in this respect with those of Ambroise Vollard. Vollard also managed to buy large numbers of works cheaply early on (1895–1905), mostly by the Post-Impressionists. But because, firstly, there was less financial volatility and, secondly, his costs were lower (small premises, no wife and family to support), he kept hold of his stockpile, and didn't have to sell them early on before their value started climbing. That was why Vollard died an even richer man than Durand-Ruel.

The early 1880s were a low point for Durand-Ruel. Looking back on that period, he even propounded the view in his memoirs that the exhibitions he mounted put him at a disadvantage as a salesman. 'Exhibitions are good for artists, whose reputations they establish, but not good for sales,' he writes. 'Too many things are viewed at once – people hesitate, consult, listen to the advice of exhibition-goers, then postpone a purchase till later. Furthermore, in the large rooms everything appeared small, hence the prices set on the paintings seemed higher than they would have if the pictures had been exhibited in smaller premises.' This is Durand-Ruel feeling sorry for himself, envying those dealers who sold one picture at a time and didn't bother with shows. But the solo exhibitions he mounted from the 1890s onwards were more successful. Monet's series paintings lent themselves to such treatment: haystacks, poplars, cathedrals, views of London, views of Venice (see plate 9). Durand-Ruel could hardly complain at the sales now. 'Monet opened his exhibition,' wrote Pissarro enviously of the *Poplars* series. 'Well, barely open my dear man, all was sold, at 3,000 to 4,000 each!'

You look in vain in Durand-Ruel's memoirs for some sort of insight into what it was about the Impressionists that captured his imagination and convinced him that their new art would be the art that endures. Most of the time all you get is a recitation of prices: how low they were in the difficult early times, how high they had become a generation later; how gratifying this was to the writer and, on occasion, how frustrating that he hadn't held on longer before selling in order to get full value from the increase. Still, reading the correspondence he conducts with his artists, there is no doubt he was genuinely concerned for them, that he was prepared to make financial sacrifices for them in the short term because he believed in them in the long term.

In the mid-1880s it was clear that Durand-Ruel must seek new markets

for the Impressionists. He took the inspired step of looking west, across the Atlantic. This was the turning point, although it didn't lead to immediate success and riches. History favoured him: he was the right man in the right place to take advantage of the aftermath of two major wars. The first was the Franco-Prussian in 1870, which destabilised French society sufficiently to allow a new and revolutionary art to gain a precarious foothold. The other was the American Civil War, the conclusion of which generated an extraordinary release of entrepreneurial energy, which in turn created a degree of wealth unequalled anywhere else in the world. The last part of the nineteenth century was a time of momentous commercial expansion in the United States. Huge fortunes were made, in coal, in steel, in railroads, in construction. Durand-Ruel had the courage to look west; fortunately, rich Americans were simultaneously discovering the confidence to look east, to renew themselves culturally in Europe, and in Paris in particular.

Americans were enchanted by France, and their admiration extended to its art. Thus something new and shocking like Impressionism was received more open-mindedly than by Europeans. It didn't mean, of course, that no sooner had Impressionism appeared on the scene than every Francophile American was queuing up to buy it. But a few appreciated it; enough to give Durand-Ruel the idea of taking an exhibition to New York in 1886. As the French art critic Théodore Duret noted, 'America is free from the prejudices of the old world; the atmosphere is favourable to novelties... in taking root there, the new art has only to overcome an opposition due to the astonishment which is at first naturally evoked by the appearance of original forms and modes of art.' He was right: America was a new young country susceptible to a new young art.

The exhibition that Durand-Ruel took to New York in 1886 is one of the landmarks not just in the history of Impressionism but also in the history of art dealing. He transported about 300 works, including twenty-three by Degas, forty-eight Monets, forty-two by Pissarro, thirty-eight Renoirs, fifteen Sisleys, three by Seurat and – a clever touch – fifty works by respectable mainstream artists as a reassurance to the public. 'Do not think that the Americans are savages,' Durand-Ruel wrote to the artist Fantin-Latour. 'On the contrary they are less ignorant, less closed-minded than our French collectors.'

How successful was this first exhibition? About 20 per cent of it (by value) sold, for a total of $17,100. Durand-Ruel summed it up: 'I didn't make a fortune, but it was a significant success which was encouraging for

the future.' In the following two years he made six further trips across the Atlantic and in 1889 felt confident enough about the American market to open his own gallery in New York. Renoir remembered that one of the early shows was held in the old Madison Square Garden. 'People would go and look at my pictures between boxing matches,' he maintained later in life. True or not, it speaks of the willingness of Durand-Ruel to improvise to get into new markets – even, it is said, to use his Catholicism to get his way. Worried that certain Renoir nudes in his consignment might upset American puritan instincts and be stopped at customs, he did some research into the chief inspector. He discovered he was a Roman Catholic, and called on him on a Sunday morning, attended mass with him, and 'ostentatiously put a large sum of money in the collection plate'. As a result the pictures were allowed in 'without a hitch'. Durand-Ruel's inventiveness and cunning were constantly in evidence in America. Renoir's *Madame Clapisson* is a case in point. It was commissioned in France in 1882 by her admiring husband, but Monsieur Clapisson was disappointed by what Renoir produced, and refused to accept it. Durand-Ruel bought the painting himself and recycled it for the American market by retitling it *Dans les Roses*. As a sentimentalised scene of generic female beauty it had appreciably more appeal than as a specific portrait of someone else's wife, and it found an American buyer in 1886. (It sold again, at Sotheby's in 2003, for $23.5m.)

'My success on the other side of the Atlantic had a significant repercussion in France,' records Durand-Ruel in his memoirs. 'The same people who either had not dared to buy a Manet, Renoir or Monet, or would only pay a few hundred francs for them, now resolved to pay as much as the Americans. So little by little the prices increased, as did the number of collectors.' By the 1890s Durand-Ruel had become such an institution that his gallery was included in the Baedeker guidebook to Paris. It was the first stop for culturally minded visitors, particularly Americans, eager to sample modern French art. Mary Cassatt, the American artist who lived in Paris and acted as adviser to a number of nervous American first-time buyers, had a frustrating but illuminating experience with one of her clients, a steel magnate called Frank Thompson. She introduced him to a small Parisian dealer called Portier, less well known than Durand-Ruel. Cassatt takes up the story: 'Portier brought him two Monets or three, cheap, but he preferred buying one from Durand-Ruel at 3,000 francs... I suppose he is the kind to prefer buying dear. I have little doubt Portier's

were the best pictures.' This is an early instance of a dealer adding the allure of his own brand name to that of his artist. A Durand-Ruel Monet became more desirable and expensive than the same painting bought from a less well-known dealer.

At the same time, however, other rivals now sprang up to deal in the works of the new school and challenge Durand-Ruel's supremacy. A significant moment came in 1887 when the Boussod-Valadon gallery gave up their contract with the arch academician William-Adolphe Bouguereau, whose work they had handled since 1866, and, under the direction of Theo van Gogh, Vincent's brother, started trading in Monet and the other Impressionists. But Durand-Ruel's biggest rival was Georges Petit. Petit's premises were extremely grand, and he presented his pictures in highly elegant surroundings, which appealed to a certain sort of American. Monet appreciated the glamorous element in the salesmanship of Petit, and wrote to Durand-Ruel to suggest an alliance with him. 'One can't deny that the public is captivated and that they dare not make the smallest criticism because these paintings are mounted advantageously, because of the luxury of the room, which together is very beautiful and imposing on the crowd.' This is the first stage in the reinvention of the Impressionist painting as luxury object.

Not that Durand-Ruel did not live well himself on the proceeds of his growing success. The diarist Jules de Goncourt reported on the dealer's home life in June 1892 as follows: 'A huge flat in the Rue de Rome, full of pictures by Renoir, Manet, Degas, etc., with a bedroom with a crucifix at the head of the bed, and a dining room where a table is laid for eighteen people and where each guest has before him a Pandean pipe of six glasses. Geffroy tells me that the table of Impressionist art is laid like that every day.' Success likes treating with success, and, as discussed earlier, rich clients tend to be reassured by signs of wealth and high living in their art dealers. But there is another group less pleased by such ostentatious display: the artists the dealer represents, especially if they don't think their own sales are going very well. In November 1894, Pissarro – who never sold as successfully as Monet – met the American collector Quincy Adams Shaw, and they worked each other up into a state of high moral indignation. Pissarro reported approvingly of Shaw: 'He hates all dealers, especially Durand, and complains, not without reason, that the dealers have assumed the task of governing tastes and of showing only those paintings they think are saleable.'

Mention of Georges Petit raises a further interesting question. He is described by René Gimpel as having the face of 'a rutting, obese, hydro-cephalic tom'. Does physical ugliness preclude you from success as a salesman of art? Not, apparently, in the case of Petit. I once knew an Italian collector who would not commit to buying a picture from a dealer until he had met and assessed the dealer's wife. I suppose there was a certain logic in his position: an art dealer may have no control over his own looks, but those of his wife are a sound indication of his feeling for beauty. Although she died young, portraits of Madame Durand-Ruel show her to have been pleasing to the eye. No doubt Madame Georges Petit was loveliness per-sonified. Or, if not, contemporary accounts attest that Georges Petit's mistress certainly was. She was the beautiful Adele Caussin, later Mar-chioness Landolfo-Carcano.

Zola took notes on various Parisian art dealers in preparation for his art-world novel *L'Œuvre* (published in 1886). What he wrote about Hector Brame gives an interesting insight into how dealers catered to the specu-lative instincts of new buyers such as Maupassant's character M. Walter. According to Zola, these were 'stupid collectors who knew nothing about art and who bought a painting as [they would] buy securities on the stock market'. Regarding the work of an artist Brame wanted to make rise in value, he would say to the buyer,

> I will sell it to you for 5,000 [francs], and if you want to return it to me next year I will buy it back for 6,000. I am going to sign a paper confirming this for you... he placed a few works in this way during the year; he made prices rise the same way prices for securities go up on the stock market, with such success that, after a year, the collector would no longer want to resell the painting to him for 6,000 francs. If the collector should return it to him, since prices had gone up, he would be sure to sell it to another collector for 7,000 francs.

It prefigures the market manipulation of dealers in contemporary art in the twenty-first century. For its success it also presupposes an effective monopoly on the production of an artist. And it is not a commercial con-juring trick that you can sustain forever, unless the artist concerned turns out indeed to have lasting quality.

Having been instrumental in introducing Impressionism to America, Durand-Ruel now spread word of it to Germany. Three of the major

influences on German acceptance of French Impressionism, Max Lieber-
mann, Harry Kessler and the museum director Hugo von Tschudi, all had
their first experience of the movement at Durand-Ruel's Paris gallery, in the
1890s. Durand-Ruel's cooperation with Paul Cassirer in Berlin meant that
plenty of Impressionist pictures found their way into Germany, and even
into German museums. 'Museums are our best publicity,' wrote Durand-
Ruel to Cassirer. He was right: Germany was one of the few places where
appreciation of the Impressionists quickly fed through via dealers and
collectors to museums. From 1899 onwards the Cassirer Gallery, supplied
by Durand-Ruel, mounted a series of high-quality exhibitions of French
modern art. Art criticism in Cassirer's magazines boosted its appreciation.
In the eulogistic article on Durand-Ruel already quoted, Arsène Alexan-
dre concluded that 'a dealer is a crucial element in the vast system of the
production of beauty that simultaneously characterises and encompasses
modern societies'. It is a good illustration of the new perception of art
dealing that Modernism created.

By the early twentieth century Durand-Ruel's position as the ultimate
impresario of the Impressionists was cemented. It became clear that he had
little feeling for the artists of the avant-garde who superseded the Impres-
sionists, but it is a gift given to almost no dealers in contemporary art to
be able to market with enthusiasm the production of the next generation
after their own. Durand-Ruel had little time for Cézanne, Gauguin or van
Gogh, and none for Fauvism and Cubism. In later life he called Cézanne's
works 'overrated' and 'dull next to works by Monet and other Impres-
sionists'. He mocked the 'fools who pretend only Cézanne, van Gogh and
Gauguin are great masters'. But that did not stop him dealing profitably
in the works of Cézanne. Mary Cassatt advised the American collector
Louisine Havemeyer to sell two Cézannes she had acquired because prices
(just after Cézanne's death) were in her judgement at 'scandalous' levels.
Durand-Ruel was a beadier reader of the market than Cassatt: he snapped
up the two Cézannes for 7,500 francs each and sold them two months
later to the great Russian collector Ivan Morozov for 30,000 francs each.
And his efforts to circulate the works of the Impressionists abroad had
unforeseen but significant consequences for the development of Modern-
ism: if Durand-Ruel had not sent Impressionist paintings to be exhibited
in Moscow in 1896, the young Wassily Kandinsky would not have seen the
Monet *Haystacks* that persuaded him to pursue abstract art.

Eventually Durand-Ruel even managed to turn the tide even in

London, where the local inhabitants had been notoriously slow to get the point of Impressionism. Twelve thousand people attended the show of modern French art that he put on at the Grafton Galleries in 1905. Three hundred works by Degas, Manet, Monet, Renoir, Pissarro and Sisley were on view. It may not have led to an immediate surge in sales to British collectors, but Impressionism had finally arrived, and was there to stay. As an international promoter of the movement, Durand-Ruel was supreme. He is another example of the importance to truly successful art dealing of the willingness to put your stock on stage coaches, boats, trains and latterly planes in order to reach markets beyond your own country.

His biggest seller continued to be Monet. The series paintings were a dealer's dream, visually stupendous treatments of the same subjects under the varying light conditions of different times of day. Ten or twenty at a time, they flowed into his gallery for exhibition and sale with the paint barely dry on them: *Haystacks* (shown in 1891), *Poplars* (1892), *Rouen Cathedral* (1895), *Views of the Thames* (1904) and of course *Water Lilies*, which occupied Monet's late years almost too bountifully. In 1908 Durand-Ruel came up with an ingenious way of countering the growing notion that Monet's production was excessively prolific, that his latest works lacked rarity value. He announced a major exhibition of new paintings by Monet in his New York galleries; then, a week before it was due to open, he cancelled it. The real reason for its cancellation may have been simply dilatoriness on Monet's part to meet a deadline. But the explanation that Durand-Ruel conjured up for the press had a touch of genius about it:

> Pictures with a market value of $100,000 and representing three years of constant labor were destroyed yesterday by Claude Monet because he had come to the conviction that they were unsatisfactory... M. Durand-Ruel told the correspondent of the *New York Times* that while he was disappointed to be unable to hold the exhibition as advertised, M. Monet's actions showed him to be an artist, not a mere manufacturer.

It was an inspired move on Durand-Ruel's part. It simultaneously reassured Americans that Monet was emphatically not a painting factory, and meant that the next batch of Monets that Durand-Ruel offered to the

New York market would come with the added cachet of having passed the master's stringent quality control.

One final vignette of the Durand-Ruel genius for selling Impressionist paintings features the next generation. How Joseph Durand-Ruel, Paul's son, inveigled the Duncan Phillipses into buying Renoir's *Déjeuner des Canotiers* in 1921 is textbook stuff. Mrs Duncan Phillips takes up the story: 'We were invited to lunch at the home of the Joseph Durand-Ruels. Much to our delight we were seated opposite that fabulous, incredibly entrancing, utterly alive and beguiling Renoir masterpiece.' What she is unwittingly revealing is a sublime piece of salesmanship on Joseph Durand-Ruel's part. Entertaining your best clients to lunch and sitting them – as if by chance – in front of the most expensive painting in your stock is a strategy much deployed by art dealers. In this case it reaped glorious dividends. Phillips was persuaded to part with the staggering sum of $125,000 for the picture.

Ironically, when at the very end of his life in 1920, Paul Durand-Ruel was inducted into France's Légion d'honneur, it was for services not to art but to foreign trade. The sheer volume of his purchases in the thirty years from 1891 to his death are extraordinary: the firm's stock books show that they comprise nearly 12,000 paintings, including more than 1,000 by Monet, 1,500 by Renoir, 800 by Pissarro, 400 by Degas and 400 by Sisley. Dr Albert Barnes wrote to Durand-Ruel in 1915, 'my collection is practically an annex of your business'. Over half of the Impressionist works in the legendary Havemeyer collection were acquired from Durand-Ruel.

What was the ultimate significance of Durand-Ruel? He was the first dealer to become an explainer, an educator of his clientele in difficult contemporary art. It is hard to think of any precedent for this in the history of art dealing, perhaps because this was the first time in history that contemporary art was perceived as difficult to appreciate and understand. He was also the first dealer to take a position in new art: he set a dealing template of buying up the works of young undiscovered artists and making money as they became recognised and established. He exploited that happy gap between the price of the thing sourced early, and the price of the thing placed later. Durand-Ruel identified the Impressionists as the school of painting that would perform this miracle. Why? What gave him that insight? This is what Renoir said about the invention of Impressionism: 'I only painted in bright colours because you had to paint in bright colours! This wasn't the result of any theory. There was a call for it in the air, and everyone felt it unconsciously, it wasn't just me.' Perhaps that's

what successful pioneer art dealers are: blessed with particularly sensitive antennae.

According to Zola, a work of art is '*un coin de la création vu à travers un tempérament*'. This is a definition born of the experience of Impressionism, and paralleled by contemporary philosophical investigation into the relation between the objective world and the subjective nature of its human perception. It is important, because it highlights the individual artistic temperament as what defines a work of art, gives it its piquancy; therefore it is temperament that is being sold when a work of Impressionist art is offered to the market. Dealers are onto something new. Whereas the Victorian paintings that Gambart was marketing were branded by subject matter, now we have branding by temperament. The Modernist developments of Post-Impressionism, and particularly the Expressionism of van Gogh, further underline the individualism of the artist. The temperament becomes even more important in what the dealer is asking the public to buy. In fact Zola has been subverted: a work of art is now '*un tempérament vu à travers un coin de création*'. This was the challenge that the next generation of dealers in Modernism – the Vollards, the Kahnweilers and the Rosenbergs – had to rise to meet.

8

THE ENRICHMENT OF AMBROISE VOLLARD

It took a certain sort of character to become a dealer in difficult modern art in late-nineteenth-century France; a cussedness, a thick skin and a pleasure in the unusual. The Ambroise Vollard who arrived in Paris in 1887 aged twenty-one was a colonial and an outsider. He had been brought up on the island of Réunion, a remote outpost of the French Empire in the Indian Ocean. Is this outsiderhood also one of the reasons why he responded almost immediately to the new art? He was tall and maladroit, and determined to the point of obstructiveness; on top of that he had a keen sense of the ridiculous, and a strong subversive streak. Probably all of those characteristics helped in the formation of an art dealer prepared to do battle on behalf of artists most of the public thought of as madmen.

Not that Vollard arrived in Paris determined to be an art dealer. He had been sent to study law, but soon found he was happiest rummaging second-hand stalls on the quays of the Seine for engravings and drawings. He gave up his law studies to work full-time at a dealership called Union Artistique, which specialised in selling the work of Salon artists such as Édouard Debat-Ponsan, a purveyor of images of picturesque countryfolk treated in a mildly plein-airist style. Vollard first saw the work of Cézanne at the shop of Père Tanguy, an elderly ragamuffin with faintly commu-nard sympathies who patronised new painters 'in whom it pleased him to see rebels like himself,' as Vollard later put it. Vollard knew that Cézanne

spoke to him in a way that Debat-Ponsan never could, and in 1893 he went solo, breaking away to set up his own somewhat ramshackle gallery in rue Laffitte specialising in advanced contemporary art. His gallery became, in his own words, 'a sort of pilgrims' resort for all the young painters – Derain, Matisse, Picasso, Rouault, Vlaminck and the rest'. But the first important show he put on was of Édouard Manet, after he had got hold of a cache of sketches from the artist's widow. It is interesting that Vollard, as with Durand-Ruel, found his engagement with modern art fired by an early enthusiasm for Manet. But for Vollard the transforming experience was his discovery of Cézanne, to whose work he gave a famous solo exhibition in November 1895.

We do not know exactly what went through Vollard's mind when he first saw a painting by Cézanne, but he called it a *'coup à l'estomac'*. It was one of those revelatory moments people occasionally experience in front of art that strikes them as totally new and marvellous. If they are art dealers, the way forward is clear to them. Here is the artist they will promote, establish and make money out of. The Cézanne show that Vollard mounted in his gallery was composed of works he had managed to buy either from the sale of the estate of Père Tanguy (who died in 1894) or from the artist himself, with whom he had made contact in Provence. He was single-minded in his conviction of Cézanne's importance, and in his acquisition of his work. For the next ten years, until the artist's death in 1906, Vollard held a virtual monopoly in his drawings and paintings. The enthusiasm between artist and dealer was mutual. 'I am glad to hear that you like Vollard, who is at once sincere and serious,' wrote Cézanne to the artist Charles Camoin in February 1902. As for Vollard, 'Cézanne was the great romance of Vollard's life,' says Gertrude Stein. Overall, more than a third of Cézanne's output passed through Vollard's hands at some point.

He bought and exhibited works by van Gogh, too. And with Gauguin, now domiciled and commercially impotent in the South Seas, he entered – exceptionally – into an exclusive, albeit miserly, contract. 'He shows nothing but pictures of the young,' said Pissarro approvingly. 'I believe this little dealer is the one we have been seeking, he likes only our school of painting...'

Vollard was a bachelor, and as mentioned previously, the fact that he never married and did not have the financial responsibility of a family played in his favour as a dealer. Durand-Ruel, by contrast, in the difficult early days found himself a widower with six young children to support

and, unable to hang on to his stock, had to sell much of it cheap. Vollard's domestic style was different as well. He gave famous dinners in his cellar at rue Laffitte, where he served chicken curry (a recipe brought with him from Réunion). His guests were generally artists, most often Cézanne, Renoir, Degas, Forain and Redon.

Vollard recounts in his *Recollections* the following dialogue between himself and a prospective buyer at his gallery:

> 'How much are those three sketches by Cézanne?'
> 'Do you want one, two, or three of them?'
> 'Only one.'
> 'Thirty thousand francs, at your choice.'
> 'And if I take two?'
> 'That will be eighty thousand francs.'
> 'I don't understand. So then all three would be...?'
> 'All three, a hundred and fifty thousand francs.'
> My customer was flabbergasted.
> 'It's perfectly simple,' I said. 'If I sell you only one of my Cézannes, I have two left. If I sell you two, I have only one left. If I sell you all three, I have none left. Do you see?'

I reproduce this exchange with some shame and trepidation. It goes against all the precepts of salesmanship now taught so religiously to operatives in the great auction houses. Week-long seminars and training courses are conducted by fresh-faced Americans with degrees in business studies and behavioural science that emphasise the simple central lesson that the client comes first. Don't tell him why it's a good deal for you, tell him why it's a good deal for him. Dwell on the joy of his owning not one but three works by the master. It seems tragic that Vollard should have been denied such wisdom, and perplexing (to the fresh-faced Americans, at least) that he was nonetheless so successful at selling paintings.

Early on in his career Vollard established a reputation for unconventional dealing strategies. Once, when selling a drawing by Forain he quoted a price of 120 francs. The buyer offered 100 francs. Vollard retaliated by raising the price to 150. As Walter Feilchenfeldt suggests, whereas Vollard was close to his artists and appreciated by them, he had a certain contempt for his clients. 'In picture dealing,' Vollard wrote, 'one must go warily with one's customers. It does not do, for instance, to explain the

subject, or show which way up a picture is meant to be looked at.' He takes a wry pleasure in the absurdities of art buyers. He was particularly amused by a group of connoisseurs who, having seen the works of three 'madmen' – Cézanne, Gauguin and van Gogh – rise dramatically in price, convinced themselves that the next sort of painting that would miraculously go up in price could best be identified by other madmen. They hatched a plan to create an investment fund, 'which they put at the disposal of some half-witted creature, and despatched him to Paris accompanied by a delegate of the group, whose function it was to send home the pictures selected by the lunatic'. For Vollard life is best understood – and relished – as a play staged in the Theatre of the Absurd. He recounts with pleasure the response of the critic Albert Wolff to an author who had begged him to write an article on his work: 'A eulogistic piece will be 25 louis. A thrash-ing, 50 louis.'

Vollard knew himself, and his own shortcomings: 'How many times have I not regretted that nature has not endowed me with an easy-going, jovial manner,' he reflected in his *Recollections*. His ideal client was the American collector Dr Albert Barnes, whose merits as a buyer of paint-ings Vollard describes succinctly: 'Unhesitatingly he picks out this or that one. Then he goes away.' But I suspect that Vollard quite enjoyed (and exploited) his own reputation as a curmudgeon. Certainly he enjoyed the little tricks of the art trade, the feints and deceptions, the detective work, and the thrill of the chase. In *Recollections* he tells with admiration of a fellow dealer who dresses up his clerk as an American private collector in order to visit the house of and do business with an owner who refuses to have any commerce with dealers. He was capable of ruthlessness in dealing with rivals. After he beat down the unfortunate Berthe Weill (a fellow dealer in avant-garde art, a lady who one can't help feeling deserved more gallant treatment) on a Redon to a shamefully low price, he had no com-punction in then telling the artist that he shouldn't sell her any more work because she was ruining his prices.

In 1901 Vollard showed that he was tapped into the most forward section of the avant-garde by giving the young Picasso his first exhibition in Paris. Opening on 24 June, it comprised sixty-five hastily assembled pic-tures and an unknown number of drawings. The event was neither grand nor well publicised. Vollard's presentational skills were never his strength, and Picasso was barely twenty, an unknown Spaniard newly arrived in France. What did he see in Picasso at that point? An energy, an exuberant

Picasso's Cubist portrait of Ambroise Vollard (1910), incomprehensible to the sitter.

relish of colour that prefigured the Fauves, a distinctively Spanish gusto. It seems that about half the exhibits sold, which was a pretty successful outcome. But Vollard didn't stay with Picasso after that: he didn't like the Blue Period works that followed. Vollard's interest in Picasso was renewed with some Rose Period works that he handled in 1906. But Cubism, in the words of John Richardson, 'utterly defeated' Vollard. As a Cubist painter Picasso was much better suited to the dealing attentions of the school-masterly Daniel-Henry Kahnweiler. It is ironic that Picasso's portrait of Vollard, painted in 1910, is an exercise in the language of Cubism. Dealers are not sentimentalists: Vollard was perfectly happy to sell it on to the Russian collector Ivan Morozov for 3,000 francs two years later.

Vollard also gave Matisse his first solo exhibition, in 1904, but missed out on him. When Matisse finally contracted himself to a dealer, it was to Bernheim-Jeune in 1909. Still, one of the Fauves Vollard did get was Derain, to whom he was introduced by Matisse in November 1905. He

Ambroise Vollard: a lithograph by Renoir.

had the resource to gamble on unknowns, and to do so in large numbers. He spent a modest 3,300 francs on eighty-nine paintings by Derain. Apparently he barely looked at them as they were loaded into his car, but he already had a plan for Derain. Part of that plan was to send him to London. The recent successful exhibition at Durand-Ruel's gallery of the works Monet painted there made a deep impression on both Vollard and Kahnweiler. Vollard despatched Derain to produce a series of London paintings in 1906; Kahnweiler tried, but could not persuade Picasso to do the same. On the face of it, grey, fog-bound London was a surprising location for a Fauve to paint in. But here is an instance of a dealer having an impact on the history of art. The series of London views that Derain produced were striking and important landmarks in the development of Fauvism, and wouldn't have been painted without Vollard. Together with Monet's 1901 series, they also stood in good stead later generations of art dealers, on the basis that many rich collectors live in London and are delighted to put their money into works by great Modernist masters that depict familiar surroundings (see plate 10).

The Vollard stock books tell a happy story of ever-increasing distance between the price of the thing sourced and that of the thing placed. In

spring 1906, for instance, he buys a Gauguin self-portrait from Victor Segalen for 600 francs; he sells it to Prince de Wagram less than two months later for 3,500. In December 1899 he buys from Cézanne's brother-in-law two landscapes for a total of 600 francs. A letter survives from Vollard in which he regrets being unable to pay more, because 'still lifes and flowerpieces are preferable to these unpolished landscapes'. But you can be sure that the lack of polish and the greater desirability of still lifes were not mentioned when he sold one of the landscapes to the German collector Karl Osthaus in April 1906 at a considerable mark-up, and certainly not when he sold the other in March 1922 to Coe of Cleveland for more than 100,000 francs. His virtual monopoly of Cézanne in what was by the first decade of the twentieth century a rapidly rising market for the artist meant that he could pick and choose when and what he sold of his large holding of the artist's work. To all intents and purposes Vollard's financial future was now not just secure, but looking very rosy indeed. It gave him the freedom to experiment in other areas, notably publishing.

Vollard's closeness to his artists is reflected in the extraordinary number of portraits they painted of him: there are memorable and multiple images by, for instance, Renoir, Cézanne, Bonnard and of course Picasso. As Picasso remarked, 'the most beautiful woman in the world never had herself painted as often as Vollard'. Such was the lasting visual impression that Vollard made on Picasso that much later in life, when carving a slice of tongue, Picasso held it up to remark upon its chance resemblance to the features of the dealer. Vollard's impact was considerable, both physically and intellectually, which was perhaps what fascinated painters: Vuillard describes him as 'serious, ironic, enormous and spirited'.

That sense of irony is an important thread in Vollard's make-up. René Gimpel records how, after some perfidy of Degas over prices, Vollard observed wryly: 'You can only trust the talentless artists to keep their word.' During the First World War Vollard's irony emerges more forcefully, as a cynical relish of the absurd, a commodity never in short supply during the conflict. Père Ubu, the alter ego in whose voice Vollard wrote a number of laconic short stories, recounts in 'Le Père Ubu a l'Hopital' how a senior medical officer (a 'Five Stripes') amputates the leg of a wounded soldier, reprimanding a junior military surgeon (a 'two-stripes') who has had the effrontery to cure a similar case without operating. 'The Censorship opposed publication of my story for cogent reasons,' reported Vollard later, continuing,

and I came round, of my own accord, to a saner appreciation of the military method. For it is easy to see how contrary to all hierarchy, and even to common sense, it would be if a 'Four Stripes' were not twice as clever as a 'two-stripes'. Obviously any cure obtained by an inferior, after a man of superior rank has failed, can only be considered null and void. I wrote my *Ubu à la Guerre* to this effect, and this time the Censorship bestowed its full approval.

His preference for artists over collectors is a feature of Vollard's dealing life. But he makes an interesting observation about collectors of the new art: he prefers Germans to the French. He describes it as 'a singularly paradoxical situation' that 'the Frenchman, who is argumentative by temperament, becomes a conservative when confronted by any new trend in art, so great is his need of certainty, and so afraid is he of being taken in. The German, on the contrary, while bowing instinctively to anything in the way of collective discipline, yet gives enthusiastic support to every anticipation of the future.'

Presentation of works of art in Vollard's 'gallery space' was not one of his strengths. Contemporary accounts of the chaos that prevailed indicate that Vollard, had he lived a hundred years later, would have benefited from the courses that international auction houses now offer their staff, aimed at 'improving the client experience'. Certainly Gertrude and Leo Stein, when they first went there, had difficulty in making their requirements understood. 'It was an incredible place,' said Gertrude Stein. 'It didn't look like a picture gallery. Inside there were a couple of canvases turned to the wall, in one corner was a small pile of big and little canvases thrown pell mell on top of one another.' By contrast with the grand premises and persuasive selling technique of a dealer like Georges Petit, Vollard was a secretive hoarder. There was no hard sell: Gertrude Stein goes on to describe him as 'a huge dark man glooming. This was Vollard cheerful. When he was really cheerless he put his huge frame against the glass door that led to the street, his arms above his head, his hands on each upper corner of the portal and gloomed darkly into the street. Nobody thought then of trying to come in.'

The Steins' first attempt to buy a Cézanne landscape from Vollard was not untypical. He brought them everything but the subject matter they wanted, disappearing upstairs and returning with first an apple, then a painting of a human back, then 'a very large canvas and a very

small fragment of landscape painted on it'. Would it be possible to have 'a smaller canvas, but one all covered,' they ask? At this point a couple of elderly charwomen follow each other downstairs and exit the premises. Gertrude Stein wonders if the artist called Paul Cézanne doesn't actually exist, but it's these two women who knock up the 'Cézannes' in a back room on orders communicated a trifle inaccurately by the proprietor.

But Mary Cassatt admired Vollard as a seller: in December 1913 she wrote to her friend and client the great collector Mrs Havemeyer: 'Durand-Ruel would not buy the things from Degas that Vollard gladly took and sold again at large profits. Vollard is a genius in his line, he seems to be able to sell *anything*.' But how? 'Doing business with Vollard was always something of a feat,' remembered Ruth Bakwin, 'because most of the time he discouraged buyers from purchasing his paintings.' When Mrs Havemeyer actually went herself to buy Cézannes from Vollard, he kept her waiting while he continued the conversation he was having with an artist. Mrs Havemeyer indicated she would miss her boat. Vollard politely answered, 'Madame, I am certain you could take another boat.' She did. The key of course is that the only way to buy Cézanne at that time was to go to Vollard. Vollard was operating from a position of strength. His monopoly gave him powerful muscles, which he rather enjoyed flexing. He had great international contacts and understood the benefits of lending his stock extensively, for instance to Cassirer in Berlin for a succession of exhibitions, to Roger Fry in London for the Post-Impressionist show in 1910, and to the Armory Show in New York in 1913, where he sold conspicuously more than any other European dealer.

In his later life Vollard formed a close attachment to the wife of an old friend, Madame de Galea, but he would have been a difficult man to live with. His bachelor habits grew more marked as time went by: Daniel Wildenstein remembers the elderly Vollard as living in fear of catching a cold and being pathologically stingy. 'Vollard give something away? Don't make me laugh,' exclaimed Wildenstein. But you can detect a grudging admiration in his tone. The big beasts locked horns when the Wildensteins attempted to do business with Vollard in the 1920s and 1930s. 'We would go to his place one or two times a week to try to buy a painting from him,' remembered Daniel. 'Everything was always on the ground, in piles... If you wanted to buy a Cézanne from him, you needed to ask for a Renoir. Not a Cézanne, certainly not that. A Renoir... And then with a little luck he would take out a Cézanne.' Was this his sense of the

absurd, his consciousness of his own strength, or very subtle salesmanship? Perhaps a bit of all three.

So identified with successful moneymaking had he become in the mind of the young Jean Renoir, the artist's son, that initially he was convinced that the unit of currency in the USA was a Vollard, not a dollar. 'Vollard is a tall awkward person, earnest, simple and engrossed in linking his name with modern art history,' noted the New York art critic Henry McBride in 1915 when introduced by Gertrude Stein. 'He has a trick of shutting one eye tighter than the other which gives an oblique line across the face.' Daniel Wildenstein described him in later years as 'massive, with a baritone voice, small beard, and a beret that covered his bald spot'. 'He was a sort of alert old bear,' said René Gimpel.

In March 1920 Vollard told Leo Stein that he now preferred writing books to selling paintings, especially since people were buying art as an investment. His objection to art as investment was not the high-principled one articulated by others, of art mattering more than money. It was the galling thought that the new owners would make profits from the paintings he sold them – profits he could make himself if he hung on to the wretched things – as the market continued on its apparently inexorable path upwards. It was intolerable. 'What's the use of letting the other fellow profit by it?' he moaned to Stein. It was better not to sell at all.

Of course the lesson of the half century from 1875 to 1925 was that any dealer who 'defends' and promotes new art does so partly on the grounds that the new artists they are introducing to the public are going to increase in value. It is an underlying premise that is essential to their financial functioning. And it is a compelling argument, too, for the prospective purchaser. The work might look a bit strange now, but in ten or twenty years' time maybe that strangeness will have been transformed into its most desirable feature, and maybe it will be worth a lot more. If an investor in the stock market picks a share that goes up dramatically thereafter, he is lauded for his commercial acumen. If an investor picks a young artist whose work goes up dramatically in the ensuing years, he is lauded both for his commercial acumen and for something even more desirable: his aesthetic discrimination. The wise art dealer doesn't lose sight of that distinction.

But Vollard had done well enough to turn away from the routine buying and selling of paintings in the years after the First World War. He was certainly prepared now and then to undertake an exceptionally remunerative

deal – for instance in November 1923 he sold two Blue Period Picassos to the American collector John Quinn for the impressive total of 100,000 francs – but he gave his attention increasingly to his projects as a publisher. Roger Fry paid a visit to Vollard in 1925 and found that all Vollard wanted to talk about was literature rather than art, and particularly his 'Ubu' stories, which Fry thought 'rather silly'. However, 'the easiest way... to win Vollard's confidence was to show a keen interest and appreciation of his publications. Indeed many found this the only key that would unlock those secret rooms where the countless masterpieces were stored.'

There is no doubt that Vollard took genuine pleasure in the marriage of art and literature that his publishing ventures blessed; printmaking tied to book publishing offered him a close and satisfying involvement in the product, denied him in the producing of paintings by his artists. And he was very good at it: very good at having the ideas that married artists to texts, and very good at the production of the plates. His printmaking immortalisation was achieved in Picasso's Vollard Suite, the most celebrated set of etchings that Picasso made, consisting of 100 prints finally published in 1937. Most of them were done in the years 1930–34, arguably Picasso's most creatively fertile period. Vollard wisely allowed Picasso free rein, and the subjects poured out in wildly experimental print effects: minotaurs, bullfights, lovers, finishing as ever with three etched portraits of Vollard himself, done in 1937.

Vollard is a good example of the lesson that, in order to succeed as an art dealer, one has to cast one's bread widely upon the waters, and accept that – to change metaphors – not all the frogs one kisses will turn into princes. In the same way that a publisher who manages to attract a range of great writers to his imprint also produces books by authors who don't make it, so Vollard's overcrowded gallery was also populated by the works of many painters now consigned to oblivion. A trawl through the gallery records of 1894–1911 shows that Vollard gave shows to a number of largely forgotten names. Today who has heard of Paul Vogler, André Sinet, René Seyssaud or Pierre Laprade? He must have seen something in them. But if you turn to the names of those he handled who did make it – Cézanne, van Gogh, Gauguin, Bonnard, Vuillard, Picasso, Matisse, Derain, Rouault, van Dongen – you realise his strike rate was pretty impressive. He may have wielded a scatter gun, but he knew pretty accurately the direction in which to point it. Renoir, for one, was impressed by Vollard's judgement of painting. His manner was deceptive: there was a certain indolence to

it. 'He had the weary look of a Carthaginian general,' said Renoir. But in front of a new canvas he was at his best. 'Other people argue, make comparisons, trot out the whole history of art, before uttering an opinion.' But Vollard was different. 'With paintings this young man was as stealthy as a hunting dog on the scent for game,' was Renoir's verdict.

All dealers do regrettable things now and then, and Vollard has been criticised on a number of counts. He was close to Renoir in his old age and admired him as an artist. But later historians have been critical of Vollard's treatment of Renoir's studio debris, of his willingness to cut up the larger canvases on which Renoir painted studies into more saleable individual pieces. At least it kept the Japanese happy in the late 1980s with a constant supply of works whose authenticity was more important than their quality. Close study of the Vollard stockbooks also reveals evidence that Vollard was occasionally remiss over sales of works by Cézanne. The records suggest a certain amount of accounting subterfuge was deployed to hide the fact that he paid the Cézanne family a lot less than he made on the paintings and drawings they consigned to him. Then there is Gauguin, whom 'Vollard acted shamefully towards', as Matisse put it, in 1952. Vollard is reproached for having been miserly in the prices at which he bought Gauguin's Tahitian works in the last years of the artist's life. But it should be said in mitigation that no one else was prepared to offer more. They were difficult to sell. Even Leo and Gertrude Stein 'thought they were rather awful' when they first saw Gauguins at Vollard's gallery. Bonnard was also the victim of unscrupulous behaviour, according to Daniel Wildenstein. He describes how Vollard got hold of a bunch of good Bonnards by taking them from the artist's studio 'for consideration'; then Bonnard forgot what he'd handed over and charged Vollard significantly below market value. But the problem was they were unsigned. Vollard did not dare go back for signatures. Daniel Wildenstein comments censoriously, 'perhaps in Réunion one buys and sells bananas like that, but this was Bonnard!'

In the partially explored territory of the history of art dealing, one area remains especially virgin: the role that restorers play in the success of dealers. The relationship is conducted in a fraught and secret place, but one that might reward the intrepid researcher. Certainly dealers such as Duveen cannot be fully understood without reference to that area of activity. And similarly with Vollard: accusations are sometimes levelled against him in relation to a small number of the many works by Degas that passed

Odilon Redon, La Conscience: *a difficult subject for a dealer.*

through his hands. He bought a large quantity in the Degas estate sale in 1917, and it seems he had very few of them improved by his restorer. Close comparison of these works with what they looked like when they first emerged from Degas's studio and were photographed as a record for the estate sale in one or two cases show alterations: a face is filled in, or a limb straightened. The problem is that, because it may have happened once or twice, unjustified suspicion is cast on all works by Degas with a Vollard provenance. This is manifestly not fair. Degas was one of the artists for whom Vollard had enormous respect. He even wrote a fond if ultimately unrevealing memoir of him. The vast majority of works by Degas that he handled are excellent examples, and untouched. It was just that when you buy in bulk, which Vollard always liked doing, you will inevitably get one or two duds in the consignment, duds that he very occasionally gave in to the temptation to hand over to the restorer for imaginative reconstruction. Perhaps it was out of loyalty to the artist's memory. What was it that Max Liebermann once said? 'It is the duty of art historians to call the artist's bad pictures forgeries.' Vollard might have added: 'And it is the duty of art dealers to present them in their best light.' Vollard could have adduced in his defence the eighteenth-century theory of Pierre-Jean Mariette, that

'an experienced connoisseur was authorised to improve a drawing in order to make visible the truth that only a specialist could see'.

Was Vollard possessed of a moral sense? One can almost hear Daniel Wildenstein exclaiming: 'Don't make me laugh.' But one drawing by Odilon Redon that Vollard owned – and never parted from – suggests that the question of right and wrong occasionally occupied him. The title of the work is *La Conscience*. Here is Alec Wildenstein, author of the Redon *catalogue raisonné*, assessing this particular drawing:

> Man has become the baggage-carrier of his conscience, which has taken the form of a giant bacteria with a human face. The man, fragile under the burden which is bigger and heavier than he is, advances to the edge of a nothingness which he contemplates, his arms outstretched but hesitant to throw himself into an abyss as unfathomable as the human mystery. Will the man really jump, taking the easy way out? Or will the conscience that weighs him down keep him on the heights so laborious to attain and so arduous to inhabit?

Of course there is another explanation for the fact that Vollard never sold this drawing. He simply couldn't find a buyer for it. Perhaps none of his clientele – the picture-buying public of the world – wished to grapple with the challenge of its subject any more than he did.

The Vollard estate, in which this work by Redon was included, remained disputed for many years. The dealer who is so successful that he can afford to set aside for himself and his descendants secret stores of masterpieces is an exciting idea. The private storerooms of the Wildensteins have for some time been part of art-world folklore. The same was true of Vollard. No one quite knew what would be revealed after his death, and when it came, in 1939, even that was shrouded in an element of mystery. What is certain is that it was in a motor accident. What is less certain is whether his head was struck by a stray Maillol sculpture also travelling in the car with him. If true, this version would have a symbolic resonance. But John Richardson has a theory that Vollard was actually murdered in an elaborate plot orchestrated by the shady Parisian dealer Martin Fabiani, who had positioned himself to benefit from Vollard's vast estate. Tracking the disposition of the estate is anyway complicated by the outbreak of the Second World War, but part of it seems to have been stolen by an ex-employee and spirited away to the Balkans. Another part was shipped

out of France to America in 1940 by Fabiani, who had apparently bought it from Vollard's brother Lucien. If this was indeed the final act in a murderous conspiracy, it was itself thwarted by unforeseen events. The boat carrying the shipment was stopped by the British authorities in Bermuda, and the contents confiscated for the remainder of the war on the suspicion that the paintings were going to be sold to raise foreign exchange for Germany. By a historical irony, the man responsible for the confiscation was a young intelligence officer called Peter Wilson, later chairman of Sotheby's. It is one of the very few instances of a collection of such quality being in his hands without his immediately inveigling it under the hammer. Regretfully he had to pack it off for detention in Canada for the next five years. The remaining part of the Vollard estate was sealed up in a Parisian bank for many decades. After lengthy legal negotiations there was a sense of Peter Wilson's shade finally being placated when Sotheby's were entrusted with its sale in 2010. Sotheby's marketed this final manifestation of the Vollard legend as 'Trésors du Coffre Vollard'.

What would have happened to the development of modern art if Durand-Ruel had not adopted the Impressionists as his cause? And how would it have progressed if, two decades later, Ambroise Vollard had not discovered and promoted Cézanne? Vollard's championing of him (and to a lesser extent of Gauguin and van Gogh) opened up recognition for the artists in the early years of the twentieth century. Would their influence – so crucial to the evolution of Cubism and abstract art – have been felt so widely without Vollard acting as a conduit of their work to exhibitions (and sales to influential collectors) in Germany, in the United States, in Russia and even in Britain? This is not to argue that modern art would have failed to take hold without the pioneering dealers who first handled it. But the form it took might have been different in its emphases and progression.

9

DANIEL-HENRY KAHNWEILER: DEALER AS PURIST

Ambroise Vollard was the dealer most responsible for the gradual acceptance of Post-Impressionism and Fauvism; he also took an early interest in Picasso, but parted company with him at the point of Cubism, which he did not understand. The dealer who did understand it, and indeed became the movement's high priest, was Daniel-Henry Kahnweiler.

Kahnweiler was Germanic, opinionated, fastidious and not blessed with much of a sense of humour. Heinz Berggruen, a fellow dealer who did business with him in the years after the Second World War, describes him as having 'the strictness of a Prussian schoolmaster'. By nature Kahnweiler was something of an ascetic. In 1937 – when the art market was, admittedly, in the doldrums – he was taken out to dinner by his old friend and client, the collector Hermann Rupf, and observed primly afterwards, 'I am no longer used to seeing so much money spent just to stuff your face.' Such self-denial does not always come naturally to the art dealing community. Kahnweiler could be heavy going. 'He liked smiling but disliked laughing,' remembered Berggruen. 'He was too disciplined to enjoy extremes.' But he was one of those art dealers who do not rely on charm to do their business. He took art very, very seriously, and sold it as if bestowing intellectual

Kahnweiler: 'the strictness of a Prussian schoolmaster'.

and aesthetic privilege on those lucky enough to be buying from him. His gallery was not a luxurious establishment. Berggruen says that he even banned flowers from the premises. 'Everything about it had a sterile and impersonal air.'

Nor was there aggressive selling from Kahnweiler. His view of the paintings he handled was that they should circulate without artificial promotion. He didn't praise or bargain. The fact that he had chosen them to offer for sale to his clients was recommendation enough. If the visitor to his gallery wanted more information about a prospective purchase, it was up to him as the buyer to initiate a dialogue with the dealer, which in itself must have been challenging. 'His intention was to transform a commercial success into a moral triumph,' says his biographer, Pierre Assouline, by which he means there was a sense of mission about Kahnweiler's art dealing that transcended grubby considerations of money. Such high-mindedness can of course itself become a compelling commercial strategy.

The great Russian collectors of the early twentieth century, Ivan

Morozov and Sergei Shchukin, bought extensively from Kahnweiler. He would send them small black-and-white photos of the latest Picasso he had for sale, usually accompanied by a brief letter. These letters were the reverse of a heavy sell, just stating with a certain finality 'This is an important painting.' He would quote a price, which he liked to feel was non-negotiable. But occasionally he would unbend sufficiently to come down a bit, 'just to make you happy', although the implication was that in forcing such a concession out of him the client had in some way acted dishonourably. Henri-Pierre Roché, another pre-First World War client, records: 'In the beginning of Cubism, Kahnweiler in his small shop introduced me to Cubist Picassos and Braques without saying a word. He *introduced* me, and his manner said it all. He had the simple authority of someone who announces. For him, Cubism, newly created, was already a classic.'

There was indeed a heroism to Kahnweiler in his early support of Cubism against a background of almost universal incomprehension of what the movement was about and consequent public unwillingness to part with money to acquire it. There was also something of the afflicted hero of Greek tragedy in what he had to suffer at the hands of unkind fate in two world wars. At the outbreak of the First World War he went into exile in Switzerland, and left behind his gallery and stock in Paris. He could have got his stock out to New York at this point, but felt it was unnecessary as, in common with most people, he expected the war to be over in a matter of months. As it turned out everything was sequestrated by the French authorities as 'enemy property', because Kahnweiler, despite his total absorption into French art and culture, had never bothered to renounce his German nationality. He came back to Paris in 1919 and mounted a campaign for the restitution of his property, but he never got his stock back, and had to witness a soul-destroying sequence of public sales of 800 of his precious paintings, often at ridiculously low prices because the market was flooded. In the First World War he was stripped of his possessions because he was German; in 1940 it happened again, but this time because he was Jewish. He managed to survive the second conflict living quietly in the French countryside, but in 1946 he had to start again. It would have broken spirits less convinced of their own rightness (and righteousness).

His earliest ambition was to be a musician:

Curiously I think the same impulse was behind this that made me

become an art dealer: an awareness that I was not a creator but rather a go-between, in a comparatively noble sense of the word, since I was not a composer myself. Later, when I became interested in painting, I found an opportunity to help those whom I considered great painters, to be an intermediary between them and the public, to clear their way, and to spare them financial anxieties. If the profession of art dealer has any moral justification, it can only be that.

You also have to be very, very sure of your own judgement to adopt this position. In the concert hall, Kahnweiler says 'My greatest pleasure was to applaud a piece of music I like in the face of hissing adversaries. The same is true of painting: I adore defending what I love.'

There was no shortage of hissing adversaries in Paris in the years before the First World War. Waves of new art had broken over a serially outraged public: Impressionism, Fauvism and the final incomprehensibility of the movement with which Kahnweiler identified, Cubism. As he himself recognised, he found the opposition positively stimulating. He relished an incident that he witnessed at the 1904 Durand-Ruel exhibition of Monet's London series. He recounts, 'I saw two cab drivers standing in front of Durand-Ruel's window, rigid with hatred and rage, their fists clenched, yelling "Any place that shows such rubbish should have its windows bashed in."'

Kahnweiler was brought up in a comfortably off Jewish household in Mannheim, Germany. Having rejected music as a career and turned down the opportunity to work in the security of his family banking business, Kahnweiler arrived in Paris in the very early years of the twentieth century determined to become an art dealer. He was backed by a small amount of family money, but it was a brave decision, and an even braver one to devote himself to difficult new art. His fascination with new art was never in doubt, but he was honest enough to recount later that he too needed time to absorb and understand it. His initial reaction to seeing the Caillebotte collection of Impressionist painting was uncertain. 'At first the room upset me very much,' he said later. 'This proves that the comprehension and even the reading of a new kind of painting is difficult for everyone. As a matter of fact, at first I found these paintings illegible, like so many blobs of colour, and only gradually did I realise that I was in the presence of a world that was new to me, new to everyone...' This rapidly leads on to the conviction that he must deal with young, living artists, not even recently

dead ones like Cézanne. 'It seemed to me that the period for that was over, for me at least, and that my role was to fight for the painters of my age.'

There is a certain type of intelligence that is stimulated by artistic newness, by the pushing of boundaries. Unquestionably Kahnweiler – like Durand-Ruel, like Vollard, like Leo Castelli in New York after the Second World War – possessed it. But what is also necessary to create a successful dealer in such material is a certain cussedness, a conviction of rightness, indeed a thickness of skin. Later Kahnweiler reflected, 'I think that beside myself there have been really only two art dealers, Durand-Ruel and Vollard, who bought paintings that did not sell or sold poorly.' You don't necessarily need charm, blandishments or a silver tongue. Sometimes – and Kahnweiler is the prime example – your very conviction becomes your salesmanship. As Roger Dutilleul, the distinguished early-twentieth-century collector of modern art, said of Kahnweiler: 'He was more of a teacher than a dealer. In truth I became his disciple.'

Kahnweiler was not interested in making money out of the artists that were easy to sell profitably. He had to believe in his artists. Where did Kahnweiler find his first stable of living painters, the ones he wanted to defend and promote? Initially at the Salon des Indépendants, the annual exhibition in Paris that showcased the avant-garde, where he first saw and bought the work of Derain and Vlaminck. His introduction to Picasso came a little later, when he visited his studio in Montmartre and was instantly smitten. Kahnweiler realised that in order to succeed as a dealer in contemporary painting he needed to own the output of artists; he wanted exclusivity. So, like Durand-Ruel, Kahnweiler took on artists and supported them. He was their kind-hearted employer, or so he imagined himself. 'I remember one day – it was the end of the month and they [the artists] were coming to get their money. They arrived, imitating labourers, turning their caps in their hands: "Boss, we've come for our pay!"'

Kahnweiler's initial encounter with Picasso came in 1907. He was one of the very few who immediately understood the revolutionary impact of the devastatingly modern *Demoiselles d'Avignon*. Although they were temperamentally opposite, and indeed an unlikely combination, their association was a productive one. Kahnweiler provided a financial structure for Picasso, which the artist in his soberer moments acknowledged. Artist and dealer shared a disdain for most art critics, and indeed any criticism of Picasso's work that they considered uninformed. For instance when Kahnweiler wrote to Picasso that one of their most faithful customers did

not like his latest work, Picasso wrote back, 'That's fine, I'm glad he doesn't like it! At this rate we'll disgust the whole world.' But Kahnweiler also understood that there was a limit as to how far you could go in asking Picasso about his work without annoying him. It was in the early stages of Cubism that Picasso is said to have purloined from a Parisian omnibus the sign warning passengers: 'Do not Talk to the Driver'. He would display it whenever someone probed too far.

On 18 December 1910 Picasso finally signed an exclusive agreement with Kahnweiler for three years. The agreed scale of prices ranged from 100 francs for a drawing to 3,000 for a big painting. This was a step up from 1905 when Picasso – selling direct from his studio – was asking 50 francs for a drawing. (As a point of reference 1 franc bought a very cheap workman's lunch, so Picasso's drawing prices rose from 50 cheap lunches to 100). Picasso's rates were the most generous that Kahnweiler allowed to any of the artists that he gathered together as his chosen stable, all under exclusive contracts. The others were Braque, Gris, Derain, Vlaminck and Léger. All were made aware that there would be a 100 per cent mark-up from the buying price to the selling price that Kahnweiler charged. Kahnweiler's grasp of the market was, of course, astute. Some years later he was at pains to explain to Braque why he needed the exclusivity, because a painting that was fresh to the market was worth more than one that had already been shown around, even though it was the same painting. As we have already seen, the virginity of a work of art is a quality that dealers still prize above almost any other.

It is interesting to look in slightly more detail at the contract drawn up between Kahnweiler and Picasso. Besides the 100 francs for a drawing and 200 for a gouache specified, the prices for oil paintings rose strictly in size terms, from 250 francs for a small one, to 1,000 for a medium one, up to 3,000 francs for a large canvas. Kahnweiler certainly wasn't unique in setting the prices that he paid his artists in this way. But, consciously or unconsciously, this demarcation of price by size is an attempt, literally, to quantify art on the dealer's part. It is only a few steps on from the pricing of paintings by weight as practised in the last resort by the Imperial Romans. It suits the dealer to treat the painter as an artisan producing a product: the more of it you get, the more you have to pay. You don't want any consideration as unquantifiable as aesthetics or genius to complicate calculations with the artist. But when dealing with buyers, the dealer adopts the opposite position. A different dynamic is in play. Now

he is indeed selling genius, now it is all about aesthetics, now it's not about anything as banal as size. Now the unquantifiable and subjective elements in a painting enable him to charge the buyer considerably more. It's the way round that he wants it.

Were there other artists whom Kahnweiler coveted but failed to contract? It seems not: although he admired Matisse, he was not fazed when the artist signed a three-year contract with Bernheim-Jeune in 1909. Certainly there were no other Cubists he wanted. He felt he'd identified the original ones in Picasso, Braque, Léger and Gris. He felt very strongly about what constituted true Cubism, and was fierce in his denunciation of artists such as Metzinger and Gleizes, the 'ersatz Kubisten', who he felt were mere imitators of the style of Cubism without understanding its deeper significance (see plates 11 and 12). To whom was vouchsafed this understanding? Probably to the Kahnweiler Cubists. And certainly Kahnweiler himself.

Critics of the system of exclusive contracts maintain that it enables art dealers to pose as protectors of the painter while in reality exploiting him, and, hand in glove with collectors and speculators, massively to be rewarded for their hypocrisy. Kahnweiler, ever the idealist, felt that contracts were appropriate when the dealer and the painter must stand together against hostile public opinion to defend work; he saw them as gestures of generosity. Vollard, more cynically, says that to call an art dealer generous is not a compliment: 'It is as if a prospector who purchased some land where he hoped to discover gold showed generosity to the person who sold him the land.' Kahnweiler was very much against contracts that specified the number of canvases the artist must deliver in a given period. Those who entered into such arrangements with artists were 'criminals who should be shot!' The purpose of agreements between artists and dealers is 'so that the painter can work without financial concerns, that's all. If you tell him he has to produce a certain number of canvases, then everything is over.'

Unlike some other art dealers, Kahnweiler's private collection was of no particular moment to him. He loved paintings, but – in the interests of growing the career of the artist – he was perfectly prepared to sell a painting he loved. 'I am not a collector,' he said. 'Like St Peter, I am a fisher of men rather than a fisher of paintings.' One of the men he was delighted to catch was Juan Gris, because Gris had a serious, almost ascetic side that Kahnweiler found deeply sympathetic. Their correspondence reveals two

Picasso's Cubist portrait of Kahnweiler, painted in 1910.

men between whom there is a profound understanding. But he himself wrote voluminously to all his artists, about the progress of their work and on the practical matters of their lives. When Gris and Picasso and Braque were in Céret in the south of France in the last summers before the First World War, Kahnweiler was regularly in touch with them by letter so that he was the only one who knew from day to day what was going on at a point when crucial advances were being made. As with all dealers in such close contact with artists making new and revolutionary art, the question is to what extent the dealer has an influence on the art that they produce. In an interview for *Je sais tout* magazine in 1912 Kahnweiler tries to explain Cubism. The journalist doesn't understand, but is impressed by Kahnweiler's sincerity. The journalist compares the young art dealer to a great couturier who could speak easily about his latest creation. But of course the creation is actually the work of the artist rather than the dealer, and Kahnweiler always maintained that great artists make great

art dealers rather than the other way round. Nonetheless, at this point in the development of modern art, where dealers played such a significant role not just in the selling of works but in their promotion and interpretation, the boundaries become hazier. There is no doubt that Kahnweiler was very, very closely involved in the development of Cubism. There are few instances of a dealer in modern art being as central to a new and revolutionary movement as he was. He elaborated the intellectual basis of what Picasso, Braque and Gris were developing instinctively. His writings on the subject are crucial. A measure of his involvement in the creative process is that he was the one who assigned the titles, based on descriptions provided by the painters, to the majority of Braque's and Picasso's Cubist paintings. Another measure of his contribution is the respect in which he was held by 'his' artists: this was reflected in the number of portraits they made of him, most memorably works by Picasso, Juan Gris and van Dongen.

The last two or three years before the Great War were particularly heroic ones for Kahnweiler, his artists and for Cubism. One of Kahnweiler's strengths was his internationalism. Like Durand-Ruel and Vollard he regularly exhibited his artists across Europe, particularly in Germany, where he formed close relations with a number of avant-garde dealers, including Alfred Flechtheim; he also contributed to the momentous shows of the Post-Impressionists in London in 1910 and 1912, and to the Armory Show in New York in 1913. He signed a contract with Messrs Brenner and Coady of the Washington Square Gallery in New York, which gave him a permanent outlet in America. Against the odds, his business was definitely moving in the right direction. In the first years of the century the Peau d'Ours collection, an early and unusually successful example of an art fund, had been formed by a group of enlightened amateurs. They had invested in the art of the avant-garde. In 1914 came the challenge of the sale of the collection. It went well, proving not only that there was a market for contemporary art but that it was strengthening. A large Picasso, *La famille de saltimbanques,* for instance, which had cost them 1,000 francs, now went for 11,500.

But ominous clouds were gathering, portending trouble for Kahnweiler. Conservatives looked at the sale of the Peau d'Ours collection and interpreted it as German interference in French art. Who were these Germans? Dealers like Thannhauser and Flechtheim, who bought in the sale, and Paris-based subversives like Kahnweiler, who was seen as inspiring the incomprehensible new direction that the French avant-garde had

taken. It was all a Teutonic plot to 'confuse, convert and conquer' France. When war broke out, Kahnweiler went into exile in Switzerland. It was a period of enforced and frustrating idleness. He became a writer and thinker – but the dealer who becomes too cerebral is in dangerous territory. It is fine for his attitude to art, and therefore his dealing, to crystallise, but not to ossify. Certainly the study of Cubism that Kahnweiler wrote at this time is an important and perceptive testament. The painter, he says, has always been a sign writer:

> fundamentally painting has never been a mirror of the external world, nor has it ever been similar to photography; it has been a creation of signs, which were always read correctly by contemporaries, after a certain apprenticeship, of course. Well, the Cubists created signs that were unquestionably new, and that is what made it so difficult to read their paintings for such a long time.

And Kahnweiler was also the first critic to make the important distinction between analytic and synthetic Cubism. But his opposition to those aspects of contemporary art of which he did not approve becomes after his exile increasingly rigid. He dismisses all art that is guilty of decoration or ornamentation. And he is censorious of his fellow-dealer Paul Rosenberg on the grounds that he placed an announcement in *La Nouvelle Revue Française* in which he advertised – with his name and address! – that he would buy paintings by van Gogh. This, says Kahnweiler with magisterial disdain, is the behaviour of an interior decorator, not an art dealer.

If the years immediately preceding the Great War were Kahnweiler's heroic period, the years immediately after were indeed tragic ones. He strove vainly to reclaim his sequestered stock and had to look on impotently as all 800 works came to auction and sold for knock-down prices. The effort left him bitter. 'I can't tell you how distasteful I find this,' he wrote to Derain. He continued:

> It's so ugly. To have worked so hard, in good faith, for a worthy cause... it was hardly worth it, by God, to have been upstanding and honest to the very end and then in time of peace to be forced to fight like a madman for the return of what had been acquired not only with my money, which doesn't merit consideration, but with the commitment of my whole existence, which deserves great consideration.

Meanwhile his artists were contracting with other galleries. Juan Gris, who would probably have starved otherwise, was taken over by Léonce Rosenberg during the war itself. Kahnweiler had to admit that Rosenberg's role in this instance was 'absolutely praiseworthy', but he was highly suspicious of his brother, Paul Rosenberg (whom he had castigated as an 'interior decorator'), and it must have hurt when the Rosenberg brothers succeeded in taking on Braque and Vlaminck by offering higher rates than Kahnweiler could afford. He lost Derain too, this time to Paul Guillaume. But the most crucial loss was that of Picasso. Ostensibly the point of disagreement was the 20,000 francs that Picasso was owed by Kahnweiler at the beginning of the war, and never got paid. In vain Kahnweiler explained that he in turn was owed money by Sergei Shchukin, funds that because of political developments in Russia never came through: Picasso was implacable. Only after the Second World War was their rapprochement finally achieved with a new contract between them. It could be that the most important art historical consequence of Kahnweiler's absence from Paris in the years 1914–18 was that it freed up Picasso to move on from Cubism.

In order to get round the difficulty of his nationality (Germans were banned from starting a business in France after the First World War) the new enterprise that Kahnweiler set up in Paris was called the Galerie Simon. He recruited a few new artists to contract, such as Henri Laurens. The faithful Dutilleul came back as a buyer. But the agony of the forced sale of his stock had to be undergone. Relations with the Rosenbergs deteriorated further, particularly when Léonce supported the auction, impervious to both its injustice and the danger it represented of flooding the market. On the day of the auction, Braque was even moved to violence against Léonce. Rosenberg's reaction was to take boxing lessons to protect himself, yet one more skill sometimes desirable in the armoury of the art dealer. Kahnweiler's loyalty to his artists remained fierce: Tériade describes the Galerie Simon in the interwar years as halfway between art establishment and welfare office.

Like Vollard, Kahnweiler turned to publishing. The imprint of Galerie Simon brought out a series of books by new authors, illustrated by his chosen artists. He was as assiduous in his cultivation of good writers as he was of painters. He met the poet Michel Leiris through publishing him. And in the realm of publishing he allowed himself to be a more aggressive salesman. His veneration for the sanctity of the individual created works of art, which he instinctively regarded as above commercial hype,

contrasted with his more pragmatic attitude to shifting books, whose sales had to be measured in multiples to make any commercial impact.

In the 1920s and 1930s Kahnweiler's increasingly inflexible disaffection with non-Cubist art narrowed his dealing options. He didn't like German Expressionism, Fauvism (excessive decoration) or Futurism (too much noise). He disapproved of the art stimulated by the Ballets Russes. While he liked aspects of literary Surrealism, he was hostile to Surrealism as an art movement. He agreed with Vlaminck when he said that 'Surrealists are people who have a telephone installed and then cut the wires.' In 1936 the Mayor Gallery in London mounted a Cubist exhibition. Unfortunately it included the work of those inferior, imitative Cubists of which Kahnweiler still so much disapproved that he tried to get it stopped.

Art dealing between the wars was also impeded by the financial crash of October 1929. The almost complete suspension of art market activity that ensued brought problems to most people, including the Galerie Simon. Contracts with Kahnweiler's artists had to be suspended. But a major compensation was that, in the early 1930s, he gradually got back in touch with Picasso. Whatever the effect of his blinkered artistic vision in other directions, he found Picasso's work of this time incredibly powerful. 'It seems as if a satyr who had murdered a woman had painted this picture,' he wrote in awe.

The outbreak of the Second World War and the occupation of Paris was the next affliction with which Kahnweiler had to contend. His gallery was taken from him once more, but he managed to have it sympathetically Aryanised under the ownership of the Leiris family, and spent the rest of the war trying to withdraw from the horror of Nazism. He settled quietly in the countryside of Limousin and immersed himself in the novels of Dickens and Trollope. Once again the art dealer is reinvented as the philosopher-writer. He ruminates on the effect of great art: 'It is in this union, it seems to me, which I experience before a work of art, that I can know what saints must experience in their union... with God. In contemplating a work of art we can momentarily escape the isolation to which we are condemned the rest of the time. We are united with humanity, with everything, with God.'

It is clear we are confronted by a very different art dealer here from, say, Joseph Duveen. Kahnweiler gives considerable further thought to the phenomenon of Cubism, and his brooding repositions the break in the Renaissance tradition from Picasso's painting of *Demoiselles d'Avignon*

(1907) to 1913, when analytical Cubism yields to synthetic. It is a moot and subtle point, and you can't imagine Durand-Ruel or Vollard making it. Kahnweiler was indeed uniquely cerebral. And uniquely scrupulous: he didn't write in those periods when he was primarily art dealing for fear that 'the public would see commercialism in it', and the seriousness of his work would be undermined.

After World War II, Kahnweiler had to begin again. And in this final phase of his career, he became a figure of huge eminence and a highly respected authority, but an authority even less likely to modify his opinions and prejudices. In his inflexibility he found another artistic movement to excite his implacable enmity: abstraction, which he characterised as 'the new academicism'. It has nothing to say, he maintained. Kahnweiler had a number of blind spots. In the 1920s and 1930s he had represented Paul Klee, but without much enthusiasm. In the latter stages of his career he latched on to a number of undeserving and now forgotten artists whom he promoted eagerly: Suzanne Roger, Eugène de Kermadec, Yves Rouvre. 'With very few exceptions one can only competently judge the art that corresponds to one's own generation,' writes Heinz Berggruen. This was true of Durand-Ruel and Vollard and Kahnweiler. He was of the Cubist generation, and he did not move on.

However, what illuminated and justified the post-war phase of the Kahnweiler story was his rapprochement with Picasso and his reinstallation as Picasso's dealer. He saw off his rivals: Louis Carré in France, for instance, and the American Sam Kootz. But Kahnweiler was patient and persistent and won back the exclusive rights that he had last held in 1914. He became virtually Picasso's wholesaler: Picasso would refer prospective buyers to him. Gradually dealers, collectors and museums learned the lesson that in order to buy Picasso you went to the Galerie Louise Leiris.

Kahnweiler's relationship with Picasso is a fascinating study. You could hardly imagine a starker contrast in character between the two. They were at opposite poles as human beings: Kahnweiler dogmatic, intellectual, rigid, principled, humourless, and Picasso instinctive, capricious, wayward, full of *duende*. There were moments when his dealer must have infuriated Picasso; and, being something of a sadist, moments when he made Kahnweiler's life hell. But Kahnweiler stuck at it, and Picasso came to value the man's reliability. That was why he allowed him back into his life in the post-war years. Still, Kahnweiler may every now and then have reflected on the letter that Juan Gris wrote him in 1923, in which he declared (after

a visit to Matisse): 'There's no doubt, painters become unbearable when they are successful.'

Kahnweiler, Picasso admitted, was different from other dealers. Françoise Gilot recounts how, the night before any other dealer's visit, Picasso was fond of enacting with her how the conversation and negotiation might proceed, with Gilot taking the role of the dealer. 'In the end,' recorded Gilot, 'it had to end with the triumph of Pablo. He had the last word because he had more wit, more fantasy, more imagination, more arms of all kinds, than his opponent.' He also owned the paintings that they wanted so much.

John Richardson records an instance of Picasso's manipulative teasing, this time perpetrated on the unfortunate Sam Kootz. When Mr and Mrs Kootz were ushered in to Picasso's presence in the artist's studio, he made great play of a drawing he was busy with that he was about to give to Douglas Cooper. That was irritating enough for the Kootzes, who had come hoping to acquire something themselves. But Picasso wouldn't be budged from his work on Cooper's drawing. 'How he dawdled over it!' records Richardson. 'Mrs Kootz looked more and more impatient. Finally she caught her husband's eye, grimaced at her watch and pointed at her hair. No way she was going to miss her hairdresser's appointment. Picasso, who had been watching this charade out of the corner of his eye, jumped up full of apologies and ushered them out with a ceremonious show of courtesy. So sorry to have held them up: of course Madame Kootz's coiffure took precedence over other considerations. Would they please let him know the next time they came to Europe?' Really, Picasso should have been given some sort of award for cruelty to dealers.

Kahnweiler was the exception, because he could bore his way to victory over Picasso. He wouldn't go away. He literally wouldn't take no for an answer, remembers Gilot. Picasso found that even if he said the most insulting things (and he did), Kahnweiler wouldn't be deterred. Picasso would say, 'You've never given a damn about me,' or 'When I think of how, in my early days, you exploited me in the most shameless fashion.' Kahnweiler would reply, 'No, no,' but very calmly, with a kind of inertia. Apparently Kahnweiler did inertia well. It was a weapon that incapacitated the hyperactive artist. Sometimes Picasso would argue philosophy or literature with him. Kahnweiler was deft, not angering Picasso, allowing him the advantage. But there was another, more ruthless side to Kahnweiler. He signed Françoise Gilot on an artist's contract with his gallery.

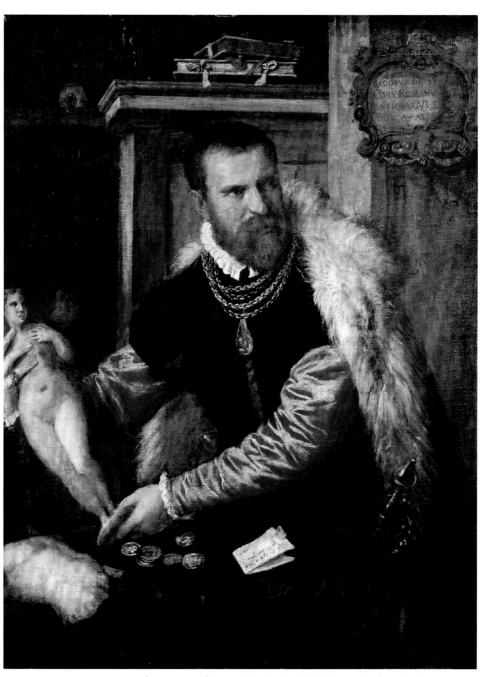

1. Titian, *Portrait of Jacopo Strada*, 1567: his hands hold the work of art but his eyes engage the unseen collector in a timeless image of salesmanship.

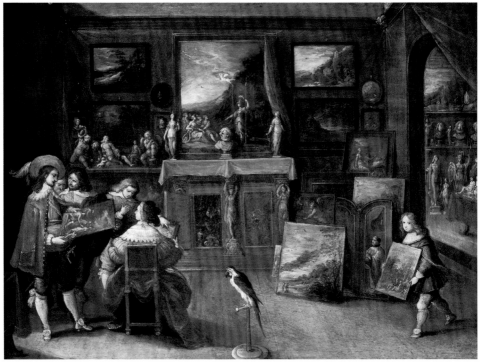

2. Frans Francken the Younger, *A Visit to the Art Dealer*: in the early seventeenth century Flemish galleries like this one were already offering their aspirational clientele a 'retail experience' that combined a grand setting and art expertise.

3. Antoine Watteau, *L'Enseigne de Gersaint* (1720): how the leading dealer in Paris broke down threshold resistance and created the first shopping mall.

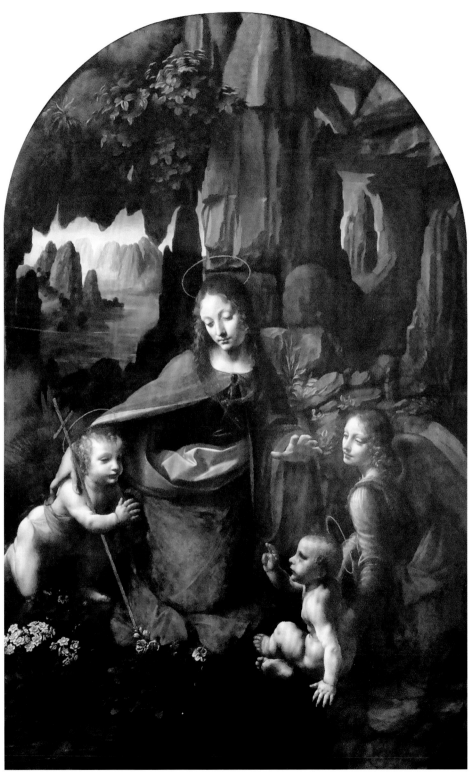

4. Leonardo, *Madonna of the Rocks*: Gavin Hamilton's greatest triumph as a dealer was to discover this picture in Italy and sell it in London in 1785 for £800.

5. Velázquez, *The Rokeby Venus*, or, as its first British owner called it, 'my picture of Venus's bottom'.

6. Rosa Bonheur, *The Horse Fair*: given the full Gambart promotional treatment, including a viewing by Queen Victoria.

7. Sir Lawrence Alma-Tadema, *A Visit to the Art Dealer*, featuring
Ernest Gambart (standing, centre) as a gallerist of Antiquity.

8. Paul Gauguin, *Riders on the Beach*: declared degenerate by the Nazis and sold by Wildenstein to the Hollywood actor Edward G. Robinson in 1937.

9. Monet, *Poplars*: Durand-Ruel encouraged his most marketable Impressionist
to paint landscapes in series, in different lights and seasons.

10. André Derain, *View of the Thames*: one of the revolutionary series of London views painted in 1905 that was the brainchild of Ambroise Vollard.

11, 12. Kahnweiler's stringent definition of Cubism excluded that of Albert Gleizes (a work of 1914, above) but embraced that of Juan Gris (a work of 1913, left).

13. Félix Fénéon, almost certainly the only art dealer ever to have planted a terrorist bomb, at work in his office (painting by Félix Vallotton).

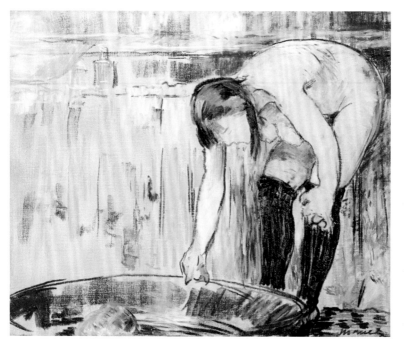

14. The Manet *Baigneuse* that Fénéon imaginatively included in his 'Fauna' exhibition because of the presence of the sponge.

15. Alfred Flechtheim by Otto Dix, 1926: the eternal art dealer, one hand
on a painting and the other on what may or may not be an invoice.

16. Paul Guillaume, from garagist to gallerist: portrait by Modigliani in 1916.

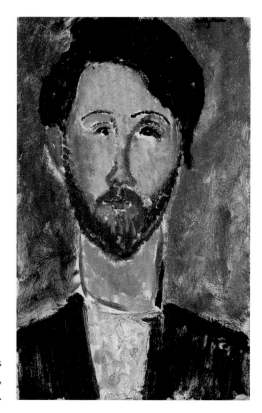

17. Modigliani's 1917 portrait of his other main dealer, Leopold Zborowski, poet turned businessman.

18. Herwarth Walden, founder of *Der Sturm* and pioneer of Modernism, who
ended his life in a Soviet detention camp (sculpture by William Wauer).

19. Salvador Dalí, *The Persistence of Memory*, which was sold
by Julien Levy to MOMA in New York in 1934.

20. Titian, *Rape of Europa*: Berenson's commission on its sale to Mrs Isabella Stewart Gardner was rather larger than he revealed to his partner.

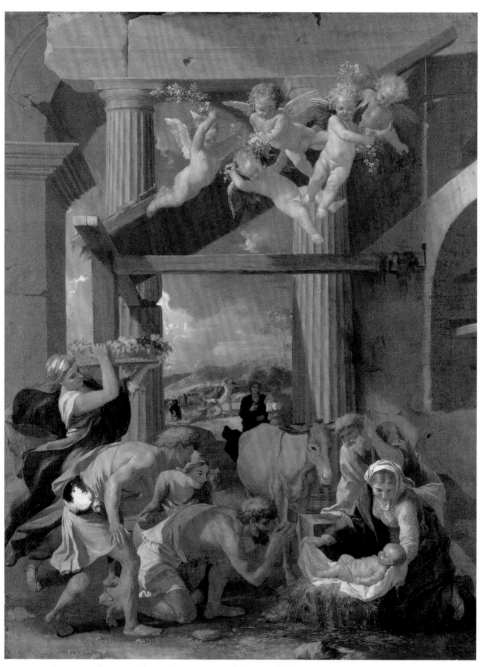

21. Commander Beauchamp's Poussin: sold by Sotheby's in 1956 for £29,000 to great fanfare. Peter Wilson lost £6,000 on the guarantee but deemed it worth the publicity.

Gilot was flattered and Picasso was touched. It was a clever manoeuvre to bind Picasso more effectively into Kahnweiler's control. But the moment Françoise left Picasso, Kahnweiler annulled her contract. Gilot's bitterness would have been understandable. She told John Richardson, with some relish, that Picasso always nursed a wicked suspicion that Kahnweiler was homosexual.

The truth is that Kahnweiler was devoted to his wife, who died in 1945, and there don't seem to have been other women in his life, let alone men. But his maladroitness with the opposite sex never particularly endeared him to Picasso's women; perhaps there was even an element of jealousy between them. Back in pre-First World War years, there had been a battle of wills between Kahnweiler and Picasso's then girlfriend Fernande Olivier. Kahnweiler knew she was dangerous. Fernande said of him: 'he was a real Jewish businessman who bargained for hours until he tired out the artist, who, finally exhausted, would agree to the reduction in price he wanted. He knew very well what he had to gain by exhausting Picasso.' Woundingly, Jacqueline Picasso told Richardson that Kahnweiler 'was mistaken in choosing to see himself as Picasso's friend'. And Dora Maar confirmed to Richardson that Picasso was ultimately detached from Kahnweiler, that they would address each other as 'vous' rather than 'tu'. But what about the rue Vignon years, the heroic time before the First World War, when Picasso went every day to see Kahnweiler at his gallery? Oh, said Dora Maar, he only went there 'out of habit, like a Spaniard who goes to the barber every day'.

There is one other way in which Kahnweiler sometimes fell short. Occasionally his eye let him down. Perhaps it is not surprising that he was taken in, for instance, by a fake Sisley in the 1920s, because the Impressionists were not his field of expertise; but, later in life, he came to grief over a notorious series of drawings that purported to be by Léger but turned out not to be. They were too attractive, according to John Richardson, whose verdict after studying them was that 'they looked too good to be true'. But Kahnweiler gave them the OK. The point is that the 'connoisseurial' demands that Modernism makes on its dealers are different from those of previous generations. Once the criterion of truth to nature goes out of the window, a new sort of eye is needed to make correct judgements, one less tied to traditional standards of quality. The expert must enter that perilous territory where the quality of the execution of a work can be less important than the quality of its concept. It is relatively easy to become familiar with

the range of distinctive styles that Modernism brings into being. What is much more difficult is identifying the individual handwritings within those styles when quality of execution, no longer tied to representation, is a less discernible criterion of merit and indicator of authorial identity.

Confronted by the uncomfortable question of forgeries on the market, Kahnweiler said grandly, 'as for me, I have the solution. I photograph every painting that I buy before it leaves the artist's studio.' His response illustrates both the strength and the weakness of his position. He was so close to 'his' artists that such a photographic record would often have been possible for him; but without it he was sometimes left defenceless. That was the case with the suspect Légers. Lacking a cast-iron provenance linking the works back to the artist's studio, always the first recourse of the modern art expert, he had to make judgements about the authenticity of the artistic handwriting. He was able to identify the style of the handwriting easily enough. It was Léger's. But he wasn't able to go a step further and distinguish between an imitation of Léger's handwriting and his genuine handwriting. Instead he resorted to a more traditional and less appropriate form of connoisseurship. The sequential conclusions that Kahnweiler reached were (1) it's in Léger's style, (2) it's beautiful, so (3) it's by Léger. A cynic might say that the correct deduction was (1) it's in Léger's style, (2) it's beautiful, so (3) it's *not* by Léger. Perhaps it's fairer to say 'It's beautiful in the wrong sort of way, so it's not by Léger.'

Heinz Berggruen recounts an attempt he made to buy a Picasso from Kahnweiler in the latter stages of Kahnweiler's career. After a long negotiation, says Berggruen,

> when I sat down at Kahnweiler's desk to fill out the cheque, I intuitively turned round to him. He was standing there, leaning forwards, right behind me. I suddenly noticed a strangely unpleasant expression on his face, a mixture of greed and satisfaction, and I didn't like it in the least. I lost all interest in buying the painting there and then. I tore up the cheque and left.

This is more than just a dealers' spat. There was indeed something chilling about Kahnweiler. But in the end his life and career was justified by his unlikely relationship with Picasso. The constantly changing, evolving, reinventing spirit of the twentieth century's greatest artist recognised in the dour and cerebral Kahnweiler an intelligence and reliability that he

couldn't find elsewhere. Kahnweiler became Picasso's interpreter. Picasso may have brandished the sign he purloined from a Parisian omnibus at others: but Kahnweiler was the only one permitted to speak to the bus driver.

10

THE FOX AND THE SHRIMP: THE ROSENBERG BROTHERS

René Gimpel was a diarist of genius, casting an amused and humane eye over the international art market as it evolved between the wars. As a dealer himself, his sympathy and preoccupation lay with selling the work of dead artists; but he watched with interest the efforts of those of his colleagues who dealt with living ones. His written portraits of the brothers Léonce and Paul Rosenberg are particularly vivid. Léonce he described as 'tall, blond, and elegant like a pink shrimp'. Paul, on the other hand, was 'no fool, with face like a short-muzzled fox'.

The fox and the shrimp were the sons of an art dealer, but they ran separate businesses and occupied different positions on the dealing spectrum. Léonce was totally, obsessively and self-destructively committed to the art of the avant-garde, and particularly to promoting the works of the Cubists. Unfortunately he brought to the challenge little business acumen and an excessively high opinion of himself. Paul, on the other hand, was altogether more successful commercially. By the First World War he had established himself as one of Paris's leading dealers in the work of acknowledged masters of the previous hundred years. But towards the end of the

Léonce Rosenberg drawn by Metzinger, who once said 'we artists were the whores and Rosenberg our customer'.

war he began looking at contemporary artists and promoting them alongside his more conventional trade in artists such as Ingres, Delacroix, Corot and the Impressionists. He was one of the first to learn the lesson that disturbing contemporary art can be rendered more palatable to your clients by marketing it alongside already accepted masters of the past. It is a lesson not lost on the wilier operators in today's art market, although they come at it differently: Paul Rosenberg used the context of established masters to lend credibility to new artists. Today's dealers in old art often take on moneymaking new artists in order to bolster their dwindling trade in artists of the past. Anyway, what makes Paul Rosenberg one of the most important dealers of the twentieth century is that in 1919 he took on Pablo Picasso, and remained his dealer all the way through to the Second World War.

It had been Léonce Rosenberg, however, who originally lured into commercial captivity the exotic beast that was Picasso. After Kahnweiler's exile to Switzerland in 1914, Picasso found himself without dealing representation. This had financial consequences. Picasso's much-quoted remark that he wanted to be a rich man who lived like a pauper was now put to the test: he found himself temporarily a poor man with increasingly rich taste who lived like a pauper. And so when Léonce came along, turbo-charged

with a compelling rhetoric of future success, Picasso was momentarily swept off balance into his slipstream. Léonce's recollection of the war years is anything but modest: 'During the entire duration of the war and even whilst mobilised I subsidised, by continuous purchases, the entire Cubist movement,' he claimed.

The gallery that Léonce established for the propagation of the Cubist movement was called L'Effort Moderne, which suggests an establishment somewhere between a gymnasium and a fashion house. It became a centre for advanced art, where modern poets would gather to read and discuss their work against a background of Cubist art. Picasso, of course, was his prize trophy. He dismissed any suggestion of Picasso ever returning to Kahnweiler, who was after all a German: 'I don't think it would be a very good idea for Picasso to be handled from Berlin or Frankfurt. The Picassos would arrive here with a vague odour of sausage and sauerkraut.' 'Together we will be invincible,' he assured Picasso. 'You will be the creator, I will be the action.' Picasso wondered out loud to Jean Cocteau if Léonce Rosenberg was only pretending to be a complete idiot. In the end he lost patience with Léonce's magnificent combination of hyperbolic talk and no sales. '*Le marchand – voilà l'ennemi,*' he declared of Léonce in 1918. It was resonant imagery to deploy at the end of the most destructive war in the world's history.

The account of Léonce Rosenberg given by other artists in his stable confirms Picasso's suspicion that the dealer periodically spiralled off into some higher realm of imbecility. Lipchitz defined him as 'a man who has worked hard to make himself liked but in such ways that he has instead made himself hated'. He issued authoritarian and restrictive contracts to his artists, regularly supplemented by edicts as to how they should and should not deploy their talents. He was very against any of them having anything to do with the Ballets Russes. 'I cannot tolerate,' he said in a letter distributed to all of them, 'either now or in the future, your participation in a category which, in my opinion, is more of a craft than a form of art.' Gino Severini, another who was contracted to him, observed how 'he could rise to the sublime in general ideas and immediately after decline to the lowly plane of commerce in the art market'. In another group letter, Severini reports, Rosenberg told them that he would present Cubism as the 'true heir of the disturbing mystery of the Chaldeans, the Egyptians, the Chinese, the Toltecs, the Indians, the Greeks and the primitives'. Immediately after this high-flown stuff came a postscript:

It is of *vital* interest that in the future, no one see your latest works, finished or not, *in your studio*, ready for consignment. Among other reasons, the fact that their existence would then be known, would not only pose an obstacle to my efforts at propaganda and proposals to certain collectors, but would also heavily influence the placement of previous works, the circulation of which throughout the world is as necessary to you as it is to me.

Metzinger put it more bluntly: we artists were the whores and Rosenberg our customer. It's the old dilemma of the thinking dealer: which should predominate, art or money? There is an underlying sense that the two are in conflict. Art is a high-flown, beautiful commodity. Money is sordid, but necessary. How to resolve it? Léonce never quite did. But, as Severini acknowledged, he came up trumps during the war: 'Rosenberg and his money permitted us to get on with our work as if the war were non-existent, an important consideration for artists.'

And there are moments when Léonce Rosenberg's letters to squawking artists are quite funny. Léger complained about some perceived lack of support from his dealer. Rosenberg wrote back:

Dear Léger, your letter, phrased in friendly terms which I greatly appreciate, reminds me of one sent by a woman whom I dearly loved 18 years ago or so. Since my linguistics were not ardent enough and I did not cry out in high shrieks, she accused me of not loving her and of preferring one of her rivals. Like you, she wanted to be loved 'overmuch'. Calm down. I love your painting, but not so much for its actual state as for what it promises.

It is a letter that gives Metzinger's image of the 'artist as whore and Rosenberg as customer' even more resonance.

So Picasso moved on to the welcoming arms of Léonce's brother Paul. It was a good move for both of them. 'The artist and the gallery owner made one another,' said Pierre Nahon later. Paul Rosenberg, already established as a leading dealer in acceptable modern French art, was altogether a more balanced and commercially sophisticated force. No heart-searching about the relationship between art and money held him back. Almost immediately he went into partnership with Georges Wildenstein (who was himself making a typically well-judged entry into the market for

contemporary avant-garde art) to sell Picasso in Europe and America. This was achieved very successfully through the 1920s. There was less pretentious rhetoric from Paul than Léonce. In a 1927 interview, Paul claimed to find no beauty in a canvas unless it sold. This was said tongue in cheek, but there is some truth in the observation of the Cubist painter Amédée Ozenfant that Léonce would take on art that he loved and fail to sell it, while Paul would take it on, hate it and sell it. Picasso, sensing the opportunity reopening to play the rich man living like a pauper, liked the sound of Paul's single-mindedness. Paul, who moved in more urbane and chic circles, turned Picasso into an urbane and chic artist. Picasso was at his most worldly in the early 1920s. But how far did his new dealer influence the direction that Picasso's art itself now took?

This is the central question of Rosenberg's relationship with Picasso. And it is a mighty one. Could it be that even Picasso was to some extent the creation of a dealer rather than vice versa? In order to understand the background, it is worth quoting Gimpel's account of a visit to Léonce's gallery in July 1919:

At Léonce Rosenberg's, rue de la Baume. A quiet little house harbours the revelation. An unobtrusive plate on the door: L'EFFORT MODERNE. I rang the bell and was let into a low-pitched entrance way, tiled very simply in black and white. I was shown upstairs to a large, long room forming a gallery. Here he has displayed cubes of canvases, canvases in cubes, marble cubes, cubic marbles, cubes of colour, cubic colourings, incomprehensible cubes and the incomprehensible divided cubically. What is on these canvases? Puzzles composed of patches of flat colours, interwoven and yet sharply differentiated. Léonce Rosenberg... does splendidly: he keeps his gravity. I can take a lesson from him, a lesson in salesmanship, for Rosenberg manages to earn his living with all this; he must be an admirable salesman. I would like to see him at work. The sculptures are the most curious. I stopped in front of a marble ball cut like a Dutch cheese. I asked Léonce what it represented, and he replied: 'It's a woman's head.' I gazed, astonished, and then he added: 'Only the form counts: it makes any representation of accessories – the mouth, eyes, and nose – quite superfluous.' ...

He showed me a kind of arch, a miniature aqueduct with two pillars, one straight and the other zigzag. 'Isn't it utterly simple and magnificent?'

'What is it?'

'A seated man. Here we have the visual sense of the figure, not the constructive sense.'

He pointed to a sort of big lentil and said: 'It's a woman's stomach.' I ought to have guessed it by the navel in the middle like a beer spout. 'It's a jeu d'esprit, not of the senses,' he added. 'We are the descendants of Watteau, Delacroix, Ingres.'

Finally I came to a statue that was all angles; it was a marble but gave the impression of being coated in steel, armour-plated from head to foot. I was relieved: I now felt that I'd made progress, that maybe I no longer needed explanations, and I declared with the authority of something seen and understood: 'Now, that's a knight.'

'No,' replied Rosenberg, 'it's a female nude.'

If Gimpel, who was after all an art market professional and not unsympathetic to developments in modern French art, reacted like this to Cubism, then how much more resistant the average art buyer would have been to it. There is no doubt that Paul Rosenberg, who had a salesman's antennae for such things, encouraged Picasso away from Cubism. At this point, Picasso was ready to be persuaded. He agreed to a lot of what Rosenberg proposed to him, including moving in to the grand house next door to Rosenberg's even grander gallery in rue La Boétie, an establishment described by Jacques-Émile Blanche as 'the Ritz Palace'. With Picasso as his neighbour, Rosenberg was able to keep a careful eye on him. He introduced Picasso to smart Parisian society and turned him into a fashionable gentleman, a role his new wife Olga was keen to buy into.

It is surely significant that, of the 167 drawings and watercolours that comprised the first exhibition Paul Rosenberg gave Picasso in 1919, not one of them was Cubist. The subjects were largely representational, harking back to the Blue and Rose Periods, although handled with an evolving dynamism. Paul knew what he could sell. His question in a letter of the time to Picasso sounds a trifle disingenuous: 'Léonce says you're a greater painter as a cubist than you are as a painter from nature... am I too narrow-minded?' Picasso seems to have been happy to reassure him that such narrow-mindedness was not a problem. He was, after all, receiving good money from Paul, who was buying his work regularly at substantially higher prices. There is no doubt that Paul recognised in Picasso a unique artistic force. But he was also keen to position him in the French artistic

tradition of the eighteenth and nineteenth century. He was selling him in the same premises where he sold works by Ingres and Delacroix, as well as Renoir, Pissarro and Toulouse-Lautrec. The fact that Picasso's portrait style became very influenced by Ingres at this time is significant; indeed the fact that he was producing a considerable number of portraits, and doing so in a realistic, neo-classical style, is a reflection of his new role as a 'fashionable' painter.

Still, an artist as strong-willed as Picasso was only amenable to a dealer's pressure so long as he agreed with the direction in which he was being pointed. He was perfectly capable of rejecting commercially motivated proposals that he didn't like. In June 1919 Rosenberg broached to Picasso the idea of a series of paintings of the Thames *à la* Monet. 'They would be a great success,' claimed the excited dealer, echoing the enthusiasm of Durand-Ruel as he despatched Monet to the Savoy, and indeed of Vollard as he sent Derain off to a rather less grand hotel in Maida Vale. Picasso was unmoved, and refused. He did do a series that year, but on his own terms, of balcony scenes in the south of France. Landscape wasn't his thing, but Paul continued to press him in that direction and reacted ecstatically when he sold a rare example of Picasso as *paysagiste*: 'The most unbelievable, the most extraordinary, the most inconceivable news... Yes, my friend, I have sold a Picasso, the one you thought was unsaleable, le paysage rousseauiste.' Under the cover of irony, Rosenberg is saying, 'See, I told you so.'

When Picasso reinvigorated his Cubism in the mid-1920s, Rosenberg went along with it. But the Cubism of the 1920s is more colourful and commercial than the Cubism of 1911–14. Rosenberg went along with it because he found he could sell it. Maybe he could sell it because to a certain extent he had consciously or unconsciously influenced the form it took. It is worth noting, too, that Rosenberg's contract with Picasso gave him the right of first refusal, rather than the obligation to buy everything Picasso painted. Implicit in this arrangement – which would not have been lost on Picasso – was the acknowledgement that Rosenberg found some of the artist's works more saleable than others. What influence, if any, this had on how and what he painted remains an intriguing if ultimately unanswerable question.

Even as late as 1939, at the very end of the Rosenberg-Picasso association, the question flickers on. Meric Callery was an American artist in Paris at the time. She gives an eye-witness account of the final Picasso exhibition that Rosenberg mounted: 'Rosi is in a state of great excitement,

it is as though the pictures were painted specifically to his taste.' It is a light-hearted comment, but there is an underlying commercial truth to it. Every work was a more or less representational still life; everything was 'pretty, colourful, and gay'; nothing was too 'difficult'. Was this Picasso's final concession to his dealer?

'Although it was short-lived and unsuccessful,' wrote John Richardson, 'Rosenberg's attempts to manipulate the artist would cast a long shadow. Critics still cite the early works that Picasso did for his dealer to disparage the masterpieces in which he challenged the canons of classicism.' But Paul Rosenberg's efforts had the desired effect commercially, with Picasso's prices doubling in 1920–21 and continuing to rise significantly till the Wall Street Crash in 1929. This was in part the result of Paul Rosenberg's judicious promotion of the artist as (again in Richardson's words) 'a protean modern master rather than a "difficult" cubist'.

Georges Braque, another who suffered during the First World War from the loss of Kahnweiler as his dealer, was also initially ensnared by Léonce Rosenberg until he took exception to Léonce's support of the Kahnweiler sale. Braque, an emotional man and no mean pugilist, landed a punch on Léonce's jaw in the saleroom itself. The fallout saw Léonce take a course of boxing lessons in order to defend himself from future attacks, and Braque – like Picasso before him – leaving Léonce's employment to sign a contract with his brother Paul. A similar process of decubicisation was already in motion with Braque, encouraged by Paul, who had no doubt that a new non-Cubist brand of Braque would be easier to market.

Paul, like Durand-Ruel before him, recognised that in the territory separating artist and collector that he as a dealer so gainfully patrolled, there was room for a further catalyst to the construction of deals: the critic. It was his strategy to get as many on his side as possible. He also had the same percipient vision as Durand-Ruel of the future importance to the art market of America. He worked tirelessly in creating a demand for Picasso in the United States. In 1923 he mounted Picasso's first show there, in Wildenstein's New York gallery. It was a largely representational show, abounding in harlequins and other motifs carefully calculated not to frighten too many horses. Nonetheless it was tough going: 'Your exhibition is a great success,' reported Paul to Picasso, 'and, like all successes, we have sold absolutely nothing.' How often has a dealer had to report that depressing gap between eagerness of critical reception and reluctance of buyers to loosen purse strings. Nothing daunted, Paul continued: 'You

must be strong like me, or crazy like me, or persistent like me, to undertake this enterprise.'

In the United States an important new client was enticed in John Quinn, although Quinn found Paul's persistent salesmanship a little wearying. But Rosenberg suffered, too. A vignette of the trials and tribulations of the gallery-owning art dealer is provided by Roger Fry's eye-witness account of Emerald Cunard's visit to Rosenberg's premises in rue La Boétie in 1925. In 'a screaming parrot voice' she demands a blue period Picasso and a Matisse. She turns down the Pink Period work she's offered, then the Matisse. 'I want a blue Picasso and you haven't one and a Matisse and you show me a silly fish on a plate.' Fry listens to her 'endless plaints and screams and Rosenberg's deferential murmurs', then recommends to her a pair of figure paintings by Braque also on view in the gallery, suggesting that they are like early Chinese paintings. 'Well, if you call them Chinese,' ripostes Lady Cunard, 'I think they're very beautiful, but if you call them French, I think they're quite stupid.' Who says art dealers don't earn every penny they make?

In 1926 Paul opened reconstructed premises in Paris, discreetly modernised. He now framed contemporary paintings in simple, uniform mouldings. Louis Quinze-style frames, traditionally and inappropriately attached to the Impressionists, were finally banished. Paul's series of major Picasso shows on both sides of the Atlantic led on to the great museum exhibitions of the 1930s devoted to the artist, in Zurich, in New York and in Hartford. Indeed the museums could not have mounted these shows without Paul's support. The quid pro quo was that Paul and other dealers retained a commercial interest in some of the exhibits. Extraordinarily the Zurich retrospective in 1932 contained eighty-five works that were actually advertised as for sale. And in the 1930s Paul strengthened his position as the leading impresario of French art by signing up Matisse on an exclusive deal. You got as good as you gave with Matisse, who was a canny and demanding negotiator, but Matisse was at a low spot in 1934 and responded to Paul's offer of an exhibition in his gallery. In Matisse's words, Paul Rosenberg 'galvanised me'.

If the serpent in Paul Rosenberg's Eden had a surname, it was probably Wildenstein. Their cooperation in America was a meeting of titans. Few people would ever get the better of a business partnership with the Wildensteins, but Paul was as well equipped as anyone to stand up to them. Paul said of Georges Wildenstein, a trifle acidly: 'He was clever enough to

understand that an exhibition of Paul Rosenberg's fine modern paintings will bring him a lot of customers to whom he might sell old paintings.' One of the prerequisites for a successful art-dealing partnership is to avoid having an affair with the wife of your business associate (or your partner's partner, in twenty-first-century parlance). But 1932 was an erotic year. Picasso was disporting merrily with Marie-Thérèse Walter. Georges Wildenstein, yielding to the zeitgeist, took up with Mrs Paul Rosenberg. When the cuckolded Rosenberg discovered his wife's infidelity, the business arrangement between Wildenstein and his company was abruptly terminated. It puts into ironic perspective Rosenberg's reply to a journalist's question as to his relations with his fellow dealers: 'I have for each of them the same respect they have for me.' Paul Rosenberg's granddaughter, the broadcaster Anne Sinclair, suggests that Paul's single-minded obsession with avant-garde art wrecked his marriage: 'all he needed to do was look away from his Picassos for a moment to gaze at the Renoir – pretty, charming and curvaceous – that he had in his bed'. If only the balance between an art dealer's professional and private life were so simple.

Although he was serious about money, Paul Rosenberg was also serious about art. It was a complicated equation. Kahnweiler may have criticised him as being more like an interior decorator than an art dealer because he advertised to buy van Goghs, but Paul felt strongly about works of art and his desire to possess them could be intense. According to his fellow dealer, Alfred Daber, his 'body began to tremble like that of an impatient child when he saw a work that he craved, a trembling that subsided only when he obtained the painting'. Clive Bell happened to be with Paul in his gallery when news came through of the death of Renoir. Rosenberg's reaction gives another vignette: the dealer 'poured out a torrent of tolerably insincere sentimentality' about the artist. 'It was unforgettable,' wrote Bell. 'This black jew, with the smutty tears on his cheeks, a lump of half-real emotion in his heart, and in his head a very clear idea of the probable rise in the price of Renoirs of which he has a sizeable collection.' So it is with art dealers: even their emotion often comes at a price.

Like Kahnweiler, Paul Rosenberg felt that Surrealism was serious in its literary form but negligible as a movement in the visual arts. 'Monsieur,' he said to Salvador Dalí when the artist asked him for representation, 'my gallery is a serious institution, not made for clowns.' The most sympathetic thing about Paul was his sense of humour, heavily flavoured with irony. If he's not telling Picasso that his American exhibition, like all successes, has

*Paul Rosenberg with a work by Matisse, whom he
'galvanised' in the 1930s, according to the artist.*

sold absolutely nothing, he's addressing him after a period of radio silence as 'dear evaporated and invisible friend'. Possibly Picasso brought out the best in Paul as a correspondent. Paul wrote him an amusing description of Deauville in high summer: 'It's the sort of country you'd like, very cubist and full of proportions. It's also full of the French and foreigners, (1) of flirtatious and respectable women, (2) of gamblers and serious people, (3) of crooks and honest people, (4) of people who have gone to prison, and people who will, (5) of people who are enjoying themselves and others who just show their faces out of snobbery.'

There must have been increasingly frequent moments in the 1930s when Rosenberg sensed his prize artist eluding his grasp. Allegedly he burst out in frustration at a particularly graphic Picasso nude of his lover Marie-Thérèse, 'I refuse to have assholes in my gallery.' (It sounds better in French, like so much to do with impropriety.) Here was one more item, to add to clowns like Dalí, that he refused admittance to his premises. But it was also an anguished *cri de coeur*, as he sensed Picasso moving away in different and alien directions. The final rupture came with the war and its enforced physical separation. Picasso stayed in France; Paul went into exile

in New York and joined the Fifth Avenue Resistance, watching anguished from afar as events unfolded in Europe and works of art – Rosenberg works of art – were expropriated by the Nazis. He never returned to deal or live in Paris, but carried on business in America for a decade after the war. It was a sad final act to his life: most of his energy was devoted to trying to recover his looted stock. And as a dealer, looking back ruefully from his New York exile, he reflected *à la* Durand-Ruel: 'it would be so much simpler and more lucrative for me to make exhibitions of the great French nineteenth-century masters rather than contemporary works that unsettle our visitors'.

What was it about Cubism that attracted as its dealing defenders such an odd range of men? There was Kahnweiler, grim, single-minded, scholarly, inhabiting a joke-free zone; Léonce Rosenberg, absurd, obsessed, a salesman with no business sense blighted by an impossibly high opinion of himself; and, a generation later, Douglas Cooper, the dealer-collector who put together one of the great Cubist collections but whose personality was so poisonous that he managed to fall out with just about everyone he had dealings with. Set in this context, Paul Rosenberg – a more ambivalent proponent of Cubism – seems rather attractive. At least he possessed some lightness of touch; he may have been obsessed with business, but he was good at it, and Picasso appreciated him for that, and for his ability to see the comic side of life. The tone of his letters to Picasso is sympathetic and amusingly ironic. It makes you regret that Picasso's replies to him have been lost.

As a dealer Paul Rosenberg was adept at understanding and reflecting back to the artist the preferences and desires of the buying public. He knew what would sell, and pushed Picasso in that direction. Kahnweiler on the other hand loved the Cubist works that Picasso produced and encouraged him to paint more; he was adept at reflecting back to the buying public the preferences and desires of the artist. The fact that he found fewer collectors to buy Cubism was a regrettable but secondary consideration. In the artist's career up to the Second World War there is no doubt which one of Kahnweiler and Paul Rosenberg made Picasso more money. For an artist who needed regular and substantial injections of cash in order to live the life of a pauper to which he aspired, that counted for a lot.

11

TERRORISTS AND TASTEMAKERS: MORE FRENCH DEALERS

Art dealers emerge from an extraordinary variety of previous or even concurrent careers. Roy Miles, who lent glamour to the market for Victorian pictures in London in the 1970s, had started life as a successful society hairdresser. William Wethered, who dealt in British pictures in the early nineteenth century, carried on a simultaneous business as a tailor. Indeed one of the most famous invoices in British art dealing history reads: '2 pairs black cas. trousers, lined throughout, £1-18s; 2 paintings by William Etty, £210'. Sidney Janis, the promoter of American Abstract Expressionism, was a shirt manufacturer; Tomás Harris, an old master dealer in London either side of the Second World War, was a spy. Louis Victor Flatow, as we have seen, was a chiropodist. But Félix Fénéon is probably unique in that, in order to become a highly regarded dealer in contemporary art in Paris in the early years of the twentieth century, he gave up a career as a terrorist.

Fénéon was many things: a man of letters, an energetic lover of women, a bicyclist, an art critic, a collector with an enthusiasm for the outlandish, and an anarchist (see plate 13). As a critic and collector, he particularly championed Seurat, and he was an early owner of the artist's magnificent *Baignade*, now in the National Gallery, London. His style of writing was

distinguished by a mordant economy. Comparing the prosaic horse painter John Lewis Brown with Degas, he noted: 'J-L Brown: Horses, jockeys, society for the betterment of the equine species, Bois de Boulogne, etc. M. Edgar Degas found twenty paintings there, and M. Brown the way to make a single one a hundred times over.' And he produced a cogent appreciation of the novelty of Toulouse-Lautrec: 'By drawing not a traced copy of reality but a set of signs suggesting it, he immobilises life in unexpected emblems.'

He was described as possessing a 'diabolic reserve'. 'What was Fénéon thinking, exactly?' wondered his colleague at Bernheim-Jeune, Henry Dauberville. 'Nobody could have known. I think that deep down he had the greatest of contempt for his contemporaries.' There was a subversive strain running through his life, which initially manifested itself in a polit-ical anarchism, rooted in the fight against social injustice. For Fénéon, anarchism was an expression of the nobility of the soul, founded on a con-viction that the aesthetic imperative must ultimately outweigh the ethical one. It was a very fin-de-siècle position. And it led to action.

Fénéon helped his anarchist comrade Émile Henry prepare for a bombing in Paris on 8 November 1892. The explosive was hidden in a kettle. Fénéon's contribution was to lend Henry one of his mother's dresses as a disguise. Witnesses saw the bomb planted by a strange woman with a large bundle in a basket over her arm. It later blew up, killing six people. 'What intimate charm in this story,' wrote Fénéon, referring to the explo-sion of 'the delightful kettle of the Rue des Bons Enfants.'

The following spring, Fénéon planted his own bomb. Planted is the operative word, as the explosive was packed into a flowerpot, rather than a kettle, and the fuse was ingeniously concealed in the stalk of a hya-cinth. On 4 April 1893 he set it off in the restaurant of the Foyot hotel, in the Latin Quarter. No one was killed, and only one person was injured. Fénéon was arrested, along with a number of other suspects. He was sent for trial, but acquitted.

Where does an anarchist go from there? In Fénéon's case to an editorial role on *La Revue Blanche*, the highly regarded journal of the arts, where he worked from 1895 to 1903. This allowed him expression of his 'intuition of the new and unusual', both literary and artistic. Art, to Fénéon, was all about colour and nothing to do with anecdote, hence his aversion to aca-demic art and his fascination with the Neo-Impressionist attempt at the scientific analysis of colour. The new and unusual for Fénéon and various other members of the *La Revue Blanche* staff also encompassed bicycling.

Fénéon was a devotee of the bicycle: it has been suggested that it appealed to his sense of the ridiculous. A less plausible story, based on his vantage point behind the handle bars, was that he occasionally filled in as sports reporter at *La Revue Blanche*.

In January 1900 Fénéon used the premises of *La Revue Blanche* to put on a big exhibition of the works of Seurat; from exhibiting and buying to selling was not a large step, and in 1906 Fénéon redefined himself yet again, this time as an art dealer, joining Bernheim Brothers in the Boulevard de la Madeleine to take charge of their contemporary art department. Bonnard, Vuillard and other Nabis were already handled by the gallery, which appealed to Fénéon. His intention was to add his Neo-Impressionist friends to the stable, van Rysselberghe, Signac, Cross and Luce. Signac sounded a note of scepticism: 'Félix has joined monkey-nut Bernheim,' he wrote. 'I don't see our friend winning out over the boorishness of those industrialists.'

It was indeed an odd reincarnation for a terrorist, to be selling art to some of the people he might have held responsible for the social injustice against which he had previously been protesting; but Signac was wrong. Fénéon proved himself singularly adept at dealing with the boorishness of the industrialists. It was almost as if Fénéon was achieving some sort of magnificent revenge. Still, there were flashes of the old subversiveness, an ambivalence with rich collectors. He was an internationalist. With Henry van de Velde, Count Kessler, Julius Meier-Graefe and others, he helped organise exhibitions of modern French art in Germany and other countries. He had no concern for France's 'national heritage', encouraging French art, of whose greatness he was in no doubt, to flow unchecked across national borders. He was an individualist, and felt paintings should be enjoyed like a love affair, a personal matter. The dead hand of the museum on a work of art was depressing to him: he had no problem with private ownership, and indeed in the role of middleman was rather like a matchmaker.

Bernheim-Jeune came into its own as an art dealership at the turn of the century, in the hands of the founder Alexandre Bernheim and his two sons Josse and Gaston. They enjoyed the patronage of the second generation of the collectors of Impressionism, men such as Auguste Pellerin, Étienne Moreau-Nélaton and Paul Gallimard. Daniel Halévy describes the 'Semitic lucidity' of Bernheim, whose position on the dealing spectrum was at the salesman rather than the scholarly end. The influence of Fénéon

was to put the Bernheims in touch with the new avant-garde. He was also good for the artists he recruited. A distinguished array of names signed contracts with Bernheim, persuaded into the commitment by Fénéon: Cross in 1906, Signac in 1907, Matisse in 1908 and van Dongen in 1909. Over the years he also held in stock works by van Gogh, Cézanne, Seurat, Toulouse-Lautrec, Picasso, Modigliani and Dufy. If Bernheim objected to the acquisition of an avant-garde work that he favoured, he sometimes bought it himself. His earnings from Bernheim were about 15,000 francs a year, a substantial sum. If there is one thing more dangerous for the established order of things than a terrorist with a bomb, it's a terrorist with a chequebook. Artists he worked with liked the way he treated them. He was surprisingly good at the commercial side of things. A junior member of the Bernheim firm remembers: 'Every time a transaction appeared to be in difficulty, he went on the road, to England, Germany, and Scandinavia.' He would sort things out by 'prudence, tact, personal charm, and prestige... He gave the impression of not being a businessman, but he was.'

He also brought a sense of humour to proceedings, always an asset in an art dealer. 'Naturally,' he wrote to another of his artists, Charles Angrand, 'you will name a price big enough to leave a large margin for the cupidity of the merchant.' He had the great dealer's genius for improvisation and lateral thinking. On one occasion he put together an exhibition entitled *Fauna*. There was a pickled herring by van Gogh, and a landscape by van Rysselberghe in which a wheeling bird could just be descried in the sky. But spectators were baffled by the pastel by Manet of a woman taking a bath. Where was the animal life in that? 'The sponge,' explained Fénéon (see plate 14).

Taciturnity as a sales technique has been practised by a number of art dealers in modern times: the 'solemn and melancholy Dutchman' E.J. van Wisselingh was, in the words of his contemporary Oliver Brown of the Leicester Galleries, 'one of the most silent men I have ever known. He would point to a picture, look at me and stroke his beard without saying a word.' Or then again there was the approach favoured by Hector Brame in Paris, described by René Gimpel as 'an eccentric dealer who shows his pictures only to people whose faces he likes'. Gimpel adds one more to the list: 'the English dealer Sulley is obviously incapable of lying; indeed he scarcely speaks at all. He takes you up to a picture, stations himself behind an armchair, and opens his lips only to tell you its price, and even then only on request.' Fénéon was in this tradition, too. Perhaps it was

the legacy of his anarchism, a lingering impatience with the boorishness of industrialists, that persuaded him to treat potential buyers with cool disdain. He would place paintings before them without any comment, or even leave the room while they were contemplating a choice. If questioned, he replied in monosyllables. It was as if the pearls presented for the admiration of the swine needed no further elucidation. When a customer queried, 'What is that?' pointing a finger at *Iris, Messenger of the Gods*, a torso with widespread thighs sculpted by Rodin, Fénéon replied, 'That is a lady, madame.'

It is testament to the loyalty of Matisse to Bernheim that he stayed twenty-nine years with the firm, even though he had to put up with the anarchic vagaries of Fénéon's salesmanship. Matisse himself recounts a typical incident:

> I had just convinced a couple who were interested in my painting to go with me to the Bernheim-Jeune Gallery where our Félix was working – the famous salesman and expert on modern art... I introduced my companions to him; he had the office boy show my latest paintings, and just as the husband seemed to have made up his mind to buy certain ones, Fénéon, who up to that moment had kept his peace, raises his voice and strongly advises them not to buy, saying it would be better to wait for some new works of mine. Well, after my two art lovers were gone, I couldn't help telling him how astonished I was at how he had acted. 'But my dear friend,' he replied, 'you surely did not want your beautiful compositions to go to live with those stuffy people!'

After the First World War, Fénéon grew increasingly reclusive from the art market. He had to be coaxed to work at Bernheim by being collected from home in a taxi. He remained an enigma. As his biographer, Joan Halperin, suggests, his whole life could be interpreted as an act, a series of roles assumed in order to protect his privacy.

Paul Guillaume (1891–1934) was an important French art dealer who set up shop in the early years of the twentieth century (see plate 16). His first job, as a very young man, seems to have been working with automobiles. Quite what he did is not clear: changing tires? Tinkering with carburettors? Actually selling the machines? Perhaps this wasn't quite as odd as it seems, in the context of the time. The automobile symbolised something innovative, exciting, even futuristic; and perhaps it wasn't such

an outlandish jump to go from that to dealing in innovative and exciting modern art – not when you opened your first gallery in that year of all years for Modernism, 1914. Guillaume's first show, in his gallery in rue de Miromesnil, was an exhibition of the works of the Russian avant-garde artists Goncharova and Larionov. The foreword to the catalogue was written by Apollinaire. For a twenty-three-year-old automobile mechanic to open a gallery in a fashionable street and show cutting-edge contemporary art, supported by one of the leading critics in Paris, suggests that he was an exceptionally daring and persuasive character.

The other thing that distinguished Guillaume at an early stage, apart from his pleasing transmutation from garagist to gallerist, was his interest in African art. Again the origins of this interest are unclear. One story has it that his first employer – at the garage – nursed an unlikely passion for the subject. Another is that his cleaning lady's nephew was posted to Africa and sent back some examples of native art that caught Guillaume's attention. But whatever the truth, the collector André Level records that Guillaume was already selling him African masks before the First World War, which makes him a pioneer in the field, particularly in view of the fact that Guillaume was not trafficking in these objects as ethnographica, but already saw them as potent stimuli to modern Western artists. It is no coincidence that at this juncture Guillaume and Modigliani were drawn to each other, as evidenced by the fact that, after buying African masks from Guillaume, the next thing Level bought from him was a work by the young Italian. Guillaume had been introduced to Modigliani by Max Jacob in 1914, and it is clear that African art was one of the formative influences on Modigliani's eye-catching and distinctive approach to portraiture. Guillaume – who wrote extensively on African sculpture himself – must surely have encouraged Modigliani in this defining direction in the artist's style, even if, as some historians maintain, he pushed Modigliani's painting at the expense of his sculpture.

Through the years of the First World War, in which Guillaume was exempted from military service for health reasons, he sold the work of a number of avant-garde artists. He gave Derain an exhibition in 1916, and he continued to support Modigliani, whom he installed in a studio in Montmartre near the Bateau-Lavoir. In fact Modigliani painted his dealer three times. The Italian, who was fond of inscribing his work with names or runic observations – possibly under the influence of drink or drugs or both – wrote on one of his portraits of Guillaume, *Novo pilota*. That's

what Guillaume clearly was: a pilot of the new, and it is a rather touching acknowledgement from artist to dealer of the role he was playing in his development at this important moment.

Guillaume's exclusive rights over Modigliani, if they ever existed, he was content to let lapse as the war progressed. The Polish dealer Léopold Zborowski, of whom more later, took over much of the selling activity. Meanwhile Guillaume was after bigger game. Once peace was declared, he moved his gallery to the elite rue du Faubourg Saint-Honoré. He marked the end of hostilities with an opening exhibition of splendid scope in December 1918 entitled *Peintres d'Aujourd'hui*. Works were included by Picasso, Matisse, Modigliani, de Chirico, Derain, Utrillo and Vlaminck. Such was the standing of Guillaume that this exhibition was rumoured to have been put together almost entirely from his own holdings. And, like other pioneering dealers before him, such as Durand-Ruel and Cassirer, he backed up his marketing of avant-garde art by publishing a magazine, *Les Arts à Paris*, which included articles and interviews subtly pitched to boost the art and artists already represented in Guillaume's collection. Not that dealing with his high-maintenance artists was plain sailing. Gimpel offers a vignette of Guillaume trying to pin Matisse down at the exhibition:

> I entered at the very moment when Matisse was leaving. Guillaume just had time to catch him by the arm. Indicating one of his canvases, he asked him the significance of a vertical blue band behind a green pot containing about ten flowers; the pot is on a little square juggler's table. The little table is as rickety as the painting. 'It's simply a moulding,' the artist replied. 'I don't paint natural wood.' Guillaume said timidly: 'It's just that I don't understand and I've got to explain to my clients.' Matisse, curtly imperious, retorted: 'My school doesn't explain.'

Here is the eternal dilemma of the contemporary art dealer: Guillaume is caught between a literal-minded clientele hungry for answers and artists who refuse to explain. But Guillaume was clearly good at navigating these difficult waters. He was becoming one of the leading personalities in the Parisian art world, and his exhibitions were attended by the social, literary and artistic elite. In 1919 he gave a 'Fête Nègre' at the Comédie des Champs-Elysées, which caused considerable excitement in avant-garde circles.

And now the bigger game that Guillaume was after emerged lumbering

out of the jungle in the demanding, contrary but discriminating shape of Dr Albert Barnes of Philadelphia. In the immediate post-war years Guillaume laid immediate and successful claim to the trophy of this famous collector. Guillaume described him as 'extraordinary, democratic, passionate, inexhaustible, charming, impulsive, generous, unparalleled'. It is either an exceptional client who elicits such praise from a dealer or a very rich one. Barnes was both. And it's clear that Guillaume provided him with a level of service he wouldn't have received from, say, Vollard: when Barnes was in town Guillaume gave him his full attention, driving him round Paris on an endless tour of visits to artists, museums and other collectors, answering his questions, indulging his whims, submitting to his aggressive commercial negotiation strategies. Through Guillaume, Barnes developed an interest in African sculpture and also made a succession of important purchases of works by the great names in French art from 1880 to 1930. Barnes was appreciative. He appointed Guillaume unofficial 'Foreign secretary' to his Foundation, and he described Guillaume's gallery as 'The Temple, Mecca', adding in awe, 'I saw there six African tribal chiefs next to four chief dancers of the Russian Ballet.' Clearly part of Guillaume's appeal was the access he gave his American client to an exciting whiff of the Parisian avant-garde. But all idylls come to an end. There is evidence to suggest that Barnes and Guillaume quarrelled after 1927. Barnes was difficult. Perhaps there was even an element of competition between them: the private collection that Guillaume put together for himself (now housed in the Musée de l'Orangerie, Paris) was substantial and impressive.

Guillaume died relatively young, in 1934. Modigliani, of course, had died even younger in 1920. It was as if Modigliani's doomed genius infected his dealers, because Léopold Zborowski, the dealer who handled Modigliani in the last two years of his life, also died early, in 1931 (see plate 17). Zborowski's first Modigliani show was held in December 1917 in the gallery of Berthe Weill in rue Taitbout. Poor Berthe Weill: she was the lonely and heroic representative of her sex in a bad male world. She constantly seemed to draw the short straw. First there was Vollard's treatment of her over Odilon Redon, when he beat down her price and then told the artist she was selling his work too cheap. Now, having lent her gallery to Zborowski for his Modigliani exhibition, she found her premises raided by the police. The nude that Zborowski displayed in the window was deemed an offence against public morals, because it showed the model's pubic hair. It had to be removed.

But Zborowski proved an enthusiastic salesman and promoter of Modigliani's work. After the sad death of the artist, he was so enthusiastic that as many people as possible should own Modiglianis that he allowed onto the market a certain number painted after the artist's demise. Osbert Sitwell, who collaborated with Zborowski in mounting an exhibition in London of Modigliani and the Paris School soon after the First World War, remembers him as follows: 'With flat, Slavonic features, brown almond-shaped eyes, and a beard which might have been shaped out of beaver's fur, ostensibly he was a kind, soft businessman and a poet as well. He had an air of melancholy...' But the melancholy poet yielded to the rather harder businessman when a telegram from Paris reached Zborowski in Sitwell's presence. The telegram announced a potentially fatal relapse in Modigliani's disease, and Zborowski immediately set about stopping all sales of his work, because the artist's death would certainly increase its value. Paul Rosenberg had, of course, been similarly beady as soon as news of Renoir's death came through. Sentimentality is all very well in its place but will only take a dealer so far. Zborowski's career was on an upward trajectory. Success beckoned. 'I shall never forget,' added Sitwell, 'the richness of the fur coat, very Russian or Polish in style, with an enormous sweep of fur collar in which he came to meet us in Paris after the turn of his fortunes.'

It is revealing to look at the direction in which Germain Seligman took his venerable firm in the interwar years. Jacques Seligmann, his father and the founder of the business, had been a traditional dealer in the artists of the past in the mould of Nathan Wildenstein or Joseph Duveen. After the First World War, the American dollar remained crucial to the success of the business, and indeed Germain records that he crossed the Atlantic more than 125 times in the sixteen years between 1924 and 1939. But, unlike Duveen, Seligman got involved in 'new' art. He mounted a series of Modernist exhibitions in his New York gallery: in 1927 a show entitled Manet to Matisse; in 1928 a solo exhibition of the works of Pierre Bonnard; and in 1929 a retrospective of Modigliani. In the same year Germain's openness to contemporary art enabled him to make one of the great coups of the time when he bought from the estate of Jacques Doucet one of Picasso's most important works, the *Demoiselles d'Avignon*. To buy in France and to sell in America was the business model of all successful dealers, and in 1937 he found the ideal buyer for it in the Museum of Modern Art in New York.

'The art dealer,' wrote Seligman, 'no less than the teaching institution

and the museum, undertakes a programme of public education when he plans an exhibition of a new artist, a new movement, or even a neglected artist or period of the past.' Sadly such noble aspirations came to an end with the outbreak of the Second World War. Seligmann, like many other dealerships, did not survive the conflict in its pre-war form. The art market since 1945 has shifted its centre of gravity from Paris to New York. The golden age of French art dealing had run its course.

I 2

FROM CASSIRER
TO BERGGRUEN:
THE GERMANS

To be an art dealer in Germany in the first half of the twentieth century was a trying experience. There was the cultural will for art to thrive. The country's considerable economic expansion in the last quarter of the nineteenth century led to huge industrial fortunes being made and a class of aspirational rich emerging ripe for the exploitation of dealers. But as the twentieth century unfolded, a series of tragic events on the wider national stage reversed the development of the art market and cruelly undermined the efforts of those engaged in trying to sell pictures: if dealers weren't put out of business by the First World War, they succumbed to rampant inflation in the 1920s; if they somehow survived that economic disaster, then the Nazi regime's suppression of modern art probably finished them off; the few that kept trading through the National Socialist era (deftly refocusing on the only remaining acceptable area of activity, old masters), were largely bombed out in the Second World War, or, if not, found themselves prosecuted for trading with the Nazis in the aftermath of hostilities. Not surprisingly, no German dealer functioning in 1914 was still functioning in 1945. They had either died or fled the country: the firm of Paul Cassirer, headed by Walter Feilchenfeldt senior, moved to Amsterdam and later to Zurich; Curt Valentin, Justin Thannhauser and Hugo, Klaus

and Frank Perls crossed to America; Alfred Flechtheim sought refuge in London (where he died in 1937), and Herwarth Walden rather quixotically in Moscow (where he died in a detention camp in 1941).

A measure of the boom times at the end of the nineteenth century was the fact that in 1895 there were only two commercial galleries in Berlin, but by 1900 there were eight. By 1905 Berlin was second only to Paris as a centre of advanced art. There were more traditional galleries, such as Keller & Reiner in Berlin, where you could find, according to Paula Modersohn-Becker, works by artists as diverse as Verrocchio, Böcklin and pointillist works by followers of van Rysselberghe, all presented in surroundings of enormous chic and splendour. Dealers' galleries flourished in other German cities, too, in the first years of the twentieth century. In Dresden there was Ernst Arnold, in Hamburg the Galerie Commeter, and in Munich the Galerie Thannhauser and the gallery of Hans Goltz. All had an eye on Modernist developments: Thannhauser, for instance, gave Paul Klee his first one-man show in 1911, and also supported Kandinsky and the Blaue Reiter group in their pioneering of Expressionism. Commeter exhibited Edvard Munch, who throughout the first part of his career found Germany significantly more receptive to the bleakness and angst of his art than his native Norway.

But the man who led the advance of Modernism in Germany was the dealer Paul Cassirer. There was only one way this advance could be achieved, in Cassirer's opinion, and that was with direction from Paris. 'I regard bringing French art to Germany as a cultural deed,' he declared. His was a genuine sense of mission, a commitment of Teutonic intensity. His gallery opened in 1898. Its rooms were spare and austerely elegant, decorated in advanced 'rational beauty' style by the Belgian designer Henry van de Velde. Cassirer operated on many fronts. He was a member of the Berlin Secession; he formed close links with the important French dealers such as Durand-Ruel, Vollard and Bernheim-Jeune, and bought new art from them with which to perform his cultural deed; he and his cousin Bruno published journals to explain the new art, and of course to sell it. An important ally was, as ever, the house critic: in this case the influential Julius Meier-Graefe.

Secessions were important manifestations of modern art, literally movements that seceded from the established academies in order to accommodate new tendencies. But they were initially driven by artists. Dealers had to insert themselves. Cassirer did this effectively, later

becoming President of the Berlin Secession and regularly giving shows to its members in his gallery. While Cassirer's name was thus synonymous with Modernism, like all good contemporary art dealers he knew it was important to give context to the new, to lend it legitimacy by interspersing it with exhibitions of older art. In 1901 he showed English eighteenth-century portraits; in 1903 and 1908 he had exhibitions of Goya.

His relationship with Durand-Ruel was at the original root of the enterprise, but in the first ten years of the twentieth century he went beyond Durand-Ruel in his understanding and championing of the French Post-Impressionists. He showed Cézanne, Gauguin and particularly van Gogh with an enthusiasm that eluded the older Frenchman. In fact he went straight to the van Gogh family to source works, forming a close if occasionally fractious relationship with Vincent's surviving sister-in-law, Johanna van Gogh-Bonger. One comes back to the cultural deed. Cassirer believed that good new art could only be given a public platform by the commercial gallery, that reinforcement of that platform needed to be provided by intelligent criticism and interpretation, which his art journals provided. The dealer is playing a crucial and to a certain extent autocratic role in the process. Perhaps you need a certain arrogance as a dealer promoting new art; your self-belief and conviction must be rock solid. Cassirer is addressing collectors and museum directors alike. He is saying 'Look at what I think is good. Accept it from me that it is supremely worth acquiring. Buy it for your collection. Include it in your museums for the benefit of posterity. And look at the way prices go up.' These are judgements given credibility and resonance by the imprimatur of money. In the memorable phrase of Robert Jensen, he who controls the market controls history.

Cassirer gave Matisse his first solo exhibition outside France in Berlin in 1909. But it is arguable that his most significant influence was felt through his championing and marketing of van Gogh in Germany, from 1901 onwards. Had not the artists of Die Brücke had the access to van Gogh's work that Cassirer's exhibitions gave them in the first decade of the twentieth century, and particularly through the show mounted at the Galerie Ernst Arnold in Dresden in 1905, Expressionism might not have developed with the colour and intensity that distinguishes it. Here is an important instance of an art dealer shaping the development of modern art.

Cassirer was not universally popular amongst artists. Max Beckmann,

although he was offered his first Berlin show by Cassirer in January 1907, was inclined to stereotype him as an arrogant Jewish businessman. Beckmann criticised his 'excessive power' over the Secession again in 1908, decrying the 'impossibility of developing German art under the absolute domination of C[assirer]'s business interests'. Beckmann reflected balefully again on 31 December 1912: 'It's terribly hard to know where to draw the line between professional relationships and one's personal sense of honour. Especially so in our case, with the firm of C[assirer].'

It is ironic that in the years immediately before the First World War the activities of advanced dealers in both Berlin and Paris resulted in the simultaneous perception in both France and Germany that the national art of each country was being unhealthily influenced by the other. In 1911 a conservative German artist called Carl Vinnen published a diatribe against foreign and particularly French infiltration of German art. 'A great, powerfully upward-striving culture and people like ours,' he thundered, 'cannot forever tolerate spiritual usurpation by an alien force. German and French art dealers work hand in glove and, under the guise of supporting art, flood Germany with great masses of French pictures.' According to Vinnen, art critics had joined the conspiracy: 'Our able writers are in the hands of the Berlin-Paris speculators!' Tempers frayed in Paris, too: Cubism was criticised as an example of the corruption of pure French art by Teutonic infiltration, because its promotion was led by a German, Kahnweiler. In both cases the infiltration was perceived to have been led by dealers. In the feverish atmosphere of nationalistic rivalry that in retrospect makes the First World War seem its inevitable outcome, one thing is clear: in the art world it was commercial enterprise that was establishing the agenda of the avant-garde.

Paul Cassirer was certainly difficult and abrasive, and suffered from depression. In 1901 Bruno and Paul Cassirer had one of those rows that seem to erupt every now and then in art-dealing families. This was a serious one: although the cause has never been disclosed, it resulted in their permanent separation. Later Paul Cassirer married the actress Tilla Durieux, who although vivacious and charming, was also demanding and difficult. Finally, worn down by the erraticism of the art market, the rampant inflation of the mark, and recurrent women trouble, he committed suicide in 1926. Max Liebermann made a speech at the funeral. It was not a totally uncritical tribute: Liebermann spoke of the Faustian element in Cassirer's character. What was the pact with the devil that Cassirer was felt to have

made? That in the end he was more interested in money than art? That he exploited his artists financially? These were the underlying suspicions, particularly amongst artists. But without Cassirer the history of Modernism in German twentieth-century art would have been significantly more insular and less stimulating.

John Richardson makes an interesting point about the number of progressive young art dealers in Germany in the early twentieth century who were Jewish. He suggests that art dealing provided an ideal resolution of the twin motivations that a younger generation of Jews were driven by: they had in their bloodstream an inherited profit motive, and often started their careers in their family's businesses; but they also had an idealism, a desire to develop spiritually, that collecting and dealing in art, and particularly Modernist art, met too. Kahnweiler, who relocated to Paris, was an obvious example. But in the years leading up to the First World War, there was Hugo Perls of Berlin, Justin Thannhauser of Munich, Alfred Flechtheim of Düsseldorf, and the colourful and charismatic figure of Herwarth Walden.

One dealer who took a more profound interest in contemporary artists than Cassirer was Alfred Flechtheim. He came from a family of Westphalian grain merchants. In Paris on business in 1909, a chance visit to the gallery of Clovis Sagot off the rue Laffitte led to his acquisition of two Picasso etchings, and the direction of his life changed. His eyes were opened to modern French art. Next he was introduced to Félix Fénéon in Bernheim-Jeune and bought drawings by Rodin and van Gogh. Then he met Kahnweiler, whose taste impressed him most, and 'influenced me to become who I am now, a spreader of propaganda for contemporary French art in Germany, what Paul Cassirer was for the Impressionists'.

Flechtheim was a very different proposition from the dogged, serious Kahnweiler, and one suspects he had more personal charm than the sometimes difficult and abrasive Paul Cassirer. According to Christian Zervos, who met him in the 1920s, Flechtheim was 'nervous, agitated, lively, shrewd, joyful, despairing, sensual, unfair, enthusiastic, chatty, theatrical'. Kahnweiler, a little stuffily, identified him as 'a salesman of the first order'. In December 1913 Flechtheim opened his first gallery, in Düsseldorf. Later there were others in Berlin, Frankfurt and Cologne. But the expansion of his art business coincided with a downturn in the family grain business, which meant that money was suddenly short. He had taken the precaution favoured by wise art dealers of marrying a rich wife, Betty Goldschmidt,

but he found he had spent her entire dowry on Modernist French art. What also didn't help his marriage was the fact that he had fallen in love with a young man, the Swedish artist Nils Dardel. Confronting simultaneous bankruptcy and marital disaster, Flechtheim contemplated suicide. He planned to be the apparent victim of an accident, having first taken out substantial insurance to benefit his wife and parents. Art dealers are almost as susceptible to despair as artists. Van Gogh's suicide in 1890 is perhaps the most famous in art history, but now, from beyond the grave, he was indirectly Flechtheim's saviour from the same fate. In September 1913 Flechtheim succeeded in selling a van Gogh to the Düsseldorf museum for 40,000 marks. It was a deal that came just in time. All at once life seemed worth living again.

Flechtheim's portrait by Otto Dix, painted in 1926, shows an older and a wiser man gazing out thoughtfully into the middle distance, one hand on a Cubist painting and the other on a piece of paper that may or may not be an invoice (see plate 15). Like many other progressive art dealers trying to sell new art, Flechtheim brought out his own arts magazine. It was called *Der Querschnitt* (The Cross Section), and the slice had an unusual angle. We have already seen how Fénéon doubled as a cycling correspondent in *La Revue Blanche* twenty years earlier. Flechtheim had different but equally compelling sporting interests. An editorial in 1921 reads: 'We consider it our duty to promote boxing in German artistic circles as has long been the case elsewhere. In Paris Braque, Derain, Dufy, Matisse, Picasso and Rodin are all enthusiastic boxing fans.' Boxing, according to Flechtheim, was 'the fight for life', and he continued, 'what goes on in the ring is real drama and not some misunderstood Saint Joan'. Almost every edition of the magazine, which ran till 1936, featured photographs of naked boxers. A particular hero was the German champion, Max Schmeling, whose portrait George Grosz painted after Flechtheim introduced them. When asked by Zervos what artist had had most impact in Germany in the twentieth century, Flechtheim's deadpan reply was 'Schmeling, the boxer.' As Schmeling wrote in Flechtheim's guestbook after a party, 'Boxing is also an Art.'

Both Cassirer and Flechtheim fed off France in their promotion of the avant-garde; Herwarth Walden was rather more the champion of indigenous German Modernism (see plate 18). He was born Georg Lewin in 1879 and initially pursued a career as a concert pianist. His decision to reinvent himself as Herwarth Walden seems to have come about 1901,

when he married the poet Else Lasker-Schüler, abandoned his musical career, and – with a calculatedly romantic new name – decided to devote himself to the cause of Modernism. In 1903 he founded an 'Association for Art', a forum for the discussion and practice of contemporary literature and visual art. His day job was journalism; then in 1910 he founded his own periodical, *Der Sturm*, a suitably cataclysmic name for the momentous Modernist tempests he wished to brew up. The journal *Der Sturm* expanded into an art gallery of the same name, launched in Berlin in 1912. Its early exhibitions featured the Blaue Reiter and the Italian Futurists, and in autumn 1913 a major survey of advanced art, the *Erste Deutsche Herbstsalon*. In Germany the avant-garde was taking control of its own destiny, and doing it through dealers, but forward-minded dealers supported by critics often writing in publications sponsored by the dealers.

Paul Klee was initially suspicious of Walden. In 1913 he encountered him at the opening of the Futurist show, which had moved on to the Galerie Thannhauser in Munich. 'Lives on cigarettes, gives orders and runs, like a strategist,' he reported of Walden in his diary. 'He is a somebody, but something is lacking. He just doesn't like paintings at all! He just sniffs at them with his good sniffing organ.' What perhaps Klee picks up on is the political agenda of Walden. Walden's insistence that works of modern art should be vehicles of political discourse as well as works of art may have wrong-footed him. Gradually Klee realises that it is Walden rather than Thannhauser who is the moving force behind this Futurist show; in fact Thannhauser, always more interested in profits than the promotion of new art, had given his premises for the show but cravenly issued a public disclaimer of any responsibility for its contents. Klee concludes, 'The real organiser is the heroic Walden from the Berlin *Sturm*'. Klee writes excitedly of being included in Walden's 1913 exhibition. 'Walden is planning an autumn salon in Berlin, and Kubin and I are to have a private room for our graphic works there!' It is as if Klee glimpses the new power of dealers, a power over art history – that if you are on the right side of them your name will live on.

Walden was good at handling artists, at knowing how to please them with his praise. Even Gabriele Münter, always suspicious of dealers, was just about won over by Walden. She reported to Kandinsky in October 1912: 'He is very nice & I like him well – he is just a *bit* too charming – perhaps he thinks he has to be with me. He praised my work highly and – at least to some degree – sincerely... He says he's never seen such perfect

yellow as in my pictures. And, furthermore, he sees my personality as this warm yellow.' Oskar Kokoschka, writing to Walden in 1913, spoke of his 'ability to make the most of modern painting'. Artists understood that he was an idealist, not a mere merchant. Kokoschka went on, 'Let the dealers peddle in pictures, you are too magnanimous and out of the ordinary for that.'

Walden was a restless soul. He promoted and pioneered with huge energy, a visionary whose motivation as a dealer was not primarily financial gain. His restlessness extended into his private life: after Else Lasker-Schüler, he married three more times. The rest of Walden's life story declines into tragedy. Progressive art dealers in Germany were bobbing corks at the mercy of the perilous currents in the political maelstrom between the wars. In 1916 Walden founded a school for all branches of the visual arts, and the next year a theatre and a bookshop, still under the brand name 'Der Sturm'. At its peak, Der Sturm's headed writing paper advertised itself as an exhibition gallery, a bookshop, a publisher of both books and journals, an art school and an art association. He continued to seek out young and promising artists, but there was an increasingly political agenda underlying his art dealing. His commitment to Communism strengthened, and in 1932 a cash-strapped *Der Sturm* published its last edition. The editor/proprietor promptly did a bunk to Moscow, which, under the Soviet regime, was hardly an encouraging environment for art dealing, even if conducted by an idealist. He was arrested in 1941, the victim of Stalinist persecution, and apparently died that year in detention in a camp. This is the art dealer as political revolutionary, and predictably it ends in tears. Could you be an art dealer as a Marxist? Only a very purist one, it seems.

So Walden disappeared to Russia; after Cassirer's suicide, Walter Feilchenfeldt senior moved the Cassirer gallery first to Amsterdam and then to Zurich; Hugo Perls and Thannhauser emigrated to New York, as we have seen; Flechtheim died in London in 1937. The remarkable 'Mutter Ey', a lady dealer with premises in Düsseldorf who had done much to market the Expressionists in the 1920s, was forced by the Nazi regime to close her operation. Who was left? Only those dealers who were prepared to adapt themselves to operate under the new government. This meant you couldn't be Jewish, of course. It meant you couldn't deal in anything modern, because it was deemed degenerate by the regime. It meant you should confine your activities to old masters, to purveying the taste of the

Third Reich as demonstrated in the ever-expanding collections of Hitler and Goering. A number of dealers emerged who were prepared to make the necessary compromises. Men like Karl Haberstock and Hildebrand Gurlitt acted as officially accredited agents for the Nazi hierarchy and were instrumental in assembling the works intended for Hitler's grandiose personal museum at Linz. The opportunities to acquire important paintings cheaply were obviously abundant, not least from fleeing Jews with good collections. Museums in Nazi-occupied countries were also rifled. William Buchanan's dictum about art dealers was singularly apposite in the Second World War: for the unscrupulous, never had troubled waters yielded so many fish. A certain sort of dealer thrives in wars: those equipped to operate like secret agents, sometimes even double agents. George Augustus Wallis in the Iberian Peninsula during the Napoleonic invasion was a case in point. And with deft footwork some dealers who were active in Germany during the war even managed to convince the liberating allies in 1945 that they'd been on their side all along. By 1951, for instance, Karl Haberstock had set up shop again in Munich and was trading once more in old masters.

Out of the art dealing desert that was mainland Europe in the immediate post-war years emerged two major German-speaking dealers, Ernst Beyeler and Heinz Berggruen. They each occupy not dissimilar positions on the dealing spectrum, halfway between businessman and scholar, between financier and philanthropist, between trader and collector. They each left magnificent museums as testament to their scholarly, philanthropic and collecting achievement, Beyeler in Basel and Berggruen in Berlin. But they could not have put such collections together without simultaneously being extremely focused businessmen, financiers and traders, and if they had not been fortunate enough to start dealing in the years after the Second World War, when there were extraordinary opportunities to buy outstanding works very reasonably indeed. Berggruen expresses the twin pulls of businessman and collector in his life rather neatly when he describes himself as his own best client.

Both Beyeler and Berggruen wrote memoirs of their lives as dealers, Beyeler in the form of an extended interview with the journalist Christophe Mory and Berggruen under the deceptively coy English title *Highways and Byways*. Berggruen makes his progress sound very simple: he says he started as an art dealer in the post-war years with no capital, only a conviction that he could accurately judge the art market and trust

Ernst Beyeler, in pursuit of a deal.

in his sense of quality. He rejects the term 'gallerist' as a description of his profession: he says it sounds too much like a 'chemist', a passive 'waiter' for something to happen who never leaves his shop. And there was an impulsive side to Berggruen's character, an energy and passion seething beneath the apparently calm and scholarly surface. It had manifested itself in the 1930s when, as a young man in America, he met Frida Kahlo and was propelled almost instantly into a raging affair with her. In his memoirs Berggruen records its three-week progress, spent mostly holed up in a New York hotel room. 'Never at any time in my life had I ever felt such a strong attraction towards a woman as I did for Frida then,' he writes with the slightly bemused tone of a man looking back on his survival of a major earthquake. Perhaps its long-term effect was to teach him the inadvisability of handling living artists, although he did have successful business dealings with Picasso later on.

Every successful gallery needs its tame expert or art historian, what Berggruen refers to as his 'house author'. Bravely – perhaps foolhardily – Berggruen took on Douglas Cooper in the role. Cooper had flirted with art dealing earlier in his career, spending a few grumpy years at the Mayor Gallery in London in the 1930s. Berggruen, in the tradition of great twentieth-century art dealer-publishers, brought out Cooper's *catalogue*

raisonné of the works of Juan Gris in 1977. It can't have been easy. Publisher had to restrain chronically combative author from including in the work abusive mentions of dealers who had sold forgeries of Gris, and collectors who now owned them.

Beyeler's reminiscences provide an important lesson in salesmanship: whenever you offer a painting to a client for sale, make clear that there is a rival buyer. This, of course, is what auction does so successfully: once the bidding exceeds the reserve, the counter bidder is a constant reminder that there is competition. Art market wisdom has it that horses always run faster when they hear the hooves of other horses. Beyeler preferred the analogy of the lazy St Bernard who couldn't be bothered to get up and eat his plate of food unless a cat was produced to show interest in it. As Beyeler put it, 'I have tried to find a cat for every transaction.'

In the 1960s and 1970s, the two dealers in modern art whose latest catalogues were awaited in London and New York with the most anticipation were Beyeler and Marlborough Fine Art (for more on which see Chapter Thirteen). Marlborough had a strong stable of contemporary artists whose careers they carefully monitored and tried to control; Beyeler on the other hand, while he dealt with living artists, particularly Picasso, fought shy of ever entering into exclusive contracts with them. When he spoke critically of certain dealing rivals who 'do not hesitate to interfere, to influence a work, to adapt it to the taste of clients', he probably had Marlborough in mind. The stranglehold in which Mark Rothko, for instance, was imprisoned by Marlborough frustrated Beyeler in his attempts to buy work direct from the artist; and of course the situation had its own costly legal repercussions for Marlborough after the death of the artist, when the extent of their maladministration of his estate was revealed.

Beyeler's prices may have been high, may have involved considerable mark-ups from what they cost, but that was justified in Beyeler's view provided the work was good enough. 'I always salved my conscience by selling first class works. You can cheat on price but you can't cheat on quality,' was his attitude. It may sound self-serving, but there is truth in the observation. It is only at the very top of the quality tree that you can get away with truly audacious hikes in price. The most successful art dealers are the ones who, firstly, are equipped to identify the very best and, secondly, recognise that the price differential between the very good and the superlative is disproportionate, but that's where the profits may most legitimately be gathered in. That's where the richest fantasy lies.

Both Beyeler and Berggruen, while they returned in the end to their German-speaking roots in their choice of museum locations, had international careers. Their clients were American as much as European, and as dealers they were products of the era of jet travel that effectively globalised art dealing. Speaking of dealers as being tied to one particular country became decreasingly relevant as the twenty-first century approached.

13

GENTLEMEN AND PLAYERS: THE BRITISH

Because the British are quite good with money but tend to be embarrassed by art, a degree of circumspection is demanded of their art dealers. The early owner of the *Rokeby Venus* dismissing it as his 'picture of Venus's backside' is an illustration of what the art trade were up against; later, the movements of European Modernism met with very little enthusiasm in London. The dealers who picked their way through these minefields most successfully were Agnew and Colnaghi. They specialised in more traditional pictures, wisely choosing not to frighten British horses with anything too daring.

Thomas Agnew & Sons were originally founded in Manchester and built a profitable business supplying art to the new rich of the north of England. In 1860 they expanded to London, and prospered for a century thereafter as the art dealers of the British establishment. If the Church of England was the Conservative Party at prayer, then the axis of virtue that linked Agnew's to Christie's by an interlocking system of Etonian brothers and uncles was the Conservative Party trading its art. Initially Agnew's staple business was handling the works of Victorian contemporary artists, but by the end of the nineteenth century political and economic developments refocused their attention on the trade in old masters. Many British aristocrats, land rich and cash poor, were in financial difficulties. Land was not easy to sell. But after the passing of the Settled Land Act in 1882,

art was. So a large number of important works were released on to the art market out of grand English houses. Agnew's were well positioned to trade these works to America, where a number of moguls, now coming into the splendour of their wealth, were ready to pay large sums to acquire the trappings of cultured European life.

The rivals of Agnew's were Colnaghi. Colnaghi, founded in 1760, were initially best known as printsellers. But by the end of the nineteenth century they were ready to compete with Agnew's in the profitable business of supplying rich Americans with European art of the past. This was largely the result of the arrival at Colnaghi as a junior partner of Otto Gutekunst in 1896. Gutekunst was clever, determined, knowledgeable and diplomatic. He knew, and was able to handle, the burgeoning force in the market that was Bernard Berenson. For a few heady years, as outlined in Chapter Five, on Duveen, he cooperated closely with Berenson to supply paintings to Isabella Stewart Gardner. Part of the success was built on their mutual respect, for while Berenson was obviously the authority on Italian art, Gutekunst matched him in his own superior knowledge of the Dutch and German schools. Gutekunst was not afraid to take issue with Berenson. He writes to him of a disputed painting in 1899: 'Your lady's portrait seems to my eyes – unclouded by knowledge – to be a very long way from Titian.' Elegantly implicit to the comment is the argument for the dealer's instinctive eye over that of the academic, burdened by an excess of learning and research.

The pursuit of works to sell Mrs Gardner was frenetic, but it was worth it. Gutekunst kept a sense of humour. He wrote to Berenson of the stress of the chase on 20 November 1897: 'If I go on moleing and digging away in all sorts of catalogues and books of reference for pictures, getting excited, I shall also have to take to massage.' The race to supply Mrs Gardner with as many Renaissance masterpieces at as high a price as possible was on. Great dealers recognise apogees in their collecting clients' buying capacities, and exploit them accordingly. As Gutekunst reported to Berenson, all you could do was extract maximum benefit from this glorious harvest, for the 'windfall' would 'stop of its own accord soon enough'. Gutekunst differentiated the sort of paintings in which he dealt into two categories: 'angel food' and 'big, *big*, BIG game'. 'Angel food' comprised the works of high quality, not necessarily weighed down with ambitious attributions, which appealed to connoisseurs, whereas the 'big game' was the trophy art by major names for which American moguls competed.

A piece of the biggest game was the *Rape of Europa* by Titian, which, with the duplicitous participation of Berenson, Gutekunst managed to inveigle out of the hands of Lord Darnley into the collection of Mrs Gardner (see plate 20). 'It would be jolly if Europa came to America,' joked Gutekunst to Berenson as they laid plans for its sale. Gutekunst succeeded in buying it from Darnley for £14,000, and agreed that Berenson would offer it to Mrs Gardner for £18,000, and they would split the profit 50–50 between them. Berenson actually sold it for £20,000, but kept Gutekunst in ignorance and only split £4,000 rather than £6,000 with him. Berenson was a quick learner in the ways of the art trade. It is hard not to sympathise with Gutekunst when he wrote much later to Berenson: 'Are you not all, like us, just after money – we openly, you quietly and less candidly!'

The British art dealer who gritted his teeth and ventured into handling modern French painting in the late nineteenth century was the Scotsman Alexander Reid. His friendship with the van Gogh brothers, the painter Vincent and the dealer Theo, might have offered him the opportunity to launch Vincent in Britain. Could he not have been the British Paul Cassirer? His failure, however, was not entirely his fault: Germany as a nation was responsive to modern French art in a way that would have horrified a much more timid and francophobe Britain.

Reid arrived in Paris from his native Glasgow in 1886. His intention was to study to become an artist, but the money ran out and in February 1887 he got a job in the art trade with Boussod and Valadon, the French art dealers. Here he found himself working alongside Theo van Gogh. They got on well, and Theo invited him to share a flat in the rue Lepic with Vincent and himself. For about six months, relations were precariously harmonious. Vincent painted; Theo and Reid sold art by the Barbizon painters and the new Impressionist school, and in the evenings they all three talked idealistically and met up with other artists. Reid's enthusiasms were kindled for Manet, Degas and Toulouse-Lautrec. Vincent was initially attracted to Reid, and twice painted his portrait. The two men were remarkably similar in appearance, with the same carrot-coloured hair, the same V-shaped beards and the same green eyes. Indeed van Gogh's portraits of Reid have in the past been wrongly identified as self-portraits. When Reid suffered a romantic disappointment and confided it to Vincent, such was their closeness that Vincent – not feeling very positive about life either – proposed that they should commit suicide together. After a night's heavy drinking, they thought better of the plan. That much

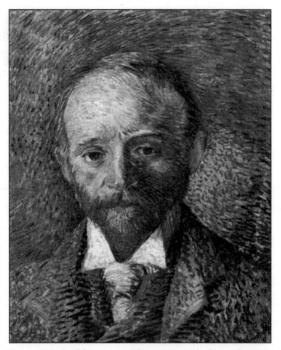

The artist's double: Van Gogh's portrait of Alexander Reid.

is certain. Conspiracy theorists, however, might enjoy the speculation that at this point the two of them decided to exploit their similarity of appearance and exchange identities. Perhaps it was the man originally known as Reid who went on to Arles, the Asylum at Saint-Rémy, and three years later shot himself in Île-de-France. And perhaps it was the man originally known as Vincent van Gogh who travelled back to Scotland and enjoyed a successful career as an art dealer in Glasgow and London. Or perhaps not. It would make a good story, though.

Certainly Reid and Vincent quarrelled soon after. Harsh words were spoken. Vincent described Reid to his brother Theo in damning terms: 'I consider the dealer stronger in him than the artist'; in fact he was no better than a 'vulgar merchant'. It got worse: Vincent wrote to his friend the artist John Russell that Reid 'acted in a way that made on me the impression that he had lost his wits'. Coming from Vincent, this was quite an indictment, but it seems that besides his romantic disappointment, Reid was grappling with financial problems. There was also a disagreement over access to works of the painter Monticelli, for whom there was an unaccountable enthusiasm in avant-garde circles at the time. Upon his return

to dealing in Glasgow in 1889, both van Gogh brothers felt let down by the way Reid refused to commit to the Impressionists by buying them outright, but took them on sale or return instead. It was a hard-headed but probably correct decision. While Reid managed to sell to canny Scots collectors occasional Impressionist works, notably by Degas and Manet, it was not a booming or very deep market. Nonetheless he gave his Glasgow gallery a modishly French name: 'La Société des Beaux-Arts', in conscious or unconscious homage to the Fine Art Society in London. Calling a commercial enterprise a society is never a bad ploy: it gives clients the impression they are dealing with what is primarily a force for social and cultural cohesion, and only secondarily a moneymaking entity.

Reid was not afraid to grapple with the big beasts in the artistic jungle. No one managed to deal with the fractious Anglo-American painter James McNeill Whistler without falling out with him, but Reid did his best. In the end Whistler described him as 'this shifty, foxy, furtive dealer', which was probably as close to a compliment as Whistler ever managed to pay a member of the art trade. Reid also took on Rodin in the 1890s, arguing the sculptor's prices down by claiming '*En Écosse nous sommes moins riches mais beaucoup plus connoisseurs que les Londiniens!*' Closer to home Reid promoted the Scottish Colourists and the Glasgow Boys, and developed good transatlantic contacts. But his most important expansion was to London. On 26 April 1926 the new company of Alex Reid and (Ernest) Lefevre came into being, with premises at 1A King Street, St James's. He shared stock with Aitken Dott in Edinburgh and Étienne Bignou in Paris. The Lefevre Gallery went on to become the most potent force in the sale of modern French art in London in the middle of the century.

Before he died, Vincent had a change of heart about Reid. In June 1889 he wrote to Theo: 'How often I think of Reid when I am reading Shakespeare, and how often I have thought of him while I was worse than I am now. Thinking that I was far, far too hard on him and too discouraging when I claimed it was better to care for the painters than for the pictures.' It was acknowledgement from a painter himself of the secret conviction that lurks in the heart of many art dealers: pictures are the saleable commodity, but the people who paint them are just trouble.

Hugh Lane was an Irishman who made his fortune in London dealing in pictures. He occupied a position on the dealing spectrum that is difficult to locate precisely. At first sight he seems close to the scholarly end of the dial; his own private collection was of exceptional quality, and he

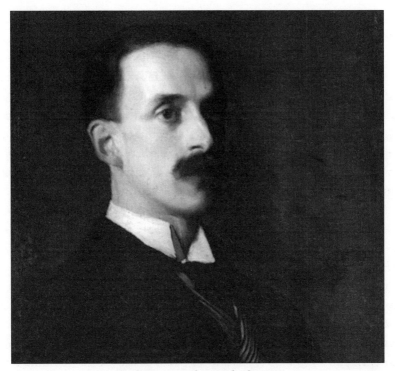

Hugh Lane: aesthete and salesman.

gave generously from it to public institutions in his native Ireland. He is best remembered for the outstanding French Impressionists that he assembled with unusual foresight and audacity. He made his first purchase, a Monet, from Durand-Ruel's London exhibition in 1905. He added important works by Manet, Pissarro, Renoir and Degas. This was a collection put together not for trading purposes but for the cultural benefit of the Irish people. His 39 modern French pictures were to be the nucleus of the Dublin Museum of Modern Art that he hoped to see founded. But a sequence of misunderstanding, ill luck and English duplicity saw them end up in the National Gallery in London, who had accepted them on loan with singular ill grace, and then clung on to them when Lane had the misfortune to go down with the *Lusitania*, the liner sunk by the Germans in 1915. When Lane was knighted in 1909 it was for 'services to art', which diplomatically covers his dual role as commercial dealer and philanthropic benefactor.

According to his first employers in the art trade, Colnaghi, he lacked that touch of practical hardness in his nature that goes to the making of a

successful art dealer. His courtly ways and a predilection for polite society were apparently against him. But he was remembered as an 'extraordinarily attractive personality', if a somewhat precious one. He was described as having an 'exceptional eye, and a wonderful taste for what was subtle in form and harmonious in colour'. His fastidiousness extended to his writing paper, which was 'a peculiar shade of azure blue, specially selected to give full effect to the pink of the penny stamp. He would never degrade it with two green halfpenny stamps.' 'Lane was never married,' his biographer goes on to tell us; 'the society of women did not seem to give him any special pleasure.'

So far, so precious. But there is another part of the Hugh Lane persona that locates him much closer to the beady merchant end of the spectrum. He was actually a very effective dealer, a particularly cunning operator within the art trade, and he eventually left Colnaghi to set up for himself. It was said that he could buy a picture in Bond Street and sell it the same day four or five doors up to some other dealer at substantial profit, which argues for an exceptional commercial eye and an exceptional gift of salesmanship. In 1913 he sold Titian's portrait of Philip II to Mrs J. Thomas Emery of Cincinnati for the astonishing sum of £60,000. His achievement with the same artist's *Man in a Red Cap* is perhaps even more extraordinary. He first bought the picture for £2,170 in 1906 and sold it to Arthur Grenfell. When Grenfell put it up at auction in 1914, Lane bought it back for 13,000 guineas. The following year he managed to sell it to Frick at a prodigious mark-up for £50,000. With successes like that it is not surprising that Lane ended up a rich man. And his lack of pleasure in the society of women is also an advantage to a dealer keen to hang on to as much of his profit as possible. Nothing was drained from it in school fees.

The exhibitions of Manet and the Post-Impressionists in 1910 and of Post-Impressionism in 1912 are legendary landmarks in the evolution of modern artistic taste in Britain. It is significant that they were the initiative of a private individual, Roger Fry, and the majority of the exhibits were loans from Parisian dealers who hoped optimistically that a few sales might materialise. In 1910 all the works by Manet were lent by Bernheim-Jeune, who had formed a consortium to buy the Pellerin Collection with Durand-Ruel and Cassirer and hence was well stocked with works by the artist. In 1912 Kahnweiler contributed twenty-four works from his stock, including thirteen of the fifteen Picassos in the show. In that sense it was a dealers' exhibition, not dissimilar to a modern-day art fair.

The artist Walter Sickert viewed proceedings with suspicion. He was worried that 'dealers, and those critics who directly or indirectly depend on them, can to a certain extent hold back or unleash a boom to suit themselves'. He probably had Roger Fry and his cosy relationship with the dealers of Paris in mind, because the example that he adduced was the manipulation of the market for Cézanne, the artist who had attained divine status in Fry's firmament. But whether Sickert liked it or not, it was through dealers that London was kept apprised of the continental avant-garde even after the First World War. There were a number of innovative London galleries showing modern French art. The Leicester Galleries held a succession of interesting exhibitions that made the British art buying public more familiar with the great names such as Matisse (in 1919), Picasso (in 1921), Degas (in 1922), van Gogh (in 1923), Gauguin (in 1924) and Cézanne (in 1925). The same was true of the Mayor Gallery, which initially operated in collaboration with Paul Guillaume in Paris: in 1933, for instance, they were showing Picasso, Braque, Léger and Miró next to Paul Nash, Wadsworth, Ben Nicholson, Henry Moore and even Francis Bacon. *The Times* observed: 'The Mayor Gallery is doing the work that should be carried out by the Tate.' Writing in September 1935 the art critic of *The Scotsman* confessed himself daunted by the modern look of the typical new art gallery: 'there seems to be something bullying in the efficiency of the place,' he reported nervously. But without the exhibitions mounted by these forward-thinking British dealers, few people in Britain would have been aware of the currents of avant-garde art in Europe. Indeed the lack of any sort of functioning museum of modern art in London was immediately obvious to intelligent new arrivals like Peggy Guggenheim. She immediately set about founding one, to be run by Herbert Read, but the project was cut off by the outbreak of the Second World War.

Arthur Tooth was another leading London dealer in modern art, but there was a limit to the artistic innovation you could countenance as a dealer in Britain and still make money (which Tooth did successfully). When Paul Nash was offered a contract by the gallery in 1933, the commercial pitch was encouraging: Nash was assured 'you will have the most powerful selling organisation in London behind you – and your work will be "pushed" to the limit'. But there was one condition: at least 75 per cent of Nash's works would have to be 'what is generally recognised as Landscapes, Still Lifes, etc., and not Abstract subjects'. This was London, after all. But the fact that Tooth was prepared to accept one in four works as

abstract shows that he was prepared to do a certain amount of battle on behalf of Modernism with the art-buying public.

A Surrealist art dealer is in some ways a paradoxical concept. Not many grappled with the challenge, but one who did was the Belgian E.L.T. Mesens. In 1920, then only seventeen, he happened to see some works by the twenty-two-year-old René Magritte in an exhibition in Brussels. In Mesens' words, 'we fell in sympathy right away'. It was a career-defining moment. Mesens was set on the road to becoming a gallery-owning idealist, never an easy combination, particularly when the ideals in question were Surrealist ones. The high priest of Surrealism, André Breton, laid down that Surrealism was more than an artistic movement: it was a commitment to a way of life. Thus the balance was not easy for a dealer simultaneously trying to sell Surrealism and to live it too. In his dealing prime Mesens was spending his days persuading the rich to invest in art, and his nights organising subversive Surrealist manifestations.

Mesens lived life tempestuously, which didn't help. His relationship with Magritte had severe ups and downs. In Mesens' own words 'there were scenes and rows and even threatenings of killing each other', but they remained close in the 1920s and early 1930s. In these years Mesens was more a collector and supporter of Magritte than a salesman of his works. In 1930, Mesens bought eleven of his pictures on the eve of Magritte's first Paris exhibition, just to help him out. In October 1932 he stepped in and bought all 150 works by Magritte, which constituted the stock of the Galerie Le Centaure, in order to prevent them being consigned in a 'fire sale' to auction which would have had disastrous consequences for the artist's prices and reputation.

Mesens' adjective for these early works of Magritte's oeuvre was 'ungrateful', in that they were good but difficult to sell. He could have used the same adjective for Magritte himself on occasion. Mesens went to considerable trouble to arrange a commission for the artist with the great Surrealist collector Edward James in London. Magritte was infuriatingly unhelpful in the wining and dining that went into securing the commission. Seated next to Edith Sitwell he spent the entire evening talking about his constipation. Mesens spent the 1930s between Brussels, Paris and London, doing some dealing, making Surrealist collages himself, and consorting with other artists. Mondrian, for instance, told him that he never had sexual relationships with the whores in Montmartre because 'every drop of sperm spilt is a masterpiece lost'. It was an insight into artistic

E.L.T. Mesens, who never quite resolved the conflict between anarchic surrealism and double-entry bookkeeping, with a work by his friend Magritte.

creativity that Mesens was fond of repeating in later years, although it was an injunction he did not himself observe, as his own thinnish oeuvre attests. In 1938 Mesens became director of the London Gallery, a commercial enterprise committed to the advancement of Surrealism in Britain. It was almost inevitable that two people as sexually voracious as Mesens and Peggy Guggenheim should soon find themselves not just metaphorically in bed together as Surrealist dealers in the same city. Like many other promoters of avant-garde art before him he started producing a journal to publicise the movement called *The London Bulletin*. He had an assistant working for him, the young George Melly. Melly's amusing memoir of Mesens, *Don't Tell Sybil*, is an excellent source for the period. Clearly Mesens never fully resolved the conflict between being a businessman and being an anarchic Surrealist. As Melly put it, what had Surrealism to do with double-entry bookkeeping? Only this: the owner of the London Gallery, a splendid woman called Lady Norton but known in the art trade as 'Peter', kept a stock book that contains entries such as 'Sold for £200, plus her fur coat.'

Mesens had his Surrealist moments as a dealer. One morning he sent Melly over to the newly opened shop on the other side of the road, which was purveying very grand luggage. Melly was instructed to seek out the proprietor and say: 'The managing director of the London Gallery opposite has asked me on his behalf to wish you good luck, sir.' He was sent back several times with exactly the same message. Each time the proprietor of the luggage shop grew more perplexed and angry. It was deemed by Mesens a highly successful piece of Surrealist theatre, or perhaps an early instance of performance art, but undoubtedly it was a fraught experience for the purveyor of grand luggage, who was after all a fellow labourer in the luxury goods market.

In the post-war years, Surrealism went out of fashion and Mesens' role as a dealer and gallerist did not adapt to the new conditions. He drank rather more, and took to railing against the UK museums for never having bought a single work from him. He had a point, of course. But dealers are great complainers and grudge bearers; holding forth about what might have been, had fate been kinder, or the world more recognisant of their talent, or their rivals less unprincipled, is a favourite recourse of the dealer in his twilight years, even successful ones. Finally the gallery had to close. Mesens, who could be obsessive on such matters, had read that the local council would pay money for waste paper if tied up in 10-lb parcels. The last days with Melly were spent on the floor of the premises surrounded by scissors and string and weighing scales, devoted to the obsessive creation of large numbers of such 10-lb parcels. Thus even in its closure the enterprise had a surreal quality.

In the years following the Second World War, art dealing in London was an odd mixture of tradition and eccentricity. There were the continuing giants, Agnew's and to a lesser extent Colnaghi, dealing grandly in the great names of the past. And there was a slew of more capricious lesser galleries, some of them struggling with the challenge of marketing to a dubious British public contemporary art from both sides of the channel. These were enterprises run by a motley but colourful band of men and women. Every art dealer needs a standby persona, a second profession if you like, for when times are difficult. Quite a few found it in betting on horses: in certain galleries the line to the bookmaker was probably more employed than the line to the Tate Gallery or the Royal Academy. Or there were the idealists: the Kaplan Gallery in Duke Street, St James's, was run by the distinguished Marxist dealer Ewan Phillips, who takes his

place in the great tradition of left-wing art traders that traces its line back to Félix Fénéon and Herwarth Walden. Phillips was the first to give Jean Tinguely a London show. In the late 1950s he took Paul Kasmin on as his assistant, who recounts that the gallery receptionist was an obliging lady who shared her favours, in a spirit of communist equality, with both Phillips and Kasmin. She introduced a little capitalist competition in the coffee breaks, however, when she liked to measure their respective sexual organs. Such a practice would not have been the norm at more staid establishments like Agnew's.

What was needed in post-war London was a more professional and commercially driven gallery to advance the cause of contemporary art. Into the breech stepped Marlborough Fine Art: 'I collect money, not art,' said Frank Lloyd, its managing director. 'There is only one measure of success in running a gallery: making money. Any dealer who says it's not is a hypocrite or will soon be closing his doors.' Normally the plea in mitigation of dealers who want to make money is that at least they are doing it working with art rather than with junk bonds. To that extent they have souls. But you get the feeling with Lloyd that he went into art because he was convinced that he could make more money out of it than in the financial markets. Pushed to the limit, the elasticity of art values can give you even more profit. And Lloyd was a compelling salesman. Once he was offering a Pope by Francis Bacon to a wavering buyer, who said, 'I like it, but I'm not sure my wife will, and it doesn't really go with the decor in our house.' Lloyd said, 'You can change your decor, you can change your wife, but you won't want to change this Bacon once you own it.' The cowed collector bought the Bacon, left his wife, and redecorated.

INTO THE CONTEMPORARY WORLD

I4

PETER WILSON AND THE INVENTION OF THE MODERN ART MARKET

Why devote a chapter to an auctioneer in a book about art dealers? Because Peter Wilson, chairman of Sotheby's from 1958 to 1979, in that time transformed the function of the auction house into something that directly rivalled and even usurped the function of the art dealer. When Wilson took over at Sotheby's, auctioneers were essentially trade wholesalers. What they sold was consigned to them by the traditional 'd' exigencies: death, divorce and debt; and to those one might add one further 'd' category, the desperation of dealers, whose last resort was to offload their truly unsaleable stock in routine sales at Sotheby's and Christie's. The people Sotheby's and Christie's traditionally sold to were in a few cases very knowledgeable and confident connoisseurs, but for the most part they were trade buyers, who then sold on to the ultimate collector. Before Wilson, auction was not necessarily regarded as the best means of selling the most important works that came for sale. They were often felt to be better and more profitably disposed of by the discreet agency of the great art dealers, away from the promiscuous hurly-burly of the saleroom.

Peter Wilson changed all that. He made the auction room glamorous,

the sort of gilded arena where the rich were happy to be seen engaging in gladiatorial contest with each other for some great artistic trophy. Thus the dealer middleman was increasingly cut out, and thus Wilson upped prices by going direct to the end user. His post-war prediction that the art market in the future would accelerate beyond all relation to its historical levels was in his hands a self-fulfilling prophecy, and changed people's perception of auction houses into places that delivered the highest prices. And besides creating and sustaining this highly satisfactory doctrine of a rising market for art, he elevated the importance of auctions in another way, too: they became the means by which art prices could be given a studiable basis, a databank. There was something definitive about the price achieved by the transparent competition of the public in the saleroom. Here at last was something akin to a stock market for art, something for the eager troop of analysts, economists and investors that are spawned by every market really to get their teeth into.

But Peter Wilson is worth studying for other reasons too. He is a supreme example of an impresario, a salesman, who brought to bear to selling people art, albeit through auction, the same personal attributes – charm, power of personality, cunning – that are part of the armoury of the supreme art dealers. The theme of this book is that the key to art dealing, and the history of its most significant exponents, is the personality of the art dealer. Wilson is a man whose character is worth studying in more detail for what defines a dealer of genius. As so often with the personality of a genius there are dark sides as well as light. But most people who knew him are united in their admiration of his passion for works of art, his rare gift of connoisseurship, the marvellous quality of his company, and his wicked sense of humour.

Wilson was born in November 1913 into the comfortable lower-middle reaches of the British aristocracy. His father was a baronet, a spendthrift rogue named Mathew 'Scatters' Wilson, a practised seducer of married women, a fully fledged bounder; his mother, a daughter of Lord Ribblesdale, had been brought up partly in France, whose culture she admired. From her Wilson inherited a continental sympathy. The key to Wilson is a series of unresolved conflicts in his psychological make-up: between his grand, establishment background and his family's lack of money, which meant the Wilsons had to decamp ignominiously from their family seat in Yorkshire; between the traditional preoccupations of the upper class into which Wilson was born – hunting, shooting, soldiering – and the more

effeminate image of his own passionate interest in works of art; between the conventionality of his upbringing and his homosexuality (initially his preference for his own sex was latent, but gradually it found troubled expression in his private life); between his charm and enthusiasm on the one hand, and his fear of self-revelation on the other.

As his Sotheby's career progressed, Wilson developed a private contempt for many of his clients. Of course he was outwardly never anything less than charming to them, but he felt the rich were fair game: the property developers, financiers, industrialists and film moguls who were often possessed of more money than taste; and the philistine and insensitive British aristocracy, dulled by centuries of inbreeding in dank northern climes, who had lost all feeling and discrimination for the art treasures a misguided providence had seen fit to pile up in their ancestral homes. He decided that his mission in life was, as smoothly and efficiently as possible, to recirculate works of art – to move them on from those who didn't appreciate them and into the possession of people who (sometimes only by spending large amounts of money on them) might come to an appreciation of them. In the process an ever-growing stream of commission was to flow into the coffers of Sotheby's, the entity in which Wilson sustained a passionate, almost messianic belief. It wasn't so much that Wilson wanted to attach himself to large sums of money per se, but money was necessary in order to indulge his own taste for art. He did have the most marvellous taste. And he did have a passionate desire for works of art that he felt an almost physical need to satisfy.

For someone like Wilson to be born without the money necessary to meet these needs was a bit like a virtuoso musician being born without access to a violin. A society that tolerated such an injustice was an imperfect society. So given this unseemly imbalance, Wilson felt himself permitted to bend the rules a bit in order to get things back into true. If an opportunity arose where briefly crossing the boundaries of technical legality might deliver the satisfactory transfer of a work of art from one pair of hands to another, and a consequent commission to Sotheby's, then it was acceptable. The end entirely justified the means. And, somewhere in the mix, there was a wicked pleasure in getting very rich people to pay rather more for very expensive things than they had at first intended. Art dealing – in the guise of auctioneering – was a game, a means of rebalancing the social and economic system in his favour.

Nicholas Ward-Jackson, an employee in the 1960s, provides a telling

vignette. He was in the room when Wilson called the heiress Barbara Hutton to sell her certain items from an upcoming sale. "'Barbara," he was saying, "you should have this marvellous gold box. I really do think you should have it." She was on the speakerphone. Her speech was slurred and she was completely out of it, and there was Peter, taking down her bids, stifling the laughter. He must have got $750,000 out of her.'"

Wilson underwent a conventional upper-class education, sent away miserable to prep school at a young age, and then on to Eton. 'I think a very happy childhood is not conducive to success in later life,' he observed tellingly. His closest friend at Eton was a Swiss boy, Richard Dreyfus. The two of them were united by a disdain for cricket and a passion for art and antiques. At weekends they made illicit trips together to Portobello Road market. Wilson left Eton with his only achievement being a prize for botany, then went on to New College, Oxford. No Waugh-like idyll here; he left after a year and went abroad, first to learn French in France and then to Hamburg to learn German. Here he met Helen Rankin, an English fellow student. She was five years his senior, but they got on well and within months they were married. Wilson's family disapproved profoundly: for a sensibility such as that of Scatters, her bourgeois background seemed even less acceptable than had she been a chorus girl. The marriage ended in divorce in 1951, but it was one of the most important and enduring relationships in Wilson's life; it produced two much-loved sons, and even after their separation he remained close to Helen, often taking holidays with her and her second husband, Philip Ballard, in an unlikely but rather touching ménage à trois.

Upon Wilson's return from Germany he got a job at Spink, and then one selling advertising space for *The Connoisseur* magazine. Neither really suited him. Finally, through his parents' friendship with the then Sotheby's chairman, Vere Pilkington, he was taken on at the firm that he was to transform over the next forty-four years. He knew immediately that Sotheby's was where he wanted to be, a place where he could not only spend all day with the things that fascinated him, works of art, but also make money out of the exercise. His first project was a consignment of antique rings, the Guilhou Collection, that he was given to catalogue; he rose to the challenge by producing a highly impressive and well-researched catalogue, with the help of Helen. He had already learned the lesson that the most effective auction salesmanship is disguised in the gravely learned language of art history. On top of that Wilson managed to get photographs

of highlights placed in art magazines in advance of the sale, common practice now but very advanced thinking for a twenty-five-year-old in the late 1930s. Indeed his marketing and promotional instincts were always prescient. Three years into his career at Sotheby's an opportunity arose when an existing partner retired and Wilson, whose wife had recently inherited £5,000 in a legacy, was able to use the money to buy the shares that were offered to him and become a partner himself.

Just as Wilson's career as an auctioneer was getting going very satisfactorily, the Second World War intervened. Wilson joined his senior Sotheby's colleague Charles des Graz in the government's postal censorship service, first in Liverpool, then in Gibraltar, then in Bermuda. In 1943 he was sent to Washington to work in intelligence. What did this involve? One of his assignments was to cooperate with Daniel Wildenstein in identifying European monuments and works of art that should be protected from military action. But what else he did is shrouded in mystery. At all events his time in Washington gave him an insight into America and Americans that stood him in good stead for the rest of his life. He admitted later that he was tempted to stay on and make a career in espionage. He didn't. But there is no doubt that certain espionage techniques he acquired in these years were an asset to him upon his return to Sotheby's once hostilities ceased. Was his MI6 code number really 007? Wilson – who was a friend of Ian Fleming – liked to claim in later years that it had been. It is one of those stories that, if it wasn't true, should have been.

A friend he knew both from the art world and from intelligence work was Tomás Harris, Anglo-Spanish art dealer, MI5 spy and bon viveur, from whom he rented half his London house in the early post-war years. According to Seale and McConville, the biographers of Kim Philby, Harris 'revealed an extraordinary skill for running double agents, and in the context of MI5's highly successful deception programme fed to the Germans an entirely false Allied Order of Battle at the time of the Normandy invasion – one of the great deception feats of the war'. It is an exaggeration to suggest that art dealers are naturally talented deceivers. But the constantly shifting elements in an art dealer's professional life – changes in price, attribution and ownership, involving chandelier bids, fakes and offshore shell companies – demand a talent for floating and uncovering deceptions that is part of the weaponry of the spy.

After the war he was initially in charge of works of art at Sotheby's, but then took on the picture department from a fading Vere Pilkington.

Through the 1950s came a series of Wilson-orchestrated sales that transformed the art market. First there was the Farouk sale in Egypt in 1954, surely the basis for some Ealing comedy as yet unfilmed, with coups d'état, duplicitous men in fezzes and a secret cache of filthy pictures. The collection of the deposed King Farouk was an eye-catching if uneven mixture of some great French eighteenth-century art, gold boxes, jewellery and Islamic works, and included a legendary assemblage of erotica. It was being offered for sale by the new government, and the auction was to be conducted in Egypt. It was a challenge that Wilson, with his eye ever vigilant for a marketing opportunity and relish for risk-taking, found almost irresistible. Having been alerted to the proposition by his old friend Richard Dreyfus (whose then wife came from an important Egyptian family), Wilson was on the case at once and cajoled his colleagues into making a winning pitch for the business. Nervous voices in London were raised about the legality of such a sale. This was Wilson at his best, sweeping aside obstacles. He got the best legal advice in London: what was needed, it seemed, was the passing of a law by the new government appropriating the royal collection to the state.

Accordingly he jumped on a plane to Cairo and, picking his way adroitly between the Levantine intriguers, got the new law passed. The sale went ahead. One imaginative inducement that was discussed but never implemented was that anyone who spent more than £5,000 on a lot would be granted a private view of the erotica collection. As it turned out, the auction was a nightmare and the duplicitous men in fezzes hung on to most of the commission owed to the auctioneers. Very little money was made, but a huge amount of international publicity was generated for Sotheby's. On balance, it had been a worthwhile exercise, and pointed an exciting new way forward for the firm with the dynamism of Wilson's risk-taking providing its locomotion.

A long-established wisdom of the art market that Wilson wanted to discredit as soon as possible was the supremacy of the private dealer as the agency to sell masterpieces. This meant competitively seeking out such masterpieces and securing them for auction. One was Commander Beauchamp's Poussin, *The Adoration of the Shepherds*, which Sotheby's got for sale in June 1956. This was a real breakthrough, because the work was indeed a masterpiece (see plate 21). Even though the painting was consigned to auction, the dealers, sensing a dangerous precedent, fought back. One made an anonymous offer direct to Beauchamp of £10,000 plus

Sotheby's commission if he would withdraw the painting from auction. Wilson kept his nerve. Leave it in, he told Beauchamp. We'll get more than that. Beauchamp returned a few days later saying the dealer had upped his offer to £15,000. Very well, said Wilson, leave it in and we will guarantee you a minimum of that amount. It was the first guarantee in Sotheby's history, and it is significant that Wilson offered it. At this point, of course, modern Sotheby's would have concretised the agreement with a contract that bound Beauchamp to leaving the picture in the sale at this guaranteed minimum. But Wilson was breaking new ground and in an era when auction consignments were generally not secured by anything more than an informal letter, the full legal obligations of the vendor had not been thought through. Just before the sale the owner returned saying he now wanted a guarantee of £35,000 or he would take the painting away. There was hand-wringing and four-letter words in the Sotheby's board-room, but Wilson was icy clear on what had to be done. The guarantee must be increased to £35,000, because, as he said, 'if we fail over this we're done for'. The rest of the Sotheby's board were horrified, but Wilson got his way. The highest bid was £29,000, but Sotheby's sold it at that figure and made up the £6,000 to Commander Beauchamp (who was either supremely lucky or supremely cunning). In Wilson's judgement it was £6,000 very well spent. The saleroom's credentials as sellers of the very best had been established. And the outside world, who knew nothing of the guarantee, saw Sotheby's selling a great painting for a stupendous price of £29,000. As with much of what Wilson achieved, appearance counted for more than reality.

A year later came the Weinberg sale. Significantly, it was Wilson's first great success in the Impressionist field. He saw before anyone that while it was desirable for an auction house to sell major old masters, they were limited in their supply, and the glamour and the really big money that lay ahead would be generated by more modern painters, particularly the Impressionists. Judged by the highest standards, Weinberg's wasn't actually a great collection, but it included ten van Goghs, and Wilson – whose antennae responded as positively to marketability as quality in art – sensed its possibilities. Having managed to persuade the executors to sell in London, he set about promoting the auction. He persuaded Sotheby's board to engage Pritchard Wood and Partners to handle presale publicity. It was the sort of opportunity that advertising men dream about, because the ten van Goghs were the selfsame pictures as had featured in the 1956

film *Lust for Life* starring Kirk Douglas as van Gogh. Here was a chance to buy pictures by the heroically doomed artist that Hollywood was making movies about, and here was the chance to buy the very ones visible in the movie itself. As if this wasn't enough, here was the chance to buy the sort of pictures that Hollywood stars themselves were hanging on the walls of their own luxurious residences. This marriage of Hollywood and Impressionism was already manifest in a number of cases, and calculated to drive demand to fever pitch. Auction hype was raised to a new level. Wilson was marketing art as glamour, and art as something to show off, not just as art, not even just as status, but in its very mode of acquisition too, in the very public spotlight of the auction.

Thus Wilson was the first to act on the realisation that Impressionism would be the locomotive to drive the post-war art market. It offered a beguiling vision of escalating amounts of money and glamour. It had become truly international. Wherever you offered a great Manet or Renoir or Cézanne it would be competed for by the same moneyed, jet-setting group. International air travel had shrunk the world and inflated Impressionist prices. Wilson was the man to exploit this for Sotheby's, demonstrating that the highest prices were now only to be achieved at auction. When the New York lawyers acting for the Weinberg estate originally sent off letters to Sotheby's, Christie's and Parke-Bernet in New York soliciting quotations for sale by auction, they were struck by the varied responses received. Parke-Bernet offered to take on the sale, but at a commission rate of 23.5 per cent. Christie's reply was polite and mildly interested, but it didn't arrive for three months (possibly because they sent their letter by sea-mail). Peter Wilson, on the other hand, was on the telephone to New York the same day he received the lawyers' inquiry, and soon after was offering the executors a knock-down commission rate of only 8 per cent. Freedom from auction tax gave London an enormous advantage over New York and Paris, which made it even easier for Wilson to secure the business. This was one of the reasons why, when the glittering prize of the Jakob Goldschmidt Impressionist collection became available for sale the next year, Wilson managed to get that for Sotheby's London, too.

Wilson and Sotheby's already had a relationship with the Goldschmidt family. Jakob, a Jewish banker who escaped Nazi Germany to settle in the United States, had died in 1955. His son and heir Erwin set about the task of selling the art collection. The first tranche, largely old masters,

was brought to London for appraisal. Wilson and his old master picture specialist, the redoubtable Carmen Gronau, were invited to the Savoy Hotel for the purpose. Negotiations proceeded; in a rather mysterious way Goldschmidt and his lawyer kept shuttling in and out of the room in which Wilson and Gronau were being interviewed, presumably in order to confabulate in private. What was going on? As they came back into the room yet again, Gronau overheard Goldschmidt murmur to his lawyer *'Die hier gefallen mir viel besser'* ('I like this bunch much better'). German being her native tongue, Gronau realised that Christie's must be pitching for the same collection in a room along the corridor. And the good news was Sotheby's were winning. (How much better a deal could Goldschmidt have negotiated out of Wilson had he had the guile to murmur in Gronau's hearing *'Die anderen gefallen mir viel besser'* ['I like the other bunch much better']. But life is full of missed opportunities.) So Sotheby's got the sale of the first tranche, and did well with it. And thus Sotheby's were first choice for the second tranche, the sale of the Impressionists, when it came in 1958.

By now Pilkington had been prevailed upon to retire, and Wilson elected chairman. It was the opportunity he had been waiting for, to announce the new direction of the art market with a magnificent auction comprising only great works by the Impressionists. There were seven of them in the Goldschmidt sale: three Manets, two Cézannes, a van Gogh and a Renoir. They were each of outstanding quality, and as a group made an even greater impact than the sum of the parts. The decision to offer them in a stand-alone sale of just seven lots was an inspired one on Wilson's part. It simultaneously emphasised the auction as an event of unparalleled glamour and importance, and focused attention on the works themselves, undiluted by anything less than a masterpiece. The decision to hold the auction in the evening and to require those who attended to wear dinner jackets, as if it were some gala theatrical event, added to the magic. The Goldschmidt sale emphasised once and for all how buying great art at Sotheby's was now a far more glamorous experience than doing so at a dealer.

Peter Wilson understood that much depended on the promotion of the sale, and building a momentum of interest in the press would be critical. It is a truth well known to establishment insiders that friendships with newspaper editors are all very well, but what really gets things done is an intimacy with newspaper owners, whose wishes tend to carry editors with

them. Wilson himself had for some time cultivated a friendship with Lord Beaverbrook against an opportunity like this. Once again he employed an outside firm to handle the promotion of the sale. A month in advance of the auction there had already been articles publicising it in newspapers and magazines in twenty-three different countries. It was billed as 'The Sale of the Century', an overworked cliché since but a novel and arresting idea then. Such was the build-up that on the evening of the sale itself, on 15 October 1958, the police had to be called to Sotheby's to control the adulatory crowds milling about Bond Street trying to gain admittance to the sale. Those who did get in included Kirk Douglas (fresh from his cinematic role as Vincent van Gogh), Anthony Quinn, Dame Margot Fonteyn, Somerset Maugham and Lady Churchill. Edward G. Robinson was linked in by transatlantic telephone. In the words of Lord Beaverbrook's *Daily Express*:

> At 9.35 tall dinner-jacketed Peter Wilson, Chairman of Sotheby's and auctioneer of the night, climbed the steps of the pulpit-like rostrum in the green-walled main saleroom. Chubby-cheeked Wilson blinked in the glare of the massed TV lamps, ran his eye over the mink and diamond-dappled audience, rather like a nervous preacher facing his first congregation, and rapped firmly with his ivory gavel.

The *Express*'s choice of ecclesiastical imagery for the occasion underlines the quasi-devotional character of a major auction. But there is a strong element of theatre, too, and the public are as much audience as congregation, the auctioneer as much performer as preacher. From then on the auction house partook of both worlds. The dappled light of Impressionism caught in the glitter of the jewellery worn by the theatre-goers-cum-worshippers. Everyone went home elevated by contact with the mysteries of great art, but also energised by their proximity to huge financial transactions, the drama of those transactions heightened by the climactic moment of the fall of the hammer. The power of the marketing, the glamour of the event, the beauty of the art: all combine to create something definitive about the pricing achieved, and to invest an authority in the ringmaster of those prices, the auctioneer. It wasn't just the Impressionists and Sotheby's who emerged enhanced. It was Peter Wilson himself.

The results were extraordinary. The seven works totalled £781,000, and the Cézanne, *Garçon au gilet rouge*, made a staggering £220,000. 'Two

hundred and twenty thousand pounds?' queried Wilson with mock sur-
prise from the rostrum. 'What, will no one offer any more?' The crowd
loved it. The Goldschmidt sale was remarkable not just for the level of
publicity it achieved, but also for the complexity of the deal that Wilson
was prepared to strike with the vendors. Various commission rates were
applicable according to the level achieved above the reserves. Above a
certain point, Sotheby's got 100 per cent of the proceeds. Below a certain
point they were losing out and had to make up any shortfall on a guaran-
teed level. In the event Sotheby's derived a revenue of about £75,000 on
the sale. Wilson had got his sums right. Lessons had been learned since
the loss sustained on the Poussin. And this time Wilson had put in place a
secret safety net. He had got Sir John Ellerman, a shipping magnate, lined
up to buy the collection in case reserves weren't reached. Thus the risk was
to a large extent offloaded. But in retrospect you realise that Wilson was
taking a succession of huge risks, basing his calculations on the assumption
that prices would be achieved way above previous records. It takes courage,
insouciance and a massive trust in your own judgement and instinct to
operate like that. But this is what he liked and what he was good at: sailing
close to the wind.

Wilson was now established as the dominant force not just in the
British but also in the world art market. It was natural that he should
look to expand Sotheby's operations abroad, most crucially in the United
States. He set his sights on the takeover of Parke-Bernet, the leading
auction house in New York. It was a daring move for any British firm to
contemplate the acquisition of an American one, when almost all the
post-war traffic was in the opposite direction. But Wilson carried it off.
His understanding of America and Americans acquired during the war
helped; he had established excellent relations with the big players in the
American art scene, collectors such as Norton Simon, and of course his
experience in dealing successfully with Goldschmidt was important. In
fact Jay Wolff, Goldschmidt's lawyer, became Sotheby's lawyer in America.
And another important ally in the takeover process – which was far from
smooth, because of obstinate Parke-Bernet shareholders and a precarious
lease arrangement on the auction premises themselves – was Brigadier
Stanley Clark.

Stanley Clark was a PR man of genius whom Wilson recruited in the
late 1950s. He proved his worth repeatedly in the generating of positive
publicity for Sotheby's big early sales. But he also played a crucial role

Anglo–American harmony: Peter Wilson (right) *after his triumphant acquisition of Parke-Bernet.*

behind the scenes in many other areas, for example in the deadlocked negotiations over the Parke-Bernet takeover. The American shareholders were holding out for a better offer. Wilson turned to Clark for some way out of the impasse. Clark's solution was to put out an unattributed story to the press that Sotheby's would start holding sales in the US whether they acquired Parke-Bernet or not. Once the recalcitrant shareholders read that, it would bring them back to the negotiating table. Wilson's delighted reaction was: 'You wicked swine.' You detect true admiration in that accolade.

The story was carried in the *Sunday Telegraph* that weekend, and

followed up in the American press. It worked. Wilson was so carried away that he proceeded to buy Parke-Bernet without securing agreement to change the disadvantageous rental arrangement on the Madison Avenue premises. As so often at crucial moments in his career, he winged it; but, with the help of Jay Wolff he achieved a successful renegotiation afterwards. They were exciting times to be working at Sotheby's. There is a photograph of Wilson standing in the doorway of Sotheby's newly acquired Manhattan headquarters, the Parke-Bernet premises at 980 Madison. Visible above his head is the allegorical sculpture with which the building is decorated, depicting 'Venus bringing the arts to Manhattan'. Somehow it is apposite that it should be Venus: sex is a lubricant to many markets, but particularly to the art trade.

Wilson's natural showmanship went down very well in the USA. In New York, a major French Impressionist sale at Sotheby's new premises was mounted with the auction room done up as a Montmartre café in tribute to the artists whose work was on offer. Stanley Clark used the new medium of television very imaginatively, for instance with an auction conducted simultaneously in New York and London by 'Earlybird' satellite. Wilson was alert to new technology, and would have loved the Internet. He also backed and encouraged sales of theatrical memorabilia from the Diaghilev and the de Basil ballet companies, which were held in theatres themselves rather than in the more staid setting of Bond Street. The auctions were choreographed: students of the Royal Ballet School danced onto the stage as the lots appeared. It was not something that you could imagine happening at conventional old Christie's.

The 1960s was probably the decade of Wilson's zenith. Great business was being won, and money was being made. Just as important, everyone was having fun. In those heady days, everything seemed possible. The recruitment of a highly talented group of young experts, Wilson protégés, helped create an atmosphere in which youthful enthusiasm was positively harnessed. Wilson not only had a very good eye for art but also a very good eye for art experts, for spotting people with an eye. He watched people's fingertips, how they handled works of art. New ideas were not just welcomed but turned into reality.

Wilson's great strength was that, whereas Christie's focused their attention almost exclusively on the British aristocracy, he made it his business to get on well with the great European and American families. And there was also an older generation of very distinguished experts still in place,

men with interesting histories such as Jim Kiddell and Tim Clarke, a great ceramics authority. Clarke, for instance, had been head of MI5 in Aleppo during the war, where he proved himself a highly adept and effective interrogator. This was a skill that must have come in useful later at Sotheby's in 'client-facing' situations. It was something of a golden age, which fostered a kind of scholarly dynamism, an inspiring blend of daring commercial initiative and the ethos of an Oxbridge college common room. Wilson himself occupied a small and untidy office behind the saleroom rostrum, a bit like a sacristy behind the altar: not a grand space, but a place that was the very epicentre of Sotheby's.

Wilson was a fervent and knowledgeable art collector himself, with a consuming passion for the chase, a pleasure in both the work and in its acquisition. 'Nobody is a patron unless they're covetous,' Wilson said. 'Without covetousness you're not going to have appreciation of art. And I think that if covetousness were destroyed by some magic, art would come to an end. It's very rare to be able to appreciate art without wanting to own it.' He encouraged his own protégés to think in the same way: 'I don't want anyone on my staff who doesn't collect. I wouldn't believe in them if they didn't.' It was a time when someone with a dealing mentality would flourish as an employee of Sotheby's. Entrepreneurialism came from the top.

Wilson was generally regarded as a supreme auctioneer. There was a suave informality to his style that people found immediately appealing: 'You see a lot of familiar faces,' explained Wilson, 'it's rather like going to a friend's wedding.' Geoffrey Agnew declared, 'He was far and away the best auctioneer I've ever known because you always felt he was on your side.' Like many of the best auctioneers he was sensitive to a kind of bidder telepathy: 'if someone in the audience wants to bid he somehow conveys by the way he holds his head or by his concentration that he wants you to look at him and you glance in his direction'. Once, Wilson was selling a work of contemporary art, a Manzoni *Merda d'artista*. This comprised a sealed tin containing the artist's excrement. At the end of the bidding he said, 'thank you so much', and wiped his nose with a handkerchief as if to dispel a lingering odour.

Wilson was the first to deploy the full panoply of a dealer's skills in the role of the auctioneer. Indeed he has been described as 'a great dealer negotiating from the rostrum'. A Wilson auction was the culminating point of an enormous amount of preparation, matching buyers to lots in the weeks leading up to the sale. Barbara Hutton was not the only rich

collector to be charmed in advance into making large bids. The idea, promoted by Sotheby's, of publishing presale estimates in catalogues was part of the same strategy. It was a means of making buying at auction easier and friendlier to private people (what in the twenty-first century is known as 'improving the client experience'). This was not something that Christie's bothered with: their more traditional view was that you might exert yourself to get the lots in, but once included in a sale they sold themselves. The trade – who were for the most part the buyers – would know what they were worth anyway.

There was an ambivalence to Wilson's relationship with dealers. On the one hand he was tantamount to a dealer himself, and his closest and most respected friends were vastly knowledgeable dealers such as John and Putzel Hunt. And on the other he was masterminding a process that was undermining the power of dealers by circumventing them in the pursuit of their clients. He could be incredibly kind to members of the art trade, going out of his way to help, for instance, Giuseppe Eskenazi, now the leading dealer in the world in Chinese art but then just starting out, by putting at his disposal the Sotheby's PR machine to publicise an early exhibition. He acknowledged the shared interests of those who had to use their own ingenuity to sell works of art. The word freemasonry comes to mind, and it emerges that Wilson was indeed a mason: he belonged to the Benvenuto Cellini Lodge, which met regularly at the old Devonshire Club at the top of St James's Street and numbered amongst its members various eminent figures in the art trade, including Harold Leger, the Rubin brothers, the Nortons of S.J. Phillips, Dennis Vanderkar and Brian Koetser. Attitudes to Wilson within the trade reflected this ambivalence: how far could you trust him? On balance, most dealers recognised that Sotheby's under Wilson, while it was in competition for their clients, nonetheless provided the art market with such a dynamic force that there were benefits for everyone.

The old joke was that when a major collector died, Peter Chance of Christie's went to the funeral and Peter Wilson of Sotheby's went to the house. It was a reflection of Wilson's superior cunning and ruthlessness. His strategy for winning business, for attracting in for sale the great works of art on which Sotheby's success depended, involved a very personal mixture of charm and bullying. He was a good closer of deals: he didn't want to leave the client's house until the deal was signed. He would secure consignments with aggressive and exciting estimates, and then ruthlessly

force reserves down nearer the sale. His tactic with American sellers, according to Michel Strauss, was often to lose his temper. He looked like thunder: 'Do you realise that if we don't sell it at the auction, it will be dead for ever?' he would threaten the unfortunate owner of a work that he had earlier persuaded them would break all price records. Americans of a previous generation seem to have been particularly vulnerable to the patrician arrogance of Wilson's lofty Englishness. Having been seduced by his charm into consigning, they were now reduced by his fury into an abject acceptance of his will. It was almost as if it was a privilege to be abused by such a splendid example of European sophistication.

If there was one relentless message that Wilson was keen to get across it was that art would go up in value. In 1966 he declared on the BBC Money Programme: 'Works of art have proved to be the best investment, better than the majority of stocks and shares in the last thirty years. I think lack of security in the world encourages that trend.' But something even more solid was needed to convince the waverers of the miraculous commercial potential of works of art. Wilson cast around and came up with the splendid idea of an art index, along the lines of the Footsie. The idea was pitched to the *Times* City Editor over lunch. It was a good lunch, and the Times-Sotheby's Art Index was born.

A young qualified statistician on *The Times*, Geraldine Keen (now Geraldine Norman), was recruited to set the Index up. Wilson was particularly keen on the Impressionist index. Being the area that showed the most dramatic rises in price, it told the story so well. Not all specialist departments were so amenable: Carmen Gronau in the Old Master Department really stood out against indexing, remembers Norman. But Wilson's pressure on her was remorseless. 'You've got to do it, Carmen. Here's a bottle of whisky. Go at it this evening. I want an index by the morning.' He got it.

Twelve different sections of market were identified, from old masters to Impressionists to furniture to porcelain. One would be published in *The Times* each month of the year, measuring annual performance in the different areas. The Index went back to the late 1950s, where it was set at '100'. It ran in *The Times* from 1967 to 1971. Great was the rejoicing whenever the Impressionist index appeared, but other areas of the market were more wobbly. Still, in the four years of its existence, by its very name it served to position Sotheby's (and Peter Wilson) in the forefront of the public's consciousness as to who the drivers of the art market were.

So long as you were on his side and doing what he wanted, he was

charming to you. But cross swords with him and his wrath could be terrible. Anyone who witnessed him losing his temper never forgot it, the way he would go white with fury and spittle would fly from his lips. Colleagues within Sotheby's who had the temerity to disagree with him were branded disloyal and 'banished to Siberia'. Others were uncomfortably aware that what he required them to do was not always legally compliant. In May 1970 the first Andy Warhol ever to be offered at auction, *Soup Can with Peeling Label*, was apparently sold by Sotheby's in New York for $60,000. But it transpired much later that the buyer's name and the price had been imaginary, and the work had been bought in. 'We would go behind a curtain after every sale,' recalled Fiona Ford of the then Sotheby's Press Office, 'and find out from Peter Wilson what we were expected to lie about.'

In 1974 a new opportunity emerged for Wilson to exploit his vision of an ever-rising art market. At a time of rampant inflation and failing equities, the British Rail Pension Fund decided to invest 3 per cent of their assets in art, and approached Sotheby's for advice. All the time and effort Wilson had devoted to appearing on television preaching the gospel of investing in art was apparently about to bear the most abundant fruit. But if Wilson saw this as an opportunity to make the project his own plaything, he was to be disappointed. The person he selected to run the scheme, Anna Maria Edelstein, although she was a Sotheby's employee, proved herself more than capable of standing up to him and retaining her independence. The fund certainly bought from Sotheby's, but by no means exclusively. Purchases were also made at Christie's and from dealers. All in all it was a success. Over a couple of decades £40 million was turned into £170 million. Although the sales did not take place till after Wilson's death, he no doubt derived a quiet pleasure in the results from beyond the grave.

Like all autocratic regimes, Wilson's had its apogee and then its decline and fall. In the decade of the 1970s things gradually began to go wrong. The first act in the drama was the ill-fated Sotheby's cigarette. Money was needed to shore up the firm, so Wilson – a non-smoker – sold the brand in return for £100,000 from W.D. & H.O. Wills. But as a venture it met with unexpected and vociferous internal opposition, and permanently damaged his relationship with his own board. And the cigarettes weren't very good either. Another ill-conceived scheme was the Stephen Higgons affair. Higgons was a French dealer whom Sotheby's funded to

make acquisitions in Paris, where prices even for important works were often cheaper, and feed his purchases into Sotheby's sales in London and New York. A lucrative supply line was established, but the bookkeeping was not as meticulous as it might have been. In fact it was chaotic. No one knew quite how much Higgons had been advanced over the years. Clearing up the Higgons mess was only one of a number of challenges that confronted those trying to impose financial discipline on Sotheby's in the 1970s. It wasn't easy, and Wilson did not take kindly to the sort of fiscal intervention that implied criticism of his methods.

Peter Spira was brought in from Warburg's by Wilson, but without consulting the rest of the board. Spira's role was to get the firm into a position to go public, the financial desirability of which Wilson could see without fully grasping the pain it might involve. For Spira it was an unenviable task, hardly less daunting than being parachuted into the Mafia and being tasked with cleaning it up from the inside. Wilson always saw Sotheby's as something akin to an old-style Swiss bank, facilitating tax avoidance, getting round export restrictions, throwing a cloak of secrecy over transactions, all in the interests of its clients, but in the greater interest of Sotheby's, who hoovered up their commission on the deals regardless.

So they came in waves, the financial men, drafted in over the years to establish some semblance of order in the company's commercial affairs. First there was the financier-accountant Hermann Robinow, then there was Spira. The more their discipline clipped the wings of Peter Wilson, the more abusive about them he was behind their backs. Finally – at the end of the Wilson regime – there was Gordon Brunton, helicoptered in from being Chief Executive at Thomson Newspapers. Wilson was once asked what he thought about Brunton. 'He's very capable,' he replied, 'and you can look up his achievements in Who's Who.' Pause. 'But if you do it won't escape you that his home address is Godalming.'

All this is not to deny that Wilson-inspired fun continued to be had at Sotheby's in the 1970s. Wilson had bought an estate called Clavary in the south of France, and it suited him to start up Sotheby's sales on his doorstep in Monte Carlo in 1975. But it was a good plan, too: holding auctions in Monaco enabled Sotheby's to penetrate the French market without having to submit to the tiresome legal restrictions that applied elsewhere in France. Once again there was a series of splendid sales yielding great publicity to get things going. First the glamorous Rothschild collection came under the hammer, then there was the sale in Monaco railway station

of a line of Wagon-Lits carriages, exquisite pieces of historic rolling stock that triggered huge publicity, high prices, but not a lot of revenue. And later in the decade there were two momentous sales in London, which represented, in retrospect, Wilson's glorious swansong. The first was the house sale in 1977 at Lord Rosebery's Mentmore Towers with its exciting Rothschild connections, and the second the superb collection from Switzerland of Robert von Hirsch. Wilson had met von Hirsch through his old friend Richard Dreyfus, who was von Hirsch's stepson. Thereafter Wilson had visited and revalued the collection on a regular basis throughout the 1960s. In 1977 von Hirsch died, and Sotheby's won the collection for sale.

Seven days in June 1978 were set aside and branded 'von Hirsch week'. The marketing was superb. One cabinet containing particularly choice works of art had to be offered first to the foundation. The idea of missing out on this element of the sale was more than Wilson could bear. So he doubled the estimates on these items, which had the effect of deterring the foundation but meant that the items had to be sold at auction with reserves at world record levels. Wilson got away with it. Luck? Yes. Bravado? Yes. But also that instinct for quality underpinning his confidence that if something was good enough it could always be coaxed up to another price level.

Not that Wilson would ask of his employees sacrifices that he wasn't prepared to make himself. 'Peter was determined to get the Impressionist and Modern pictures belonging to the Sharp family,' remembers Peregrine Pollen. 'We both went out to California in 1968 to pursue them. The elderly Mrs Sharp took a shine to Peter and he went dancing at Los Angeles nightclubs with her. There he was, dancing with this rather fat woman in order to get her pictures. He said, "I'll marry her if necessary," and I knew that he meant it.'

If the situation demanded it, Wilson was also very good at sending appealing young men to be nice to clients. In a notorious, possibly apocryphal, episode earlier in his career, Peter Wilson had masterfully deployed the charms of his then employee Bruce Chatwin to get what he wanted out of Somerset Maugham. Maugham's Impressionist collection was consigned to Sotheby's in the summer of 1962. A few days before the auction, Maugham arrived in London to stay at the Dorchester Hotel, but was afflicted with toothache. Severely disgruntled, he called Wilson to announce that he'd changed his mind about the sale and was keeping his Impressionist pictures after all. Wilson's reaction is another illustration of

his Machiavellian genius, his readiness to exploit human frailty to achieve what he wanted.

Wilson sent for Chatwin and asked him to go round to the Dorchester to have tea with Maugham, to tell him how well his paintings were going to do, and what a privilege it was for Sotheby's to sell them, and how much it would mean to Chatwin personally as he had catalogued them. Oh, and before he went, would Chatwin mind just washing his hair? Susan Sontag described Chatwin as having 'the kind of looks which enchant and enthral... It isn't just beauty, it's a glow, something in the eyes. And it works on both sexes.' It worked on Somerset Maugham, and the pictures stayed in the sale.

By the end of the 1970s, the chaos finally caught up with Wilson. It became clear that the management of Sotheby's would have to devolve into other hands. The men from Godalming were at the gates. This was hard for Wilson to come to terms with. But he was not well – his diabetes was getting worse – and withdrawal to the South of France became increasingly attractive as a means of satisfying his aversion to paying tax. And the more Wilson thought about it, the more the possibility of retaining power in Sotheby's from afar seemed a viable one. So in 1979 he went to live permanently in Clavary (but with his own private hotline to Bond Street, which made running the company fairly difficult for those nominally in charge in London). By this time his attitude to money was changing, too. He had always liked it, but as a means to an end, that of surrounding himself with beautiful things, and of boosting the fortunes of Sotheby's. But now a third end asserted itself: the need to establish his own financial security, and that of his children.

One of the steps he took in the direction of financial security was his private acquisition of a stake in the Sevso Silver hoard. This was a collection of fourth- or fifth-century silver that appeared discreetly on the antiquities market at the time of Wilson's retirement. It had been made for a Roman official in the Empire of Constantine the Great, and appeared to emanate from Lebanon. Whatever the problems of its provenance, there was no doubt about its supreme quality. They were beautiful, marvellously preserved, and he was seduced by them. Buying them seemed like the final coup to cap his career, but this time a coup whose proceeds would go straight into the Wilson coffers rather than benefiting Sotheby's. The divorce had taken place: Wilson was now a single private dealer rather than the head of Sotheby's. The Marquess of Northampton was a

partner in the deal and took nominal ownership, with Wilson having a stake. Even so, Wilson did not have enough money to pay for it, so he had to sell his Sotheby's shares. So what if he wasn't technically allowed to at that juncture in the year, as a continuing member of the Sotheby's board? He needed the money, so he went ahead. It was another instance of his assumption of a lofty position at some considerable distance above the rules.

Export regulations were not details with which Wilson normally bothered much. Flouting them was a game you played with the authorities; sometimes you won, and sometimes you lost, and the worst that could happen if you lost was that you had to pay a fine. There was a lingering assumption amongst people of Wilson's generation that these were foreign laws often put in place by disreputable fascist governments, and it was ignominious for an Englishman to pay more than cursory attention to them. That said, in this case Wilson and his partners did go to considerable trouble to get the export papers from the Lebanon. This was partly prompted by their desire ultimately to sell the hoard to the Getty Museum, and their awareness that American institutions had rather rigorous requirements about such things. Unfortunately the papers they obtained turned out to be fakes. Then the pieces were misguidedly sent to the USA, where three countries made a claim for them. The pieces were returned to 'Spenny' Northampton, but no one would buy them now. Once again Wilson hoped he could wing it; but on this final occasion his luck had finally hit the buffers. A large proportion of his money appeared tied up in an asset that was unsaleable. It cast a shadow over his last years in semi-retirement in France. He died in 1984 with the problem unresolved, although his heirs have since managed to place the collection in the Hungarian National Museum.

Beneath his gregarious surface, Wilson was ultimately a loner. Hence perhaps the persistent rumours about his having been a Soviet spy, linked by some secret understanding to Burgess, Maclean, Philby and Blunt. Certainly Wilson and the Cambridge Spies had a number of mutual friends in British Intelligence, not least Tomás Harris. Geraldine Norman once asked Wilson outright whether he was the Fifth Man. 'Really, just stop and think,' he replied. 'I am completely conservative, I am interested in people who are rich and noble, do you think I could be working for the Soviet Union? It doesn't make sense.' It's true, it doesn't really make sense; also, as his long-time secretary Katherine MacLean observed, he was too

indiscreet to be a spy. But the theory is not totally implausible. The days Wilson spent working for British Intelligence in Washington from 1943 to 1945 are shadowy ones, and Donald Maclean was serving in the British Embassy during the same period. They must have known each other, but how well? There is no evidence of any act of treachery on Wilson's part, but the cast of mind was there: Wilson was possessed of an ultimate self-ishness, a sense of outsiderhood in relation to a British establishment whose interests and priorities were not always aligned with his own. He had to stifle laughter when a rich person came unstuck, when a scheme to separate a philistine capitalist from his money played into his hands. Which side of the divide was he actually on?

Wilson's outsiderhood in England is worth analysing further. At Eton he was drawn to the non-British boy in his year, Richard Dreyfus. Perhaps it was only with a foreigner that he felt he could admit his passion for art collecting. For Wilson's generation, an interest in fine art and connoisseur-ship tended to compromise your virility in English society. Certainly the more conventionally minded directors of Christie's struggled to resolve this dilemma. Some did so by deliberately not cultivating too much personal art expertise. That was a job they left to the specialists, a back-of-house, almost subterranean race of men and women who pursued arcane interests like reading silver makers' marks in the depths of the building, while the directors themselves, strong, confident, healthy types of outdoor endeavour, went off to shoot grouse on ducal estates. Or if, like Patrick Lindsay who ran the Old Master Department, you did possess genuine expertise yourself, you compensated for the lapse by spending your leisure flying Spitfires and racing vintage motor cars.

Under Wilson, Sotheby's had a reputation as more pro-European, more pro-art trade, more pro-Jewish than Christie's. For instance, after the war Jim Kiddell sold property for Jewish families at 0 per cent com-mission, aware of their plight. There were more foreign languages spoken at Sotheby's. Did Wilson, as was sometimes alleged, actually prefer to deal with Jews than Dukes?

Wilson's losses of temper were latterly exacerbated by his diabetes. His colleagues noticed that he was much easier to deal with after he'd just had a shot of insulin, rather in the way that, as Duveen found out, it was more effective to offer paintings to Maurice de Rothschild if his constipation had yielded to treatment that morning. In Wilson's case, he was also prey to occasional moments of disenchantment. At his flat in Green Street,

Duncan McLaren witnessed his chairman in a filthy mood one morning. Wilson was on the telephone, then slammed it down, and said to himself, looking out of the window in a fury of rage: 'There are only two things of any importance in the art market: one is a dead client and the other is a dead artist.'

There were further disillusioned reflections at this stage. He confessed to a colleague:

> When I go and advise someone to sell their picture because now is the moment to sell it, and they're going to make more money than they'd ever dream of, and there's never going to be another moment like this, I know that I'm giving them the wrong advice. I should be telling them to keep their picture, because isn't that what we are telling our buyers – that now is the ideal moment to invest, and that they should all be buying?

A little late in life, Wilson here admits the potential conflict of interest inherent in the auctioneer's role, the obligation to act for both buyer and seller. These are the moral quicksands to be negotiated by everyone, art dealers included, who operates as a commercial middleman.

There was in Wilson the occasional need to shock, to deceive, to make people feel uncomfortable – to show that the normal rules of behaviour did not necessarily apply to him. What was it? Boredom, perhaps. A shyness beneath a carapace of smooth charm. He was merciless in the deployment of that charm on people. Once he had got what he wanted from them (the sale of their collection), he tended to drop them. 'You know, one just isn't so interested afterwards,' he admitted with a weary candour to Simon de Pury. It is the cry of the serial Don Juan, moving on from the conquest just made to the next seduction. But the fact remains that when he chose to unleash them, the impact of his wit, his intelligence, and his charm was almost irresistible.

Wilson constructed Sotheby's as his own personal citadel from which to confront the world, a private domain in which art was the religion and he was the king. In the process he recast the art market, putting auction at the very centre of it and forcing dealers to reinvent themselves, in many cases, from principals to advisers. But perhaps the last word on Wilson should go to Peregrine Pollen, who recalls the sheer fun of being with him:

'What are we going to do about Ralph Colin?' I asked him once. 'How are we going to get his pictures?'

Ralph Colin, besides having a great collection, was a rather stuffy and difficult New York lawyer. 'Oh,' Peter replied, 'I think we'll smother him with rose petals.'

THE ART OF
SHOPPING: DEALING
IN THE USA

In 1856 Michael Knoedler, who had been sent to New York by Goupil the Paris dealer ten years earlier, boasted that he had sold a painting for $300, 'the highest price that will ever be paid for a picture in America'. He couldn't have foreseen the prodigious expansion of the American economy in the latter part of the century, its unshackling after the Civil War leading to fortunes being made in steel, in sugar, in railroads, in banking. Within a generation $300 was barely noticeable as a price for a painting. New American money had decided that what it needed most was European art. There was no shortage of European art dealers prepared to cross the Atlantic to sell it to them. Goupil, of course, had been the trailblazer, but by the early twentieth century Duveen, Wildenstein and Seligmann had also come over and set up permanent and luxurious bases in New York selling old art, or contemporary art in an old style by painters such as Meissonier. As we've seen, Chapters Five and Six tell their story.

The exception was Durand-Ruel, purveying new art to a new country. We have already seen the effect of his arrival in New York in 1886. He dared to offer difficult contemporary art in the form of the Impressionists and generally got a better reception than in Europe. One of the reasons for that may have been that certain US buyers, having had their fingers burned

by the dubious authenticity of the old masters they were being offered by unscrupulous European dealers, fell gratefully upon 'modern' French art, where at least they could rely on not being sold fakes. But what Durand-Ruel also understood was the need not to frighten too many horses, so the new French art was still presented in reassuringly old eighteenth-century frames.

But what of indigenous American dealers? The first significant convert to Modernism was Alfred Stieglitz. Stieglitz was one of the great American photographers, but his career is intertwined with that of a pioneering art dealer. He originally opened the Little Galleries of the Photo-Secession at 291 Fifth Avenue in 1905 as a venue for showing photographs. Gradually '291', as it became known, developed into a centre for avant-garde art of all kinds, operated by Stieglitz on a rigidly not-for-profit basis. The idealism that prevented him from taking any commission on sales was made easier by the $3,000-a-year allowance he received from his father, and the fact that he had married a rich wife. Nonetheless, there was something splendid about his disdain for moneymaking. Man Ray records how he was initially disappointed that Stieglitz was asking the huge fee of $1,000 for taking a photograph of a rich client's wife. But Man Ray's confidence in Stieglitz was restored when he heard that the client's agreement to the price had prompted Stieglitz to up it to $1,500. He was notoriously garrulous, holding forth at length about the works he had on view. The artist John Sloan recorded a visit to the gallery: 'I went to 291 once, and he talked off one ear. It has grown back pretty well, but I never returned to 291.' There is indeed a certain sort of dealer more interested in delivering opinions on art than in making money from it. The possession of a gallery is useful as provision of a locus for lecturing that might not otherwise be available to the dealer. In his early days Stieglitz seems to have fallen into this category. 'It is sometimes a question in our minds,' reported one contemporary critic, 'whether it is Mr Stieglitz or the pictures on the wall that constitute the exhibition.'

With the help of Edward Steichen in Paris, Stieglitz started showing modern French art. An early show was of Matisse's work. This was only the second time that Matisse had had a solo show outside France (the other was in Germany at Cassirer), so Stieglitz was remarkably ahead of the pack. A few drawings were actually sold, two to the pioneering collector John Quinn. Encouraged, in March 1911 he put on the first one-artist exhibition of Cézanne in America. Here was an almost irresistible opportunity

Alfred Stieglitz: liable to 'spout like a geyser'.

to indulge his anarchic streak. Twenty watercolours by the master were displayed, plus one work in Cézanne's style done by Stieglitz himself. It was the Stieglitz pastiche that drew most admiration from visitors to the exhibition. Here is the dealer as parodist; a very early instance, perhaps, of performance art, or a gesture of Surrealist anarchy. There is no doubt that Stieglitz's radar was acutely tuned to the forefront of the Parisian avantgarde. Another subject that excited his admiration was African sculpture, which he discovered on a visit to Paris in 1910 and as a result showed in 291. He also exhibited works by Picasso, probably for the first time in America.

The famous Armory Show of 1913, which introduced the American public to a broader range of European modern art, was enthusiastically supported by Stieglitz. He bought eight works from the exhibition, including examples by Archipenko and a marvellous Kandinsky, *Improvisation 27*, now in the Metropolitan Museum. The experience inevitably stimulated his verbosity: at the exhibition he was described as 'spouting like a geyser for three weeks and then, after a proper interval, like Old Faithful, began again'.

Before 291 went out of business in 1917, Stieglitz gave their first shows in America to Brancusi, Braque, Severini and Georgia O'Keefe (whom he later married, creating another art world power couple). But the divorce that enabled him to take on O'Keefe both matrimonially and commercially put a dent in his spending power. Thereafter he focused on building the reputations of certain American artists, particularly his wife. One of Stieglitz's last shows of defiance at 291 was of Duchamp's *Fountain*, after it had been rejected for exhibition by the Society of Independent Artists. He was one of the very few people in America to understand it.

The interwar years saw a steady stream of art dealers seeking refuge from Europe in America and bringing with them first-hand experience of Modernism: Perls, Thannhauser, Otto Kallir, Curt Valentin, Nierendorf came from Germany and Austria, and Pierre Matisse from France. But the Julien Levy Gallery, which opened on 2 November 1931, was a home-grown establishment. Levy was a New Yorker. His background was impeccable: he had studied under the great connoisseur and art historian Paul Sachs at Harvard (as had Alfred Barr, the first Director of the Museum of Modern Art). He had private means, which was obviously an important asset. In January 1932 he devoted an exhibition to Surrealism, fresh from Paris. The movement was a cause he espoused enthusiastically, including the work of Salvador Dalí, Duchamp, Max Ernst and Man Ray. Dalí's *The Persistence of Memory*, which Levy had bought for $250, was priced at $450. Two years later this classic Surrealist image, depicting melting pocket watches, had entered the Museum of Modern Art in New York (see plate 19).

There is of course something in the nature of Surrealism that draws a dealer, if he is committed to the movement, particularly close to what he is selling, maybe even gives him the illusion that he is capable of creating the art as well as marketing it. Once the idea becomes more important in the work of art than its execution – the theory of all conceptual art – the dealer can sometimes be beguiled into becoming the originator. You could argue that this was what was in play with Stieglitz and his Cézanne pastiche. He wasn't saying he was as good an artist as Cézanne, but rather experimenting with the ideas of authenticity and audacity that Modernism was bringing forth. Mesens also crossed the boundary between dealer and practitioner. And Levy, while he didn't actually create personally, was instrumental in the creation of others. He discovered Joseph Cornell, and it may well have been his idea to get Cornell to work in three dimensions, the suggestion coming as early as 1931, although not executed till 1936.

Levy also had an influence on Alexander Calder, specifically in the advice he gave him to abandon motorising his mobile sculptures and to let them drift in the arbitrarily variable existing currents of air. Conceivably it was Levy's advice that persuaded Gorky away from representational art into abstraction. What resulted was an important bridge between Surrealism and Abstract Expressionism.

To be selling avant-garde European art to a dubious American public during the Depression was a challenge that Levy was ready to meet, but it was hard and disheartening work. In 1941 he took Surrealism to California – in some ways a natural home for it – when he put on a show in Los Angeles. Getting the stars into your gallery is an important part of the fashionable art dealer's job, so Levy must have been overjoyed when John Barrymore visited the exhibition. Unfortunately the actor had had too much to drink, and in a gesture that was either a critique of Surrealism or an early example of spontaneous performance art, he relieved himself on a work by Max Ernst.

Pierre Matisse was another of the Europeans who set up as art dealers in New York in the years before the Second World War. He actually arrived in 1925, and proved a friendly rival to Levy, and a better salesman, with the advantage of being in touch through his father with important Paris artists. Not that his relationship with his father was plain sailing. Although Henri Matisse had suggested his son's emigration, he hadn't reckoned with his choice of career. 'My father didn't like it at all that I became an art dealer,' Pierre recounted later. 'He thought it was a distasteful occupation. In fact he wanted me to change my name so that the name Matisse would not be associated with such a profession.' Even with the distance of the Atlantic between them, resentment still simmered. After the war Pierre Matisse's comments on his father's cut-outs, which he refused to handle, were hardly calculated to create harmony between them. He told Heinz Berggruen that he regarded them as 'the desperate attempts of an old man trying to find a new form of expression'. Still, the name Matisse was a good one to brandish amongst Manhattan art collectors, and Pierre was as commercially successful as anyone in his time.

Andy Warhol once said that Americans are better at shopping than at thinking. An interesting American experiment in the 1940s was to integrate the sale of art into department stores, to make it more directly part of the retail experience. Sam Kootz, for instance, had a sale at Macy's in which a Rothko was offered at $200 but did not find a buyer. Part of the Hearst

Collection was offered in department stores with a suitable accompanying sales pitch: 'Have you always wanted an ancestral portrait? We have some – and who's to care (or know) whether it isn't your grandfather's aunt?' But, even in America, this kind of consumerisation never took off. Ultimately it ran counter to an embedded perception of what art was all about; that it was unique, special, separate from the masses, interesting precisely because it was not the sort of thing you could buy at a department store.

Sam Kootz came into his own in the post-war years in New York. He had had other careers earlier, in law, in advertising, and in the silk business. But he was increasingly engaged in the contemporary art scene, as a collector and as a critic with a perceptively clear-sighted view of the opportunities that war in Europe was opening up for American artists. 'Now's the time to experiment,' he exhorted them in 1941. 'You've complained for years about the Frenchmen's stealing the American market. Well, things are on the up and up. Galleries need fresh talent, new ideas. Money can be heard crinkling throughout the land. And all you have to do, boys and girls, is get a new approach, do some delving for a change. God knows you've had a long rest.'

This was a prescient rallying cry. And he followed it up with action on his own part, by taking the young Robert Motherwell and William Baziotes under his wing and subsidising their work. In 1945, having abandoned his Macy's project, he opened his own gallery at 15 East 57th Street, next to Betty Parsons, a dealer similarly engaged with the cutting edge. 57th Street was becoming the epicentre of the contemporary art-dealing scene. Kootz didn't abandon Europe. His first exhibition, besides work by his protégés Motherwell and Baziotes, also included paintings by Fernand Léger. And in 1947 he achieved a coup in staging Picasso's first solo show in America since the war. We have already seen Picasso's ambivalent attitude to Kootz when he punished Mrs Kootz for indicating that she would rather be at the hairdresser's than in the artist's studio. But Picasso must have been impressed by Kootz's American bravura in presenting him with a white Cadillac at their first meeting. It stands supreme as a metaphor of the conquest of European culture by American consumerism. For ten years Kootz operated in prime position as Picasso's US dealer.

Meanwhile Kootz was enthusiastically promoting the American Abstract Expressionists, although he initially saddled them with the cumbersome name of 'The Intrasubjectives'. For an exhibition staged in 1950 he enlisted the participation of an eminent art historian, Meyer Schapiro,

and an influential critic, Clement Greenberg. Together they chose the twenty-three emerging artists represented. It is another instance of the wise dealer in contemporary art triangulating forward with the help of the tame critic, art historian or museum curator. It may well be that, as Robert Jensen wrote, he who controls the market controls history. But it cuts both ways: he who controls history also helps win power in the market.

Peggy Guggenheim is a classic case of a trustifarian who succumbs to addiction. She was born in 1898 into large wealth – the Guggenheim family were one of the richest in America – and she was spoiled in the many ways that the rich are spoiled. She was impatient, constantly in search of new sensation, and expected as of right to get her own way. She married frequently and left a trail of wreckage in her wake in her personal life. But her salvation was her discovery of modern art, which was the major addiction of her life. There are worse things to be addicted to. It resulted in her pioneering recognition and support of a number of major contemporary artists, not least Jackson Pollock, and in her assembly of a tremendous personal collection.

How far was she an art dealer? She opened and ran art galleries, first in London in the late 1930s and then in New York in the 1940s. But although she did not do so primarily in order to make money she did what good dealers in contemporary art do by providing commercial support to artists – buying their work from them on a regular basis and selling it on – and opening a bridge between new artists and the public. She discovered art in the 1930s. She wanted to start something cultural: it could have been a bookshop, or it could have been a publishing house. But she gravitated to art, for which she realised she had a genuine feeling. She went to Paris. The man she was sleeping with at the time, the young playwright Samuel Beckett, encouraged her away from old masters into contemporary art. Modern art was 'a living thing', he told her. It was not to be a question of 'Waiting for Corot'.

She set up her gallery in London and called it 'Guggenheim Jeune', simultaneously a homage to Bernheim-Jeune in Paris and the cocking of a snook at her uncle Solomon Guggenheim, the great collector and museum-maker in New York. It provoked a reaction, a rebuff from Baroness Rebay, curator of the Guggenheim museum and Solomon's mistress: 'It is extremely distasteful at this moment, when the name of Guggenheim stands for an ideal in art, to see it used for commerce so as to give the wrong impression, as if this great philanthropic work was intended

Peggy Guggenheim animating a Calder mobile.

to be a useful boost to some small shop.' The 'small shop' was nonetheless responsible for introducing to London a number of Surrealist and other avant-garde artists better known on the continent, but it wasn't profitable. In fact it lost $6,000 in its first year. As Peggy remembered later, 'In 1939, after a year and a half of Guggenheim Jeune, it seemed stupid to lose so much money for nothing, and I decided to open a museum of modern art instead'. Her plans for this much-needed institution included appointing as director Sir Herbert Read (whom she called 'Papa'). Sadly it never saw the light of day because the Second World War intervened. An indication of how backward the English museum world had become was provided by a sculpture show she put on including works by Brancusi, Pevsner, Arp, Laurens and Calder. On their importation from Paris for the exhibition, British customs, refusing to believe they were works of art, tried to levy on them a higher duty as lumps of bronze, marble and wood. The director of the Tate, James Bolivar Manson, was appealed to. He refused to acknowledge them as art.

In 1939–40 Guggenheim was in France, buying art for her museum and attempting to set up a colony of artists. She concluded the latter was

a futile enterprise as they would only fight each other. So she got out of Nazi-occupied Paris and went back to America, taking Max Ernst with her. And now began the second phase of her art dealing. She set up a gallery in New York, called 'Art of This Century', in which to show her collection of avant-garde European Modernism. It was a revolutionary space with an advanced lighting and hanging system, a daring design somewhere between an amusement arcade and a futuristic restaurant. Opening night was 20 October 1942, at which the proprietress wore one earring designed by Tanguy and one by Calder to show her impartiality between Surrealism and abstract art. She was not afraid to assert herself commercially. She offered Max Ernst a flat sum of $2,000 (minus the cost of his ticket to America) for all his early work and for the right to pick whatever new work she liked. Was this the action of a ruthless businessperson, or a besotted woman anxious to tie her lover in close? That was the trouble with Peggy Guggenheim as a dealer: it was probably a bit of both.

And now she began to exercise her undoubted ability to spot new talent amongst the young generation of avant-garde New York artists. In her gallery she gave shows to Motherwell, Baziotes, Reinhardt, Rothko and Jackson Pollock: she was in at the birth of Abstract Expressionism. In the spring of 1943 she brought some security to Jackson Pollock by putting him under contract for $150 a month, to be deducted from his sales. If he didn't generate enough sales to repay her investment, she was to recover the balance in paintings. Looking back, what Peggy regretted most was giving away eighteen of the Pollocks that she owned. She just wasn't the kind of dealer who thrives on making sales. 'I comfort myself by thinking how terribly lucky I was to have been able to buy all my wonderful collection at a time when prices were still normal, before the whole picture world turned into an investment market,' she said later. In time her artists left her, mostly for Sam Kootz, although when Pollock finally moved on it was to Betty Parsons. Later, in 1961, Peggy entered an acrimonious legal dispute with Lee Krasner, Pollock's widow, on the grounds that Krasner and Pollock had kept back certain paintings from her in the period when Pollock was under contract to her. It wasn't so much about the money. It was resentment, perhaps, that Peggy had not got as much credit as she felt she deserved for her role in the early promotion of Pollock. And it was jealousy of Krasner, too. After all, Pollock was one of the few of her artists that Peggy Guggenheim didn't get to sleep with.

She deployed her lifelong enthusiasm for sex as an art-dealing strategy.

She did sleep with Max Ernst, Yves Tanguy and Roland Penrose. She also slept with E.L.T. Mesens, who managed the gallery next door to her own in London. She tried to sleep with Marcel Duchamp, but he resisted. In the end she even married Max Ernst, although it didn't last. At one point it was suggested she should marry Brancusi in order to inherit all his sculptures. But Brancusi was not amenable to the idea. She was once asked how many husbands she had had and replied, 'My own or other people's?' Looking back on her life, she reflected, 'I have always found husbands much more satisfactory after marriage than during.' She remained friends with most of them.

Exhausted by running the gallery in New York she returned to Europe, this time for good, and in 1951 set up her collection in Venice (where it remains to this day). As a young woman in her twenties, before Samuel Beckett had persuaded her of the merits of contemporary art over old masters, she had avidly absorbed the art criticism of Bernard Berenson and travelled Europe to see Renaissance masterpieces in search of the tactile values that Berenson assured her informed them. In Venice she finally met the eighty-five-year-old Berenson when he came to see her collection. He was horrified by her modern art. Peggy told him it was 'one's duty to protect the art of one's time'. He asked her who she was going to leave her collection to. She said, 'To you, Mr Berenson.' She never lost her sense of humour.

Peggy Guggenheim stands in a position of honour in the ancestry of female art dealers, a line that starts with the Irish adventuress Laetitia Pilkington selling prints in London in the eighteenth century, continues through Mary Cassatt and the put-upon Berthe Weill in Paris, and proceeds via the pioneer of dealing in American art Edith Halpert and 'Mutter Ey' in Germany in the interwar years. After the Second World War women in the art trade have flourished, as attested by names like Betty Parsons, Ileana Sonnabend and Mary Boone. But even for Peggy Guggenheim things weren't always easy. She was once rudely rebuffed by Picasso, who was badly in need of counselling on sexism issues. When she called on him in his studio, he opened the door to her and asked, 'Now what can I do for you, Madame? Are you sure you're in the right department? Lingerie's on the next floor.'

Betty Parsons wrote in her journal, 'I have loved the illegitimate and the unapplauded.' It was a statement relevant to both her love life and her taste in art. She came from a wealthy, conventional background from

which she emerged into adulthood determined to be an artist. After a disastrous early marriage, she realised that her preference was for her own sex. Later she may even have had an affair with Greta Garbo. She persuaded her family to let her study art, which she did in Paris in the later 1920s under Bourdelle and Zadkine. It was Betty Parsons who made the classic remark about her father: 'if he had never worked he would have been a very rich man'. But he did work, and lost almost everything. It meant that the financing of Betty's art-dealing activities, into which she moved realising that she was not going to be able to keep herself solely as an artist, was a constant problem. Rich friends helped. This, of course is where she differs from Peggy Guggenheim, who although she spent a lot was never similarly cash-strapped. But the parallels in their rich backgrounds are significant. And the fact that they were both women who kept stables of male artists has tempted some commentators to see them as nurturing rather than brutally commercial forces. Today the American artist Robert Longo graphically describes his relationship with his dealers Janelle Reiring and Helene Winer: 'I'm the car crash and they're the ambulance.' But there was a feeling in the 1940s and 1950s that the artists looked after by Guggenheim and Parsons, in order to make money, had to move on to more businesslike male art dealers.

Betty Parsons set up in East 57th Street soon after the Second World War, as we've seen, next to Kootz. The giants of her gallery were the ones she called 'The Four Horsemen', Pollock (whom she got from Peggy Guggenheim), Mark Rothko, Clyfford Still and Barnett Newman. It is an impressive list, even if she didn't hang on to them for long. And she pioneered a presentation that depended on a totally neutral background. White walls predominated in her gallery. The simple, minimalist, furnitureless setting was perfect for pictures of the size and impact that the painters were producing, of course. 'A gallery isn't a place to rest,' she said. 'It's a place to look at art. You don't come to my gallery to be comfortable.'

One of the reasons why the painters moved on is revealed by Betty herself: 'Most artists don't think I'm tough enough, that I don't go out and solicit, call up people all the time. I know how people hate that sort of thing, because I hate it myself, so I don't do it.' It's a bit like a front-line soldier admitting to reservations about firing a gun. The beneficiary of this reticence was Sidney Janis (1896–1989), who took on many of Betty Parsons' artists, most notably Jackson Pollock in 1952. While he was an elegant figure whose gallery produced a series of scholarly and high-quality

catalogues, Janis had no problems with gun-firing. He had started life as a professional ballroom dancer, and in 1926 founded the M'Lord shirt company (perhaps Duveen bought his shirts there, in anticipation of his peerage). The business was successful enough to enable Janis to collect modern art, which he did on a number of trips to Europe. In 1949 he became a full-time dealer, opening the Sidney Janis Gallery with a series of exhibitions of European masters, including Léger, Delaunay and Arp. And in the 1950s he captured most of the major American Abstract Expressionists to his gallery: not just Pollock, but also de Kooning, Rothko, Kline and Motherwell. Like Leo Castelli, he was also involved in the beginnings of the Pop Art movement. Towards the end of his life he made a magnificent gift of his collection to New York's Museum of Modern Art. Janis's transformation from ballroom dancer to major donor is a metaphor for the development of American art dealing in the first half of the twentieth century.

16

LEO CASTELLI AND THE AMERICAN DREAM

The post-war years saw a remarkable shift of power in the art world. The centre of gravity of contemporary art moved from Paris to New York; for the first time all-American movements were at the centre of the world stage, as Cubism, Dadaism and Surrealism – essentially European phenomena – stuttered and waned, to be replaced by Abstract Expressionism and, a generation later, Pop Art. The new energy in America was helped by an influx of European artists and dealers, dislodged from their homelands by the war. Artists such as Max Beckmann, Léger, Max Ernst, Miró and Josef Albers took up residence and created an atmosphere in which home-grown invention thrived. There were dealers already established in Europe, such as Thannhauser, Curt Valentin and Paul Rosenberg, who sought refuge in New York but brought with them a European style, sensibility and experience, and others who came as immigrants from Europe and made their reputations as art dealers in America. The most important of the latter category was Leo Castelli, who became dealer-midwife to both the Abstract Expressionists and to Pop Art. He was the man who sensed and exploited an exciting opportunity: America for the first time leading the world in its contemporary art coinciding with America's global economic hegemony. When these two supremacies were fused the result

was a booming market and a series of ever-escalating prices. The richest country in the world was producing its most innovative and expensive art. Jealous Europeans suggested that American art had become the most expensive in the world simply because America was the richest country in the world. But it didn't matter. The result was the same.

In the 1960s and 1970s, at the height of Castelli's power and influence, he discovered, exhibited, promoted and sold Jasper Johns, Robert Rauschenberg, Frank Stella, Cy Twombly, Lee Bontecou, Roy Lichtenstein, John Chamberlain, Andy Warhol, James Rosenquist, Donald Judd, Christo, Edward Higgins, Robert Morris, Kosuth, Flavin, Nauman, Sonnier, Serra, Artschwager, Ed Ruscha, Claes Oldenburg, Lawrence Weiner, Ellsworth Kelly, Darboven, Noland, James Turrell, Julian Schnabel and David Salle. It is a roster as impressive in its way as the list of artists to whom Vollard gave exhibitions between 1894 and 1911. And Castelli's promotional reach did not just extend to America: his web of European contacts meant that he marketed his artists just as effectively on the other side of the Atlantic too. At home, such was Castelli's status as an impresario of artistic innovation that, as an aspirant artist in Soho or Chelsea at the time, you could buy a T-shirt with the wistful inscription: 'Leo Castelli Looked at My Slides.'

I am not a dealer, I am a gallerist, Castelli tells his biographer, Annie Cohen-Solal, by which he means to emphasise his role in discovering new talented artists, and giving them exposure in exhibitions in his gallery. Heinz Berggruen rejects the term 'gallerist' as a description of what he did, on the grounds that it sounds too much like 'chemist', a passive 'waiter' for something to happen. But Castelli was never a passive waiter. His energy and enthusiasm were extraordinary. It points up an essential difference between the dealer who is a promoter of new art, and the dealer whose stock in trade is old art, the secondary market. Castelli was clear in the definition of what he did: 'the function of an art dealer, of a good art dealer, a dealer who really cares about art and not about making money, should be to find new artists, to make them known to the public, before museums can do it... we are the real vanguard'. How did he do it? 'You have to have a good eye, but also a good ear,' he told Calvin Tomkins in an interview in the *New Yorker*. 'There's no other way if you want to make a good choice. You hear things, feel vibrations, gauge reactions. You spot movements emerging, and you try to pick the best practitioners.'

Leo Castelli was born Leo Krausz in Trieste in 1907. His father's family

came from Hungary, and his mother's from Italy. It was fitting that a man who became an international dealer and agent of such renown should have been born in what was an ancient trading centre at the intersection of western and eastern Europe, between the Balkans and the Alps. As a young man Castelli spent four years based in Bucharest, selling life insurance all over Europe. In the evenings he led an active social life in Bucharest; he was always socially adept, and people liked him, particularly women. He was amassing a series of attributes that would later stand him in good stead as an art dealer: charm, salesmanship, ability with languages and an internationalism. He got married in Bucharest, to Ileana Schapira, the daughter of a rich industrialist. One of the things that brought them together was a shared interest in contemporary art. They were young, they were modern, and they both had a taste for Dada. They set up house in Paris when Leo was posted there to work at the Banque d'Italie. In Paris Leo gravitated away from banking towards contemporary art. He set up his first gallery – the Galerie René Drouin (named after its cofounder), in Place Vendôme – where his first exhibition, in 1939, featured Surrealist works by Max Ernst and Leonor Fini.

Once war broke out, the Castellis' vulnerability as Jews was clear. Fortunately they were rich enough to secure their passage to America, and they finally got to New York in March 1941. Ileana was 'terrified at the idea that the United States was a country without any culture. That's why we insisted on bringing along a trunk full of books,' she explained. And perhaps America still felt a bit like this: moneyed, certainly, but materialist, philistine and naive, dependent upon Europe for its culture. The process by which all this was to change so dramatically in the next two or three decades would find Leo Castelli as one of its driving forces.

After studying for an economics degree at Columbia University, Leo joined the US Army and was sent back to Bucharest for war service. At the end of the war he returned to America, and took over as manager of his father-in-law's knitwear factory in Jamestown, New York. Perhaps all first-generation art dealers need an initial experience in some other field that doesn't suit them in order to give extra energy to the ultimate direction of their careers. Kahnweiler was meant to be a banker, Vollard a lawyer, Nathan Wildenstein a tie salesman. Castelli's sojourn in the knitwear factory went on for ten years, but his heart clearly wasn't in it. More and more often he would duck out of the office after lunch to visit galleries and museums. His preferred destination was the Museum of Modern Art, a

collection authoritatively assembled by the legendary director Alfred Barr as an encyclopedia of European Modernist art. In New York, this was the period when Surrealism was in recession and the Abstract Expressionist school was just beginning. Leo started buying works of new art himself. It was also an intellectual engagement, and he grew increasingly involved in contemporary art theory. He admired the visual perception of Clement Greenberg, the Modernist guru, but found his narrowness of interpretation began to jar.

Gradually the idea took root in Castelli's mind of putting on his own exhibitions of the new contemporary art that appealed to him. Like Sidney Janis, he evolved from small-time collector to dealer, but at this stage the emphasis was as a promoter and defender rather than as a money-making operator. He was still looking back to Europe, and expended a lot of energy coping with the very difficult widow Nina Kandinsky and her husband's estate. As he had no gallery of his own, he put on a Kandinsky exhibition in Sidney Janis's Gallery in 1949. He showed great patience, but his experience with her perhaps taught him a lesson that was the reverse of Nathan Wildenstein's precept: sometimes dealing with living artists is easier than dealing with dead ones, particularly if a difficult widow is part of the negotiations. In 1951, again in the Janis Gallery, he put on an exhibition of young American and French painters.

At the same time, exciting developments in Leo (and Ileana's) life were taking place at 39 East Eighth Street, where a club that included the most avant-garde artists in America had formed. Ileana and Leo Castelli and the dealer Charles Egan were the only three non-artist members. Amongst the artist membership were de Kooning, Rauschenberg, Ad Reinhardt and Franz Kline, and Mark Rothko gave a lecture. Jackson Pollock occasionally put in an appearance. Ileana remembered:

> Everyone was desperate at the time, the artists really felt isolated. They had no audience, nothing. It was hard for them to survive. And yet they kept at it, feeling that they were working only for themselves... a speaker would come talk about his own work or someone else's, or share his views on a current exhibit. Afterwards the debates became very heated, even violent. We passed the hat and someone went to get some whiskey from the Cedar Tavern downstairs. Everybody got drunk and then went home.

The club opened three evenings a week and lasted for six years. East Village became New York's Montmartre, the place where the bohemians enacted their triumph over the philistines. It was all about the artists, with each meeting 'like an extended psychoanalysis'. And Castelli, although he was not yet a full-time dealer, was at the centre of it, in some ways the Vollard of the piece. Like Vollard, his interest was in the artists. There must have been something intoxicating about his proximity to the avant-garde. 'I've always had a certain involvement with hero-worship,' he confessed later in his career. 'You are not the boss; the artists are.' This was one of the most important new visions that Castelli brought to America. In a country that had been inclined only to understand artists as commercial artisans, as signwriters or illustrators, not romantic geniuses, he introduced the idea of the artist as hero.

Other observers weren't quite sure what Castelli was up to at this point. 'He was interested in artists, he would come to all the parties,' recalled Ernestine Lassaw, a friend of de Kooning. 'He especially liked to dance: that's how he got involved with artists. But he was a tie salesman, he had a factory!' It was clearly time for Castelli to move on from the garmento phase of his life, to assert his credentials as a serious 'gallerist'. A step in that direction was the 9th Street show, which was mounted in May 1951 in an abandoned antiques shop rented for the occasion. Financed by Leo, it gave the artists of the club the chance to exhibit together, and to draw in other names with whom they felt sympathy. Robert Motherwell took part, despite being forbidden to do so by his dealer, Sam Kootz. Leo organised the hanging, giving pride of place to Jackson Pollock. 'Hanging the show,' he remembered, 'I must have hung it about twenty times! Every time I thought it was done, one of the artists came in and complained about where I'd put their work!' There was no doubting the success of the venture in terms of creating interest. Now Alfred Barr was the one impressed – How did you do it, he asked Leo – and subsequently Leo was the one initiating Barr, into the cutting edge of American Abstract Expressionism.

Leo was established at the epicentre of the avant-garde. He was the man Pollock turned to for advice on where to go after Betty Parsons. Castelli directed him to Janis. 'I decided it was finally time to open a gallery because of the very banal fact that I had to make a living, that I saw that there was no other way for me to make a living, and that I had to become serious about it if I wanted to go on paying my rent and my grocery bills'.

That was Leo looking back in 1969. He was ready for it. He'd met the challenge of dealing with Mrs Kandinsky, and making sales from her husband's estate. He'd witnessed and learned from Sidney Janis's experience of running a gallery. He had a good relationship with Alfred Barr. And above all, he'd got to know the artists. He wanted to work with them. The excitement of finding and nurturing new talent really was intense. As Ileana commented, 'Leo was more interested in what was coming up than what had already bloomed.' It's a good summing up of the cast of mind of a certain sort of dealer: a Kahnweiler before the First World War, or a Vollard before 1907. Certainly not a Duveen.

So on 3 February 1957 Leo opened his gallery in his apartment on East 77th Street. His first show was dominated by a confrontation between two large works by Pollock and Delaunay. America and Europe was the theme, but he became increasingly absorbed in America. And now came a change in direction: 'I studied art history and figured out that one movement followed another and that there were changes that occurred periodically... I knew all the Abstract Expressionists, knew what they were doing. They dominated the scene for a while, so I felt something else had to happen. I tried deliberately to detect that other thing and stumbled upon Rauschenberg and Johns.' Instances of art dealers prescribing what artists are actually to paint are rare: with the great dealers it is often a more subtle process than that. They are at their most potent as catalysts to developments in the history of art, identifying the new direction and promoting the artist or artists who are driving in it. Castelli never told his artists what to produce. When their paintings got bigger, he simply made his gallery doorway bigger. He was a facilitator, not a dictator.

The encounter with Johns represented an epiphany for Castelli, 'total and absolute love at first sight'. It was reminiscent of the shock of pleasure that Durand-Ruel felt when he first encountered the work of Manet in 1872, and acted on the compulsion to buy the entire contents of his studio, or what Vollard felt in his stomach when he saw a painting by Cézanne for the first time. Castelli saw Johns's *Green Target* in an exhibition. 'I can't say I understood it,' he came home and told Ileana, 'but I liked it immensely. It intrigued me so much that I can't think of anything else.' The new direction was in many ways a reaction against the avant-garde art that had gone before. After the visionary wildness and often chaotic technique of the Abstract Expressionists Johns brought something different, what

Who's whose muse? Jasper Johns and Leo Castelli.

an early reviewer described as 'his elegant craftsmanship, the poignancy of a beloved hand-made transcription of unloved, machine-made images'. In January 1958, Castelli's first Jasper Johns exhibition opened. The Abstract Expressionists were shocked, even felt betrayed by Castelli. 'If this is painting I might as well give up!' cried Esteban Vicente as he stormed out of Castelli's gallery.

But other more influential figures felt differently. Thomas Hess, editor of *ARTnews*, gave the Johns show important early publicity, and Alfred Barr was rapidly won over. Soon works by Johns were bought for MOMA. A new template of power in avant-garde art had been established. In the Impressionists' time, it was a triangulation of artist-dealer-critic that pushed back boundaries and won gradual acceptance for innovation. Now to the artist-dealer-critic combination is added a fourth force, the museum curator. With the invention of museums of modern or contemporary art, a new breed of museum curator comes into existence, one au courant with the avant-garde and prepared to buy earlier in the artist's cycle of development. Castelli was the first dealer in America properly to understand

and facilitate this. Part of his mission, he felt, was not just to win over the MOMA curators to buying his artists, but also to explain to a sceptical public how his artists fitted naturally into MOMA's collection, to establish their art-historical genealogy. 'The key figure in my gallery is someone I never showed, and that was Marcel Duchamp,' Castelli said. 'He was the great influence on all the younger painters in my stable.' This is not just fitting new artists into art history. It's also establishing a version of art history that will serve a dealer's interests. It worked, because Castelli's discrimination and instincts about his artists were good, but, as Cohen-Solal says, Castelli pioneered a functional link between the market and the museum, between commercial agents and cultural arbiters, and for a time even usurped the cultural arbiter function. There was a perception that Castelli manipulated the sort of shows that museums put on. 'At that time,' he remembers, 'people thought of me as being a sort of monstrous schemer... that I was practically corrupting the whole art world.' What was at issue was the question of how far museums were enshrining a view of contemporary art emanating from a dealer, prescribing a compartmentalisation of new movements that became too glib. As Thomas Hess put it: 'the function of a museum is not to tidy up a landscape but to contemplate it'.

This is one of the crucial relationships in the development of avant-garde art in the twentieth century, sometimes leading to accusations that museum curators have become too close to dealers. In Castelli's career, his relationships with museum directors and curators were important: Barr, of course, and Alan Solomon of the Jewish Museum, and Henry Geldzahler. The parallel here is the relationship forged by Durand-Ruel and Vollard, via Cassirer, with the enlightened museum directors of Germany in the first decade of the twentieth century, which led to French Impressionism being early on represented in German public collections. The best – like Geldzahler – were in close touch with Castelli but retained their independence of judgement.

It wasn't just Rauschenberg and Johns. Castelli had a series of epiphanies in the ensuing years. There was Frank Stella, there was Roy Lichtenstein; to a lesser extent there was Andy Warhol. The impact of Lichtenstein was a case in point. Ivan Karp, who had become Castelli's assistant, remembered how the two of them were initially jolted and unsettled by the cartoon content of the works that Lichtenstein showed them. Their immediate reaction was 'you can't do this'. But they decided to put them in the racks

and take them out again and see how they felt as the days went by. 'And after a time we agreed it was really an intelligent and original innovation,' said Karp. Warhol was taken on, too – this time on the insistence of Castelli's now-divorced wife Ileana. Even if Castelli's enthusiasm for Warhol may have been initially muted, it gradually sank in that between them Lichtenstein and Warhol represented a huge new direction, that Pop Art, besides being totally American, was a movement that would have resonance throughout the world.

In this respect, Castelli had a unique flexibility, an openness to the new in different manifestations that is almost unprecedented amongst dealers in avant-garde art. Not only was he there in the club in the early days, thrilled to the marrow by what the Abstract Expressionists were trying to do. He was also prepared to move on, with his enthusiasm for the new, to Pop Art. He absolutely got that too. Unlike Durand-Ruel, who adored the Impressionists but found the Post-Impressionists a step too far, or Vollard, who got the Post-Impressionists and the Fauves and early Picasso, but was defeated by Cubism, or Kahnweiler, who was besotted with Cubism but had no time for later developments like Dada and Surrealism, Castelli had the mental agility to move on from the Abstract Expressionist disdain for mass culture to Pop Art, which embraced and appropriated it. As Ed Ruscha said of Castelli: 'the funny thing is that this man with his severe look and his European elegance, always had the mind of a youngster' – and, significantly, a hero worshipper.

In his own eyes Castelli was as much a patron as a dealer. 'There was that sense of history I always felt in connection with what I was doing,' he claimed. And he once summed up his own aesthetic vision succinctly to Jeffrey Deitch as 'a fusion of Marcel Duchamp and Piet Mondrian'. But he was also an operator, and not above deploying his own status as a patron as a selling technique. 'I was going to keep that for myself, but for you it's great' was a persuasive line to a wavering buyer. Victor Ganz, after telling him that a certain Johns painting was like a late Beethoven quartet, overheard Castelli making exactly the same comparison to a potential buyer. Why not? In the allusive world of selling non-figurative art, all similes are fair game, even other people's.

On another occasion he had Rauschenberg's *Musician* delivered to MOMA on the pretext that he had a donor prepared to buy it for the museum. Somehow the donor never actually materialised, or rather the mythical donor was presented as now preferring to acquire the painting and

keep it for himself. In an apparently generous effort to forestall the private buyer, an invoice was sent along, made out to the museum, complete with 10 per cent discount. Castelli knew all about brinkmanship and its compulsion. But in this case the museum resisted. His manipulation on behalf of Rauschenberg was more successful in the matter of the Venice Biennale of 1964, where thanks to a campaign of enormous political energy and shrewdness, lobbying critics, lunching judges, persuading politicians, he arranged for his artist to win the Grand Prize. It was typical of Castelli's vision. He saw the importance of an American victory in establishing the global reputation of his artists. And his understanding of the European mentality gave him the experience and confidence to win through. In the immediate postwar years, most American art dealers were still felt to be a trifle provincial. Not Leo Castelli. As Tom Wolfe put it in a magazine profile:

> Castelli, New York's number-one dealer in avant-garde art, is a small trim man in his late fifties... the eternal continental diplomat, with a Louis-salon accent that is no longer Italian; rather, continental. Every word he utters slips through a small velvet Mediterranean smile. His voice is soft, suave and slightly humid, like a cross between Peter Lorre and the first secretary of a French Embassy.

Castelli was uniquely a man at home on both sides of the Atlantic.

Castelli was selling to a wide variety of people. In New York there was, for instance, Robert Scull who owned a fleet of taxis. He was the quintessential brash American. 'You could not like Scull,' said Frank Stella. 'He was horrible. He defined vulgarity.' But he was seriously committed to contemporary art, an illustration of the sad truth that brilliant collectors are sometimes appalling human beings. The collector Leon Kraushar put into words the appeal of the art that Castelli was purveying: Pop Art was 'a timely and aggressive image that spoke directly to me about things I understood. The paintings from this school are today. The expression is completely American, with no apologies to the European past. This is my art, the only work being done today that has meaning for me.'

But Castelli was also purveying great American contemporary art to Europeans: one was the Italian collector Count Giuseppe Panza di Biumo, who first made contact with Castelli to buy a Rauschenberg in 1959. Initially Castelli upped the stakes by emphasising the difficulty of getting hold of a work by the master. 'Rauschenberg does not produce

manufactured canvases; rather each of his pieces is an invention,' he told Panza. He must wait his turn. It was reminiscent of Durand-Ruel fifty years earlier, disappointing his New York clientele expecting an exhibition of Monet's waterlilies, cancelled on the grounds that Monet was not satisfied with the most recent works he had produced. Monet was not a machine. There was strict quality control in his production. But Castelli gradually recognised that Panza had the stuff to become a great collector. There was nothing socially aspirational about Panza's collecting. His motivation was predominantly aesthetic and intellectual. Panza was equally appreciative of Castelli: he was a 'philanthropist in merchant's guise'. The German Peter Ludwig also became a client, largely through an initial contact with Ileana (who although now divorced from Leo and returned to Europe, proved a productive source of European client contacts for him via the gallery she opened in Paris with her husband, Michael Sonnabend). Ludwig, a rich industrialist, was responsible for one of those gear-changes upwards in pricing that happen periodically with contemporary art: he had set his heart on a work by Lichtenstein that the artist didn't initially want to sell, so the collector doubled the price that Lichtenstein normally charged in order to acquire it, with lasting consequences for the artist's market.

The *New York Times* called Castelli 'the Svengali of Pop'. Certainly he had introduced the European principle of paying the artists in his stable stipends, in return for which he handled all their production. He demanded total control: if other dealers wanted their work, they had to obtain it through Castelli. But he was also meticulous in his record-keeping, establishing archives of the oeuvres of his artists and providing an information and photographic service to critics, art historians and museums. In this respect Castelli's gallery was also a cultural institution, in the tradition established by Durand-Ruel and developed by Wildenstein.

The phenomenon of Leo Castelli mirrors the career of Peter Wilson. He rose to prominence in the 1950s, and hit his zenith in the 1960s. In 1967 there was a celebration of his tenth year in business. The consensus of praise focused on his achievements as entrepreneur, explorer, risk-taker, market-maker and missionary. He had a media profile in New York perhaps even higher than that of Peter Wilson. People wanted to go to his openings, to be seen there. He was responsible for making the whole country more art-conscious by his cooperation with curators and critics, and for fomenting an atmosphere in which artists like Warhol could do

what they were best at: being famous. The artist as rock star was one of Castelli's inventions. So too was the art dealer as rock star. Castelli was dapper, sophisticated, charming and a relentless ladies' man. In March 1977 Andy Warhol records attending another party, this time to celebrate Leo's twenty years in the art business. Warhol notes wistfully of Leo, 'all the girls fall in love with him for some reason'.

Castelli was remarkably durable, and lived on till 1999, but in his later years there was a sense that perhaps he had passed his peak, that the energy was now with the next generation. Critical voices began to be heard. Robert Hughes wrote of him (in heroic couplets):

But in the seventies, a decade drear
He took to seeing mainly with his Ear.

Castelli's old ally, the increasingly influential curator Henry Geldzahler, suggested that the Castelli myth had been a bit overdone, that he hadn't gone out and found the artists – they had been brought to him by others and 'he was cultivated enough to understand what he was looking at'. In other words he deserved credit only for the packaging. Then there was Arnold Glimcher's verdict. He acknowledged him as 'the first celebrity art dealer', concluding that he was better at the celebrity part than at the dealing: 'Leo was a wonderful host but he was not a good dealer. He placed too many works in the same hands. If you were friends with him, you were part of the club. If you were not friends with him, you were not part of the club... Leo was a social climber, even if he did it with great style.' 'It wasn't money that interested him but *power*,' remembers the curator Robert Storr. 'He was a dealer, like a dealer in luxury goods, who guaranteed his clients quality and *cachet*... Leo had both European manners and American chutzpah.'

What also kept him in power at the centre of a web of influence were his wide-ranging dealer partnerships. He had satellites across Europe and America, arrangements with galleries as far flung as London, Cologne and Turin, as well as Los Angeles, Dallas and Miami. He supplied them with works by his artists, and through them kept in touch with the worldwide community of collectors and museum directors. He understood that the future of successful art dealing, particularly in contemporary art, was global reach. Like Peter Wilson he had a vision of the way new technology, in the form of jet travel and rapid communication of images and

information, would revolutionise the selling of art. 'You can email a paint-ing to Moscow and they email you back the money, instantly!' says Larry Gagosian. 'I'd love Leo to be alive and watch it today.' On his own admis-sion, Gagosian learned a lot from Castelli, and is sometimes described as his heir. The highly impressive museum-like historical shows that Gago-sian mounts, involving superb catalogues put together by top scholars, are part of that legacy.

Besides his international satellites, Castelli kept innovating at home: in September 1971 he opened a huge new premises at 420 West Broadway, in acknowledgement that you now needed to be able to handle art that wasn't just pictures, and for that you needed a 'space' rather than a tradi-tional gallery. So plugged in to new directions was he that in 1977 he even closed his uptown gallery. But by the 1980s, again like Peter Wilson, the dream began to disintegrate a little for Castelli. His artists started leaving him, first Rauschenberg for Knoedler, then Donald Judd and Julian Schnabel for Glimcher. 'The first year, I made nine million dollars on Schnabel,' reminisces Glimcher modestly. These were profits hardly calcu-lated to soothe Castelli. But what hurt most was when Glimcher arranged the sale of Jasper Johns' *Three Flags* from the Tremaine collection to the Whitney Museum for $1m. It was deeply wounding to Castelli in view of his long-time championing of Johns and his seemingly privileged relation-ship with the Tremaines. He felt he should have done it. This is a moment that afflicts all art dealers at some point, even the very best: the moment of betrayal by a valued client, the moment when you realise that money counts for more than personal loyalty.

The America that Leo Castelli found in the 1940s and 1950s was a very different place from the America he left behind when he died in 1998. Kirk Douglas recounts the reaction of John Wayne to Douglas playing the role of Vincent van Gogh in the 1956 biopic *Lust for Life*: "'Christ, Kirk,' exclaimed Wayne angrily, "how can you play a part like that? There's so goddamn few of us left. We got to play strong, tough characters. Not those weak queers.'" Bob Monk, who worked for ten years at Castelli's, reflects that 'the United States remained, until the late sixties and early seventies, a somewhat philistine society', a place where 'when a man could quote poetry or look at a painting, he was considered feminine, a fop. But Leo showed a whole group of businessmen that one could epitomise masculinity and still love art and culture... they could watch baseball and still appreciate Jasper Johns.'

Indeed, thanks to the efforts of Castelli, it became a kind of statement of American cultural rectitude to hang a Johns or a Lichtenstein or a Warhol on your wall, and commitment to that ideal of cultural rectitude was not inconsistent with membership of a golf club. This was because Johns or Lichtenstein or Warhol were artists a lot of financiers had heard of. They were hip, they were American, and at the same time their names were also a financial force, like a currency. Not a weak currency either, but one you could have confidence in. Not many dealers have achieved so much.

17

THE CUTTING EDGE

In the twenty-first century art dealing has moved up another gear: today major dealerships such as Gagosian, Pace or White Cube have the resources to dress up their galleries as museums of modern art. They mount exhibitions of museum quality that include major loans, giving context and ballast to the two or three works embedded in the shows that are actually for sale. They are also globalised in their structure and reach: they attract the brightest new artistic talents by offering them shows in their own gallery premises in New York or London or Rome, in Mumbai or São Paulo or Hong Kong. Their salesmen crouch over screens at desks arranged in lines like those on trading floors. Their operations are impressively commercial. Often they are selling paintings not yet painted; when major artists unveil exhibitions of their new work in the leading galleries, it is mostly sold in advance to collectors who haven't yet seen exactly what they are buying. This system of privileged access to an artist's production, controlled by art dealers, is not universally admired. 'Pompous, power-hungry and patronising, these doyens of good taste would seem to be better suited to manning the doors of a night club, approving who will be allowed through the velvet ropes,' wrote Charles Saatchi in 2009. It depends on your view of Saatchi whether you interpret this as the *cri de coeur* of a frustrated collector, or as an act of defiance in a turf war amongst different types of dealer.

Yet as the contemporary art market has become more cut-throat, driven by dealers of extraordinary financial sophistication and commercial

persuasiveness, a cloak of euphemism has descended over their activities. Those who buy and sell art for commercial gain are no longer dealers. They are 'curators' or they are 'gallerists'; occasionally they are 'art professionals'. Curating has a high-minded ring to it. It's what people in museums do. A curator is a kind of quality controller, in it not for the money but for the pleasure of seeing something done supremely well, of putting together collections of the very best. Curating, in fact, is a concept that has been extended in the twenty-first century to cover many aspirational fields. There are not just curators of art, but curators of food (who work in upmarket restaurants), and even curators of people. In New York you can meet hostesses who will tell you earnestly of their pleasure in 'curating social interactions'. In art dealing the effect of calling yourself a curator is to bring your gallery closer to the status of a museum. The erosion of the boundary between the two is a modern ideal of the art trade. In default of the ultimate fantasy of being able to buy the exhibits in a museum, you can at least present your operation, in which the exhibits *are* for sale, in as museum-like a way as possible.

Art dealers also call themselves gallerists. Despite Heinz Berggruen's objection to the word, its popularity has increased as a fashionable term for a dealer with a gallery; except that, rather confusingly, a gallerist does not generally now have a gallery, but a 'space'. A 'space' has a reassuring ring of commercial neutrality, a setting in which you can concentrate on the artistic impact free from the contamination of profit. In theory, anyway. The cordon sanitaire is strengthened by the way that twenty-first-century art dealers do not buy and sell paintings: they 'source' them and 'place' them, terms from which the financial pollutant has also been hygienically drained, implying that the process is an almost exclusively aesthetic one, carried out by philanthropists barely aware of the difference between the price at which they acquire the work and the price at which they find it an appropriate and appreciative home. Occasionally a deal founders because of an overambitious valuation of a piece. The euphemism employed at this point is that the 'art professional' offering it is 'ahead of the market'.

In the interests of making sales, a language has been evolved by that familiar combination of the dealer and the critic to enhance and illuminate the artist's creative process. It seems that prospective buyers are reassured by the imagery of market gardening, and artists are presented as willing tillers of the land. Once they have broken new ground (a groundbreaking work) with something sharp enough (a cutting-edge work) and

planted seed in it (a seminal work), what emerges creates a new feature on the art landscape (a landmark work). Occasionally they may feel moved to pull it all up by the roots and start again (a radical work). Artists have long since abandoned having careers; they now enjoy 'journeys' or 'trajectories'. What they create on that journey or trajectory is sometimes described in quasi-religious terminology as a 'canon' of work, or their corpus, oeuvre or opus. Although the reality of contemporary art is that dealers market their artists as brands, it is better not to use the word. Something more solemn is appropriate. Thus anything supremely emblematic of an artist's brand is described as 'iconic', another word with religious overtones.

Art fairs now loom large in the art world calendar. They are the dealers' riposte to the fearsome power of the auction houses in the marketplace. At the big international fairs – Basel, Miami and Frieze in London for modern and contemporary art, Maastricht for older masters – the world's leading commercial galleries assemble in one place and offer their wares to the globalised art-buying public. Here is the modern equivalent of the fifteenth-century Antwerp 'Pand'. The aim of today's big art fairs is to replicate the excitement, the frenzy even, of a big international auction week in London or New York. Large numbers of rich collectors, critics and museum people do indeed congregate. Local airports are suddenly jammed with private planes. Local restaurants flourish, for if there is one thing that modern dealers relish, sometimes even more than the art they purvey, it is good food and drink. The most successful fairs manage to generate a feverish anticipation amongst collectors. Buyers exert maximum leverage on their reputations and spending powers in order to get privileged access to the exciting new material being unveiled for the first time by the exhibitors. There is a rush to be first into the hall. Fairs are places of enormous art-world activity: primarily commercial, of course, but there is also incessant gossiping, boasting and networking. There are even a few artists present, although their attendance at such events can be traumatic, having been memorably likened to a child unwittingly seeing its parents making love.

The role of those who promote and deal in contemporary art in the twenty-first century received its original momentum two hundred years ago. With the coming of Romanticism and its heroicising of the artist, dealers were given extra impetus to market pictures as the product of inspired individual temperaments, even of genius, rather than as mere decorative objects. And in the hurly-burly of Modernism, it is relevant to

ask how far '–isms' have been invented, or at least encouraged, by dealers as a way of branding art for the education and consumption of the buying public. They offer a security for the collector: the simultaneous branding of the artist as both individualist, as unique temperament, and as part of a branded movement of modern art that relates him to other geniuses. So the '–isms' start following one upon the other: Romanticism (Géricault, Delacroix, Goya, the landscapes of Turner), followed by Realism (Courbet), then Impressionism, which evolves into Post-Impressionism (Cézanne, van Gogh and Gauguin), which acts in turn as the bridge to the great early developments of modern art, Expressionism and Cubism. Simultaneously the emergence of Symbolism, as a different thread, leads on to Dadaism and Surrealism, and ultimately to Pop Art. In the first half of the twentieth century Expressionism and Cubism both evolve into different sorts of abstract art: the former via Kandinsky into the Abstract Expressionism of Jackson Pollock, and the latter via Malevich into the purer geometricism of Arp and Mondrian. So the works they sold were helpfully fitted by dealers into categories, or brands: the temperament that produced it, and the movement in the history of modern art in which that temperament belonged. Thus dealers took a major hand in the evolution of modern art, in the writing of its history. Once again Robert Jensen's maxim with reference to the early promoters of Modernism is relevant: 'the control over the market for art meant the control over history'.

In answer to the questions posed in the Introduction to this book, the evidence of the previous sixteen chapters shows that dealers do sometimes influence what artists produce. There are various examples: Uylenburgh with Rembrandt, Vollard with Derain, Guillaume with Modigliani, Paul Rosenberg with Picasso. But these are short-lived episodes rather than strangleholds exerted over whole careers. It remains true that great artists make great dealers rather than vice versa. Dealers also influence the public's taste in the art of the past. At their most pioneering, they influence the public's acceptance of new art: Durand-Ruel with the Impressionists, Kahnweiler with the Cubists, and Leo Castelli with post-war American art all made crucial contributions to the development of Modernism. Is it a good thing that the progress of art should find itself not just charted but sometimes even directed by the forces of commerce? Is it inevitable? How fair a muse is money? Herbert Read wrote in surprise of the dealer-diarist René Gimpel that 'he possessed an acute sensibility which had not been blunted by a long commerce in works of art'. The assumption that long

commerce in works of art will tend to blunt your aesthetic sensibility is a mistaken one. In many cases it is precisely that 'long commerce in works of art' that gives such dealers the edge. 'Many art dealers are the leading world experts on the artists they deal in,' writes Walter Feilchenfeldt. 'Due to their direct and continuous exposure to art they often have a greater knowledge than museum curators and university professors.' And, one might add, the constant necessity to answer to the commercial imperative sharpens their judgement.

But if the blunted sensibility that Read observes in dealers is actually not aesthetic but moral then perhaps he is closer to the truth. The history of art dealing is the story of many varieties of human folly and duplicity, interspersed with ingenuity, inspiration and occasional acts of heroism.

BIBLIOGRAPHY

Introduction

P. Assouline, *An Artful Life: A Biography of D.H. Kahnweiler, 1884–1979*, New York, Fromm, 1991.

W. Feilchenfeldt, *By Appointment Only: Cézanne, Van Gogh and Some Secrets of Art Dealing*, London, Thames & Hudson, 2006.

R. Hughes, *Nothing If Not Critical: Selected Essays on Art and Artists*, London, Penguin Books, 1990.

G. Reitlinger, *The Economics of Taste: The Rise and Fall of Picture Prices, 1760–1960*, London, Barrie and Rockliff, 1961.

Chapter One

C.M. Anderson, *The Flemish Merchant of Venice: Daniel Nijs and the Sale of the Gonzaga Art Collection*, New Haven, Yale University Press, 2015.

J. Brown, *Kings and Connoisseurs: Collecting Art in Seventeenth-Century Europe*, Princeton, Princeton University Press, 1995.

D. Ewing, 'Marketing Art in Antwerp, 1460–1560', *Art Bulletin*, December 1990.

F. Haskell, *Patrons and Painters: A Study in the Relations between Italian Art and Society in the Age of Baroque*, New Haven, Yale University Press, 1980.

F. Lammertse and J. van der Veen, *Uylenburgh & Son, Art and Commerce from Rembrandt to De Lairesse, 1625–1675* (trans. Y. Rosenberg, M. Pearson and L. Richards), Zwolle and Amsterdam, Waanders Publishers/Rembrandt House Museum, 2006.

N. de Marchi and H.J. van Miegroet, 'Art, Value and Market Practices in the Netherlands', *Art Bulletin*, September 1994.

J.M. Montias, 'Art Dealers in the Seventeenth-Century Netherlands', *Netherlands Quarterly for the History of Art*, 1 January 1988.

M. North and D. Ormrod (eds), *Art Markets in Europe 1400–1800*, Aldershot, Ashgate Publishing, 1998.

Pliny the Elder, *The Natural History* (trans. J. Bostock and H.T. Riley), vol. 5, London, George Bell and Sons, 1855–57.

J. Stourton and C. Sebag-Montefiore, *The British as Art Collectors from the Tudors to the Present*, London, Scala Publishers, 2012.

J. Turpin and A. Warren (eds), *Auctions, Agents and Dealers: The Mechanisms of the Art Market, 1660–1830*, Oxford, Archeopress, 2007.

Chapter Two

T.M. Bayer and J.R. Page (eds), *The Development of the Art Market in England: Money as Muse, 1730–1900*, London, Pickering and Chatto, 2011.

B. Cassidy (ed.), *The Life and Letters of Gavin Hamilton*, London and Turnhout, Brepols/Harvey Miller, 2011.

J. Farington, *The Farington Diary*, 8 vols, London, Hutchinson & Co., 1922–28.

S. Foote, *The Works of Samuel Foote, Esq.*, London, G. Robinson & Co., 1799.

L. Lewis, *Connoisseurs and Secret Agents in Eighteenth-Century Rome*, London, Chatto & Windus, 1961.

L. Lippincott, *Selling Art in Georgian London: The Rise of Arthur Pond*, New Haven, Yale University Press, 1983.

P. Mattick, *Art in its Time: Theories and Practices of Modern Aesthetics*, London, Routledge, 2003.

A. McClellan, 'Edme Gersaint and the Marketing of Art in Eighteenth-Century Paris', *Art Bulletin*, September 1996.

I. Pears, *The Discovery of Painting: The Growth of Interest in the Arts in England, 1680–1768*, New Haven, Yale University Press, 1988.

K. Smentek, *Mariette and the Science of the Connoisseur in Eighteenth-Century Europe*, Farnham, Ashgate Publishing, 2014.

D. Solkin, *Painting for Money: The Visual Arts and the Public Sphere in Eighteenth-Century England*, New Haven, Yale University Press, 1993.

J. Stourton and C. Sebag-Montefiore, *op. cit.*

J. Turpin and A. Warren, *op. cit.*

E. Vigée-Le Brun, *The Memoirs of Elisabeth Vigée-Le Brun* (trans. S. Evans), London, Camden Press, 1989.

H. Walpole, *Anecdotes of Painting in England*, London, G.G. and J. Robinson, 1798.

Chapter Three

H. Brigstocke (ed.), *William Buchanan and the Nineteenth-Century Art Trade: 100 Letters to his Agents in London and Italy*, London, Paul Mellon Centre for Studies in British Art, 1982.

W. Buchanan, *Memoirs of Painting*, London, R. Ackerman, 1824.

J. Farington, *op. cit.*

G. Reitlinger, *op. cit.*

C. Sebag-Montefiore, *A Dynasty of Dealers: John Smith and successors, 1801–1924, a study of the art market in nineteenth-century London*, Arundel, The Roxburghe Club, 2013.

J. Turpin and A. Warren, *op. cit.*

P. Watson, *From Manet to Manhattan: the Rise of the Modern Art Market*, London, Random House Publishing Group, 1992.

Chapter Four

T.M. Bayer and J.R. Page, *op. cit.*

G. Flaubert, *L'Éducation Sentimentale*, Paris, Michel Lévy, 1869.

P. Fletcher and A. Helmreich (eds), *The Rise of the Modern Art Market in London, 1850–1939*, Manchester, Manchester University Press, 2011.

J. Hamilton, *A Strange Business: Making Art and Money in Nineteenth-Century Britain*, London, Atlantic, 2014.

J. Maas, *Gambart: Prince of the Victorian Art World*, London, Barrie & Jenkins, 1975.

N. Wallis (ed.), *A Victorian Canvas, The Memoirs of W.P. Frith, RA*, London, Geoffrey Bles, 1957.

Chapter Five

S.N. Behrman, *Duveen*, London, Hamish Hamilton, 1952.

K. Clark, *Another Part of the Wood: A Self-Portrait*, London, Ballantine Publishing Group, 1974.

R. Cohen, *Bernard Berenson: A Life in the Picture Trade*, New Haven, Yale University Press, 2013.

R. Cumming (ed.), *My Dear BB: The Letters of Bernard Berenson and Kenneth Clark, 1925–1959*, New Haven, Yale University Press, 2015.

C. FitzRoy, *The Rape of Europa: The Intriguing History of Titian's Masterpiece*, London, Bloomsbury Continuum, 2015.

E. Fowles, *Memories of Duveen Brothers*, London, Times Books, 1976.

R. Gimpel, *Diary of an Art Dealer* (trans. J. Rosenberg), London, Hodder & Stoughton, 1966.

G. Reitlinger, *op. cit.*

M. Secrest, *Duveen: A Life in Art*, New York, Knopf, 2004.

G. Seligman, *Merchants of Art: Eighty Years of Professional Collecting*, New York, Appleton-Century-Crofts, 1961.

C. Simpson, *Artful Partners: Bernard Berenson and Joseph Duveen*, New York, Macmillan, 1986.

B. Strachey and J. Samuels (eds), *Mary Berenson: A Self-Portrait from her Letters and Diaries*, London, W.W. Norton and Co., 1985.

Chapter Six

H. Berggruen, *Highways and Byways*, Yelverton Manor, Pilkington Press, 1998.

M. Goldstein, *Landscape with Figures: A History of Art Dealing in the United States*, Oxford, Oxford University Press, 2000.

L.H. Nicholas, *The Rape of Europa: The Fate of Europe's Treasures in the Third Reich and the Second World War*, New York, Knopf, 1994.

D. Wildenstein and Y. Stavrides, *Marchands d'Art*, Paris, Plon, 1999.

Chapter Seven

P. Assouline, *Discovering Impressionism, The Life of Paul Durand-Ruel*, New York, The Vendome Press, 2004.

A. Distel, *Impressionism: The First Collectors*, New York, Harry N. Abrams, 1990.

P.-L. and F. Durand-Ruel (eds), *Paul Durand-Ruel: Memoirs of the First Impressionist Art Dealer*, Paris, Flammarion, 2014.

E. and J. Goncourt, *Pages from the Goncourt Journal*, London, Penguin, 1984.

P. Hook, *The Ultimate Trophy: How the Impressionist Painting Conquered the World*, London, Prestel Publishing, 2009.

G. de Maupassant, *Bel-Ami*, Paris, Victor-Havard, 1885.

S. Patry (ed.), *Inventing Impressionism: Paul Durand-Ruel and the Modern Art Market*, London, National Gallery Company, 2015.

C. Pissarro, *Letters to his Son Lucien*, New York, Pantheon Books, 1943.

J. Renoir, *Renoir, My Father*, London, Collins, 1962.

H.C. and C.A. White, *Canvases and Careers: Institutional Change in the French Painting World*, New York, John Wiley & Sons, 1965.

E. Zola, *L'Œuvre*, Paris, G. Charpentier, 1886.

Chapter Eight

W. Feilchenfeldt, *op. cit.*

R. Jensen, *Marketing Modernism in Fin-de-Siècle Europe*, Princeton, Princeton University Press, 1994.

N.M. Matthews (ed.), *Cassatt and her Circle: Selected Letters*, New York, Abbeville Press, 1984.

R.A. Rabinow (ed.), *Cézanne to Picasso: Ambroise Vollard, Patron of the Avant-Garde*, New Haven, Yale University Press, 2006.

D. Sutton (ed.), *Letters of Roger Fry*, 2 vols, London, Chatto & Windus, 1972.

J.R. Taylor and B. Brooke, *The Art Dealers*, New York, Hodder & Stoughton, 1969.

A. Vollard, *Recollections of a Picture Dealer*, London, Constable, 1936.

A. Wildenstein, *Catalogue Raisonné of the works of Odilon Redon*, 4 vols, Paris, Wildenstein Institute, 1992–8.

D. Wildenstein and Y. Stavrides, *op. cit.*

Chapter Nine

P. Assouline, *An Artful Life*, *op. cit.*

H. Berggruen, *op. cit.*

Y.-A. Bois and K. Streip, 'Kahnweiler's Lesson: Cubism, African Art and the Arbitrariness of the Sign', *Representations*, April 1987.

D. Cooper (ed.), *Letters of Juan Gris,* London, privately printed, 1956.

M. Gee, *Dealers, Critics and Collectors of Modern Painting: Aspects of the Parisian Art Market, 1910–1930*, New York and London, Garland Publishing, 1981.

D.H. Kahnweiler, *My Galleries and Painters* (trans. H. Weaver), London, Thames & Hudson, 1971.

J. Richardson, *A Life of Picasso*, 3 vols, London, Pimlico, 1991–2007.

J. Richardson, *The Sorcerer's Apprentice: Picasso, Provence and Douglas Cooper*, New York, Knopf, 1999.

Chapter Ten
M. Fitzgerald, *Making Modernism: Picasso and the Creation of the Market for Twentieth-Century Art*, New York, Farrar Straus & Giroux, 1994.
R. Gimpel, *op. cit.*
J. Richardson, *A Life of Picasso, op. cit.*
G. Severini, *The Life of a Painter*, Princeton, Princeton University Press, 1995.
D. Sutton (ed.), *op. cit.*
A. Sinclair, *My Grandfather's Gallery: A Family Memoir of Art and War* (trans. S. Whiteside), New York, Farrar Straus & Giroux, 2014.

Chapter Eleven
L. Des Cars, 'Destini Incrociati. Modigliani e Paul Guillaume', *Modigliani e la Bohème di Parigi*, exhibition catalogue, Turin and Paris, 2015.
J. Halperin, *Félix Fénéon: Aesthete and Anarchist in Fin-de-Siècle Paris*, New Haven, Yale University Press, 1988.
M. Hoog, *Catalogue of the Jean Walter and Paul Guillaume Collection*, Paris, 1990.
O. Sitwell, *Laughter in the Next Room: Being the fourth volume of left hand, right hand!*, London, Macmillan & Co., 1949.
Modigliani and the artists of Montparnasse, exhibition catalogue, Albright Knox Gallery, 2002.
Great French Paintings from the Barnes Foundation, exhibition catalogue, Washington, 1993.
P. Watson, *op. cit.*

Chapter Twelve
D. Bathrick, 'Max Schmeling on the Canvas: Boxing as an Icon of Weimar Culture', *New German Critique*, no. 51, 1 October 1990.
S. Bauschinger, *Die Cassirers: Unternehmer, Kunsthändler, Philosophen – Biographie einer Familie*, Munich, Verlag C.H. Beck, 2015.
M. Beckmann, *Self-Portrait in Words: Collected Writings and Statements, 1903–1950*, Chicago, University of Chicago Press, 1997.

H. Berggruen, *op. cit.*

W. Feilchenfeldt, *Vincent van Gogh and Paul Cassirer*, Zwolle and Amsterdam, Waanders Publishers, 1988.

V. Grodzinsky, 'The Art Dealer and Collector as Visionary: Discovering Vincent van Gogh in Wilhelmine Germany 1900–1914', *Journal of the History of Collections*, vol. 21, 2009.

A. Hoberg, *Wassily Kandinsky and Gabriele Münter: Letters and Reminiscences, 1902–1914*, Munich, Prestel, 2005.

F. Klee (ed.), *The Diaries of Paul Klee, 1898–1918*, London, Peter Owen, 1965.

O. Kokoschka, *Oskar Kokoschka Letters 1905–1976*, London, Thames & Hudson, 1992.

C. Mory (ed.), *Ernst Beyeler: A Passion for Art*, Basel, Scheidegger & Spiess, 2011.

P. Paret, *German Encounters with Modernism, 1840–1945*, Cambridge, Cambridge University Press, 2001.

S. Prideaux, *Edvard Munch: Behind the Scream*, New Haven, Yale University Press, 2005.

Chapter Thirteen

T. Bodkin, *Hugh Lane and His Pictures*, Dublin, Nolan, 1956.

O. Brown, *Exhibition: The Memoirs of Oliver Brown*, London, Evelyn, Adams & Mackay, 1968.

P. Fletcher and A. Helmreich, *op. cit.*

F. Fowle, *Van Gogh's Twin: the Scottish Art Dealer Alexander Reid 1854–1928*, Edinburgh, National Galleries of Scotland, 2010.

D. Garstang (ed.), *Art, Commerce, Scholarship: A Window onto the Art World, Colnaghi 1760–1984*, London, P. & D. Colnaghi & Co., 1984.

C.D. Goodwin, *Art and the Market: Roger Fry on Commerce in Art*, Ann Arbor, University of Michigan Press, 1998.

G. Melly, *Don't Tell Sybil: An Intimate Memoir of E.L.T. Mesens*, London, William Heinemann Ltd, 1997.

C.S. Sykes, *Hockney: the Biography*, 2 vols, London, Century, 2011–2015.

Chapter Fourteen

N. Faith, *Sold: The Rise and Fall of the House of Sotheby*, London, Macmillan, 1985.

J. Herbert, *Inside Christie's*, London, Hodder & Stoughton, 1990.

F. Herrmann, *Sotheby's: Portrait of an Auction House*, London, Chatto & Windus, 1980.

P. Hook and K. MacLean (eds), *Peter Wilson and the Art Market of the 1960s and 1970s, an Anthology of Memories,* to be published, 2017.

R. Lacey, *Sotheby's: Bidding for Class*, London, Little Brown & Co., 1998.

G. Reitlinger, *op. cit.*

P. Seale and M. McConville, *Philby: The Long Road to Moscow*, London, Hamish Hamilton Ltd, 1973.

M. Strauss, *Pictures, Passions and Eye: A Life at Sotheby's*, London, Halban Publishers, 2011.

P. Watson, *op. cit.*

Chapter Fifteen

M. Goldstein, *op. cit.*

P. Guggenheim, *Out of this Century: Confessions of an Art Addict*, London, André Deutsch, 1980.

L. Pollock, *Girl with Gallery: Edith Gregor Halpert and the Making of the Modern Art Market*, New York, Public Affairs, 2006.

F. Prose, *Peggy Guggenheim: The Shock of the Modern*, New Haven, Yale University Press, 2015.

T.R. Rogers, 'Alfred Stieglitz, Duncan Phillips and the "$6,000 Marin"', *The Oxford Art Journal*, 1992, p. 9.

Chapter Sixteen

A. Cohen-Solal, *Leo and His Circle: The Life of Leo Castelli*, New York, Knopf, 2010.

K. Douglas, *The Ragman's Son: An Autobiography*, London, Pan Books, 1988.

P. Hackett (ed.), *The Andy Warhol Diaries*, London, Simon & Schuster, 1989.

R. Hughes, 'The SoHoiad: Or, the Masque of Art, A Satire in Heroic Couplets Drawn from Life', *New York Review of Books*, March 1984.

T. Hulst, 'The Leo Castelli Gallery', *Archives of American Art Journal*, January 2007.

Chapter Seventeen

C. Saatchi, *My Name is Charles Saatchi and I Am an Artoholic*, London, Phaidon, 2009.

ACKNOWLEDGEMENTS

I am indebted to a large number of friends and colleagues for help and advice in the writing of this book. I would particularly like to acknowledge Ulla Dreyfus, Ian Dunlop, Walter Feilchenfeldt, Colin Mackay, Duncan McLaren, Katherine MacLean, David Nash, Geraldine Norman, Peregrine Pollen, David Posnett, James Stourton, Michel Strauss, Christopher Simon Sykes; Teresa Bimler, Thomas Boyd-Bowman and Dorian Büchi at Sotheby's; and the ever helpful and efficient staff of the London Library.

COPYRIGHT SOURCES

Colour Plates

1. Kunsthistorisches Museum, Vienna, Austria/Bridgeman Images
2. The Artchives/Alamy Stock Photo
3. Josse Christophel/Alamy Stock Photo
4. World History Archive/Alamy Stock Photo
5. Interfoto/Alamy Stock Photo
6, 9, 10, 11, 12, 14, 16, 17, 18. © Sotheby's
8, 21. classicpaintings/Alamy Stock Photo
13. Private Collection/Bridgeman Images
15. Artepics/Alamy Stock Photo
19. Martin Shields/Alamy Stock Photo
20. GL Archive/Alamy Stock Photo

Text Illustrations

p14. Historical Picture Archive/Corbis/Corbis via Getty Images
pp19, 49, 62, 64, 131, 138, 218. © Sotheby's
p75. George C. Beresford/Beresford/Getty Images
p78. David Seymour (Chim) (photographer), American, 1911–1956 – Bernard Berenson, Borghese Gallery, Rome, Italy, 1955. Gelatin silver print (printed later). Image: 336 × 505 mm (13¼ × 19⅞ in.). The Fine Arts Museums of San Francisco, gift of Ben Shneiderman, 2006.150.17
p95. Paul Slade/Paris Match via Getty Images
p106. Peter Barritt/Alamy Stock Photo
p130. Gosudarstvennyj Muzej A. S. Puskina, Moscow, Russia/De Agostini Picture Library/ Bridgeman Images
p142. Weston/Getty Images
p148. The Art Institute of Chicago, IL, USA/Gift of Mrs. Gilbert W. Chapman in memory of Charles B. Goodspeed/Bridgeman Images
p159. Portrait de Léonce Rosenberg en poilu, 1914. © ADAGP, Paris/photo © Centre Pompidou, MNAM-CCI, Dist. RMN-Grand Palais/Philippe Migeat
p168. Rosenberg family archives/All rights reserved
p195. Painting/Alamy Stock Photo
p233. World History Archive/Alamy Stock Photo

INDEX